THE USA
A HISTORY
IN ART

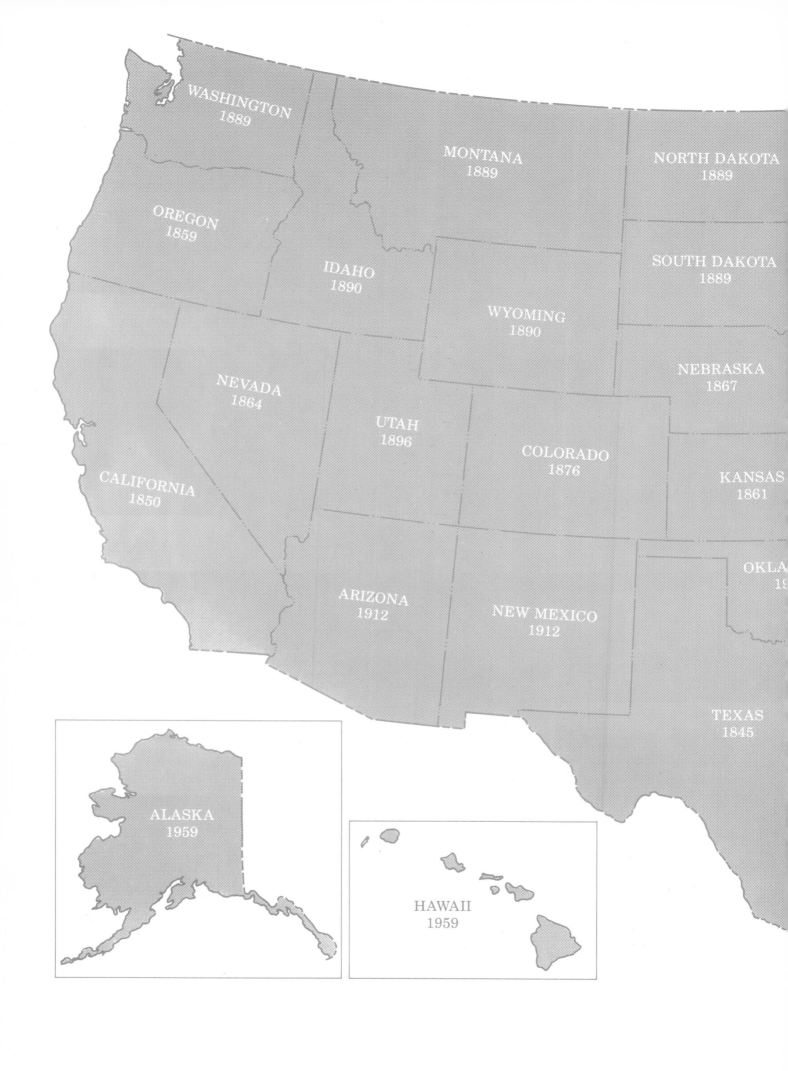

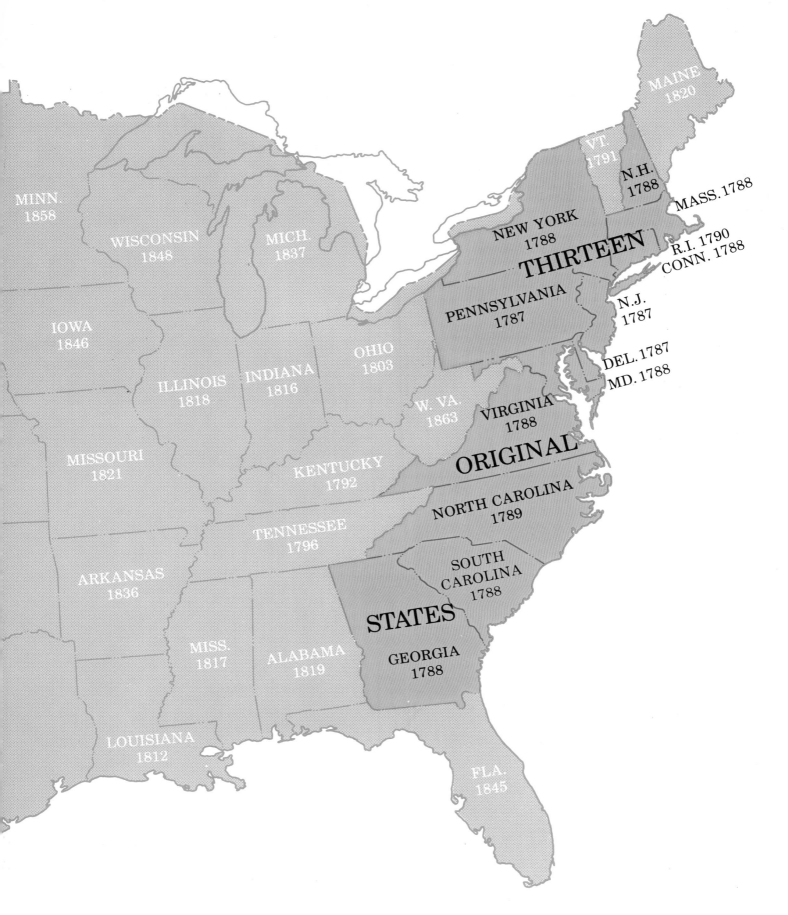

MINN.
1858

WISCONSIN
1848

MICH.
1837

MAINE
1820

VT.
1791

N.H.
1788

MASS. 1788

NEW YORK
1788

THIRTEEN

R.I. 1790
CONN. 1788

IOWA
1846

ILLINOIS
1818

INDIANA
1816

OHIO
1803

PENNSYLVANIA
1787

N.J.
1787

DEL. 1787
MD. 1788

MISSOURI
1821

KENTUCKY
1792

W. VA.
1863

VIRGINIA
1788

ORIGINAL

NORTH CAROLINA
1789

ARKANSAS
1836

TENNESSEE
1796

SOUTH
CAROLINA
1788

STATES

GEORGIA
1788

MISS.
1817

ALABAMA
1819

LOUISIANA
1812

FLA.
1845

The USA THEN and NOW

The USA

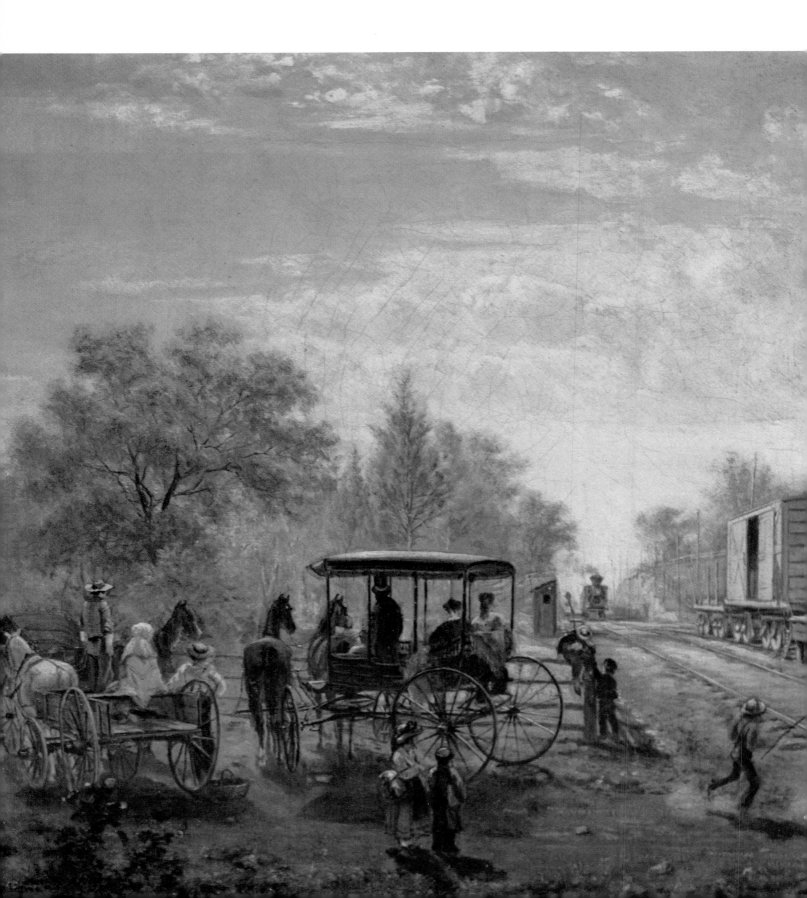

A HISTORY IN ART *by Bradley Smith*

A Gemini Smith Inc. Book *Doubleday & Company, Inc., Garden City, New York*

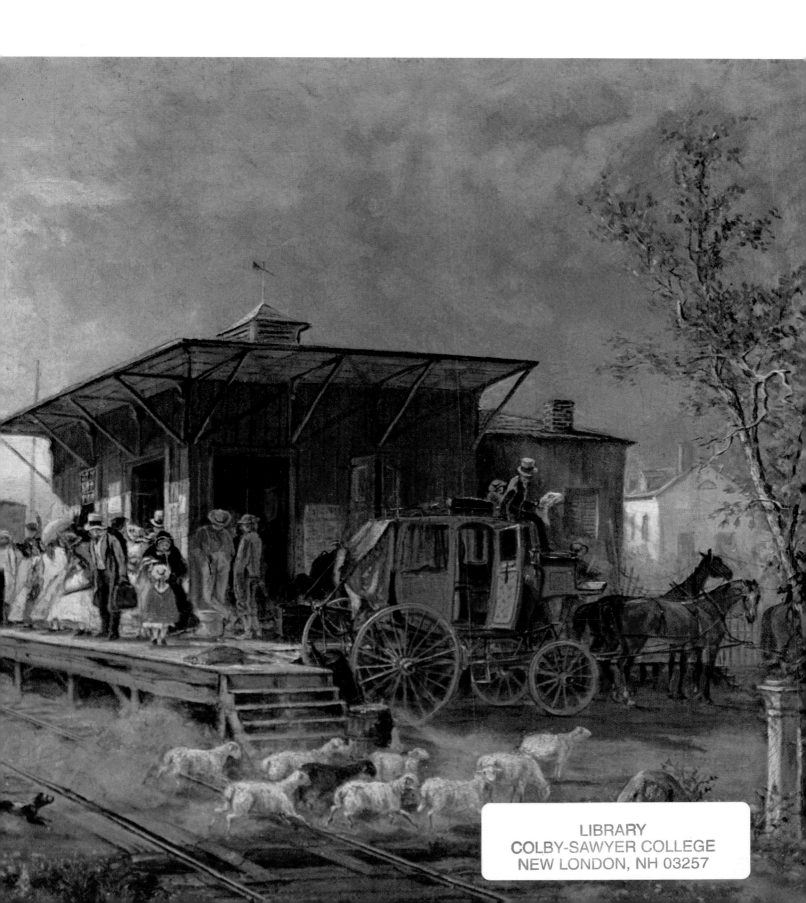

Art Direction and Design:
Bradley Smith

Text:
Bradley Smith
Booton Herndon
Michael Smith

Consultants:
Dr. Louis C. Jones and Agnes Halsey Jones
Dr. David Burner Dr. Robert D. Marcus

Production Director:
Sharon Weldy

Graphics Consultant:
Andy Lucas

Manuscript Preparation:
Florence Kronfeld

Color Separations:
Toppan Printing Company of America

Printing:
Kingsport Press

Typography:
Litho Art Service, San Diego

This book is set in Century Schoolbook. It is
set with word and letterspacing instead of end
of line hyphens for easier reading.

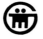

ACKNOWLEDGMENTS

*In the Works of Art section beginning on page 288 the
paintings and sculpture used in this book are
described and the museums and private collectors who
contributed are identified. Yet the author wishes to
make grateful acknowledgment of the special
cooperation and assistance given to him as he traveled
about the United States in search of the art that made
the book possible.*

*In the West: Dr. Carl Dentzel, Southwest Museum,
Pasadena; Mr. and Mrs. Glenn E. Quick, Sr., Phoenix,
Arizona; Lawrence Dinnean, The Bancroft Library,
University of California, Berkeley; George Neubert
and Susan Burns, The Oakland Museum; Louise
Vessell-Fiellen, E. B. Crocker Art Gallery, Sacramento;
Mr. and Mrs. S. H. Rosenthal, Jr., Encino, California;
Liz Brady, Department of Commerce, State of
California; Rick Kiefer, Division of Tourism, State of
Alaska; Nancy Moure, Los Angeles County Museum of
Art; Edward Goldfield, Goldfield Galleries, Los
Angeles; Henry G. Gardiner and Martin E. Petersen,
Fine Arts Gallery of San Diego; Brewster C. Reynolds,
San Diego Aero-Space Museum; and Peter C. Davis,
Los Angeles.*

*In the South: William A. Fagaly, New Orleans
Museum of Art; Jay P. Altmayer, Mobile, Alabama;
and George E. Jordan, William R. McHugh, New Orleans.*

*In the East: Kathleen Kissane, National Gallery of
Art, Washington; Carol Cutler, National Portrait
Gallery, Washington; Harriet Baumgarten, Library of
Congress, Washington; Marge Byers, National
Collection of Fine Arts, Washington; Peter C. Welsh,
New York State Historical Association, Cooperstown;
James J. Heslin and Martin Leifer, The New York
Historical Society, New York City; Lucretia Lucky,
Karin Peltz, Laura Giese, and Sue Reed, The Museum
of Fine Arts, Boston; Parke Rouse, Jr., Colonial
Williamsburg Foundation, Williamsburg, Virginia;
Karol Schmiegel, The Henry Francis Du Pont
Winterthur Museum, Winterthur, Delaware; Thomas
Armstrong and Patricia Hills, Whitney Museum of
American Art; Museum of the City of New York; Bob
Willis, Division of Tourist Development, State of
Maryland; Margaret Harrington, The Warner House
Association, Portsmouth, New Hampshire; Donna D.
Orlans, New School for Social Research, New York;
Herbert A. Goldstone, New York; Coe Kerr Gallery,
Inc., New York; Arthur G. Altschul, New York;
Edward Shein, Providence, Rhode Island; Richard E.
Kuehne, West Point Museum, U.S. Military Academy;
E. V. Thaw, New York; Mrs. McCook Knox, Washington, D.C.*

| Contents | ACKNOWLEDGEMENTS | 6 |

PREFACE

THE USA: A HISTORY IN ART is an informal sketchbook designed to show how the United States looked to artists who created its image in their own way, beginning in prehistoric times and continuing to the modern period. It is not a formal history of the United States. It is not a definitive work on the economics, politics, or any phase of American history or culture — not even art. Not all of the exceptional events, important personages or turning points in the history of the American people could possibly be covered in any one work, let alone one centered on the visual approach, and no attempt has been made to do so. The purpose of this book is rather to evoke the spirit, the movement, the energy and restless drive of the people who settled, fought for, and nurtured the growth of this great country. It is a mosaic of impressions of the USA as recorded by talented eyewitnesses, a broad variety of experiences that make the history and culture of the United States unique. Running through the mosaic are two interwoven elements, one the reflection of life as each individual artist saw it, the other the spirit of the era in which he lived and worked.

The very first men and women to occupy the continental United States began a visual tradition that has continued for more than 2,000 years. The first Americans, referred to by Columbus as Indians in his erroneous belief that he had reached India, left a record of their culture etched on rocks sacred to them, in the caves that they occupied, and in the many varieties of portable art and artifacts such as arrow points, knives, necklaces and effigies of birds, animals, flowers and people, all created before the European discovery of America.

The explorers and settlers who came in from the East also left a distinct visual record of the past. During the past 500 years in the history of the continent, the past two centuries in the history of the USA itself, painters, sculptors, etchers and lithographers have documented, sometimes realistically, sometimes imaginatively, the changing life styles and the impacts of great events they themselves experienced or observed.

Tragedy, triumph, compassion, heroism and views of the human comedy are seen through the eyes of the artists, themselves sensitive, passionate people. These artists, working within their own chronological perimeters, recorded significant events in our history, as well as the men and women who made those events significant. Their efforts show what the country and its people looked like in the various periods of its growth.

The interested observer will find sudden insights into the succeeding cultures, revealed in unexpected detail: a band of slaves escaping through a swamp, politicians having a drink together on the eve of an election, George Washington at home with his family, a trapper moving his family down river in a canoe, a painted Indian with his painted horse, a steelworker portrayed on the day he took out his first citizenship papers. Nor did the artists neglect the mainstream of US history: the farmers who stood firm against the British at Lexington and Concord, General Jackson at the Battle of New Orleans, Admiral Perry's ships approaching the coast of Japan, a sailor sacrificing his life for that of Lieutenant Stephen Decatur, the young Marquis de Lafayette at the age of 24, conferring with his friend George Washington.

All of the artists who painted the canvases reproduced in this book were Americans except for those visiting Europeans in the early chapters, and a German soldier impressed by the D-Day flotilla off the coast of Normandy. All the paintings were made during the period of the event depicted. Not all periods in art correspond with historical periods, yet the artist does mirror the times, not only in what he elects to paint but in the way he paints it.

The paintings shown are reproduced unretouched, and in actual time sequence so far as is possible. Some paintings were made closer to the actual event than others, so minor liberties have been taken. As it would be impossible to cover 500 years of history in words and reproductions of art in the pages of one book, certain gaps occur, and some whole eras have been telescoped.

While THE USA: A HISTORY IN ART is neither a political nor a cultural history, it has some of the elements of both. Its purpose is to give the reader and observer an overall view of the history of the United States of America from prehistory up to the end of World War II and the beginning of the space age.

Bradley Smith

INTRODUCTION TO THE ART OF THE USA

The oldest and most readily discerned constant in American painting is the emphasis on the fact, on an uncomplicated vision, on a realistic statement created by the truly recorded flow of line. Our artists, predominantly, have sought to be good and careful reporters and this is what their public expected of them.

This was true of the prehistoric Indians who painted men and animals on rocks. The early explorer-scientists, like John White and Jacques LeMoyne de Morgues, were primarily determined to carry back to Europe accurate visual records of the flora, fauna and natives. The early limners were guided by literalness; their reputations and success depended on creating a good likeness of which the sitter's kinfolk could say, "That's him, all right." When Thomas Cole said, in effect, that art should be subservient to the subject and never an end in itself, he was applying the same principle to landscape. Consider the popularity of genre painting with its meticulous description of everyday details and, later, the popularity of *trompe l'oeil.*

We are always uncomfortable with generalizations about so diverse and varied a people as ourselves, but it is safe to say that Americans have been more at home with things than with ideas, with facts than with philosophies — what we could touch we understood. There were, of course, painters who worked outside this literal vision: Allston, Rimmer, Davies, Ryder, Blakelock, but these were dreamers, romantics; as a people we have distrusted such, whether in art or in politics. This predilection for the recognizable fact helps to explain why Impressionism had relatively little impact on American painting; it was too subjective, too likely to lean on unfamiliar techniques. Up until World War II American art stressed the conservatively recognizable, the non-innovative. Along with this has gone a strong awareness of light and atmosphere. One sees the play of light on the subject first in Copley, but Charles Willson Peale, Cole, Durand, Mount were equally responsive to it, while Bingham, Homer and Johnson convey a sense of barometer that is often striking. Light and atmosphere are also facts and thus comprise a component of the tradition.

Through the Colonial period and for the first half century of the Republic, American painting was dominated by portraiture. This was what our citizenry expected of artists and the only kind of art for which they had much use. Until the popularity of landscapes and scenes of everyday life (genre) widened his opportunities, painting portraits was the one way an artist could make a living, and no matter how much he might yearn to paint something else, that's what he did.

Some of the colonial painters, like other craftsmen, came across the sea to try their luck. Others were natives who were trained as sign painters or decorators and moved on to something they hoped would be more profitable. They learned from each other, from engravings of English portraits and by trial and error, for there were no academies and no museums and few examples of good portraits for them to study.

As it was the face, the true likeness, that counted, they worked in a late medieval tradition which was flat and strongly linear, dependent upon vigorous design and color. Despite the limitations of this style a surprising number of painters achieved a projection of inner character that reaches to us across the centuries.

There was a quality of unadorned directness in early American portraiture that puzzled the British and Europeans. An English critic, writing of Gilbert Stuart, summarized American style when he stated, "When we speak of him as

the most accurate painter, we mean to say that having a very correct eye he gave the human figure exactly as he saw it without any attempt to dignify or elevate the character; and was so exact in depicting its lineaments that one may almost say of him what Hogarth said of another artist, 'that he never deviates unto grace.' " For grace, read flattery.

For more than half a century Benjamin West was the bridge between European tradition and American creativity. To the primitive strength of the young Americans who studied with him in London he added the refinements made possible by knowledge of long established painterly techniques. Many of them went home to make major contributions to our art history: Gilbert Stuart, Charles Willson Peale and John Trumbull among others.

A generation before, on the eve of the Revolution, the foremost painter in the Colonies, John Singleton Copley, had left America never to return. Lloyd Goodrich has pointed out that in London his "native style gave way to a more knowledgeable elegance but without the primitive power of his American work. Thus America lost her greatest artist, to add another good painter to the British School." The European experience for American artists always held the danger that in refining the style, the rugged emphasis on content would be vitiated and the result drained of its vitality.

Like the seventeenth century Dutch portraitists, the Americans gave us a great body of information about the world in which their sitters lived. Portraits become documents detailing furniture, costume, rugs, draperies, fenestrations, wall hangings, jewelry, implements of their occupations.

After 1825 the proportion of portraits to the total body of paintings dropped as it became possible for an artist to sell other kinds of pictures. The camera, after its invention in 1839, radically reduced the painting of portraits; it was quicker, cheaper and in its way closer to reality.

As for history painting, despite the intense nationalism of the new country, there were remarkably few paintings of any quality recording the Revolution, except for those few completed by John Trumbull. This paucity is in contrast to the many popular histories of the war, the *ex post facto* illustrations and the ubiquitousness of patriotic iconography — the flag, the eagle, Miss America, Liberty, George Washington. Exuberant patriotism — or vulgar chauvinism, as our critics saw it — was everywhere except in the works of our established artists.

The War of 1812 produced some respectable paintings of sea battles by Thomas Birch and others, but nothing came out of the Mexican War except a few paintings in Texas and some lighthearted sketches by that rascal, Samuel E. Chamberlain. The Civil War was best recorded by its photographers except for the genre pieces of life behind the lines done by Eastman Johnson and Winslow Homer. By the time of the two World Wars our government was sending artists into the field to paint what they experienced.

The Age of Jackson saw two radical new directions in American painting, the creation of a body of work which described the everyday life of our everyday citizens and the discovery of the American landscape.

The first of these, genre painting, would appear to be in response to a climate of opinion which Jackson and, more especially, the Jacksonians created. The farmers, the working men, the families beyond the tidewater demanded to be heard and seen, and in the work of a new group of artists they *were* seen, in their shirtsleeves and their aprons. Ironically, the pattern was set by a Russian, Pavel Petrovich Svinin, and a German, John Lewis Krimmel, painting in the Philadelphia area in the 1820's. By the 1850's scores of street scenes, gatherings in village taverns, political rallies and poor women's kitchens, and every aspect of farm life were on canvas.

In an age when the issue of slavery was darkening the political sky, the Blacks were seen as gentle, happy observers, off to the side of life. With two or three exceptions there was no whisper of the slave issue. (The truth of the white laboring classes is similarly absent.) Like so many other things, all this changed with the Civil War; after that the Negroes and their ways of life became central to the subject matter. The urban poor and immigrants, factory workers and tenant farmers replaced the euphoric picture of a land where nobody cried.

After almost dying out in the late nineteenth century, genre painting came back to vigorous fruition in the twentieth century with the rebels around Robert Henri and again with the Midwest painters like Curry, Benton and Wood. Here is the statement of simple facts, realistic reportage, paintings which Americans who are not trained in the arts can enjoy and in which they see themselves.

If genre was nourished by political and social forces, landscape painting owed much of its acceptance to religion and poetry. One can say that there was almost no religious art in Protestant America in the 18th and 19th centuries. Girls were taught to do water color and needlework pictures of scenes from the Bible, but art welling up from religious emotion was unknown except in the Spanish and Catholic Southwest. Before 1825 there had been topographical artists and forerunners like

Thomas Doughty but no artists to whom landscape was a profoundly moving, religious experience. Romantic poets like William Cullen Bryant and James Fenimore Cooper, on the other hand, were fusing the love of nature and the love of God. In the 1830's comes the articulation of the transcendental view by Emerson and Thoreau. By 1825, when Thomas Cole's views of the Catskills were discovered, there was already an intellectual awareness ready to appreciate his work. Just as genre declared the average American and his everyday life worthy of the artist's best abilities, so the landscapists said, ''Look about you! The mountains, the wildernesses, the valleys are beautiful to the eye and evidence of God's grace." No longer was the wilderness an enemy to be cut low but a thing of beauty in which Americans could take pride. Landscapes replaced portraits as the staple of the artist's production.

The original impulse for landscape painting centered in the Catskills and the Hudson Valley (hence the term "Hudson River School") but it soon spread east to the Connecticut Valley and the White Mountains, west to the valleys of the Mohawk and Genesee, thence to the prairies and the Rockies. By the second half of the century, landscape, genre and contemporary history were merged with scenes of the migrants crossing the plains and mountain passes, their wagons and gear carefully delineated, with Indians, buffalo and death often in the background.

The thirty years following the Centennial Exposition found Europe dominating American painting for the first time. From West's time onward, some of our artists had studied in Rome or London, later in Düsseldorf, and had come home to blend their newly learned techniques with the directness of their native tradition. But now only those who studied in the conservative academies of Paris were acceptable. Their work was more painterly than that of their predecessors, but they had lost the native touch; their paintings were bland and genteel, carefully conceived lest they offend the corseted sensibilities of the Victorian upper class. The great mogul collectors were putting their money into old masters. The productive relationship between artist and patron which had been so remunerative for the landscape painters was over, and the popular support which had come to the genre painters from the lotteries of the American Art Union was outlawed. Some of the more successful and more completely Europeanized — Whistler, Cassatt and Sargent, for example — never came home. Yet it was in this very period that two of the giants of American art did work which towers above their times and their contemporaries.

Both Winslow Homer and Thomas Eakins were loners. Working outside the fashionable pattern of their time, they hated and eschewed affectation. Homer is a painter of the out-of-doors, the silent Adirondack lakes, summer life along the coast and women and children in everyday scenes, but especially of the sea and the light on waves and the light on men who make their living from the sea. One senses the intense artistic concentration that produced one powerful masterpiece after another. Eakins is a prober, carefully calculating the mathematical factors which underlie his composition, studying human anatomy in the medical school so that when he came to do a portrait he would sense the whole structure of his sitter to the very marrow. For him the nude, male or female, was the first step in art and a source of beauty and artistic understanding. He was tuned to the scientific progress of his time; he was, as Walt Whitman said, "a force." As the years pass both Eakins and Homer become more truly a national monument.

John I. H. Baur has pointed out that in the early twentieth century American artists made two significant discoveries. First, that American life held many areas worthy of their attention which had not been explored; second, that art could be created solely in terms of form and color. They discovered the city as a place of dark beauty, a landscape newly found. A group of newspaper illustrators formed around Robert Henri in Philadelphia. When John Sloan, William Glackens, Everett Shinn and George Luks, members of the group, went on to Greenwich Village, in New York, they already had eyes trained to see urban detail and were synchronized to the city's beat. They, with the younger George Bellows, moved painting out of the Victorian parlor and away from politeness into the crowded, colorful life under the elevated, among the pushcarts and in the prize fight arenas. There was in their work a throbbing sense of human vitality. As Luks said, "Guts! Guts! Life! Life! That's my technique."

The scorn of their professional contemporaries was one of the reasons why these men, plus other unorthodox artists of the time, notably Marsden Hartley and Arthur B. Davies, conceived the Armory Show of 1913, a landmark in the history of painting in America. Sixteen hundred paintings by more than 300 Americans, many of them young and hitherto undiscovered, were shown. But the most explosive element was the International (mostly French) Section, where for the first time an unprepared public came face to face with the Impressionists, Post-Impressionists and the Cubists. For decades each new movement in art was shouted down by a philistine press.

But a new complex of styles, shuttling back

and forth across the Atlantic for its origins, was emerging. The point at which the native realism and the European abstraction came into a single focus is perhaps exemplified by Sheeler. He is very American in his strong appreciation of man-made objects, Shaker chairs, tables, factories, machinery, and he paints them always recognizably but with an awareness of Cubism.

With the Depression, many of the artists registered their anger with the social system and their strong sympathy with strikers, the unemployed, the Okies, the Blacks, all those whose lives were being crushed by the economic disaster. For the first time the national government, through the Federal Arts Project, hired artists on a large scale to do murals, landscapes and to record the native designs our people had developed in making everyday things.

Like the 1830's, the 1930's were characterized by self-examination and reassessment on a national scale; one of the results of this was a new regionalism in literature and art. John Steuart Curry, Thomas Hart Benton and Grant Wood created paintings rooted deeply in the Western past, its legends, heroes and folkways. There was laughter here, sometimes the great guffaw, sometimes the ironic smile. In the East these men were balanced by a brilliant trio: For Reginald Marsh the great theme was the indomitable vitality of the urban poor; for Charles Burchfield there was a haunting attraction in dreary working class houses, Edward Hopper chose and made memorable the everyday sights of gas stations, diners and rows of identical houses. Whatever magic these men may have cast over their subjects, they were dealing with the recognizable, the realistically present object.

A generation of highly creative artists were driven to America by Hitler; once the war was over they played an important part in the new experiments in painting which puzzled and intrigued a public that sometimes suspected its leg was being pulled. And the new "young Turks," like William de Kooning, Franz Kline, Robert Motherwell and ultimately the most famous, Jackson Pollock, sought to do in oils what Proust and James Joyce had done in prose: to let the mind have its free play, following no preconceived design but encouraging the paint to speak for the subconscious. But there were scores of other approaches besides this profoundly subjective one. Abstraction in all its possibilities was tried and often quickly discarded.

This radical experimentation caught the attention of artists and collectors in Europe and Asia and by the 50's New York was the art capital of the world. On the other hand, the taste of the people was slow to accept the new forms. The most popular artist in America was Andrew Wyeth, whose cool, silent, simple statements were a nostalgic but genuine refuge from the deliberate discordances of his contemporaries.

Thus, finally, we come back to a strong emphasis on the fact, on the importance of light, on the significance of human character recreated by paint on canvas. This is the tradition of Copley, Cole, Bingham, of Homer and Eakins — this is the essence of American painting.

Louis C. Jones and Agnes Halsey Jones

INTRODUCTION TO THE HISTORY OF THE USA

America began as a land of dreams. The first explorers and settlers could only understand these vast and mysterious continents as projections of their hopes and fears. Here might be realized the utopias of medieval legend: "Antilla," "Lyonesse," the "Islands of the Blest," garden lands without care or evil inhabited by Christian brothers or the lost tribes of Israel somewhere far west of the Straits of Gibraltar in the unknown Atlantic. Yet the New World was also primitive and dangerous territory: Early accounts tell of cruel pagans — murderers and cannibals, and of wild furies of nature — monstrous rivers, hideous jungles, mountains of ice. Most contradictory of all, America was Eldorado, the land of gold, an inexhaustible source, it seemed, of that softly ambiguous metal which promised wealth and ease but served principally to release the vice and cupidity of ferocious Europeans whose civilized restraints could all too conveniently be left on the Atlantic's other shore.

The seventeenth-century English men and women who began the European settlement of what is now the United States appear to have been far more sober folk than the Spanish *conquistadores* of the century before. Yet they too stretched their vision to fit the horizons of the New World. They projected elaborate schemes for the societies they would build in the New World and watched uncomprehendingly as their plans misfired. The English philosopher, John Locke, visualized a hierarchic nobility in what became South Carolina, but the raw wilderness produced none of the "landgraves" and "Caciques" described in his *Fundamental Constitutions*. William Penn labored over his "Holy Experiment," but Pennsylvania proved less holy and considerably more experimental than he had hoped. John Winthrop and his fellow Massachusetts Puritans found that their "citie on a hille" lost its grand vision among those in the valleys, who became engrossed in their own struggles. America began as a land that fulfilled private dreams but disappointed public expectations, its history a search for one or another lapsed utopia. Facing an uncertain future in a spacious continent, Americans looked for self-definition in the series of pasts they were abandoning in the forward thrust of their lives.

At first they thought of themselves as Englishmen, at the center of the English Reformation, of the eighteenth-century religious revivals, of the great wars with France for Empire. Virginia gentlemen sent their children to English schools when they could, read English books, and imported English goods. This world of colonials striving so hard to be English is in fact the colonial America celebrated by the Daughters of the American Revolution and the illustrators of American history texts — the world of Benjamin Franklin, maple furniture, and Mount Vernon. These first "Americans" during the troubles of the 1760's and 1770's claimed the rights of Englishmen and defended the British Constitution even as their American nationalism began to flourish.

The culture of this new revolutionary age seems strikingly more modern than the world of the seventeenth and early eighteenth century. The influence of the European Enlightenment significantly altered religious sensibilities: Belief in the practical value of science and the rational capacity of people to organize their lives

decisively shifted American thinking into a more secular course. Instead of being a religious society tormented by worldly ambitions, we rapidly moved toward the modern position of a distinctly secular and materialistic society touched frequently by pangs of idealism and conscience. The church remained an important institution, but political organizations, and scientific, educational, and philanthropic groups like the American Philosophical Society, along with organs of secular culture such as newspapers, journals, and schools, edged religion to one side. And a burgeoning nationalism would soon impart a separate character to the United States of America.

The struggle for independence shows many facets. From one perspective it reflects a radical change in European diplomacy: from another a revolution in national identity, in assumptions about the distribution of power within a society, and even in theories of human nature — for many had denied man's ability to create a new form of government. Most important, the war ushered in an age of democratic revolutions throughout the world.

The Revolutionary generation proved itself in the organization of a new government. We consider the Constitution to be the great achievement of the age, but it is more fruitful to see a lengthy process of constitution-building which spanned half a century: the assertion of rights in the Stamp Act crisis and the Continental Congresses, the evolution of an American diplomacy, the Articles of Confederation, the Northwest Ordinance, the Constitution itself, the many precedents of the Washington administration, the Hamiltonian policy, the rise of political parties, the orderly transition of government in 1800, and the work of the Supreme Court under Justice John Marshall. Our American Constitution was not produced in one meeting in Philadelphia but in the entire experience of the Revolutionary generation.

The men who guided the destinies of the United States of America through the violent political quarrels in the first decades of the nineteenth century were bound together by a common commitment to American nationality. Foreign policy dominated the politics of the early Republic as the wars of the French Revolution and the Napoleonic era split Europe into armed camps. While American sympathies in this struggle divided, all the early presidents subordinated their ideological concerns to American national interests. John Adams upset his own party by making peace with France in 1800; Jefferson went back on Republican ideology to purchase Louisiana in 1803. The fragile young Republic avoided war in its infant years when war threatened to destroy the slender stalk of national growth. A new generation, however, no longer intimidated by European powers, determined to establish its independent place in the world. The stalemate with Great Britain in the War of 1812 showed achievement enough; the victory at New Orleans under General Andrew Jackson was sheer glory, even though it occurred after the peace treaty. The United States by 1815 had become securely independent. Its borders now stretched far beyond the Mississippi, its national identity and governmental structure were largely set, its relations with foreign powers steered a calm course, and the nation turned its mind and energies to settling the West, creating wealth, and building its institutions.

The expanding nation found an important symbol in Andrew Jackson. Rough, yet aristocratic, imperious yet egalitarian, Jackson seemed to represent the aspiration of the rising West and the democratic longings of the common man. Before he won the presidency in the election of 1828, the number of voters already had increased vastly, elected offices had multiplied, and the undemocratic caucus system had lost much of its influence. His election injected this subterranean social process into the nation's consciousness. All men, the Jacksonians proclaimed, could hold office, and no one man should control the sources of opportunity. This ideology, however inadequately realized in practice, rapidly came to dominate American perceptions of their society.

Jackson also represented ardent nationalism. In diplomacy this meant the Monroe Doctrine and Manifest Destiny; in economic policy, even Southerners like John C. Calhoun, later to be identified with States' Rights, endorsed national financing of economic improvements such as canals and roads. In literature and the arts, Americans sought escape from what they considered the shackles of European tradition. William Sidney Mount's vision of the rural scene immediately about him met the new standard Ralph Waldo Emerson had announced to the assembled Harvard scholars in 1837, that their subject must be the society around them: "the familiar, the low . . . the meal in the firkin; the milk in the pan; the ballad in the street."

The nationalism of the earlier nineteenth century gave way to antebellum sectionalism over the thirty years leading to the Civil War. Both North and South resolutely moved westward, but an economy and society arose in the developing Southwest of Alabama, Mississippi, and Louisiana different from those in the new Northwest of Ohio, Illinois, and Wisconsin. Plantations and slave labor challenged farms and free workers; agrarian aristocrats dominated one society, cities, entrepreneurs, and lawyers the other; one

produced conservative religion and fears of change while the other spawned liberal religions and reform movements. Beneath it all lay a fundamental — and national — antipathy to the Black race which made Southerners fearful of the abolition of slavery and Northerners committed to halting its expansion.

The struggle over slavery shattered the Republic's vulnerable national institutions one after another. Churches, charities, and cultural societies divided into Northern and Southern wings. National parties broke in half. Finally, a new political party, the Republicans, with virtually no support in the South, swept to power in 1860, electing Abraham Lincoln President.

Lincoln soon replaced Jackson as the dominant image in American life. The new President shared the contradictory attitudes toward slavery and toward Blacks that troubled the national conscience, but he also rose above them to champion and sustain a Union dedicated to liberty, a nation overtly committed to the eventual equality of Afro-Americans. Emancipation and the final repression of sectional ambitions set the mold for a transformation of the nation into a vast industrial power which emerged rapidly from the ruins of war.

The Civil War left the nation with two major commitments: the sectional economic ambitions which had triumphed with the Union cause, and the defense of Negro rights in the South — the second a commitment never honored. The policy of radical reconstruction in the South failed, leaving in its wake a memory of noble experiments, a tradition of terrorism and race warfare, and a chronic economic problem. The reconstruction of the Union into a new industrial nation, however, dramatically succeeded in the North: Protected by tariff walls, buoyed by a national banking system, and extended by vast railroad subsidies, the industrial evolution which had begun in about the 1840's took a vast leap forward. It created new industries, farms and jobs and a new class of multimillionaires; at the same time, it gave rise to an orgy of corruption, materialism, and economic instability that decimated the older agrarian and commercial America.

By the 1870's industrialism had become the new Eldorado, but not until depression hit in 1873 did Americans begin to think of its costs, and only in 1877 did its possible social effects come home to the middle class with the violence of the great railroad strikes in that year. This disturbance — followed by the Chicago Haymarket riot of 1886, the steel and mining strikes at Homestead, Pennsylvania, and Coeur d'Alene, Idaho, in 1892, and especially the Pullman, Illinois, railroad strike of 1894 — marked a shift from the individual violence of the American frontier to a new form of mass violence. Faced also with rapid growth of corporations, changes in technology symbolized by such inventions as the automobile and the electric light, an extraordinary mushrooming of cities, and a rapid increase of immigrants, Americans apprehensively perceived a large-scale erosion of old ways and the inauguration of strong new social currents whose direction they could not predict.

Vast new social changes engulfed the old comfortable Republic, and social thought, literature and politics all struggled unsuccessfully to come to terms with the sweep of events. A naive philosophy of social Darwinism which saw society as the product of impersonal forces rather than human decisions fit the feeling of helplessness, but became an utterly futile stab at social analysis. Most writers adopted sentimental conventions and a covering of gentility to avoid those new areas of life they could not imaginatively grasp. The greatest American writer of the age, Henry James, had to flee to Europe to view America at all. Only in the 1890's did a more adequate realism slowly invade literature through the influence of journalism, producing a writer like Theodore Dreiser whose vision, although crude and flawed, was at least adequate to urban America.

National politics in the late nineteenth century abysmally failed to cope with the flood of problems it faced. The hope of gaining control over the forces of industrialism seemed confined to minor parties and visionaries who dreamed much and achieved little. Then a cruel depression came in the 1890's. Governmental response to it became the theme of the remarkable electoral battle of 1896 when William Jennings Bryan argued for new, experimental approaches to social problems. But Bryan based his campaign on a single issue — bimetallic currency — of interest only to a rapidly diminishing segment of the agrarian population. Bryan's defeat by William McKinley and the end of the depression brought a whole new role for the American middle class. The fear of social revolution and the sense of helplessness and political tension which dominated the nineties gave way to an optimism expressed in two major ways: by an outward thrust into the world — the Spanish-American War, and after Theodore Roosevelt succeeded McKinley by a new effort at domestic reform.

This new reform movement called progressivism marked the point at which the capacity to organize, to think through social problems, and to reform the political and economic systems finally caught up with the problems of industrialism. Men believed they could organize city governments, control giant corporations, eliminate corruption, and improve

the life of the less fortunate. The Progressive Era renewed the sense of political experiment that had so sharply marked America in its earliest years. The period showed a growth in the power of the presidency, and fostered organizations dedicated to charity and the improvement of the quality of life. With it came a rich harvest of social thinking, seminal political journalism called "muckraking," and useful political leadership from men like Theodore Roosevelt, Robert M. La Follette, and Woodrow Wilson.

With its entry into World War I, the USA hesitantly and unhappily entered the modern age in which we live. The war, begun in a burst of nineteenth-century idealism, ended in a massive twentieth-century disillusionment. Americans glimpsed the responsibilities of power and, finding them too great a burden, tried to withdraw. The nation then left Europe largely to its own fate and only discovered a generation later that America's destiny had also been left at the peace table. After 1914 Europeans knew they lived in an age of total war and never doubted that war could come again; Americans learned more slowly the true nature of the postwar world.

After the breakdown of prewar values, Americans began to search again for political identity, unity, and purpose, in spite of or perhaps because of their social, economic, and cultural diversity. The first great prophet of the new America, Randolph Silliman Bourne, noted this central change in American life when he called the country a "federation of cultures." Its people comprised a mixture of ethnic groups with their roots in other cultures, their lives in this one, and their allegiances divided — a "dual citizenship" — in which local or group allegiance became the mediating agency for participation in national life.

Progressivism survived the war, but not the peace, continuing only as a fragmented movement which could do little more than prune the excesses of the prosperous Coolidge era. After a generation on the defense, business once again asserted its central place in American life and found its claim accepted by all but a few old progressives and a number of new writers. A mass-production and welfare-minded capitalism promised to do all that progressives had wished and more. Herbert Hoover, the most sophisticated theorist of the New Era as well as its ablest administrator, promised the end of poverty in the United States. While presidents before and since have made similar statements, Hoover had the misfortune to be believed, so that when the Great Depression made mockery of his promises, the New Era collapsed like an overextended stock flotation.

The Great Depression shocked middle-class America anew as had the collapse of the 1890's, producing fears of social revolution and preparing the way for a greater acceptance of governmental involvement in the economy. The election of Franklin Roosevelt, a politician with a willingness to experiment, speeded the change in outlook that had been proceeding slowly through the century. Government-encouraged mass unionization gained acceptance even from the business community, and the unions entered national politics as a liberal and anti-revolutionary force. Also marking the New Deal were the new immigrant groups entering the Democratic party and governmental service in great numbers, a prelude to their greater access to American professional, intellectual, and business life.

As the USA finally accepted an enlarged role for government, so it came to terms with the Wilsonian commitment to internationalism. The fall of France in 1940 transformed a hesitant nation, grudgingly supporting the Allied cause behind a barrier of neutrality legislation, into the "arsenal of democracy." Even so, it took another year and a half and an overt attack at Pearl Harbor before Americans became direct participants in the Second World War. The defeat of Germany and decimation of Europe left a power vacuum in what had once been the political center of the world. The United States and the Soviet Union quickly filled that gap, precipitating a cold war which destroyed the warborne hopes — symbolized by the establishment of the United Nations — for a peaceful world.

And what of the dreams with which America began? The self-consciously modern intellectuals of the early twentieth century assumed that the patterns marking America's past had faded, that the modern world of doubt, diversity, and insecurity had obliterated the golden visions of the first explorers and the Enlightenment dreams upon which the nation had been founded. Yet the atomic cloud that seemed a giant exclamation point — or perhaps a question mark about man's survival — also suggested to Americans a new "atomic age" in which technology would supply the miracles that the first inhabitants had claimed to see in the geography of the New World. The American people had certainly not abandoned their belief in progress, and intellectuals and artists increasingly looked at the nation's past to find bearings for a future that left them as much frightened as exhilarated.

David Burner,
Associate Professor of History,
State University of New York, Stony Brook

Robert D. Marcus,
Dean of Undergraduate Studies,
State University of New York, Stony Brook

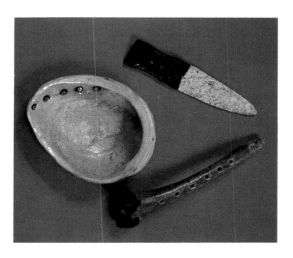

2000 B.C.-1500 A.D.
PREHISTORY:
THE FIRST AMERICANS

Who were the earliest inhabitants of North America? Where did they come from? From what, and for what did they live, before the arrival of European observers? What can we ever hope to learn of their appearance, their mores? The mute language of art and artifacts, carved in wood, bone and stone, speak to us of these enigmas more distinctly, with each new archeological find.

HISTORICAL CHRONOLOGY		ART CHRONOLOGY	
35,000 – 15,000 B.C.	Immigration waves from Asia via Bering Strait land bridge.	2000 – 1500 B.C.	Primitive, undecorated pottery at Ocmulgee Mounds, east of Macon, Georgia. Excavated in 1933-41.
10,000 – 8,000 B.C.	Sandia points discovered in fifth stratum level of cave near Albuquerque, New Mexico, with bones of extinct horse, camel and mammoth. (Some archaeologists ascribe dates as early as 22,000 B.C. to Sandia points.)	c. 300 B.C.	Beginning of Hohokam and Mogollon cultures in Southwest.
		200 B.C. – 1000 A.D.	Adena and Hopewell cultures in Ohio region. Thousands of their burial mounds, containing pottery, pearls, stone pipes, copper bracelets and textiles have been excavated with skeletal remains.
c. 9000 B.C.	End of Pleistocene or Ice Age period.		
c. 8000 B.C.	Folsom points found between ribs of Ice Age bison discovered in 1927 at Folsom, New Mexico.	100 B.C. – 1100 A.D.	Earliest Hohokam pottery extant.
c. 7000 B.C.	Nearly 100 sandals woven from shredded sagebrush bark found in Fort Rock, Utah.	c. 200 A.D.	Beginning of Anasazi (or basket maker) culture.
5000 – 4000 B.C.	Traces of earliest domestic animal: the dog.	c. 500 A.D.	Eskimos carve realistic human figures in ivory and wood.
3000 B.C.	Corncobs (from domesticated maize) found in Arizona and New Mexico. Carbon 14 dated.	700 – 900 A.D.	Early Pueblo period.
c. 500 A.D.	Bow and arrow replaces atlatl.	1000 A.D.	Hohokam invent acid (cactus-derived) etching technique for shell decoration.
c. 1000 A.D.	Hohokam Indians dig extensive irrigation system.		
c. 1300 A.D.	Mesa Verde cliff dwellings abandoned after more than 250 years of occupancy.	1100 A.D.	Classic age of Pueblo culture.
		1100 – 1300 A.D.	Prolific period of Mimbres pottery.
c. 1350 – 1600 A.D.	Old Iroquois culture. Bone needles, fishhooks and weaving tools.	c. 1400 – 1700 A.D.	Key Marco art from Florida Coast. Painted birds and alligators on carved wood. Wooden masks with human features.

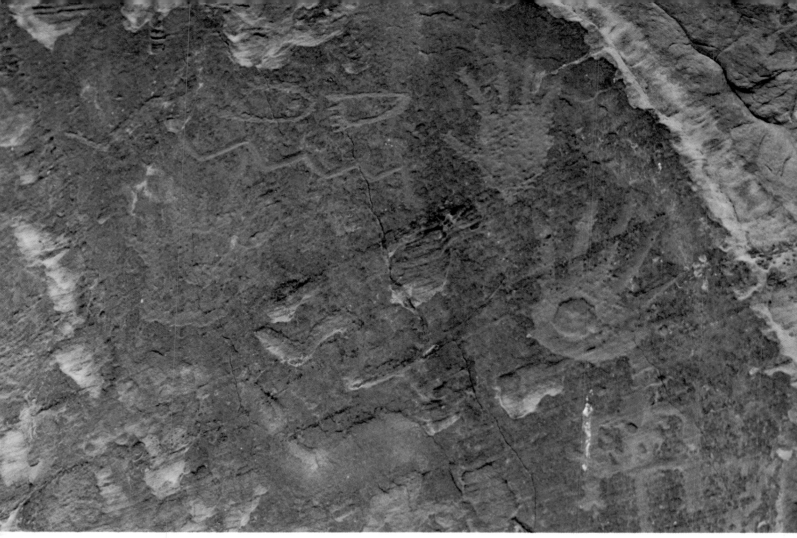

Human hands and feet, two snakes and two anthropomorphic figures carved on a sheer cliff wall in north-central New Mexico reveal some of the interests of prehistoric man as artist.

The Beginning

Over many hundreds of years in a sporadic journey spanning thousands of miles a Mongoloid people made their way towards North America and what is now the northwest border of the United States. They moved slowly through Asia — no one knows from what part — following such Ice Age animals as the ancient bison, caribou, mammoth, giant sloth, camel and smaller game that they hunted and fed on. It is believed that they lived in extended family groups or small tribal units as they traveled ever eastward to survive.

For thousands of years a land bridge, possibly up to 100 miles wide, extended from Siberia to Alaska. It was no narrow corridor but more like a peninsula of the Asian Continent extending all the way to what is now Alaska. Some anthropologists now believe that these people, spreading out from Asia and following the huge prehistoric animals, may have peregrinated for many generations not realizing they were moving over an uninhabited minicontinent toward North America. This so-called land bridge had been created when enormous quantities of water became locked in glacial ice which reduced the sea level and exposed the land.

According to research done by a U.S.-Soviet team of scientists, at least two waves moved across the wide land mass. Both were Asians. From the first group, over thousands of years, a new race evolved, now called Amer-Indians. The migrants who traveled the route thousands of years later became the Aleuts and the Eskimos. Both groups had learned to keep warm by covering their bodies with the furs of the game they killed; both were big game hunters; both had spears with stone points; both used fire.

When they reached America the first arrivals had no way of recognizing that they were on a new continent. They continued their migration, proceeding in their first millennia on the new shores down the coast to the warmer Southwest regions, later fanning out to the Middle West, the Northeast and the South of the huge uninhabited land.

Tirelessly one generation followed another and individual characteristics slowly built up. In the Northwest they soon found that, in addition to game, there were salmon, clams and other types

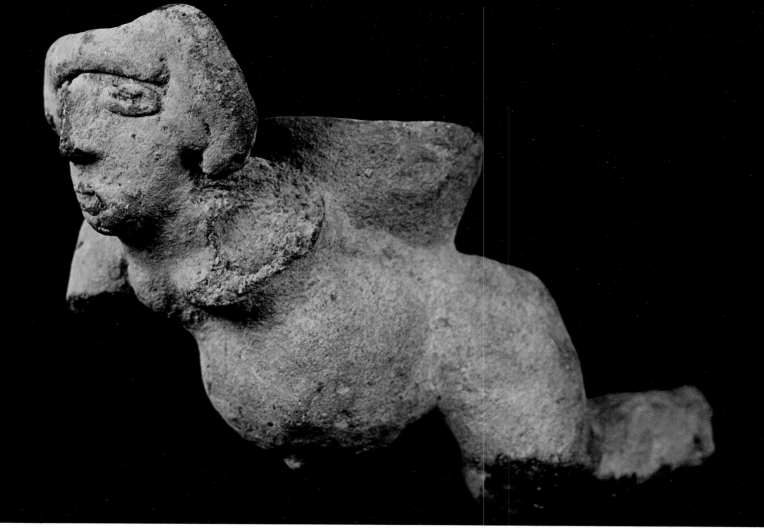

An ancient symbol of fertility in the New World, this kneeling, pregnant female Hohokam figurine *has a strong aquiline nose and coffee bean eyes. The bowl on her back may be for an offering.*

of edible fish and mollusks. With human ingenuity, they learned to trap fish and seek out young seals and club them. As they garnered more food, more of the group survived and more infants were born. Some of the new Americans remained in the Northwest; others made their way southward, learning to use rafts and canoes and finding passes through the mountains. As they reached warmer and more fecund regions, roots and wild berries became part of their diet. Using spears with stone points and the atlatl, a sling from which a short spear could be launched, they killed big game hitherto impervious. They traveled on foot, these early men and women, for there were no true horses when these first hunters spread across North America. There was only a small animal, little larger than a greyhound. They hunted this miniature horse and probably contributed to its disappearance.

These early hunters may also have been responsible for the disappearance of most of the larger animals that lived in the Pleistocene Age. We know they hunted the mastodon, mammoth, giant sloth, peccary, tapir and camel among others. It is probable that these prehistoric mammals were driven over cliffsides by shouting, noise-making individuals working together, who often killed much more game than was needed for food. These early hunters may also have used fire for slaughter, burning large areas and following in the wake of the fire to eat the roasted meat. Whether man was responsible for the extinction of these prehistoric beasts is conjecture. Yet it is true that they disappeared within a comparatively short time after the arrival of the hunters in North America.

When did all this happen? How do we know that the immigration happened at all? Are we sure that these ancestors of the American Indians were Asians? The answer to the first question deals with a timetable drawn from geological, botanical, zoological and archaeological evidence. The data clearly indicate that there were periods when both the Bering Sea land bridge and the corridor into what is now the northwesternmost member of the United States were high and dry above the oceans and unblocked by ice. Estimates range from as recently as 10,000 B.C. to 28,000 B.C. or even 32,000 B.C. for the first migrations.

Two methods have made it possible for us to learn the dates that ancient villages were occupied, when skeletal remains were buried and spear points and hide-scrapers abandoned. One is

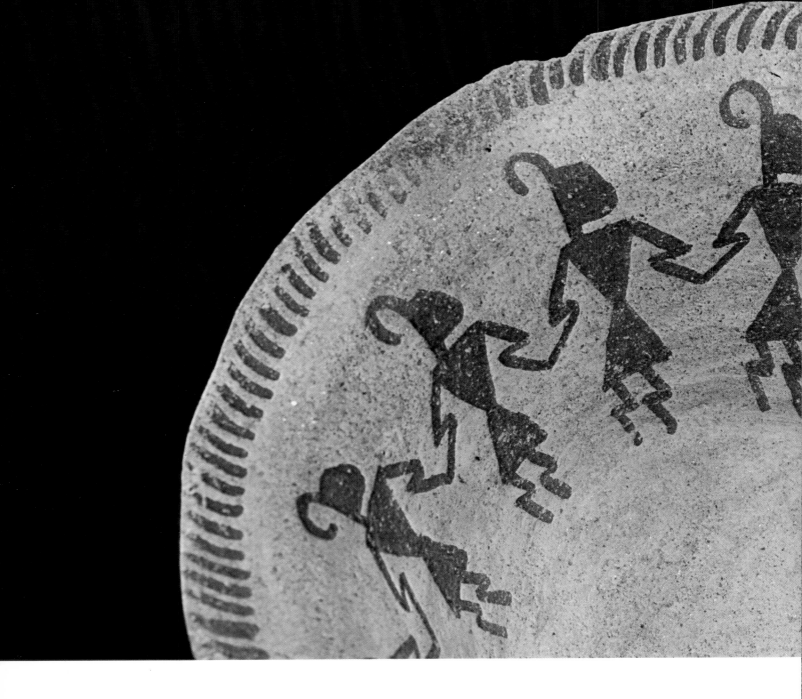

dendrochronology, or tree-ring dating, the other carbon 14. A third method, the recently-developed uranium isotope technique, enables archaeologists to determine the approximate dates that pieces of pottery were fired. More anthropological evidence is being turned up constantly and it seems to point to the earlier rather than the later dates for man's arrival in North America.

As to the second question, pertaining to the immigration of these first Americans, we know on the basis of skeletal remains, dated by the new and generally reliable uranium isotope method, that humans inhabited North America at least as early as 17,000 to 13,000 B.C. But there are no traces of any kind of primitive (or pre-Homo sapiens) hominids in the Western Hemisphere — no great apes, no evolutionary line that man could have sprung from. So we

must assume that the first settlers came from the Old World. Could they have come by sea? It is most unlikely, for sea-going vessels had not been developed by the date of man's appearance in North America.

The answer to the third question is yes, we are sure that the first Americans came from Asia. Physical characteristics of the American Indian are dominantly Mongoloid. Even when considerable differences begin to appear in later tribal physiology, there are more basically Mongoloid characteristics than any other. The physiological and anthropological evidence is clear: The American Indian is descended from a Mongoloid-type native to Asia.

As we have seen, the first stream of these ancient hunters worked its way down the West Coast of the United States and into California and the Southwest, where some of the earliest

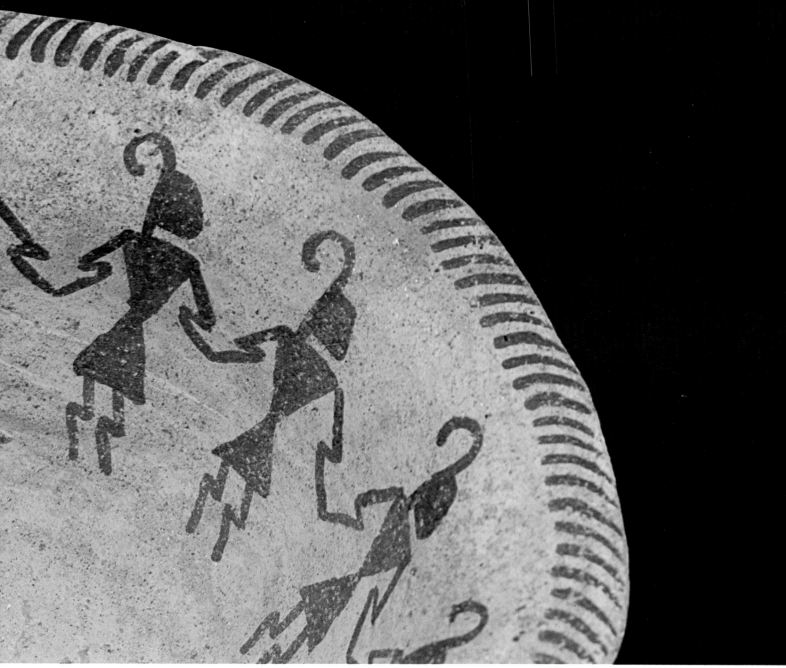

Dancing figures hold hands on the inside of this helmet pot from the Santa Cruz phase of the Hoho-kam Indian culture. It dates approximately 700 years before the European discovery of America.

artifacts have been found. The Southwest Indians of Arizona and New Mexico utilized the caves and cliffs and developed a high culture, building elaborate utilitarian structures into and around the rocky promontories. Others continued on down the coast into Mexico where, in the valleys, the early people of central Mexico found a new source of food. While harvesting wild maize, the food-gatherers naturally selected the largest plants, and some must have contained a mutant strain. The further development into corn was doubtless accidental. Perhaps the mutant seeds were thrown upon refuse heaps; from these seeds may have come the first domesticated corn. Once domesticated, Indian corn spread rapidly both north and south from Mexico and made it possible for many Indian tribes within the Continental United States to change from nomadic hunters to relatively

sedentary farmers. There is distinct evidence that maize was domesticated and cultivated as early as 3000 to 4000 B.C. The Southwest Indians, long before the advent of the Europeans, must have been in touch with Mexican Indians for we know that they, too, cultivated maize at an early date.

Yet this changeover brought major risks, for if it developed that too much time was devoted to the maize crop at the expense of hunting and fishing, and if the crop failed, as it often did from flood or drought, then starvation could follow. Thus the hunting tradition was never permitted to lag, and even those tribes who domesticated corn, beans and squash never became entirely dependent upon agriculture. Skill with the bow, spear and snare was recognized as essential to survival. With the coming of agriculture, villages came into being, and with them ceremonial

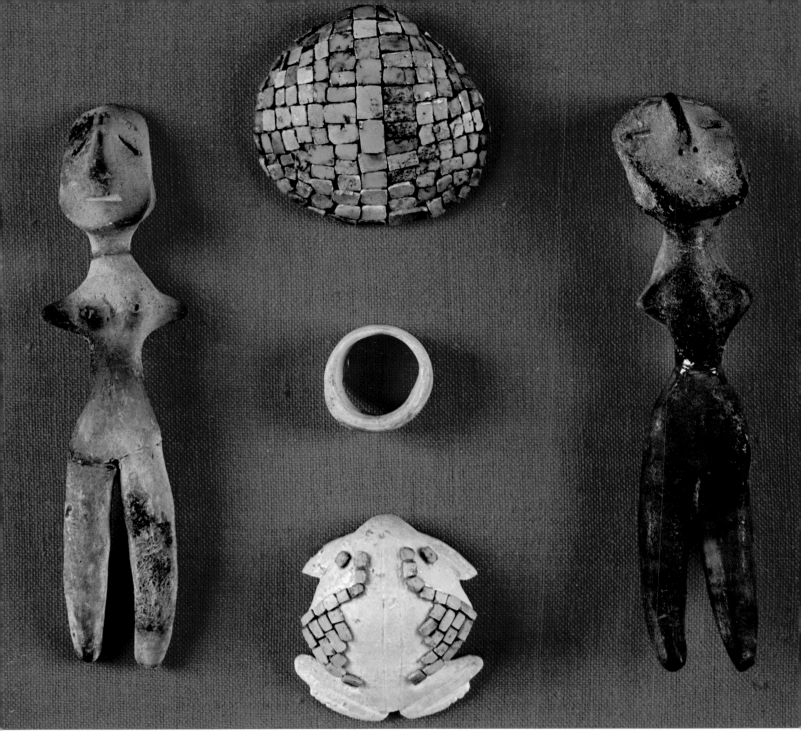

Sides: Two rare female figurines. Top center: a shell overlaid with turquoise. Center: bone ring.

Bottom: shell in shape of frog with turquoise eyes and decoration. All Hohokam c. 900 to 1400 A.D.

houses where religious rites were performed. Some towns were walled with stone and adobe. Other communities were composed of cliff dwellings well-protected by sheer walls; ladders could be pulled up in the event of attack by warlike neighbors.

For at least 1,200 years the Anasazi (the old people) culture developed in the Southwest. The Anasazi are known to have kept dogs, cultivated tobacco and, in time, made pottery, woven fabrics and intricate baskets from plant fibers, and created decorative shell vessels. They improved their hunting equipment by adding the bow and arrow to the spear somewhere around 500 A.D. As generation followed generation, apartment houses grew larger, and kivas, ceremonial

amphitheaters, were awesomely and majestically constructed.

From the Anasazi came the Zuñi, Tewa, Keres and Hopi Nations. Early cities such as Acoma and Taos still retain some of the ancient architecture and prehistoric ways of living that date from the Anasazi times.

Another ancient people who inhabited the Southwest were the Hohokam (those who have disappeared). These people, who lived in southern Arizona, developed their own irrigation system, and domesticated beans and squash in the arid desert. They made an attractive red-on-buff pottery but their greatest distinction was their creation of human effigies, small figurines of men and women created from red

clay. More than any of the other Southwestern cultures, the Hohokam created works of art in miniature, such as etchings of crabs and frogs on shells, and even inlaid turquoise work.

A third group of early settlers were the Mogollon, who inhabited the east-central portion of what is now Arizona and the west-central portion of New Mexico. All three of these people must, at some time, have maintained or reestablished connection with the Indians of Mexico, for they were domesticating maize and beans at the time of the dawn of Christianity in Europe.

Between 1100 and 1300 A.D. began what is known as the Classic Pueblo Period, when Anasazi cultural achievements reached their peak. Cliff dwellings became larger and surface building sometimes reached several stories high. Within them were hundreds of apartments of individual dwellings. The late Anasazi became expert at the weaving of cotton. When most of the area occupied by the Anasazi people became too arid they moved into the Mogollon and Hohokam regions. By the time the Spanish arrived in the first half of the 16th century, the intercultural contact between these groups was well established.

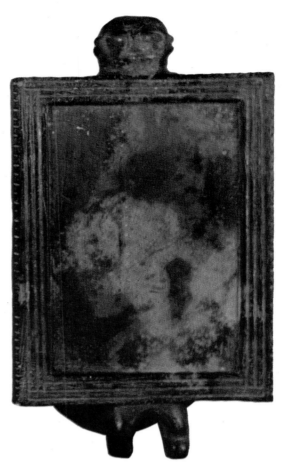

A unique paint palette made of slate. The center panel is recessed so body paint could be mixed.

Classic figurine shows two men wearing helmet-like headdress holding a ceremonial mixing bowl.

This unusual sandstone object indicates the high degree of design talent in the Hohokam culture.

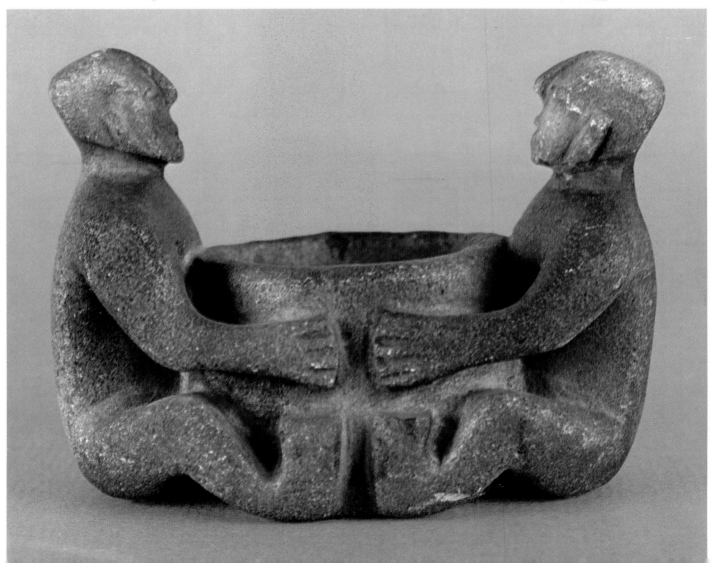

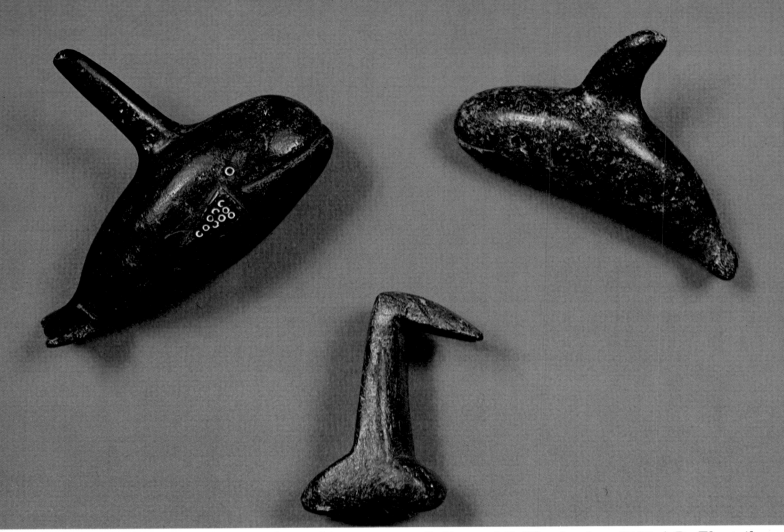

Two whales and a pelican carved out of stone are typical of the polished stone art of the coastal Indians of California circa 1000 A.D. The tails of the whales are curved to indicate motion.

Animals, Artists and Craftsmen

The beginnings of Indian art reflected the life of the sea and sky, of the rivers, mountains and desert. Working with shell and stone, artisans created likenesses of birds, turtles, lizards, whales, pelicans, eagles, mountain goats, dogs, skunks, frogs, snakes and many unidentifiable animals that may have been imagined or since become extinct. Images of animals and birds entirely native to the coastal regions — whales, seals, pelicans and gulls — found their way hundreds of miles into the interior.

Early artist-craftsmen employed two methods. They etched figures on shells by scratching, or even with acid. For more practical work, they used what is known as the pecking and grinding process. Using a hard stone as a tool, the artisan would chip away at a chunk of softer stone, but one compact enough to resist fracturing, until he had a rough model. Then he would grind it, or polish it, into its final form. In this way the artisans made early stone axes and mauls (later combined into the tomahawk), chisels and pipes. Decorative knives and scrapers were fashioned from hard minerals like quartzite and obsidian. Creative craftsmen might find a stone reminiscent to some extent of a particular bird or animal, then, working from that rude form, they could chip or peck away, grind and polish, until it was clearly identifiable.

The artisans also drilled holes in objects in order to make necklaces, or to depict the eyes of animals on their sculptures. The drill tool was a straight shaft of wood with a hard point, fashioned of reed, stone or bone, on the end. The craftsman rolled it between his palms.

Hundreds of years passed between the generations who made the earliest stone objects and those who first created dynamic representations of animals in clay. The earliest pottery was not fired, but simply dried in the sun, and it was of course easily fragmented. The firing process seems to have started around 700 A.D.; within a hundred years elaborate pots were being shaped into bird forms. The art progressed rapidly, with potters creating human heads and figurines, and forms of dogs and mountain goats.

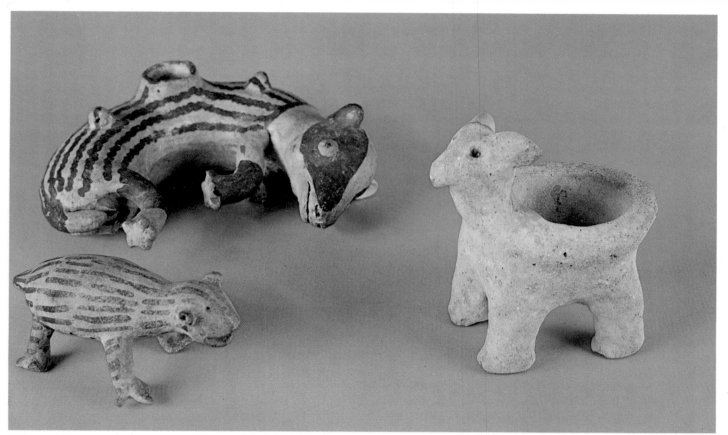

The reclining dog is a water vessel; the striped animal may be imaginary or possibly a wildcat.

This animal must have been imagined rather than seen. It is a water pot with spout and opening into

Both are Anasazi figurines. The Hohokam bowl is an effigy of a mountain sheep.

which water could be poured. The horns are unique; the artist may have had deer in mind.

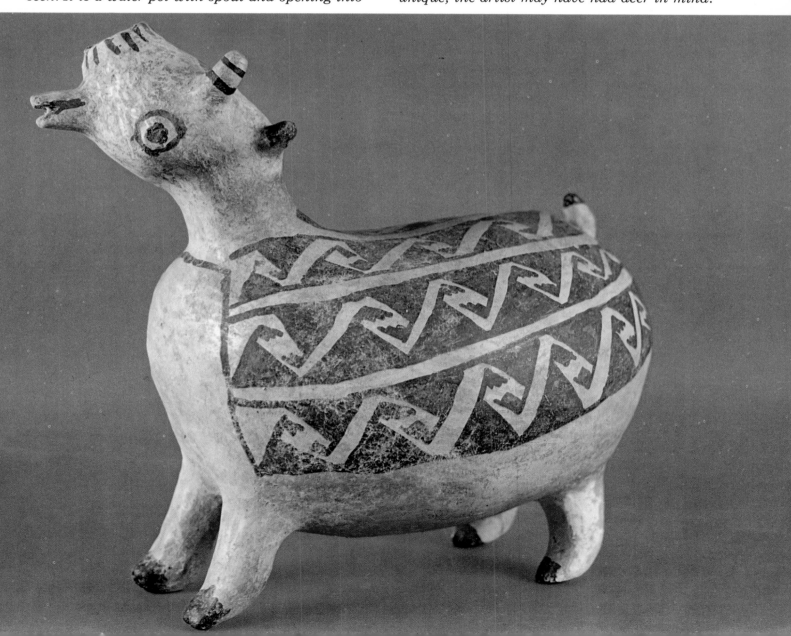

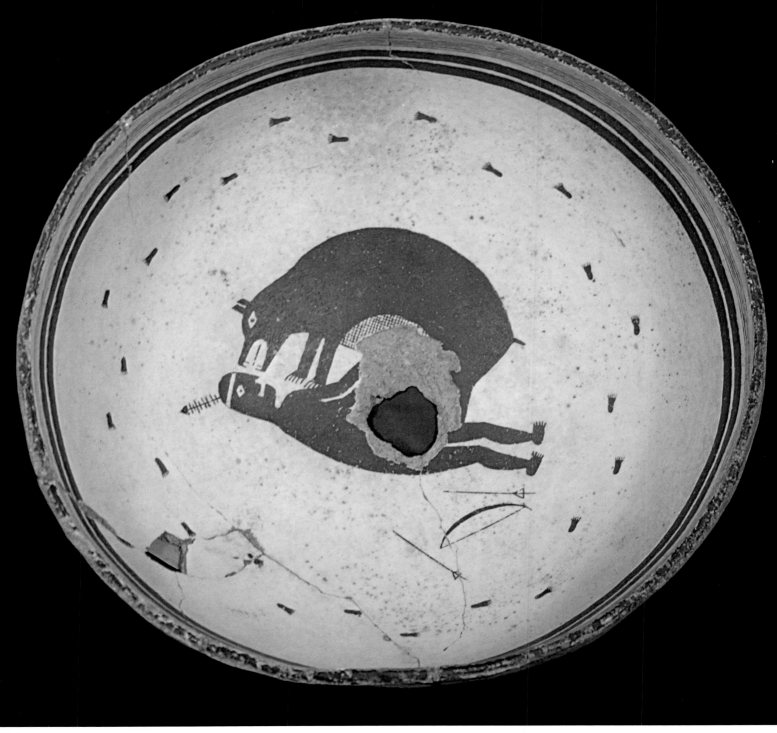

A prehistoric artist of the Mimbres culture record-ed this scene representing death of a hunter.

Tracks used as decoration around the rim show how he met up with, and was bested by, a bear.

History in Pottery

A historical record dating back to some 3,000 years ago has been left by the artists among the Mimbres Indians of the Southwest. The Mimbres lived in the hot desert-like southwest corner of New Mexico and left, buried in the dry sand, artifacts revealing their keen observation of animal, bird and human behavior. From this rich variety in Mimbres art one gets the impression that either all of the Indians of this unique culture practiced creative pottery making, or that they selected a distinct group of artists and artisans and employed them to create pottery for beauty and for use.

The storytelling artists among the Mimbres treated fish, animals and humans both realistically and fancifully. Their purpose was obviously decorative, yet the attitudes of the images reveal much about their way of life. Somewhat like the early Olmec art of prehistoric Mexico, their work shows people engaged in ordinary daily activities. But animals and humans are also seen as symbols representative of ideas. Some of the symbols involve hunting activities, others puberty rites, marriage and domestic felicity. The pottery bowls reflect an acutely developed sense of humor.

Every bowl, every pot, every figurine is balanced in size and shape, and the objects depicted become a part of the total design. In technique these pre-Columbian artists attained a high degree of perfection. Their black and white designs, as well as the three-color polychrome designs they developed later, intrigue and delight the eye. They are balanced so perfectly that it is hard to believe they were made without a potter's wheel.

Not all of the Mimbres' depictions are realistic. There is another phase, that of the geometric abstract type. No two geometric bowls have been found to be alike. Lines are drawn with the sure touch of an accomplished artist. Occasionally geometric designs are worked out in combination with a realistic form, such as an intricate pattern on the back of a turtle or the design within a woven blanket wrapped around the torso of an obese female.

The Mimbres were not prudish in their depiction of male or female genitalia nor even the sex act. In their black and white pottery men are often shown with penis erect and women with distinguishable genitalia. One unique bowl shows a priest demonstrating the act of intercourse to six gesticulating maidens standing by. The artists have a classic touch; whether understating or overstating, they are never offensive.

As with the prehistoric Chinese and Japanese, many pieces of this effigy pottery were used as mortuary offerings and placed with the deceased at the burial. The great majority of Mimbres bowls found today have a hole drilled or punched into the bottom. It is believed that this was a symbol of release for the spirit. This may or may not be a correct interpretation, but it is certainly true that most Mimbres bowls were punctured in this way, which, unfortunately, destroyed at least a portion of the illustration.

During this same period another gathering of great Indian artists, the Casas Grandes, neighbors of the Mimbres, inhabited the area just north of the Rio Casas Grandes, near the present Mexico-New Mexico border. These ancient Americans delighted in forming their clay vessels into effigies. Their bowls represented owls, quail, serpents and most often humans, who were depicted both nude and clothed. At times they painted their figurines wearing ornaments such as rings, bracelets and earrings, and in a variety of colorful jackets and robes. Although later Indians in the East, South and Middle West produced a great variety of art in baskets, pottery and wood carvings, it is safe to say that no tribe within the borders of the United States created so amazing a gallery of animals, people and designs as did the Mimbres, the Casas Grandes, the Hohokam and the Anasazi of the Southwest, for these were the seminal artists.

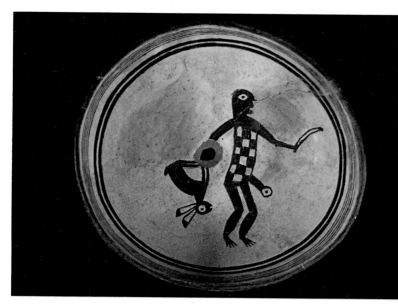

A shallow bowl shows a proud hunter carrying his bow in his left hand and swinging a large rabbit.

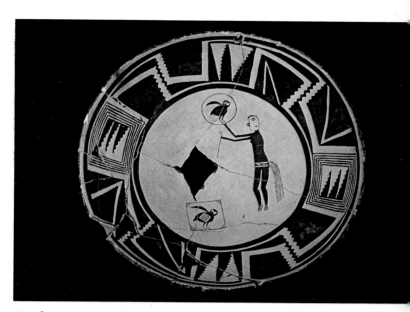

A shaman is displaying two captive birds. Intricate geometric designs decorate the outer rim.

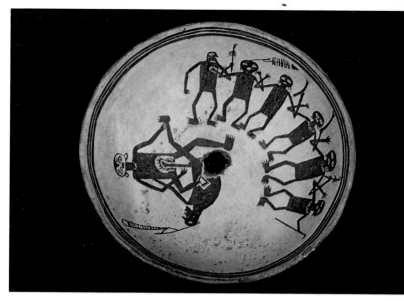

Gesticulating figures watch the act of sexual intercourse being demonstrated, probably by a shaman.

From Coast to Coast

A late (but prehistoric) male Anasazi figurine is wearing a necklace and is seated in the lotus position. His ears have been pierced and he is wearing a pillbox type headdress or hat.

As the early, prehistoric Indians spread out from the West, advancing slowly eastward through the Middle West to the Northeast and the South, they left, in comparison to the civilizations of the Southwest, fewer records for archaeologists to decipher. Their cultures did not develop in any direct sequence but rather depended upon the terrain — prairie, hilltop or riverside — they occupied and the natural resources available around them.

The Plains Indians who populated the prairies were big game hunters who depended, until their agricultural efforts were successful, upon hunting. Buffalo and deer were their primary prey; they killed them with spears or, later, the bow and arrow. Plains Indians were nomadic for a longer period of time than their cousins in the Southwest. There are no signs of any permanent dwellings. Cliffside caves and building stones were not generally available to them; it is believed that they lived in portable tipis, tents made of skins. Unlike the Indians of the Northwest and the Southwest, they left little weaving or basket work.

From the plains of the Middle West these Paleo-Indians spread out over the eastern woodlands, a huge area bounded roughly by the Mississippi River, the St. Lawrence River on the north, the Atlantic Ocean and the Gulf of Mexico. As in the plains, terrain and food supply determined the cultures that developed. Along the rivers where the land was fertile, agricultural settlements and village life came into being. But in the northern regions, where they depended upon hunting, supplemented by fishing, groups followed the game, moving from place to place. Even in their constant movement, these creative people were able to fashion efficient snowshoes. They made canoes out of birchbark, sturdy enough to be functional, but light enough to be carried along in the incessant search for game.

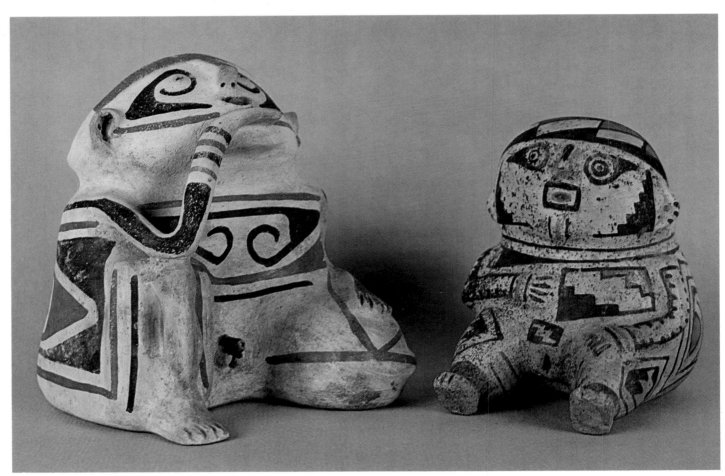

At the height of the Anasazi culture beautifully shaped and highly decorated stylistic pottery was made in the shapes of male and female human figurines. These are circa 900 to 1400 A.D.

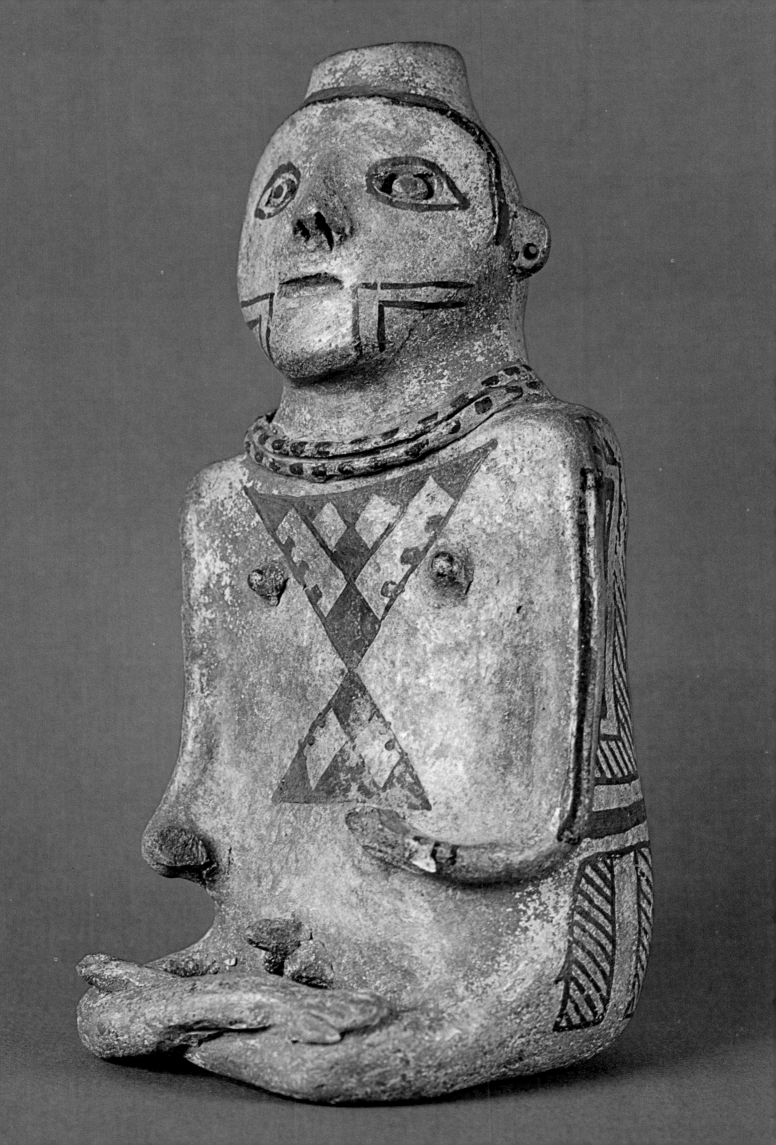

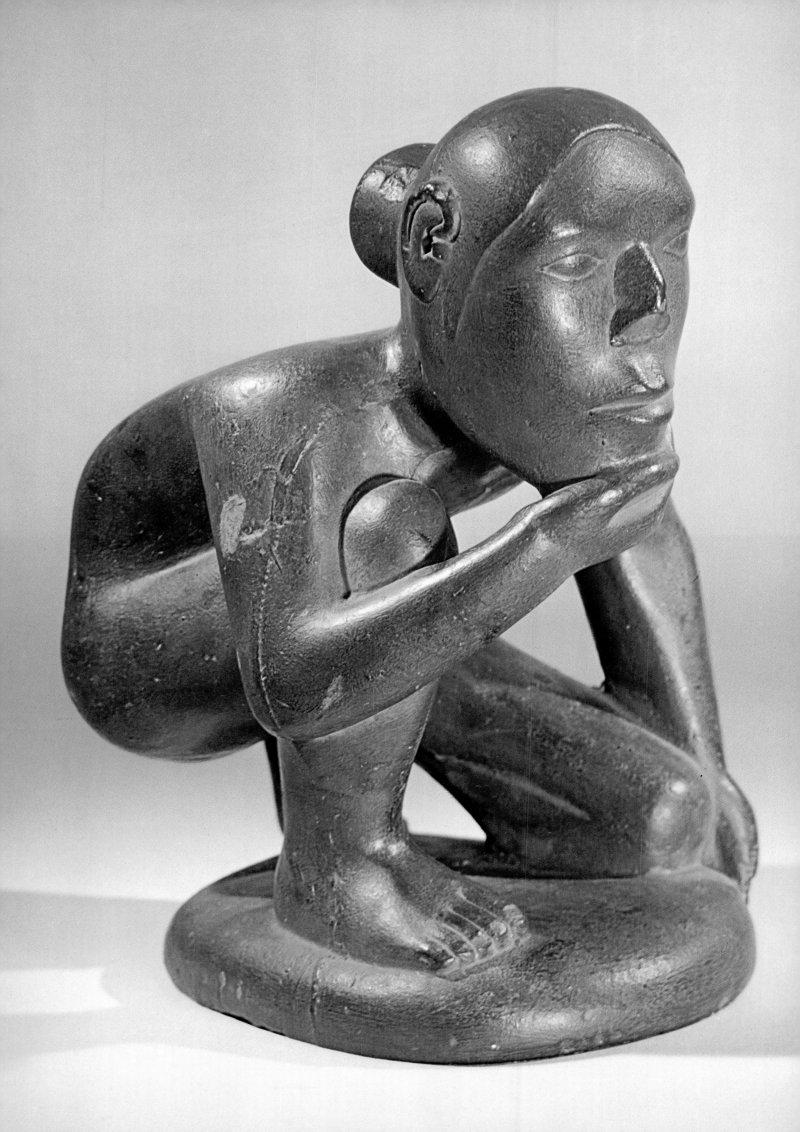

One group of Indians who developed agriculture and a village life left a unique artistic heritage in a large area extending south from the Ohio River Valley. There they built literally thousands of intricately shaped mounds. Some of these huge man-made earthworks must have been used as ceremonial temples. They reached a height of 100 feet with flattened tops and sloping sides. At least one, still intact, is larger than the largest Egyptian pyramid, for it measures 100 feet high, 1080 feet long and 710 feet wide.

Most of the mounds were built in the shapes of effigies — birds, humans, serpents. The bird and serpent motifs are those seen most often, and are somewhat similar to the ancient stone art of Mexico and South America. An important difference between the effigies built in stone by the Mexican cultures and those built of earth by the North American Indians is the enormous scale on which the Ohio River Valley groups designed and executed their projects. The creators of these intricately formed effigies must have imagined how they would look from high above, anticipating the helicopter. Indeed, this is the best way to study the figures; they can be recognized only from the air. The mounds extended as far as Louisiana and western Florida.

At least a thousand years before the coming of the Europeans, the Indian had created pottery and basketry, made pipes and cultivated such crops as tobacco, corn, beans, pumpkins and squash. During the period before the discovery of America by Columbus, for some 600 years between 900 and 1500 A.D., there was rapid progress among Indian civilizations across what is now the continental United States.

Language groups were extended and tribes speaking the same or similar language patterns organized themselves into confederations. Religious rituals became more formal. Protective walls were built around villages, irrigation systems created and trade routes established and extended. Sophisticated stone carving became relatively common. Decorative as well as utilitarian basketmaking was widespread. Polychrome pottery appeared. Wall paintings date from 900 A.D., and elaborate murals from around 1300 A.D. in northeastern Arizona.

During this period agriculture prospered and the Indian population increased. How far the North American Indians might have gone, what heights their creative works in arts and crafts might have reached, what type of ultimate civilization they might have developed, we will never know. For, just as they were reaching this critical stage in their ethnic development, came **the European discovery of America.**

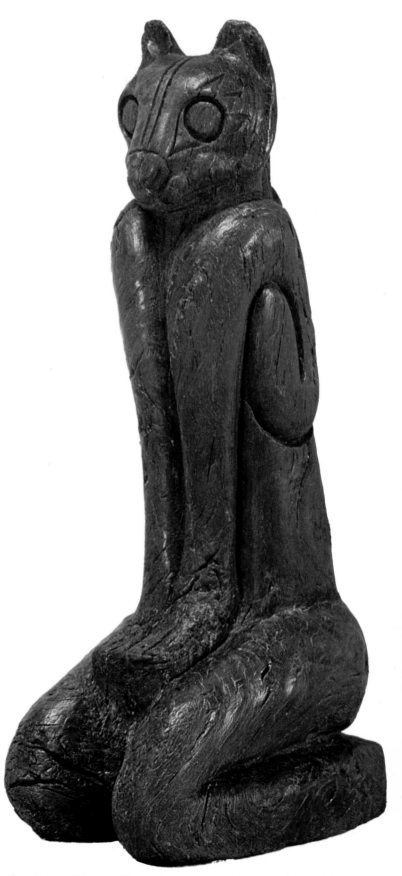

Looking like an Egyptian cat goddess, this prehistoric seated cat figure is carved of wood and comes from southern Florida. While the Indians of the East created pottery, they excelled at sculpture.

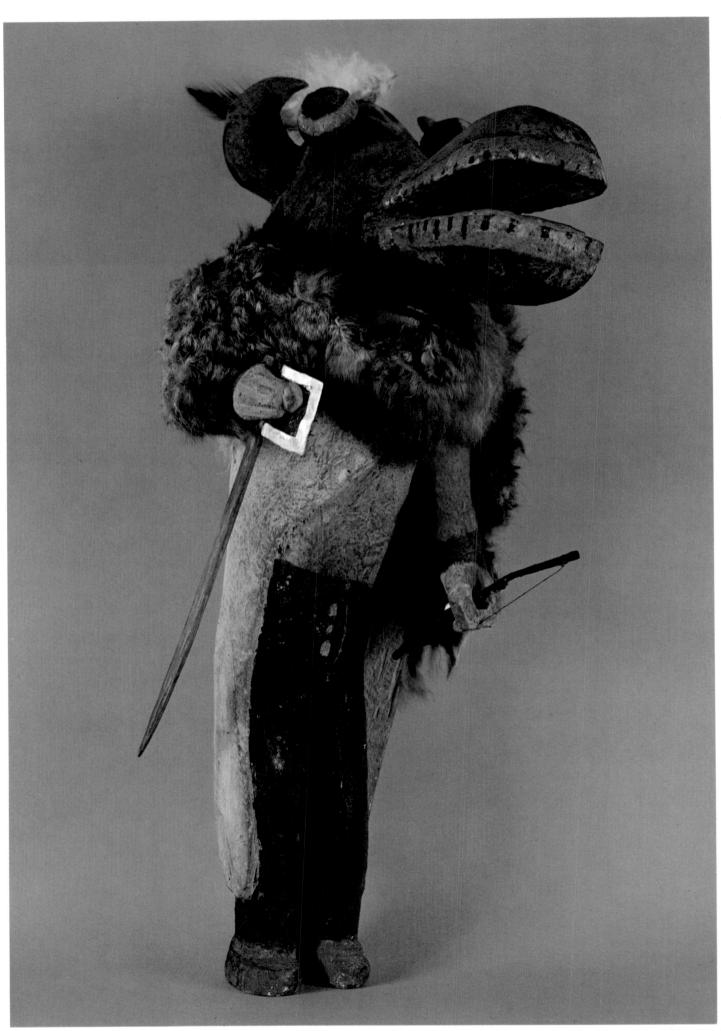

Bridging the gap between prehistory and history, between Indians and Spanish explorers, is this Ka- *china figure, half man, half animal, holding in its left hand a bow, in its right a Spanish sword.*

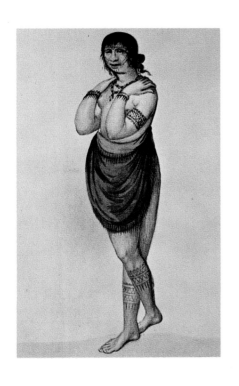

THE EXPLORERS

Norsemen explore the northeastern reaches of the New World but leave no settlers. Christopher Columbus, a Genoese sailing for Spain, opens the new lands for exploration and colonization. Las Indias become America. English and French explorers follow Columbus. Spain explores the South and West while the English and French struggle for an East Coast foothold.

HISTORICAL CHRONOLOGY	ART CHRONOLOGY
1492-1504 *Columbus makes four voyages across the Atlantic and discovers the islands of the West Indies and the coast of South America.*	1500 *Map of New World shows certain islands of the West Indies painted by Juan de la Cosa, pilot on Columbus' first voyage.*
1513 *Ponce de Leon is first European to explore mainland. Lands in Florida.*	1507 *Martin Waldseemüller's geography suggests the New World be named America after Americus Vespucci.*
1540 *Discovery of the regions now Arizona (Grand Canyon), New Mexico, Oklahoma and Kansas by expedition of Francisco Vasquez de Coronado.*	1564 *Paintings of Indian life executed by Jacques LeMoyne while in Florida on Huguenot colonization attempt.*
1541 *De Soto leads expedition to Mississippi River*	1566 *Discours de l'histoire de la Floride, a firsthand account of the French in Florida, written by Nicholas Le Challeux.*
1542 *California discovered and claimed for Spain by Juan Rodriquez Cabrillo after entering San Diego Bay.*	1579 *Sir Francis Drake sails up California coast, anchors at what is now Drake's Bay above San Francisco, claims "New England" by attaching brass plate to tree.*
1562 *Parris Island on Carolina coast occupied by French Huguenots commanded by Jean Ribaut.*	
1565 *Spanish plant first permanent colony in future U.S. at St. Augustine, Florida.*	1585-87 *English artist John White, surveyor and later governor of Roanoake Colony records Indian life.*
1585 *English try to establish a colony in Roanoke, Virginia.*	1588 *Thomas Hariot writes A Brief and True Report of the New Found Land of Virginia.*
1607-c.1609 *Jamestown, Virginia settled by the English.*	
1610 *New Mexico's capital moves from San Gabriel to Santa Fe.*	1590 *Theodore de Bry of Holland publishes engravings by Le Moyne and narratives by Le Challeux about North America.*
1612 *Dutch trading post in New York and another at Albany, New York.*	1593 *Drawing of the Fort of St. Augustine, Florida.*
1619 *Virginia planters buy first slaves from Dutch traders.*	1608 *Book by Captain John Smith A True Relation of Occurrences in Virginia.*
1620 *Pilgrims land at Plymouth Rock in Massachusetts.*	1609 *Champlain at Ticonderoga (anon) engraving.*
1626 *Indians sell Manhattes Island to the Dutch for 60 guilders.*	1616 *Painting in oil of Pocahontas (anon).*
1629 *Massachusetts Bay Colony settled.*	

The Age of Exploration

Cristobal Colón, known to us as Christopher Columbus, never saw an Indian of the mainland of North America. The nearest he came was the island of San Salvador some 250 miles away, which he reached on his first voyage. Had he continued to sail west rather than south and east, he would have made the Florida coast, and the history of the modern world would have been a different one. For while the rulers of England, France and Portugal were all poised on the edge of the Atlantic, Spain pointed her expeditions toward the South.

As early as 1496, less than four years after the Columbus discovery, the King of England commissioned another Italian, Giovanni Caboto, better known as John Cabot, to explore the northern route and attempt to find a short passage to the Orient. He reached the northeast coast of Newfoundland, but found no passage, no gold, no spices.

It was 1534 before France, in the person of Jacques Cartier, began the search for a northwest passage to the East. Cartier discovered the St. Lawrence River region, and on a second voyage reached the mouth of the Saguenay River. Misunderstanding his Indian guides, he believed that he had discovered the Kingdom of Canada — the word actually meant village. On a third voyage he made his headquarters near Quebec and gathered what he thought were precious stones; they proved to be worthless when examined in France. Sixty years later Samuel de Champlain mapped the coast of New England. He made three voyages and on the third one left a permanent settlement in Quebec.

The first European to set foot on any part of what is now the United States was the romantic realist Ponce de León, conqueror of Puerto Rico. In 1513 Ferdinand granted Ponce a roving commission to discover new land for the Crown, and Florida was his first discovery. He had heard from the Indians that there was a spring or a river whose water when drunk had the magical quality of renewing sexual vigor. Landing at a harbor now called Ponce de León Inlet, south of Daytona Beach, at Easter, he named it Pascena Florida, or La Florida. The expedition failed. The Indians were unfriendly; there was no trade in gold and, worst of all, no one had ever heard of the fabled restorative fountain. Ponce came back eight years later, hoping to plant a settlement. But on this voyage the Indians resisted strongly; wounded by an arrow, he died at the age of 47.

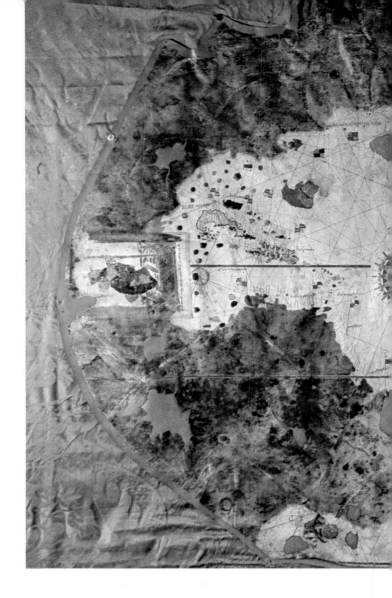

In the early years of the discovery of America there was humor, tragedy and confusion. During his lifetime Columbus never stopped believing that he was in India and insisted upon calling the natives Indians. The North American mainland was not named after Columbus, who pioneered the way, nor Ponce de León, who discovered it, but for a banker-entrepreneur who, like Columbus, never reached the continent. He was Amerigo Vespucci, an Italian living in Spain who came to the New World first as a passenger, again as a scribe. But if Amerigo was not an explorer, he was an excellent writer-propagandist. His writings were widely printed and distributed throughout Europe. Because he mentioned no other discoverers except himself, he became the best known explorer of the New World. A Dutch geographer working in France was so impressed by his book that he wrote:

". . . a fourth quarter [of the world] was discovered by Americus Vesputius (as you will hear in what follows); I don't see why anyone should object to calling it Amerige, or the Land

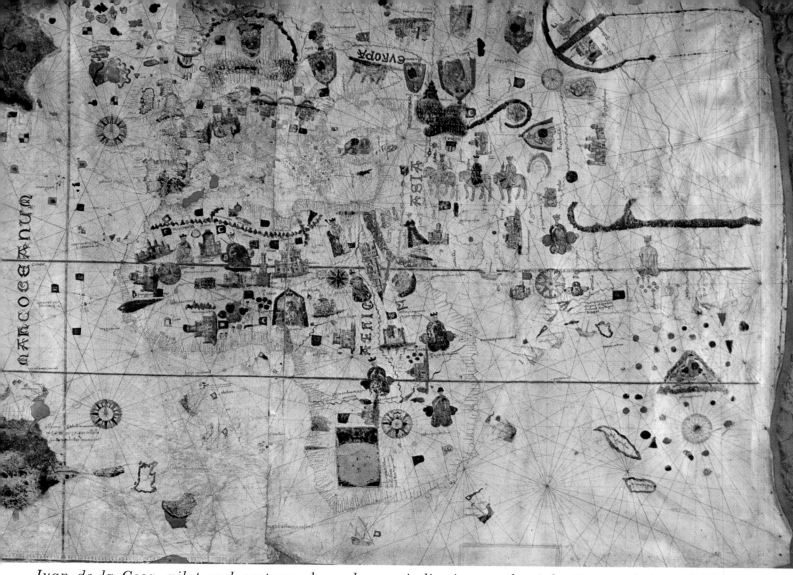

Juan de la Cosa, pilot and cartographer who sailed with Columbus, drew this map in 1500 indicating, on the right, Europe, Asia and Africa and, on the left, some of the Caribbean Islands.

of Americus, or (since both Europe and Asia have feminine names) America, after its discoverer Americus, a man of innate wisdom."

In addition to the confusion about who discovered what and which names would become permanent, one fact stands out. Neither the Spanish, the Portuguese, the French nor the British discovered a new route to the Spice Islands of the Orient. What they discovered was what was blocking the route. When they finally realized that it was a new continent, they all tried to move in.

The Spanish were the most active, the most able and the most successful of the early explorers of North America. Led by Hernán Cortés, a thick-haired and heavily bearded muscular man of medium height who had been engaged in the art of warfare for half of his 34 years, the Spanish conquered Mexico and began the northward expansion that finally led them into what is now Southern California, Arizona and New Mexico.

Christopher Columbus, hands folded in prayer, kneels before the Virgin. Left is St. Christopher.

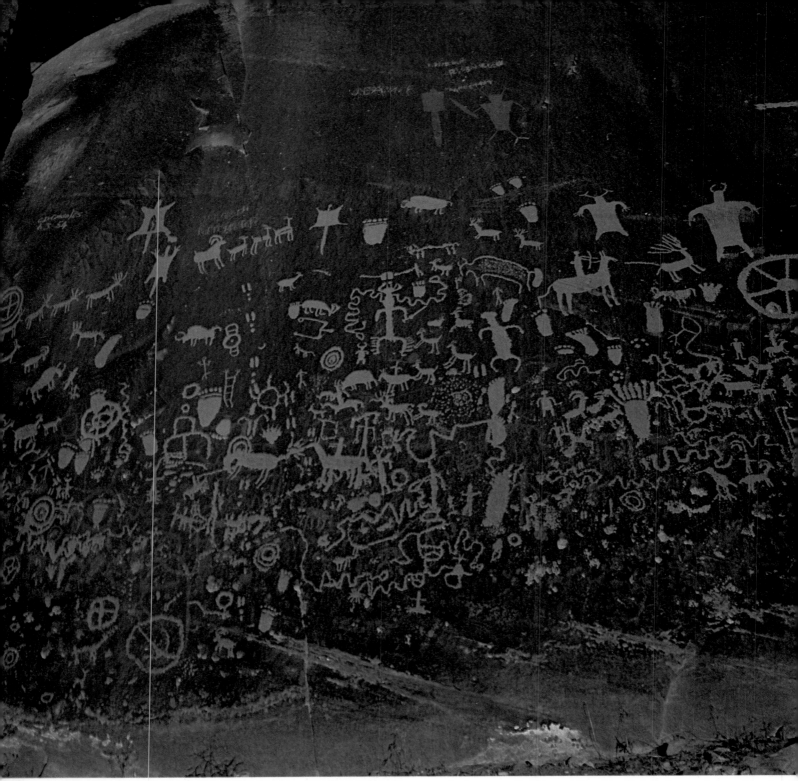

Three distinct periods of American Indian art are shown on Utah's "Newspaper Rock." At upper right, an Indian shoots deer from horseback indicating that drawing was done after 1519.

Indians Get Their Horses

On April 19, 1519, a fateful day for the Mexican and Amer-Indians, Hernán Cortés brought 16 horses to the North American mainland, the first horses the Indians had ever seen. The Indians thought they were monsters, half man, half beast, which could run faster than a man, yet fight with weapons of steel. The Spaniards kept up the illusion, and it was only after the Indians had killed both men and horses that they realized they were dealing with not one but two animals.

At first the Spanish forbade the Indians to mount horses, but with the growth of ranches they became vaqueros, the first cowboys. Indians took to horses like the Spaniards took to gold. They begged, borrowed and stole them — Indians did not consider taking this living beast an immoral act — and by 1560 were breeding their own stock. Horse and Indian population soared together, for horses improved the hunting, and more and more Indians on horseback were seen. By 1800 most tribes were mounted.

For protection against Indian arrows, this 17th century Spanish frontier guard wears a vest of seven thicknesses of leather. Such outriders were often killed for their fine Barbary horses.

What the well-dressed cavalry officer wore is shown in this 17th century documentary drawing of a member of the border troops that battled the Texas Indian tribes over land and horses.

On his first voyage to <u>Florida</u>, Jean Ribaut had his crew build this stone column carved with the French coat of arms. Ribaut returned to France. A new French expedition arrived in Florida two

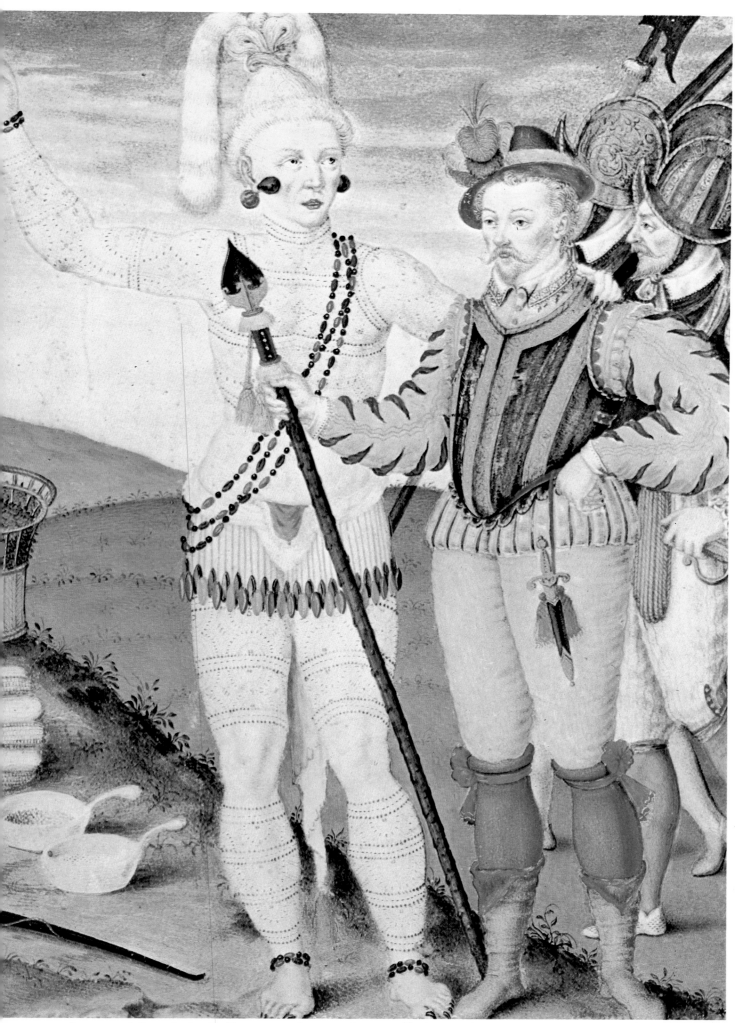

years later and found the Indians worshiping the garlanded monument around which they placed offerings of fruit and grains, bow and arrows. LeMoyne painted the historic encounter.

overleaf
White's map of Virginia shows Sir Walter Raleigh's coat of arms, flying fish, and whales.

English soldiers wade ashore to the fort built by colonists on St. John's Island, Virginia.

The Adventurous Englishmen

England made no serious attempt for 65 years after the Cabot voyages to implement the claim to North America. In 1562 an English seafarer, John Hawkins, set out on what was primarily a slave-trading project, buying slaves in Africa and selling them in the Indies. It was profitable and he undertook a second expedition. After unloading the slaves, Hawkins explored along the Florida coast; on his return voyage he stopped at the French base in Florida, Fort Caroline. These voyages of Hawkins, and later those of Francis Drake, were partly gold-hunting expeditions, although they inevitably brought back useful information. Even such potential colonizers as Sir Humphrey Gilbert and his half-brother Sir Walter Raleigh, who spoke in

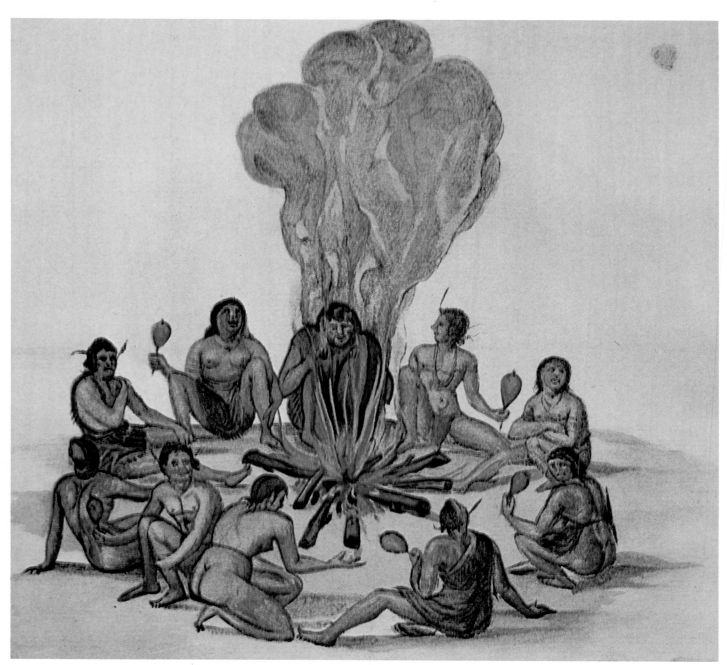

Indians of Roanoke Island are seated around fire in watercolor painted by John White.

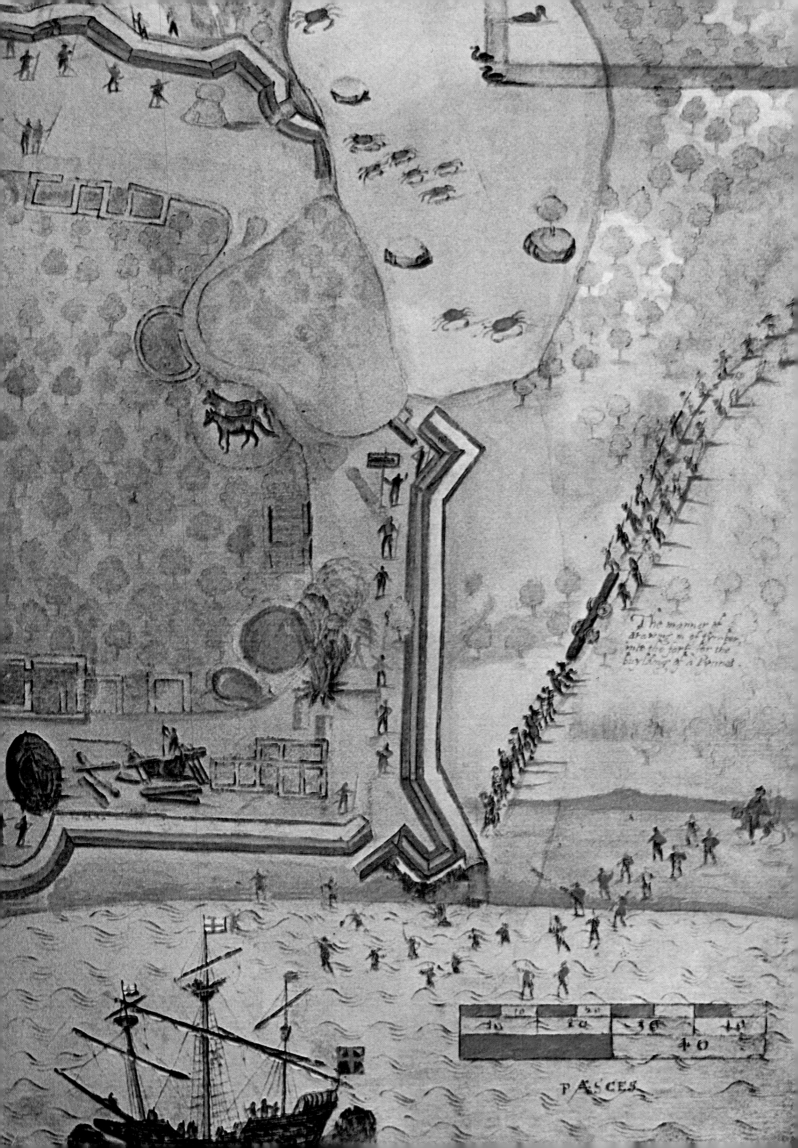

The manner of drawing in of Timber into the fort for the building of a Pinnas.

PÆCES

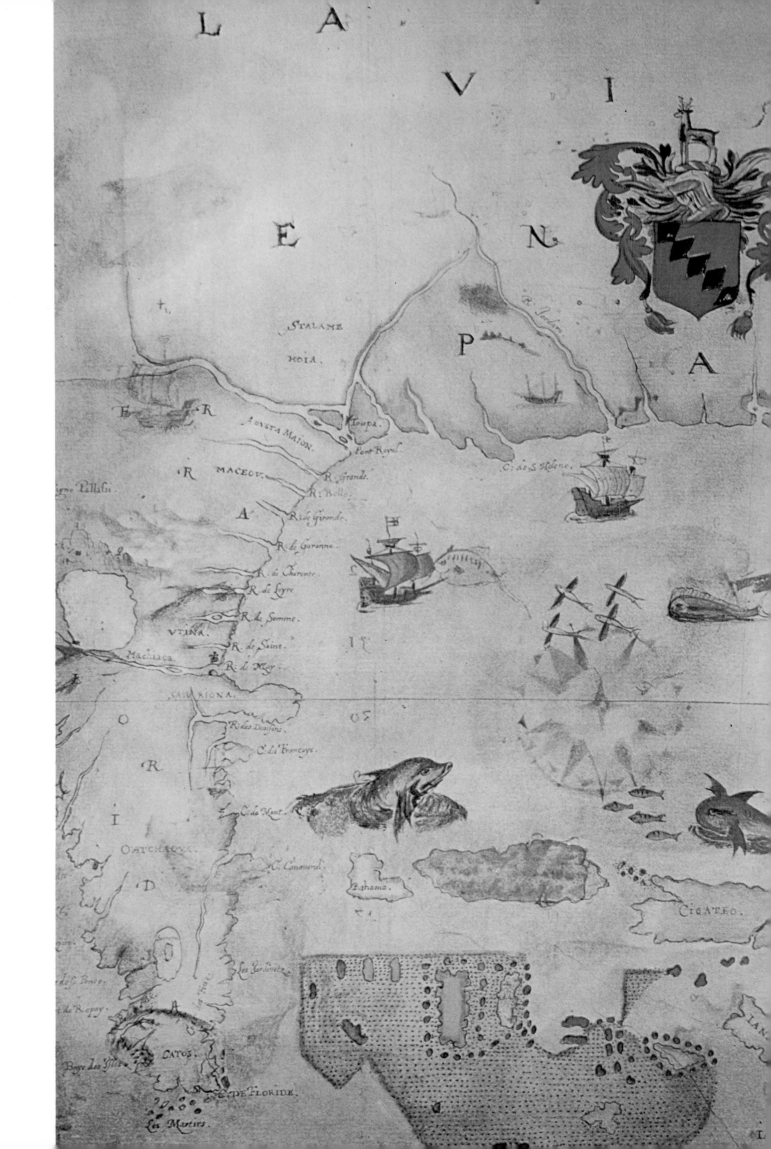

LA VI
E
N
P
A

STALAME
HOIA.

+

E R R

ADISTA MAION.

R MACEOU.

igne Pallassi.

A

VTINA.

Machiaca.

SAIVARIONA.

O

R R

I I

D

OATCHAQUA.

Ioupa.
Port Royal.
R. Grande.
R. Belle.
R. de Gironde.
R. de Garonne.
R. de Charente.
R. de Loyre.
R. de Somme.
R. de Seine.
R. de Mer.

R. des Dauſins.

C. de Françoys.

C. de Mont.

R. Canaveral.

C. de S. Helene.

R. Iordan.

Bahama.

CIGATEO.

Les Gardines.

de S. Ponce.

de Repoy.

CATOS.

Boye des Yſles.

C. DE FLORIDE.

Les Martirs.

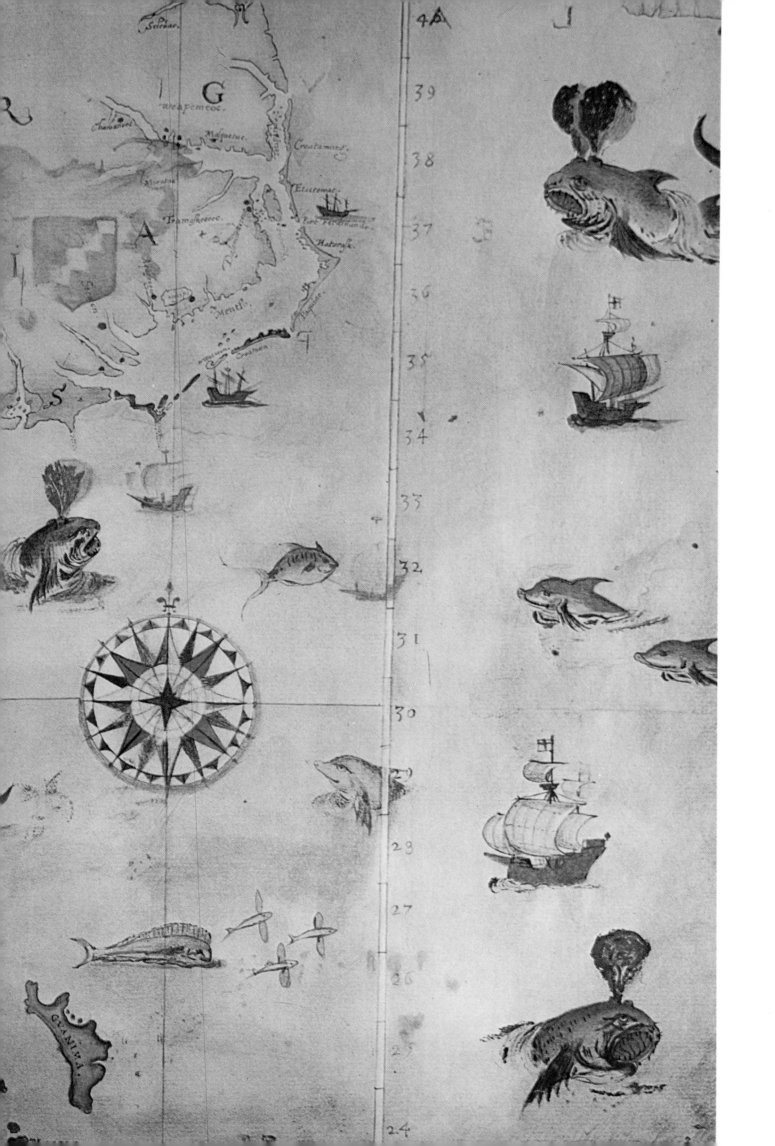

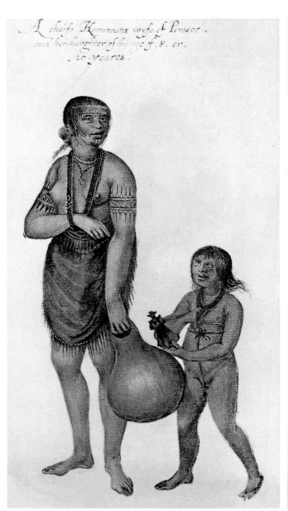

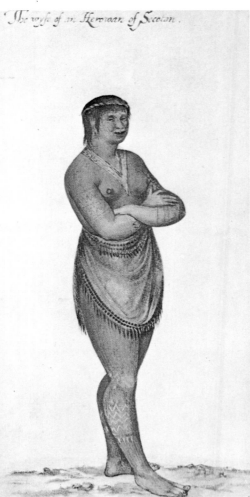

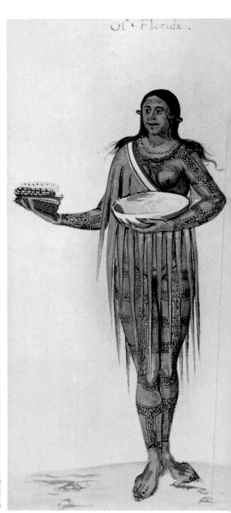

In this series of John White's full-length portraits an Indian king's daughter carries a European doll; a tattooed chief's wife stands with folded arms; a semi-nude woman holds a pottery bowl.

terms of settlements, were more interested in gold, silver and silks. Gilbert tried first. Queen Elizabeth granted him a patent in 1578 "to inhabit and possess at his choice all remote and heathen lands not in actual possession of any Christian prince." His attempt at exploration and colonization failed, for he and his crew vanished at sea. Even in his failure a precedent was set. For his charter allowed him to pass laws for the colony but they must "be as neere as conveniently may, agreeable to the forms of the laws and policy of England."

Undismayed by the loss of his half-brother, Raleigh sent two ships to explore North America's coast. Their reports convinced Raleigh and the Queen that a larger expedition would be profitable. He suggested to the virgin Queen that this pristine land be named Virginia in her honor. She accepted. The members of the expedition were, unfortunately, fortune-seeking explorers and on landing at Roanoke Island on what is now the North Carolina coast they angered the natives and ignored colonization. On the verge of starvation, they were fortuitously rescued by Sir Francis Drake. This extraordinary sailor, explorer and sometime pirate had previously succeeded in sailing around the coast of South America, up the West Coast to a point

north of what is now San Francisco, which he called New England and claimed for the Crown, then on across the Pacific, around the Cape of Good Hope, and home for the first English trip around the world. On a later naval expedition he picked up the disenchanted explorers on Roanoke Island and ferried them back home.

Raleigh was persistent. A year later, in 1587, he financed and sent out a new contingent, commanded by a veteran of the first, John White, artist, naturalist, explorer and governor. Upon arrival at Roanoke Island, White quickly organized his company of some 150 persons, including his daughter and 16 other women. He had to go back to England for necessities and reluctantly sailed shortly after the birth of his grandchild, Virginia Dare, the first child born in America of English parents.

It took White three years to finance his return voyage, and when he got back in 1590, Roanoke Island was deserted. The only clue to the colonists' disappearance was the word *Croatoan*

The Indian town of Pomeiock; a protective palisade of timbers completely surrounds it.

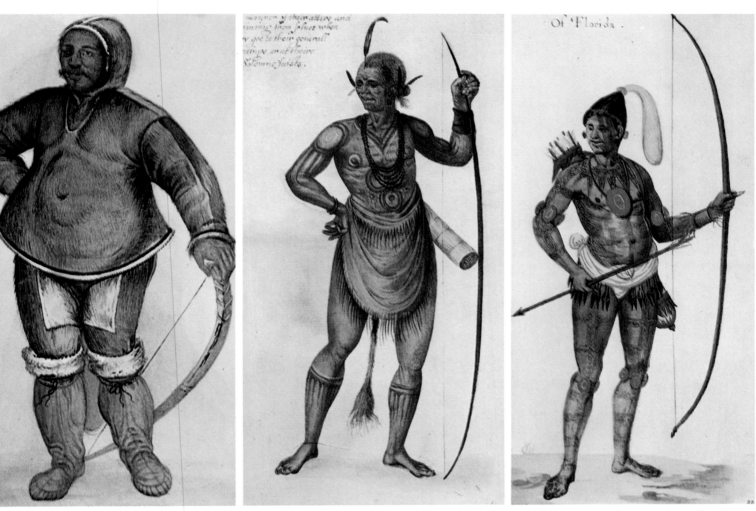

A skin-clad Eskimo holds a walrus tusk bow; next to him is a chief wearing an animal tail; at far right, a tattooed warrior of Florida, carries a long bow and wears an elaborate headdress.

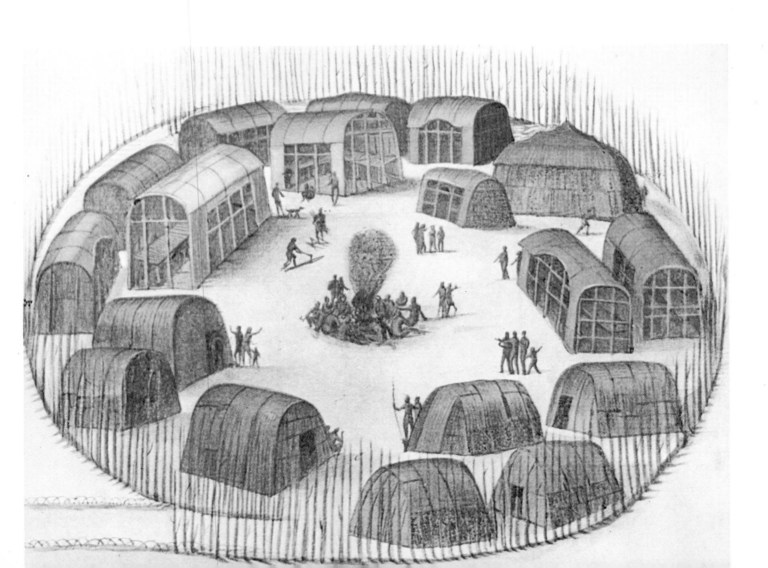

carved on a tree. This was the name of a nearby island and White hoped that his daughter, grandchild and the rest of the colonists may have escaped there. But a storm prevented his landing on Croatoan, and his ships were blown back out to sea. They returned to England and none of the colonists of Roanoke Island were ever seen again.

Historians owe a great debt to John White, who painted Indians and Indian life and documented the birds and fish he observed. These delicate watercolors are more than a first view by an Englishman of the East Coast; they are fine examples of watercolor painting.

A more complete account of the land, natives, flora and fauna was given in *True Report* by Thomas Hariot, a member of the first group of colonists. Hariot was something of a scientist and naturalist, and a superb reporter. He described the Indians in perceptive detail, and the various native foods, but even more fascinating to Englishmen was his description of tobacco which the Indians called *uppowoc*. The leaves were dried and crushed into a powder, he wrote, then smoked by being sucked through clay pipes into the head and stomach. He suggested that the fumes purged "gross humours" from the body by opening all the pores and passages, thus preserving it. He gave credit to tobacco for keeping the natives in excellent health. Tobacco was not only useful, according to Hariot, but was magic as well. It was used in sacrifices, being thrown into the water to calm the waves, into the air to ward off danger. He had brought some tobacco back with him and demonstrated it.

Even with Hariot's glowing report, it was 26 years before a new Virginia Company was formed. Conceived as a profit making enterprise, it was a joint stock company with a membership that included all classes of English society. In 1606 the company sent out its first colonists, under the command of Captain Christopher Newport. The voyage across the Atlantic from embarkation to landing took a long four months with a short stay on the island of Dominica in the West Indies. The ships entered Chesapeake Bay, and finally anchored at a point of land on the Virginia Coast which they named Archers Hope; it seemed that from this point it would be easy to defend themselves. Their fort was named James Towne after James I then King of England.

As dissension broke out among the council, a strong leader emerged. He was Captain John Smith. Under his leadership the dissenters were

At sunset, Indian dancers at a feast are shown in a dramatic detail from a John White watercolor.

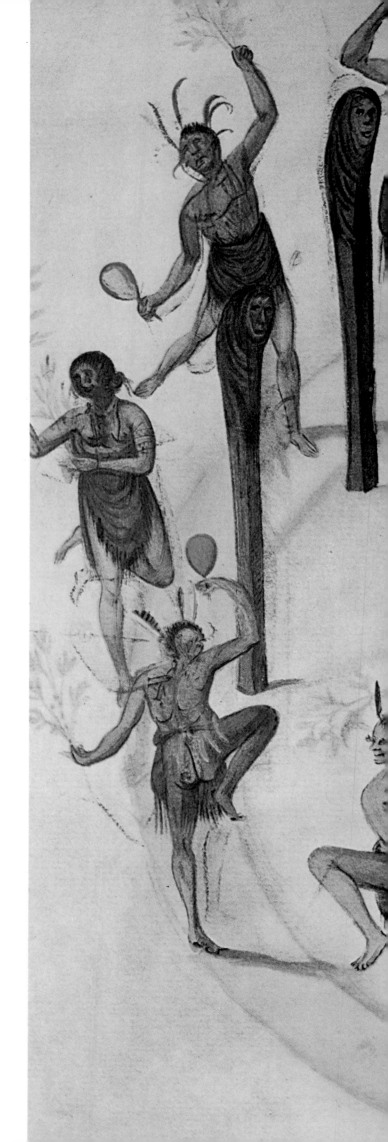

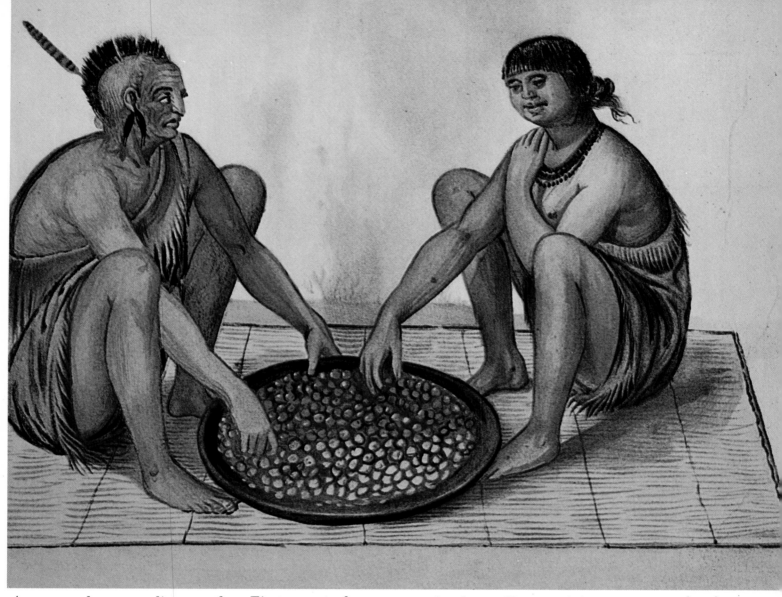

A man and woman dine together. First a mat of twigs was laid on the ground, then they ate from a *pottery bowl usually containing a stew made of boiled maize, available meat and/or fish.*

controlled and forced to work. But Smith was injured in the second year of the James Towne Colony and returned to England. While he was away the colony became disunited and indolent. There inevitably came a period which was called "the starving time." Colonists ate their horses, dogs and cats, rats and mice, and even their boots and shoes. They dug into the earth for wild roots. Many ran away from the fort to live with the savages and were never heard of again. Only one in ten survived. But the will of those who remained was strong. A new Deputy Governor, Sir Thomas Dale, arrived to reestablish law and discipline, and the colony was saved. Its economic success was assured by tobacco. Though described by King James I as "A custome lothsome to the eye, hatefull to the Nose, harmefull to the braine, dangerous to the Lungs" it was the salvation of James Towne. John Rolfe blended West Indian tobacco with the native Virginia plant so successfully that it became a profitable export.

In 1619 two events occurred which further insured the colony's economic success. The first was the recruiting of a hundred women to be sent out from England — " Maides young and uncorrupt to make wifes to the Inhabitantes and by that meanes to make the men there more setled & lesse moveable who by defect thereof (as is credibly reported) stay there but to gett something and then to returne for England . . . "

The same year the first Negroes were brought to Virginia on a Dutch man-of-war and sold to John Rolfe. In the years to come many more women would migrate from England, many more slaves would be transported from Africa.

While James Towne was becoming more profitable and more solidly settled, another exploratory group set out from England. Known as the Pilgrims, these men, women and children, intent upon leaving England because of their differences with the established Church of England, had decided to risk the unknown life of North America. Their colony, like the Virginia Company, was to be a profit-making venture and was supported by a company of London merchants. On September 16, 1620, they crowded into a small ship, the *Mayflower*, and set sail,

47

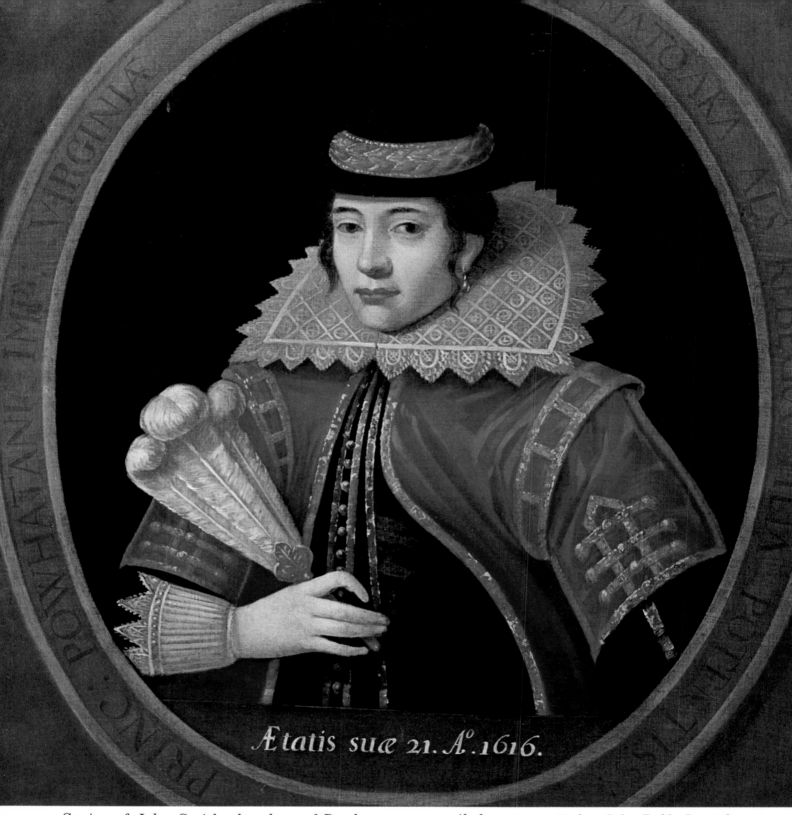

Æ tatis suæ 21. Aº.1616.

Savior of John Smith, daughter of Powhatan, Pocahontas was kidnapped and held as a hostage until she was married to John Rolfe. Later known as Rebecca, she died at the age of 22 in England.

hoping to land to the north of the James Towne Colony in Virginia. Two months later they made a landfall in Cape Cod Bay. There the men of the company drew up and signed an agreement electing their own officers and binding themselves together for the common good. It read, in part, " and by virtue hereof to enact, constitute and frame such just and equal laws, ordinances, acts, constitutions, and offices, from time to time, as shall be thought most meet and convenient for the general good of the colony; unto which we promise all due submission and obedience."

After the compact was signed, exploring parties were sent out to search for a suitable place for the second permanent English colony in North America. Four days before Christmas, 1620, they made a landing in a sheltered harbor and landed on a rock on the shore. The settlement of New England had commenced, not on the West Coast where Sir Francis Drake had made his claim, but on the northeast shore.

1629-1764
THE SETTLERS

Jamestown is first permanent colony in New World. Tobacco, Pocahontas and Captain John Smith save the threatened settlement. The Puritans, arriving on the *Mayflower*, settle Plymouth Plantation. Subsequent colonies in Virginia, Massachusetts, Maryland, Pennsylvania, Connecticut and New York. Harvard College founded in 1636. First Negro slaves sold by Dutch merchants in Virginia in 1619.

HISTORICAL CHRONOLOGY	ART CHRONOLOGY
1630 Boston founded by John Winthrop.	1630 John Winthrop begins his diary, 1630-1649. William Bradford's History of Plymouth Plantation is written.
1636 Roger Williams founds Rhode Island.	
1637 First major battle with Indians.	1640 Bay Psalm Book is published.
1664 New Netherlands surrenders to British, becomes New York.	1670 Portrait-engraving of Richard Mather by John Foster, who also sets up first printing press.
1673 Father Marquette and Louis Jolliet, a fur trader, explore Mississippi River area.	1690 Benjamin Harris writes New England Primer.
1676 Nathaniel Bacon leads rebellion of Virginia.	1700 Samuel Sewall publishes tract in Boston, The Selling of Joseph, condemning holding of slaves.
1677 First large group of Quakers emigrate.	
1682 City of Philadelphia laid out. La Salle descends Mississippi, claims region for Louis XIV of France, calling it Louisiana.	c. 1700 Henrietta Johnson of Charleston, S.C., is first known woman painter in America.
	1702 The College of William and Mary designed by Sir Christopher Wren.
1701 French settlement at Detroit.	1704 Boston Newsletter begins publication continuing until the Revolution.
1706 Birth of Benjamin Franklin in Boston.	
1718 New Orleans founded by French.	c. 1720 Portrait of Ann Pollard is painted.
c. 1720 French expansion from Louisbourg at the mouth of the St. Lawrence westward and south.	1721 Gustavus Hesselius receives first public art commission in Colonies for The Last Supper.
	1727 Portrait of Cotton Mather engraved by Peter Pelham.
1732 George Washington is born.	1729 John Smibert, academic painter, arrives.
1734 Peter Zenger establishes precedents for freedom of the press.	1732 Benjamin Franklin begins Poor Richard's Almanac.
1749 Ohio Company chartered by George II whose claims were to conflict with those of the French.	c. 1735 Van Bergen Overmantle, landscape, document of Hudson Valley Dutch farm life is painted.
1752 Benjamin Franklin performs his kite experiments to test the properties of electricity. Royal charter granted to James Oglethorpe for formation of colony of Georgia.	1738 John Singleton Copley is born. Benjamin West is born in Springfield, Pa.
	1741 Charles Willson Peale, artist, naturalist, and inventor, is born.
1754 Beginning of the French and Indian War.	1752 Lewis Hallam establishes a repertory theatrical company.
1755 Braddock is defeated near Fort Duquesne.	1754 Franklin publishes what is believed to be first American cartoon calling for unity against the French.
1763 French and Indian War ends with the Treaty of Paris; all French claims except New Orleans ceded.	1755 Joseph Blackburn paints Winslow Family.

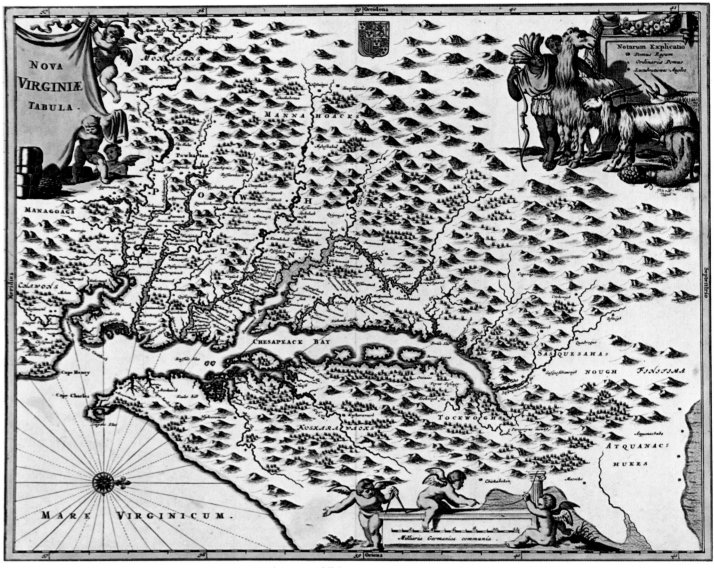

This hand-colored engraving was made in 1671 from Captain John Smith's original 1616 map of *Virginia. Smith oriented his map with north at right, thus placing Chesapeake Bay at the bottom.*

And Then There Were 13

The first English settlements in the New World were inspired not by adventure, not by the British Crown, nor even the search for religious freedom. Each of the three may have contributed, but it was the commercial trading companies of England, made up of merchant capitalists and monied noblemen, who provided the impetus for the first settlements in what is now the United States. These stock companies, somewhat similar to today's corporations, were given royal charters by the Crown for the purpose of increasing British trade and revenue throughout the world. Companies of this type, including the prestigious East India Company which successfully ventured into the Pacific and traded on the coasts of the Indian Ocean, had had some success at least 50 years before the New World ventures.

Seminal to the settlements in the U S were two stock companies which were granted charters in 1606. One was the London Company, so-named because the organizers and stockholders resided in London. They were the holders of the Virginia charter, which authorized the colonization of the American coast between the parallels of 34° and 41° north; it dispatched the expedition that founded the colony at Jamestown.

A second company was given colonization rights between 38° and 45° north. As its stockholders were based in Plymouth, this venture was called the Plymouth Company. It was financed not only by profit-seeking merchants but also by members of a small sect of Fundamentalists who called themselves Separatists. They were a homogenous group who had considerable experience cooperating with one another, as religious persecution had driven them to Holland where they remained some 11 years before returning to England. These Pilgrims, or religious travelers, consisted of

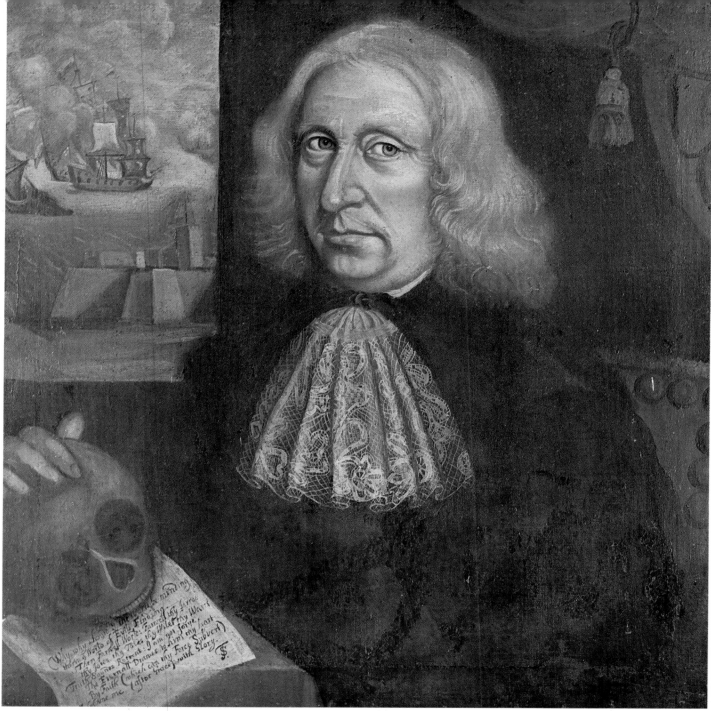

Artist, poet, resident of Boston and Bermuda, Thomas Smith painted this portrait of himself in *the last quarter of the 17th century. Known to be a mariner, he painted ships in the background.*

freemen who had contributed to the expedition and who would share in the profits, indigent but devout men and women who were called saints by their fellow religionists, and other bondsmen and servants, known as strangers. In return for the opportunity to live as Separatists in the New World, saints and strangers contracted to labor for seven years. To transport the first group two vessels were outfitted, but one never got under way and on September 16, 1620, the entire group of 101 or 102 Pilgrims was crowded onto the one remaining, the *Mayflower*.

It had not been too difficult to raise the money for by that time the Virginia settlers had already proven that considerable profits could be made by the export of tobacco. Plymouth stockholders,

Seal of the Massachusetts Bay Colony, *a woodcut, was carved in 1675 by John Foster.*

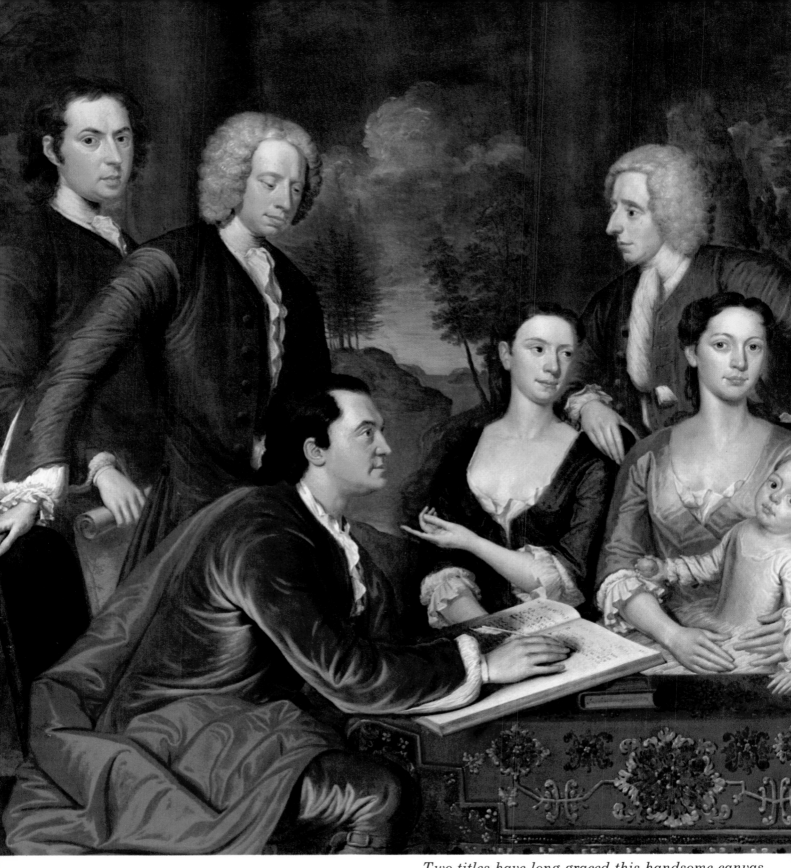

Two titles have long graced this handsome canvas.
Painted in 1729 by John Smibert, it is

too, had invested wisely for although their
emissaries abroad met with great hardships and
privations ·they were able to supply valuable
timber and furs to the market. Within ten years
after the landing of the *Mayflower* at Plymouth
Rock the company paid off its debts and
reorganized its stock company arrangement into
a private enterprise system of individually
owned properties.

The Pilgrims of Plymouth Rock and the
Puritans are sometimes confused, but although
they were both members of the Separatist
religious movement their two colonies had little
else in common. The Pilgrims were for the most
part from the lower classes. The Puritans
included country gentlemen, university
graduates, members of nobility and experienced
clergymen. Their aim was to set up the ideal

known as The Bermuda Group *and also as* Dean George Berkeley and His Entourage.

religious state by purifying Protestantism. Far more rigid than the earlier Pilgrims, who drank beer and strong water and shared their beverages with the Indians, the Puritans frowned on almost every kind of pleasure with the exception of sexual activity. Widows and widowers rarely remained unmarried more than a few months and families proliferated rapidly. They also accelerated the colonization of New England through a great migration that moved at least 300 ships carrying 20,000 settlers to America by 1641.

The Puritans were sponsored by the Massachusetts Bay Colony, which obtained its royal charter in 1629. They were extraordinarily fortunate in that their charter did not locate the head office in London. This gave the colonists themselves control over their governors and assemblies, and made the Massachusetts Bay Colony the most independent of the first three settlements. The Crown, of course, continued to have some control, though the English merchants did not, but though the Crown guaranteed that the colonists would have the rights and liberties of British subjects, in the Massachusetts Bay Colony, because of the religious base, a strict church state emerged with voting rights limited to church members. Churchmen were all powerful in the organization of civil affairs. Persons guilty of a wide variety of seemingly trivial religious disagreements were labeled heretics, for example, and banished.

The restrictive atmosphere was most unsuited to people with a strong affinity for tolerance and freedom, and splinter groups began breaking away. Roger Williams left with a few followers in 1636, founded the town of Providence, and thus helped create the colony of Rhode Island. Thomas Hooker moved to the Connecticut River and founded settlements that ultimately became the colony of Connecticut. New Hampshire, at first controlled by the Massachusetts Bay Colony, also broke away.

The New England Colonies cooperated politically and economically over the generations. The Massachusetts Bay Colony, with its royal charter confirmed by the King, rapidly became the strongest single colony in America. After only 13 years it boasted a population of 16,000. In the 17 years after the colonization of Virginia, by comparison, the population was only 1,200 men, women and children.

Such a difference is understandable when the two different types of settlement are considered in terms of terrain and government. In Virginia the colonists spread rapidly over the fertile soil along the coast. Tobacco quickly impoverishes the soil, and as it became the major crop, increasingly large amounts of land were needed. Out of the large plantations developed in this way grew a pattern of slow growth that continued in Virginia over the next 150 years. At first white indentured servants from Ireland, Scotland and England were brought in to work without wages from four to six years in return for their transportation and support. As these bondsmen completed their terms, they moved to

unoccupied land, cleared it, and began growing and shipping tobacco.

A major contribution to the development of these plantations was inaugurated in 1672 when King Charles II issued a charter to the Royal African Company, which was organized specifically to trade in slaves. Within a hundred years some 200,000 slaves were working Virginia plantations. Without them the huge plantations could never have become economically viable, and the rural aristocracy that emerged from them would not have existed. Well educated, rich and powerful men and family dynasties controlled vast plantations and exerted great control over the government.

The evolution of New England was entirely different. As the terrain prevented the development of large spreads of fertile land, towns appeared, rather than plantations. Unlike the centralized system of government of Virginia, the towns themselves held much of the power. Though the state legislature might make the rules, it was often the towns that decided which individuals should be allowed to settle. Each town had control of the land allotments and the management of the farms around it. The system has been likened to that of an English manor with the town council, rather than the lord of the manor, as its head. Each town had its church with the minister as the community leader. Taxes, elections and military service were discussed and decided at town meetings.

The New England Colonies had a better acceptance with the Indians than the Virginia group, for they were more insistent upon making treaties with the Indians for the land they occupied, and paying for it. Nor did they try to

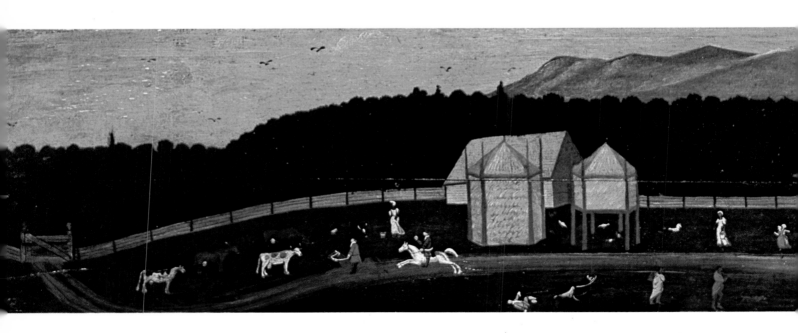

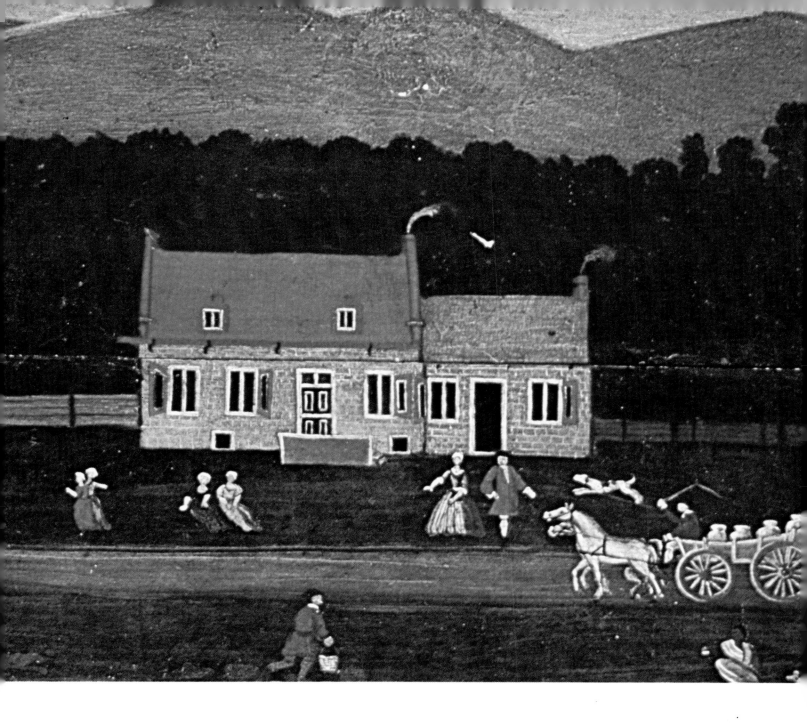

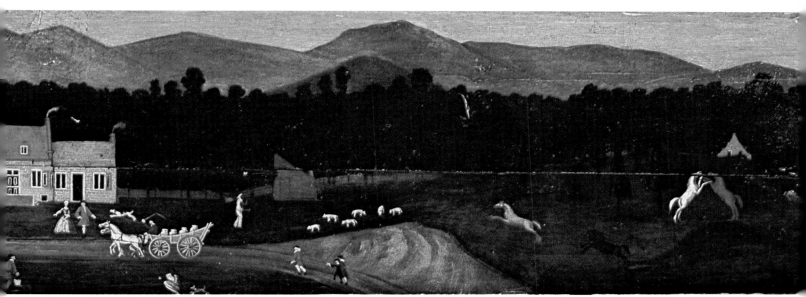

The Van Bergen Overmantel *by an anonymous itinerant painter shows the Marten Van Bergens* *in front of their stone house with their barns, pastures, numerous animals and servants.*

This copperplate engraving of the 1740's shows, at top center, the principal building of William and Mary College designed by England's Sir Christopher Wren. At right is the Indian School.

push them too far from these lands. In fact, the Plymouth Colony fortuitously got off to a good start in that it was settled on land the Indians had abandoned.

As word of the profits being made spread through England, more stock companies were formed. There was even more activity along the lines of the individual proprietorship or royal grant type of colony. In this system a single individual became proprietor of a huge tract of land; in effect he was king. One such great proprietor was William Penn. A gentleman by birth, he was also rich, and for icing on his cake he had a claim of 16,000 pounds against King Charles II. At Oxford he grew interested in the Quakers, at the time the most radical religious group in Europe, and as a result became a unique combination of entrepreneur and religious radical.

In order to provide the Quakers, or, as they called themselves, The Society of Friends, with a place they could call their own, Penn used his influence to obtain a proprietary charter for all of the land that became Pennsylvania; later his control extended to Maryland. He arranged for

settlers to purchase large tracts of land from his company for a specific sum plus a percentage of the profits. He also instituted a liberal rental agreement which began at one penny per acre. To indentured servants, when their period of service was up, he granted 50 unencumbered acres. His sociological policies were also liberal and tolerant. His colony had only one religious rule, that the settlers acknowledge God Almighty.

As far as the makeup of the colony was concerned, Germans, Welsh, Swedes and Jews were all welcome, and many seized the opportunity. By 1685, 90 ships had sailed for Pennsylvania with over 7,000 passengers. It soon had the largest white population of any of the Colonies, and only about half of them were English. The colony was most successful. Even in the early years there were exports of wheat, beef, flour and timber. Within four years after the town of Philadelphia was settled it had 600 brick houses.

The situation in what was to become New York was quite different. The Dutch had set up a trading post after purchasing the Island of

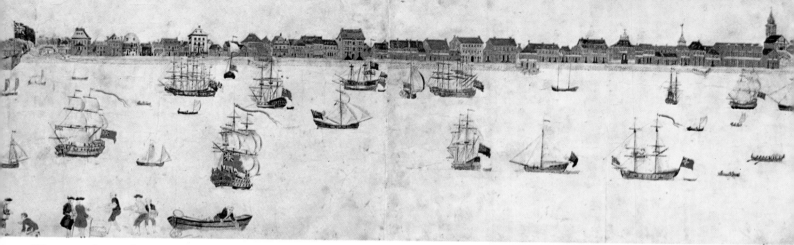

Watercolor shows the harbor and town of Charleston, South Carolina. It is the earliest painting of Charleston. Bishop Roberts painted in Charleston from 1735 until his death in 1739.

Manhattan from the Indians. But although tentative attempts were made at settlement, their primary interest was in the fur and slave trade. Their unique and unsuccessful method of colonization, the patroon system, allowed any rich burgher who brought out 50 families within a period of four years to receive a huge estate and become absolute ruler of it, subject to minimum interference from Holland. Without the base of comparatively liberal English law, the patroon system soon developed into feudal estates. The Dutch settlers looked with envy at the colonies around them with their liberal British policies. When England threatened the New Netherlands Colony, displaying a show of force, Holland acquiesced to British control. New York was added to the growing English Colonies.

Proprietor and patronymic of the new colony was none other than James, Duke of York, and brother of King Charles II. James was generous with the Dutch settlers, allowing them to keep their lands, language and religion. As New York was never a corporate colony, there was no stockholder pressure on it to return profits, and thanks to its proximity to the sea and the comparatively easy passage to England, it quickly grew into an important financial, trading and shipping center.

The southern part of the old Dutch colony ultimately separated from New York, resulting in two more colonies, New Jersey and Delaware, being added to the growing English possessions in America.

The region south of Virginia was also colonized on the basis of proprietorship. In 1663 eight noblemen received a grant which included the area that became North and South Carolina. The Carolina Colony, to avoid competition with the established plantation colony of Virginia, did not plan to grow sugar or tobacco, but rather to produce wines, fruits, oils and silks, which England had to purchase from foreign markets. The early colonists came from New England and

Bermuda, and from across the northern border. A Virginian, William Drummond, became the first governor. By 1700 considerable colonization had occurred in both the northern and the southern sections, and two distinct governments had been organized. Two more colonies existed: North Carolina and South Carolina.

Meanwhile Connecticut had received a royal charter, as had Rhode Island. A colony was lost a few years later as Plymouth was absorbed by Massachusetts. New Hampshire became a colony in 1678.

Now there were 12. The last of the 13 colonies to be founded by England was Georgia. Like most of the others it was founded on the proprietorship principle but with an important difference. Georgia was founded not by profit seekers, but by a group of philanthropists, religious men whose motives were to assist the deserving poor of England, of which there were many. They hoped to get some of the beggars off the streets, some of the debtors out of prison, some of the chronically unemployed out of the labor market, by providing them all with a new start in a new land. Plans for this idealistic endeavor began in 1730, and three years later General James Oglethorpe, representing the philanthropic group, landed at what is now the town of Savannah with 114 colonists. The Georgia Colony was marked by a morality and discipline even stricter than that of the early Puritans at Massachusetts Bay. All strong liquor such as rum and brandy was prohibited. No colonist was permitted to own slaves, or more than one limited piece of land; he could bequeath his land only to a male heir. These restrictions did not remain in effect for very long, as the hold of the idealists loosened and the colony began to have more in common with the Carolinas. As the southernmost outpost in North America of the British Empire, Georgia's development was important as a buffer against the Spanish colony of Florida.

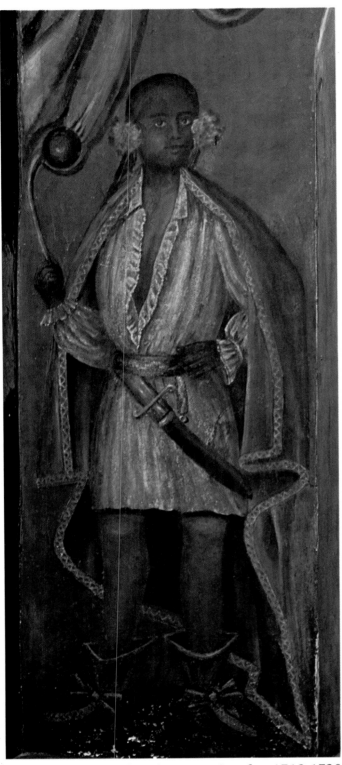

American Indian kings were painted c. 1716-1720 by an anonymous painter in the stairwell of the

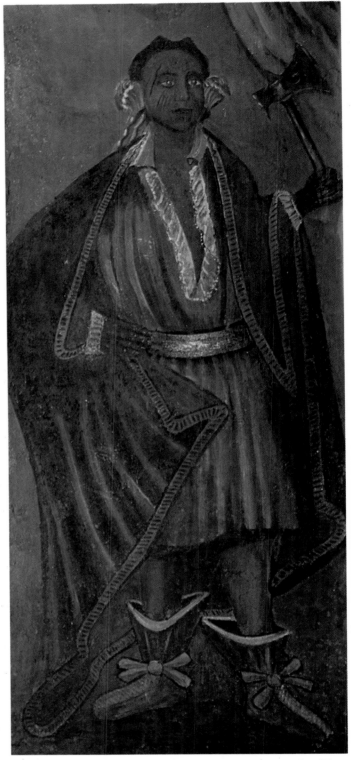

Macphaedris-Warner House in Portsmouth, New Hampshire. They are copies of earlier paintings.

The Kindly Indians

Any belief that the early European settlers carved an empire out of a wilderness with only their energy, ingenuity, faith and courage is completely unfounded. These characteristics were of value, but in the final analysis it was the Indians who enabled the British colonists to maintain a foothold on the Atlantic Coast. First was their passive action in simply permitting the

white man to live, for at any time during the early days of any colony the Indians could have obliterated it. During the starving time at Jamestown, for example, and even in the recovery period after reinforcements had arrived, the colonists were surrounded by natives who were not only numerically superior, but overwhelmingly better organized.

True, the Jamestown colonists succeeded in kidnapping Pocahontas, daughter of the powerful Chief Powhatan, after she had successfully interceded with her father when Captain John

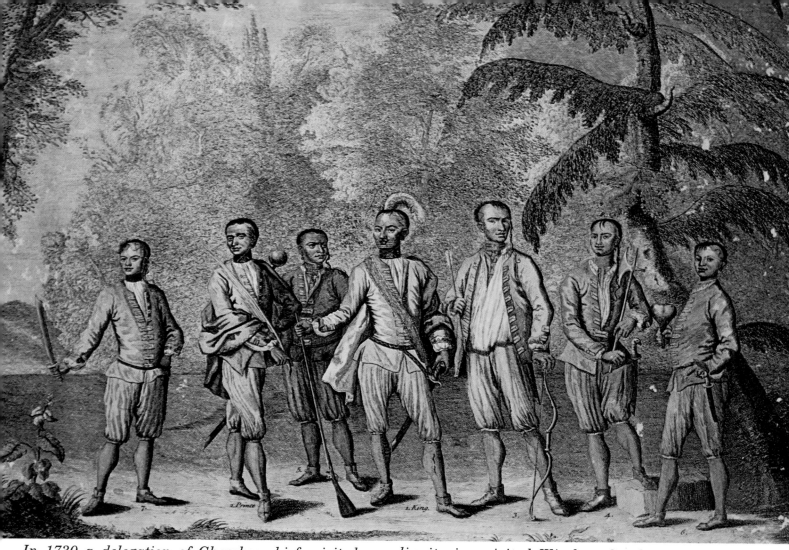

In 1730 a delegation of Cherokee chiefs visited London. They were treated as important dignitaries, visited Windsor Castle, met King George II and signed a friendship treaty.

Smith had been captured. Partly through her influence, partly through the goodwill of most of the tribesmen, they kept the peace.

More directly they prevented the colonists from starving to death by providing grain, fish and meat. They supplied the seed for the early crops of maize, and the crop that led to the Colony's prosperity and way of life — tobacco.

When the Pilgrims came ashore on the rock-strewn New England coast they found the mounds in which the Indians had buried their seed corn. Planting it in fields previously used by the Indians resulted in their first harvest.

Some three months after the Pilgrims landed they were visited by an Indian named Samoset who welcomed them in English. He had come from the North where he had picked up the language from fishermen. Through Samoset they learned of another English-speaking Indian, Squanto. With the two serving as interpreters, the Pilgrims made a treaty with Chief Massasoit.

So by their nature did the Indians make the first settlements possible. The colonists lived on the produce long cultivated by the Indians, corn, beans, squash and pumpkins, learned from them how to harvest game and fish, and made fortunes on the weed they smoked in their peace pipes.

As keepers of the peace, George II (1757) and George III (1764), gave medals to Indians.

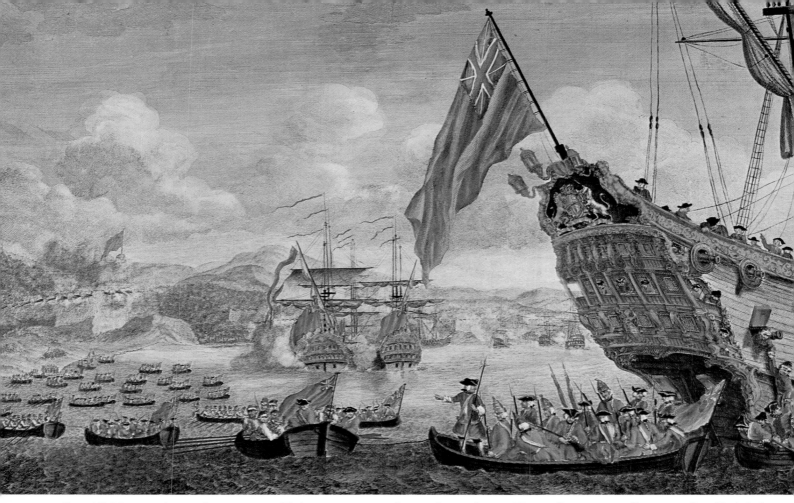

In 1745 an American expedition captured Louisbourg in an attempt to destroy North American French power. Later, the British disappointed them by returning it to France.

France Defeated

Two great rivals for control of the vast land that was to become the USA were France and England. The Spanish, even with their early foothold in Mexico, California and Florida, were never a serious threat. But the French fought every inch of the way in their efforts to carve a New France out of the wilderness. The earliest of the conflicts came in 1689 when the Comte de Frontenac, head of the Catholic state of New France in North America, threatened British domination with a well-trained, well-supplied army. The British colonials drilled their militia. Both sides used the services of what Indian allies they could attract, and staged sporadic raids against one another with bands of guerrillas.

A greater threat was the deep penetration made into the heart of North America by French explorers. Among the first was Louis Jolliet, a 27-year-old cartographer who would have the trapping and trading rights in the region he discovered. Father Jacques Marquette, a 35-year-old Jesuit missionary who could speak six Indian languages, accompanied him. They made their incredible journey in two frail canoes, passing through one Indian territory after another. They paddled down the Wisconsin River to the Mississippi, then followed it past the

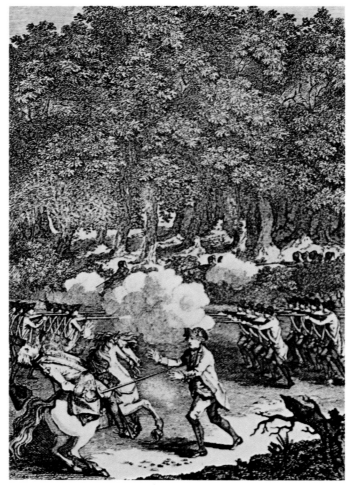

Braddock met defeat and death when his army was ambushed by French and Indians in 1755.

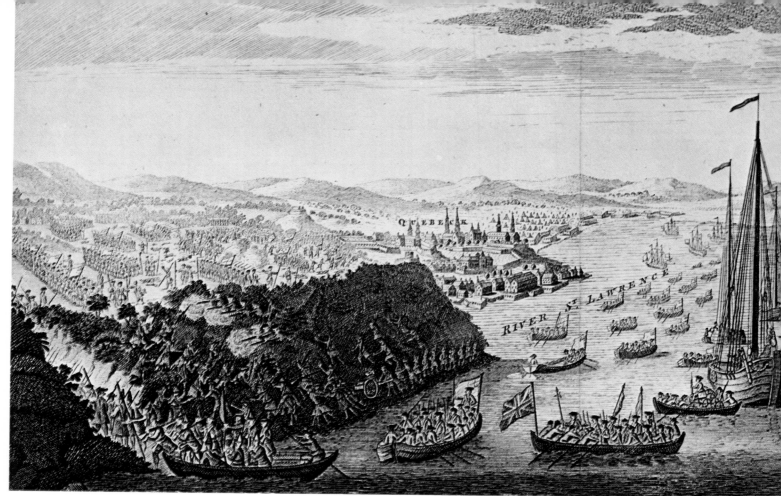

By scaling the cliffs, lower right, the British and Colonial Army under General Wolfe capture the French capital of Quebec and eliminate the threat of French power in North America forever.

Missouri, the Ohio and the Arkansas. Some of the dozens of tribes they encountered could understand the dialects spoken by Father Marquette, and from them the explorers learned that the river flowed into the Gulf of Mexico.

Next Frenchman down the Mississippi was the adventurous and temperamental Sieur de La Salle, with a contingent of 50 French frontiersmen. Their 1682 expedition nailed down France's claim to the wild country extending from Canada south to the Gulf of Mexico and west to the Pacific.

New France expanded rapidly. As one war in Europe followed another, the French and British raids against each other continued. Then came the showdown. The French claimed the entire Ohio Valley and extended a chain of forts into what is now Pennsylvania. The threat to the English Colonies no longer came only from explorers, but from trappers and settlers; as a matter of fact, the French warned English traders to stay away. The English sent a small group under George Washington, a 21-year-old major, to investigate and report on French expansion. Washington's message warned the French to withdraw, but it was peremptorily rejected. As a result of the foray, Governor Dinwiddie of Virginia sent a force of soldiers and workmen to build a fort at the spot where the city of Pittsburgh now stands.

So began the French and Indian War, known in Europe as the Seven Years' War. The early battles of this major British-French conflict were won by the French, as when British Major General Edward Braddock attacked the French at Fort Duquesne. Young Washington, Braddock's aide, wrote in his diary:

"... The English soldiers ... broke and ran as sheep before the hounds ... The general (Braddock) was wounded behind in the shoulder and into the breast, of which he died three days after. ...

"I luckily escaped without a wound, though I had four bullets through my coat and two horses shot under me. ..."

The war dragged on. Finally, in the summer of 1759, General James Wolfe found a pathway up the cliffs that led to Quebec. As a result of the Battle of the Plains of Abraham, General Wolfe died, as did the commander of the French forces, the Marquis de Montcalm, but the British won decisively. A year later Lord Jeffrey Amherst took Montreal for the English.

It was the end of any French threat to the burgeoning British Colonies. At the Treaty of Paris Great Britain took all of the French possessions in America east of the Mississippi, leaving only New Orleans on the Gulf of Mexico. Spain, which had also entered the war, ceded Florida to Great Britain as well. Now the whole eastern half of the continent was an English colony.

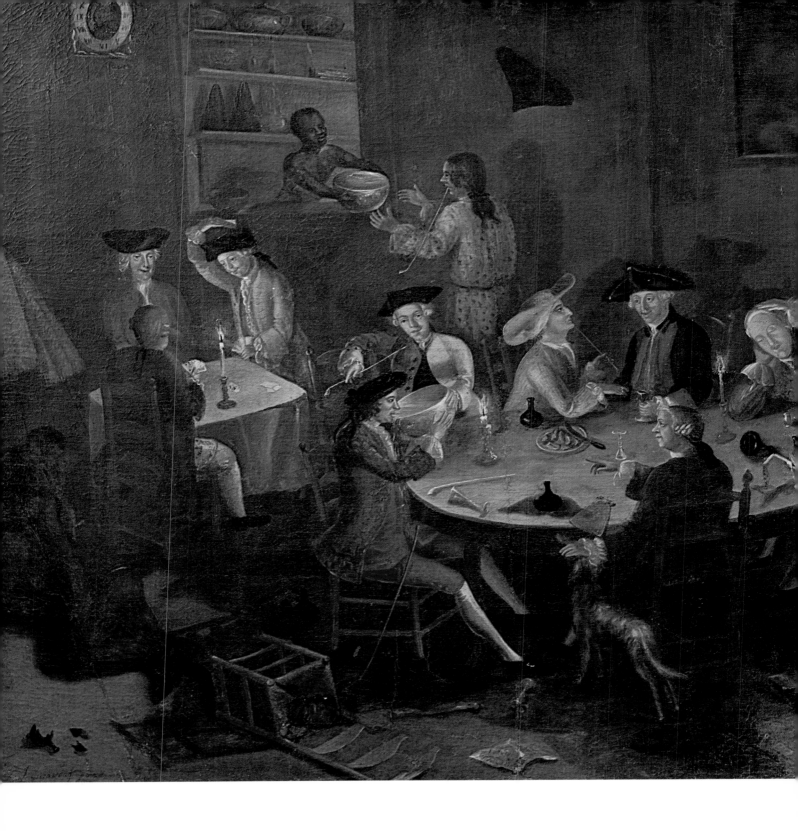

Riches at Sea

The highways of the Colonies in the early 18th century were the rivers and the coastal ocean lanes. Shipping lanes also crisscrossed the Atlantic from the East Coast to the West Indies, Africa and England. American ships, built in Boston, Philadelphia, Norfolk and other ports, carried pork, beef, vegetables and rum to the Bahamas, Bermuda, Jamaica and Barbados, and all these plus tobacco, sugar, rice and lumber to England. The richest part of the cargo to the West Indies was the prolific codfish, caught in quantity off the banks of Newfoundland. Cod could be easily salted, dried and packed, and sold both cheaply and profitably. Plantations throughout the West Indies and the South fed it regularly to their slaves, and sometimes the masters partook of it, too. The lowly codfish became the cornerstone of some of the great fortunes of Boston and New York.

Shipping merchants became the equal of

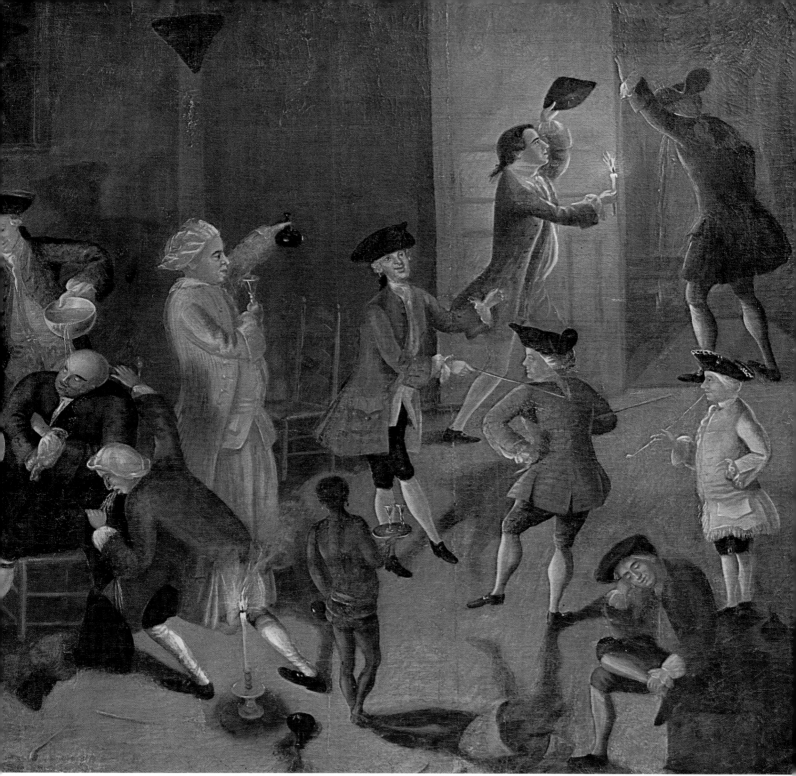

Dutch, French and English privateers, pirates and slavers often met in Surinam (Dutch Guiana). Known as the "Wild Coast" it provided a safe haven for carousing sea captains.

lawyers, land proprietors and clergy in social standing, and their superiors on the economic level. If the shipping merchants were the aristocracy, the captains were not far behind.

With almost continuous war between the European powers going on in the years between 1730 and 1763, privateering was also a most profitable colonial enterprise. The Americans did not initiate the profession. France, England and Spain all supplied "letters of marque and reprisal," or their equivalent, to their nationals. The English colonists in America were not only provided with letters of marque but urged to arm their vessels and go out to use them. They would capture enemy ships, bring them into Atlantic seacoast ports, and there divide and share the loot with the Crown. When a privateer captain could not manage to bring a captured vessel to port, his "papers" authorized him to take off her valuables and sink her then and there.

For all of the Crown's proprietary interest in the Colonies' enterprises, England allowed no coins, gold or silver to be imported, no coins to be minted. In this numismatic vacuum "bills of

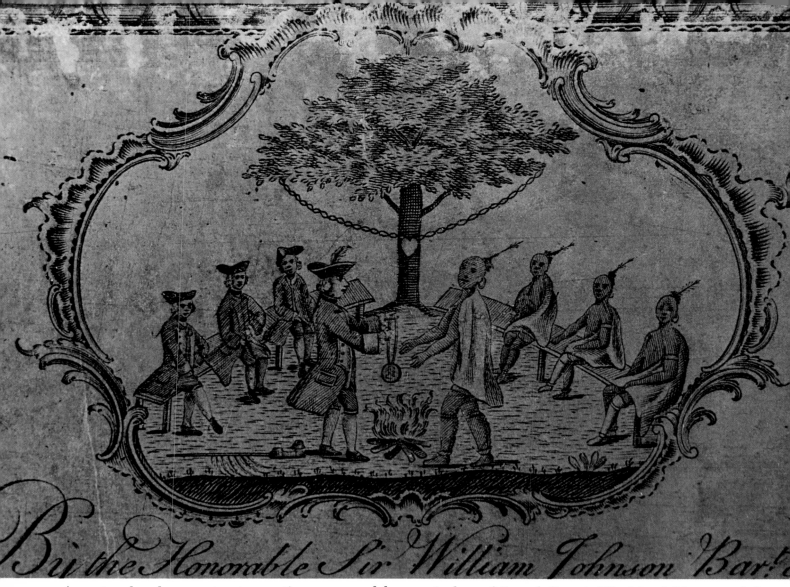

A cartouche shows a treaty meeting arranged by Sir William Johnson, fur trader, and father-in-law of Joseph Brant. His friendship caused the Indians to help the British against the French.

credit," crude IOU's, were passed around. They were based in value on the only coin generally available, the Spanish piece of eight. It was milled so that it could be broken into eight bits — two bits equaled a quarter. After the Revolution, the USA used "dollar" for its monetary unit, the Spanish piece of eight for value. Dollar bills date back to the bills of credit.

Privateering contributed to the growth of the thriving young shipbuilding industry. Seagoing captains tended to specialize, and some designed their ships for fighting. They ostensibly traded with the West Indies but kept a sharp lookout for any Spanish or French ship — depending upon who was the enemy at the time — that could be taken as a prize. Some sailed strictly merchant ships to and from England and the West Indies.

A third type of vessel was the slaver, specially built for human cargo. The slave trade was for many years dominated by the Royal African Company of London, but very slowly New Englanders, New Yorkers and then the shipping interests of Baltimore, Norfolk and Charleston got into it. By 1750 what became known as the "triangle trade" was well established and

American ships were playing an important part. The first leg began in New England, where more than a hundred distilleries were producing rum, largely for the trade. Laden with barrels of rum, the ships sailed to northwest Africa where the rum was traded for slaves. From Africa the ships, packed with slaves usually lying down in one spot during the entire voyage, sailed to the West Indies, where the slaves were traded. The ships returned to New England with cargoes of molasses which became rum, and the pattern was repeated. Many of the slavers, as well as the privateers, were otherwise peaceable and godly Quakers, Anglicans and Presbyterians.

The molasses and sugar trade became a major factor in the colonial independence movement. In 1733 England imposed the Molasses Act which carried a duty of six pence per gallon on all molasses, rum and sugar imported into the American Colonies from the West Indies. Thirty years later, George Grenville, Chancellor of the Exchequer, began enforcement of the Molasses Act, and added a Stamp Tax as well. Smuggling increased and the stage was set for a showdown between England and her American Colonies.

1764-1800
REVOLUTION AND INDEPENDENCE

Massachusetts denounces Townshend Acts as taxation without representation. England lands royal troops to garrison Boston. Sons of Liberty rise in opposition. Boston Tea Party leads to meeting of First Continental Congress. Colonists defy British at Lexington. Second Continental Congress meets in Philadelphia as colonial militia stands firm at Bunker and Breed's Hill. Washington chosen commander in chief. Congress declares United States independent. The new United States Army, with the help of France, defeats England.

HISTORICAL CHRONOLOGY	ART CHRONOLOGY
1764-1767 *Sugar, Stamp and Townshend Tax Acts resisted by colonists.*	**1760's** *Joseph Blackburn and John Wollaston prime popularizers of rococo style of portraiture.*
1768 *Massachusetts legislature dissolved for resistance to Parliament.*	**1766** *Major Robert Rogers writes* Ponteach, or the Savages of America.
1769 *First Spanish missionaries in California. San Diego de Alcalá founded.*	**1767** *Thomas Godfrey's* Prince of Parthia, *first American play performed professionally.*
1770 *Boston Massacre; Townshend Acts repealed.*	**1769** *First California mission established by Fr. Junípero Serra in San Diego.*
1772 *Tea Act to support East India Tea Company leads to Boston Tea Party.*	**1771** *Benjamin West paints* Death of Wolfe. *Pennsylvania's treaty with the Indians. Phillis Wheatley, black poet of Boston, publishes* Poems on Various Subjects *in London.*
1774 *First Continental Congress.*	**1771-75** *Significant American artists study abroad.*
1775 *Battles of Lexington and Concord, Ticonderoga, Bunker Hill.*	**1772** *Charles Willson Peale paints first lifesize portrait of George Washington.*
1776 *Declaration of Independence. George Washington named commander in chief.*	**1774** Royal American Magazine *begins publication.*
1777 *Victory for U.S. at Princeton. Stars and stripes adopted for U.S. flag. Burgoyne surrenders at Saratoga. Lafayette, aged 20, appointed major general by Washington. Winter at Valley Forge.*	**1775** *Edward Barnes writes lyrics to* Yankee Doodle *and sets them to old English tune.*
	1776 *Thomas Paine writes* Common Sense.
1778 *France recognizes independence. Signs treaty with Franklin, Deane and Lee. Spain and Holland join in recognition.*	**1778** *John Singleton Copley recognized as important American painter.*
1779 *John Paul Jones on* Bonhomme Richard *defeats Britain's* Serapis.	**1780** *American Academy of Arts and Sciences organized at Boston.*
1781 *Cornwallis surrenders to Washington and French allies.*	**1784** *San Xavier del Bac, masterpiece of Hispanic baroque style, begun in Tucson.*
1783 *Peace of Paris guarantees freedom of U.S. from England. Boundaries: Canada to Florida and west to the Mississippi.*	**1787** *First American comedy, Royall Tyler's* Contrast, *an immediate success.*
	1788 The Federalist *papers are published.*
1787 *Northwest Territory established.*	**1792** *Duncan Phyfe in New York City rapidly earning his reputation as most famous furniture maker.*
1788 *The Constitution is drafted and adopted.*	*Construction of the Capitol and White House, both in the classical style.*
1789 *Washington elected President.*	*The Farmer's Almanac founded by Robert B. Thomas.*
1791 *Bill of Rights added to Constitution.*	**1794** *Franklin's* Autobiography *published.*
1794 *Whiskey Rebellion, a protest against taxing liquor.*	**1796** *Gilbert Stuart paints George Washington's portrait.*
1799 *Death of Washington.*	

The American Revolution

The roots of the Revolutionary War lie in the Old World rather than the New. England had waged a successful series of wars against Spain and France and had opened up trade throughout the known world. But in the process she had made enemies. These enemies, especially France and Spain, were to build up their military resources until they were again able to constitute a considerable threat against England. Britishers thought that if the American Colonies were allowed to become independent, revolution might spread to Ireland, where they desperately feared the French would move in and gain a foothold adjacent to them.

But despite these international overtones, the American Revolution was also a civil war, for the American colonials were traditionally, and many of them were by birth, British. So the war for independence was fought not only against England but against friends and relatives as well.

The misnomer is not total, however, for the American Revolution was also a revolution. It was not a revolution as most such conflicts had been before and were to be later — of slaves against masters or serfs against feudal lords. It was a separation from the privileged nobility and a fight against a tradition of inequality, against the established rigidity of the Church of England and even against tradition itself. The colonists were determined to rip the fabric of the past and weave a new one for the future.

A sometimes confusing but traceable sequence of events finally brought about the actual conflict between the Colonies and the mother country. Some of these events were founded in injustices devised by the British Crown under George III and his bumbling ministers. Some of the causes lay in the fear, as mentioned, that Ireland might follow America's lead in revolt, or the fear that the American Colonies would become increasingly competitive in exports with England. They no longer served the purpose they had been founded for — to supply raw materials and, in return, purchase manufactured goods.

England's dissatisfaction with the Colonies lay partly in this competitive attitude, partly in that the Colonies were a drain on the British Treasury, especially in the large sums spent for defense against the Indians and the French. England insisted the Colonies pay their own way, that taxation was a reasonable measure. But the Colonies could not see why they should pay the cost of an occupation army or be involved in England's wars. They felt threatened only by England.

But George III and his ministers did not think that tax laws were a threat to the Colonies. Prime Minister Grenville said: "All men wished not to be taxed." Yet he did not realize that the colonists, unlike the citizens of England, were unaccustomed to taxation and would not be docile about paying. And George III simply could not understand the difference between the American colonists and any other colonial. He had come to the Crown young and immature and his instability was somewhat responsible for his ever changing sequence of ministers, all equally unable to solve the colonial problem. But the King believed that he could force their acquiescence to his will. No colonial, in his view, could successfully attack the center of traditional power. With an appropriate ring of finality he uttered his decree: "The Colonies are not to be emancipated from their dependency upon the supremacy of England." The inflexibility of the King was, however, only one reason for the ultimate dissolution of ties between the two.

It must be remembered that between 1771 and 1774 there were a great number of patriotic liberal men and women who felt as Mercy Warren did when she wrote:

"America stands armed with resolution and virtue; but she still recoils at the idea of drawing

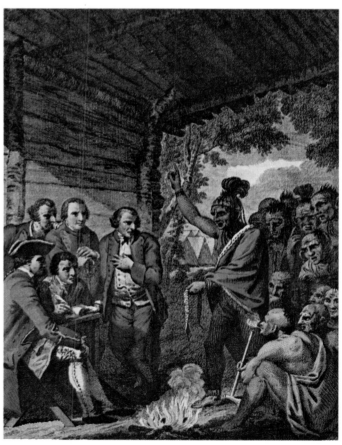

Americans objected to paying taxes for being protected from Indians by British soldiers.

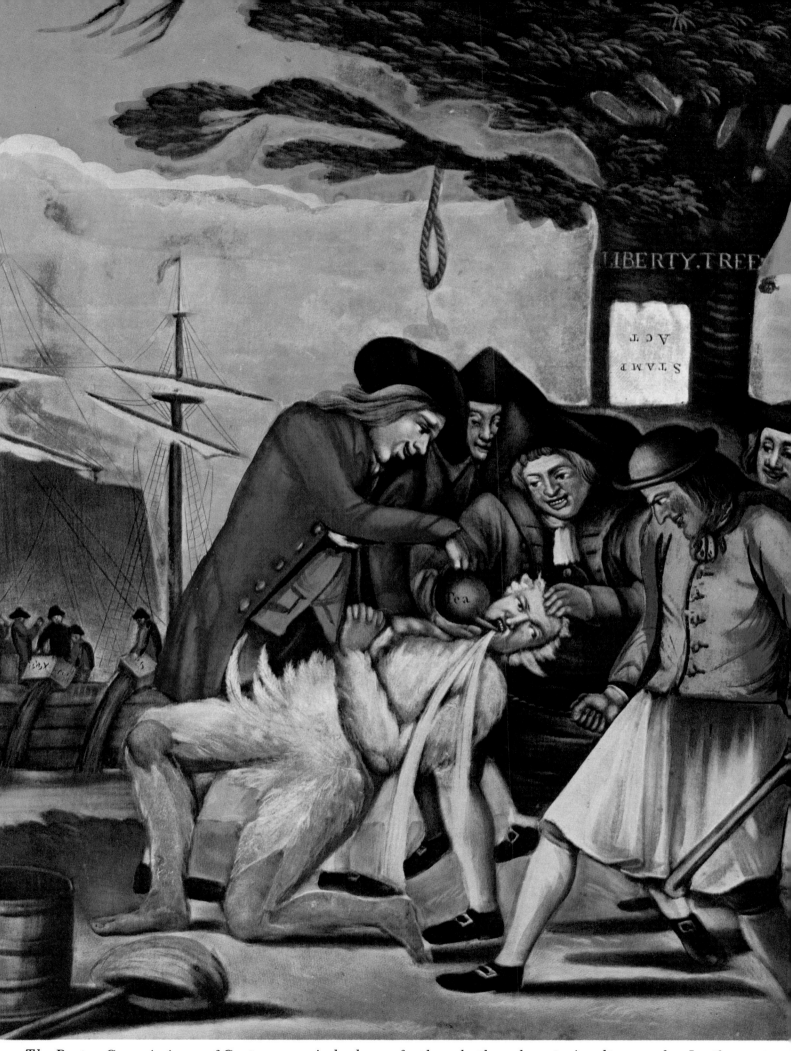

The Boston Commissioner of Customs was indeed forced to drink tea as well as being tarred and feathered, though not simultaneously. In the background the Sons of Liberty spill the tea.

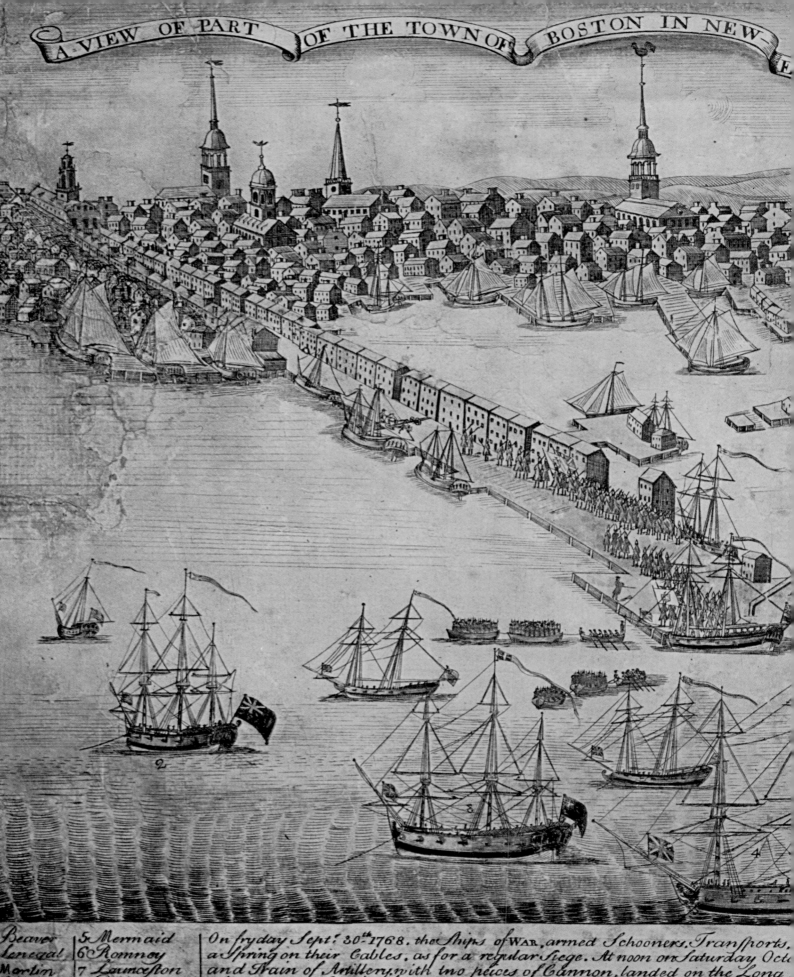

A VIEW OF PART OF THE TOWN OF BOSTON IN NEW-E

Beaver 5 Mermaid On fryday Sept! 30th. 1768. the Ships of WAR, armed Schooners, Transports,
Seneca! 6 Romney a Spring on their Cables, as for a regular Siege. At noon on Saturday Octo
Martin 7 Launceston and Train of Artillery, with two peices of Cannon, landed on the Long
Glasgon 8 Bonetta playing, and Colours flying, up KING STREET. Each Soldier having rece

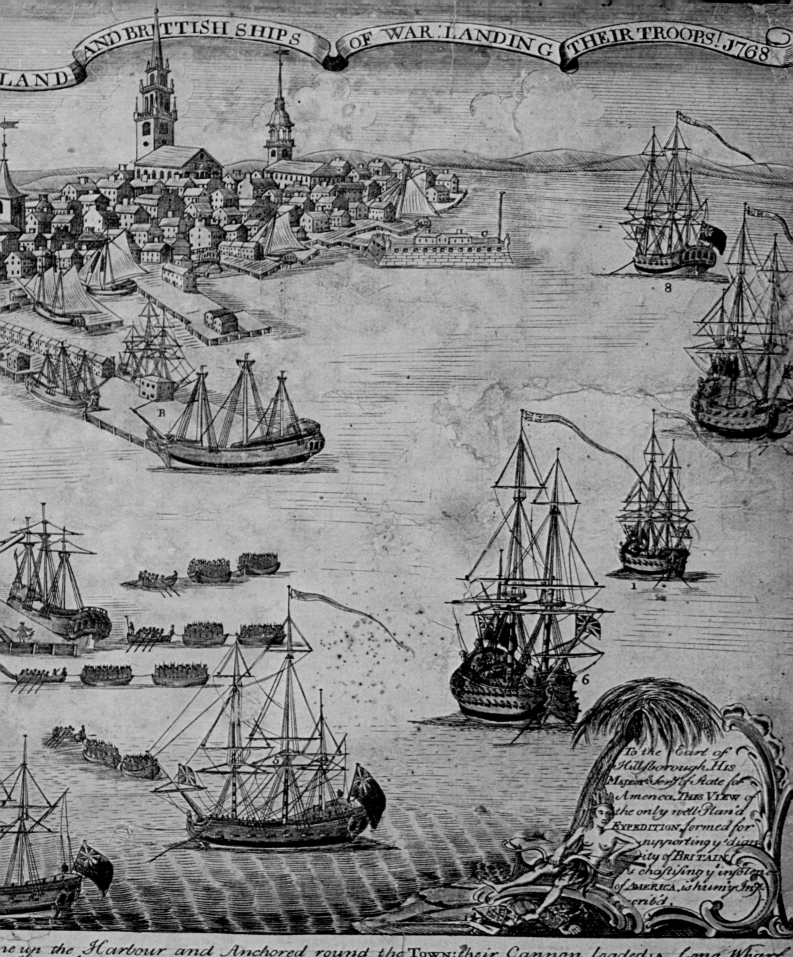

LAND AND BRITTISH SHIPS OF WAR LANDING THEIR TROOPS! 1768

B

8

1

6

5

To the Earl of
Hillsborough, His
Majesty Secretary of State for
America. This VIEW of
the only well Plan'd
EXPEDITION formed for
supporting y dignity of BRITAIN
& chastising y insolence
of AMERICA, is humbly Inscrib'd

...e up the Harbour and Anchored round the Town; their Cannon loaded. A Long Wharf
...t the fourteenth & twenty-ninth Regiments, a detachment from the 59th Regt. B Hancock's Wharf
...there Formed and Marched with insolent Parade, Drums beating, Fifes c North Battery
...rounds of Powder and Ball.

ENGRAVED, PRINTED, & SOLD by PAUL REVERE. BOSTON.

British ships sailed into the port of Boston in
October, 1768, and again in November, putting
ashore a total of four regiments. Bostonians
and Redcoats were in almost daily conflict.

the sword against the nation from whence she derived her origin. Yet Britain, like an unnatural parent, is ready to plunge her dagger into the bosom of her affectionate offspring. But may we not yet hope for more lenient measures...."

Other reasons for the American colonials' final break with England were not political, but sociological and philosophical. The British system of government was rooted in the acceptance of inequality of station. But in America, pursuits such as farm work, trapping and fishing leveled the status of the settlers. And the thoughts of the French philosophers of "The Age of Enlightenment" were seditiously wending their way to American shores. Montesquieu's *Spirit of Laws*, which reviewed various types of government, gave preference to a system of checks and balances in democratic government by dividing the roles of the judicial, legislative and executive branches. This format was to become part of the United States Constitution. The *Social Contract* of Jean-Jacques Rousseau (1762) spoke with the greatest tone of assurance to future revolutionaries. "We have a duty to obey only legitimate powers," it proclaimed, and went on to define legitimate power as being that which was derived, not from any "divine right" of kings, but from the "sovereign people," who retained the right to revoke their leader's mandate at any time. These new views reached out across the Atlantic to inspire American leaders.

One of the leaders so affected was Samuel Adams, a true revolutionary. There were other activists such as shipping merchant John Hancock, but Adams might well be the man responsible for setting the spark that ignited the explosion. Adams was a Bostonian and a solid practical politician who believed the Colonies should be independent. He understood the value of propaganda and realized the necessity of demonstrating, as dramatically as possible, that the English were always in the wrong. He was at the very center of the Sons of Liberty and he made full use of John Hancock's money, the talent of pamphlet writer James Otis and the speaking ability of Joseph Warren.

While Adams was not responsible for all the early confrontations between the British and the colonials, his shadowy presence can be seen behind most of them. When the ship *Lydia*, belonging to John Hancock, was boarded by customs officers, Hancock followed them, ordered the customs officers into the small boats and took them ashore. When another of Hancock's ships, the *Liberty,* arrived in port, he had the customs officers locked up in a stateroom while the dutiable wine was unloaded. The angry customs officials sent out an order to seize the ship. When Samuel Adams spread the news of this, there was a small riot. The rioters moved on, each with a torch held high in one hand and a club in the other, breaking the windows of customs officers' homes and finally setting fire to a sailing vessel owned by a high customs official.

The Crown responded by dispatching 4,000 experienced and well-armed troops from England to be quartered in and around Boston. At a protest meeting called by Samuel Adams, John Hancock and James Otis, there was inflammatory talk of a rebellion. But a call to arms was not issued. Still, a resolution was passed suggesting that every household have ready a musket and ammunition.

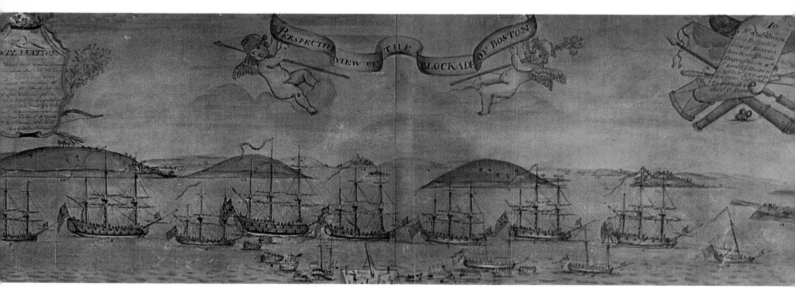

A grand sweep of the blockade of Boston by the British warships is shown in this watercolor by Christopher Remick, which also depicts, in the center, troops coming ashore on Long Wharf.

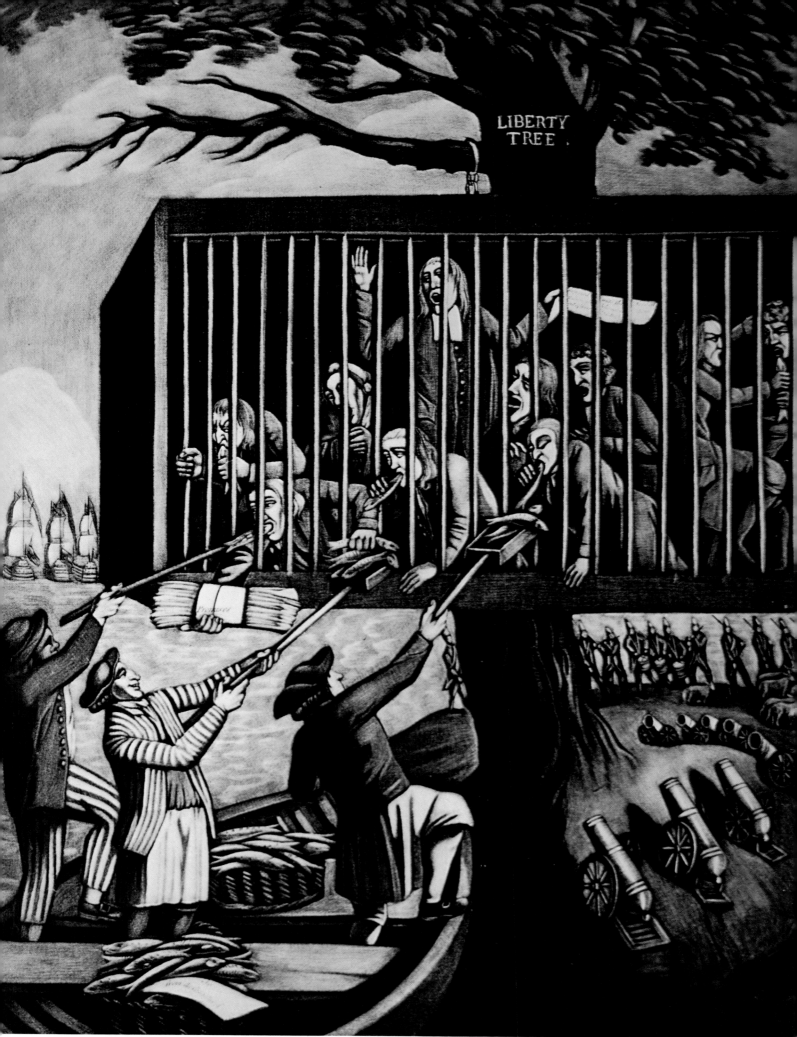

Though the Boston blockade isolated the town, the residents were not actually at the point of starvation. But political caricaturists on both sides of the Atlantic drew inflammatory views.

Violence in Boston

The active phase of the Revolution began with the occupation of Boston. Altercations between citizens and British soldiers became almost routine. Both groups felt the mounting tension. Then, on the evening of the fifth of March, 1770, a group of rowdies began baiting a British sentry in front of the customhouse. The sentry is said to have finally used the butt of his musket to strike one of his tormentors. In minutes he was surrounded. The crowd became loud and ugly. The British Captain Preston, who was in charge of the main guardhouse, ordered seven men to go with him to rescue the beleaguered sentry. Arriving, he ordered the crowd to disperse. The mob dared the soldiers to shoot and continued to threaten them with clubs. When one soldier was knocked down with a club, he fired his weapon. Only then did the crowd move back as other soldiers raised their guns and fired. Within a few seconds Samuel Gray, Patrick Carr, James Caldwell, Samuel Maverick and ex-slave Crispus Attucks were dead.

Samuel Adams and his propaganda group called it the "Boston Massacre" and published the inflammatory and inaccurate engraving by Paul Revere. But now Sam Adams the agitator found himself opposed by his conservative first cousin John. For lawyer John Adams agreed to defend the British Captain Preston and his troop. Lawyer John Adams was convinced that the soldiers had acted in self defense and, with the help of Josiah Quincy, he ably defended them. Witnesses produced evidence that Preston had never given an order to fire. Other onlookers testified that it was the intimidation and violence of the crowd, which included the striking of the soldiers, that had brought about the incident. Toward the end of the trial Adams said, "I believe [the civilians] would not have borne one-half of what the witnesses swore the soldiers bore." After only two hours of deliberation, six defendants were found innocent; two, Matthew Kilroy, charged with killing Samuel Gray, and Hugh Montgomery, charged with firing the first shot, were found guilty of manslaughter and given "benefit of clergy." This meant each sentence was reduced to branding on the thumb.

The Sons of Liberty made good use of the incident. Samuel Adams and his fiery group of patriots celebrated a day of martyrs on each successive fifth of March in an effort to keep alive resentment against the British troops. Yet the populace generally accepted the verdict. They had great respect for the law and for John Adams and Josiah Quincy. Besides, the country was moving into a period of prosperity. The Townshend Acts, which had been at least partly responsible for the resentment of the populace, had been repealed. Export of American corn and wheat reached a peak and for the first time the English payments were in gold.

But the spark of patriotism still glowed and a small number of men and women kept that spark alive. They were vigilant. Adams, Warren and Otis continued to look for, and found, reasons why the colonists should fight for their rights. When it was found that the Massachusetts judges of the Supreme Court were on the Royal payroll, the public was informed of it. The burning of the revenue ship, the *Gaspee,* by Rhode Island patriots inadvertently created a new issue. For England threatened to bring the perpetrators to trial in England and this would obviously violate the right of trial by jury of their own peers.

When the other Townshend Acts had been repealed, the duty of three pence per pound on tea was not removed. Neither was there any serious objection to it by the colonists, partly because they were used to the duty and partly because almost as much tea was smuggled in as arrived legitimately. But the British East India Company was not making enough money, so England allowed it to become an exclusive exporter to the Colonies. Had there been no publicity, tea would probably have sold for less. However, the Sons of Liberty made much of the tax, the monopoly and the fact that all the tea was consigned to Loyalist merchants.

The Sons of Liberty organized well. From Charleston, South Carolina, through Philadelphia and New York, arriving tea was either put under bond or the ships were turned back. And Boston had Samuel Adams, a master at creating inflammatory incidents. When the ships sailed into Boston Harbor, at least 150 patriots armed with hatchets, axes and clubs blackened their faces with burnt cork or streaked lampblack and red paint on their faces, wrapped themselves in blankets, boarded the *Dartmouth* and dumped 342 chests of tea into the water. Conservatives in America and even American supporters in England considered this act a pointless destruction of private property. Revolutionaries naturally reveled at the news. The most clear-sighted opinion came from the austere John Adams, who this time agreed with the audacious Samuel Adams, writing in his diary: "This Destruction of the Tea is so bold, so daring, so firm, intrepid, & inflexible, and it must have so important Consequences, and so lasting, that I cannot but consider it as an Epocha in History."

He was right, for the confrontations at Lexington, Concord and Bunker Hill were soon to follow.

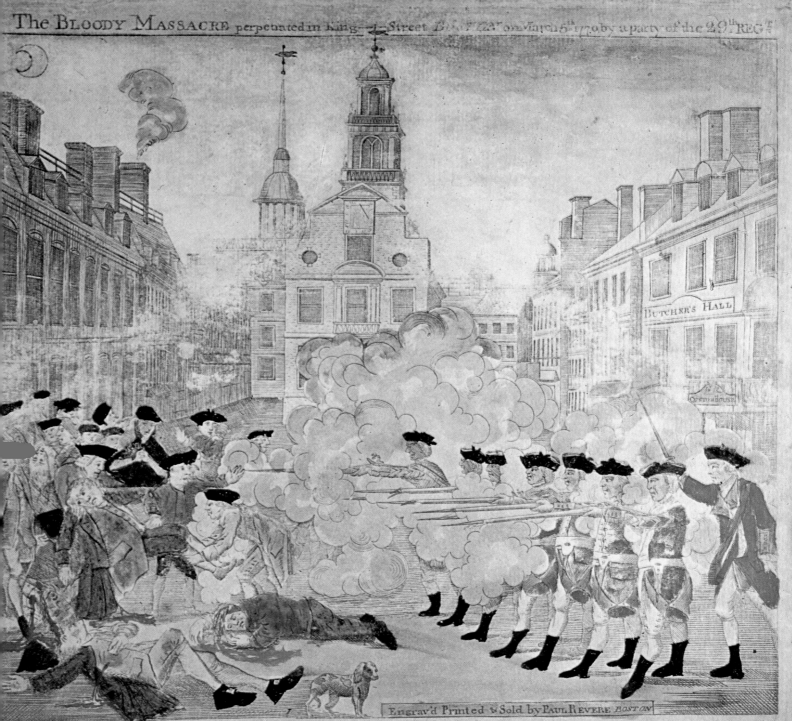

Engrav'd Printed & Sold by PAUL REVERE BOSTON

Unhappy BOSTON! see thy Sons deplore,
Thy hallow'd Walks besmear'd with guiltless Gore:
While faithless P—n and his savage Bands,
With murd'rous Rancour stretch their bloody Hands;
Like fierce Barbarians grinning o'er their Prey,
Approve the Carnage and enjoy the Day.

If scalding drops from Rage from Anguish Wrung,
If speechless Sorrows lab'ring for a Tongue,
Or if a weeping World can ought appease
The plaintive Ghosts of Victims such as these:
The Patriot's copious Tears for each are shed,
A glorious Tribute which embalms the Dead.

But know, FATE summons to that awful Goal,
Where JUSTICE strips the Murd'rer of his Soul:
Should venal C—ts the scandal of the Land,
Snatch the relentless Villain from her Hand,
Keen Execrations on this Plate inscrib'd,
Shall reach a JUDGE who never can be brib'd.

The unhappy Sufferers were Mess's SAM¹ GRAY, SAM¹ MAVERICK, JAM⁸ CALDWELL, CRISPUS ATTUCKS & PAT⁸ CARR
Killed. Six wounded; two of them (CHRIST⁸ MONK & JOHN CLARK) Mortally

Published in 1770 by Paul Revere Boston

"Engrav'd, Printed & Sold by Paul Revere," this etching of The Bloody Massacre *has substituted* Boston ladies and gentlemen, and a small dog, for the club-swinging rowdies actually involved.

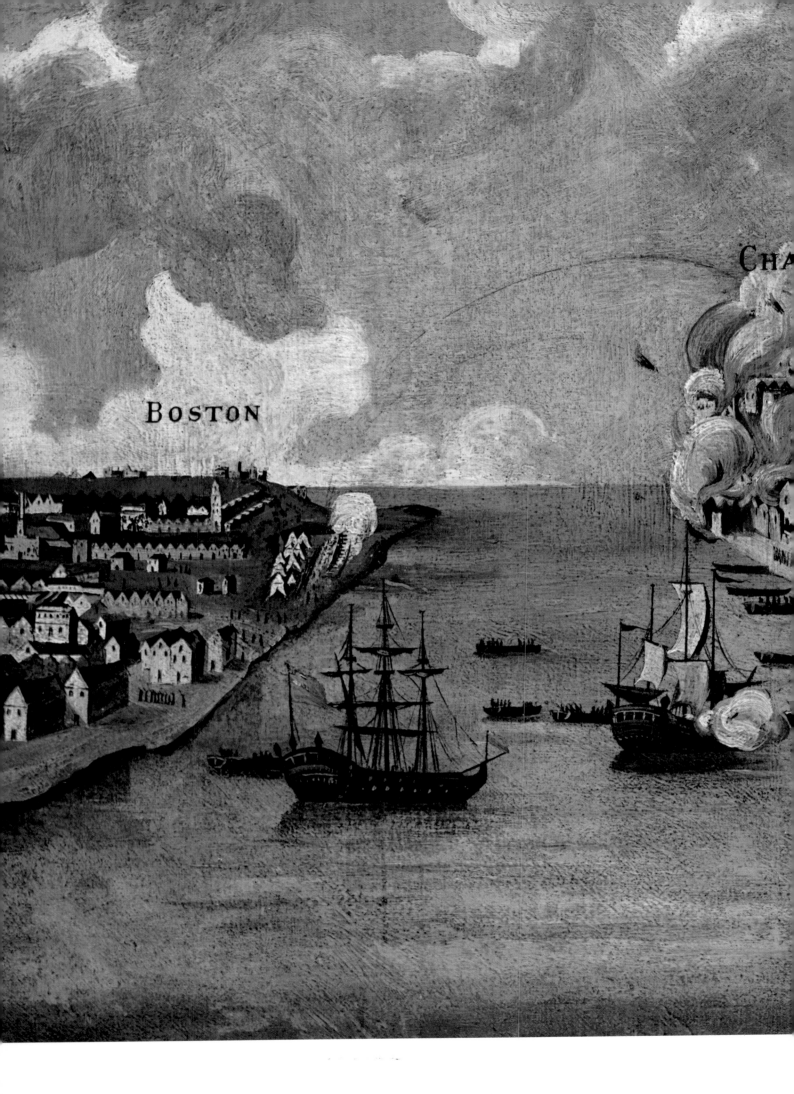

BOSTON

CHA

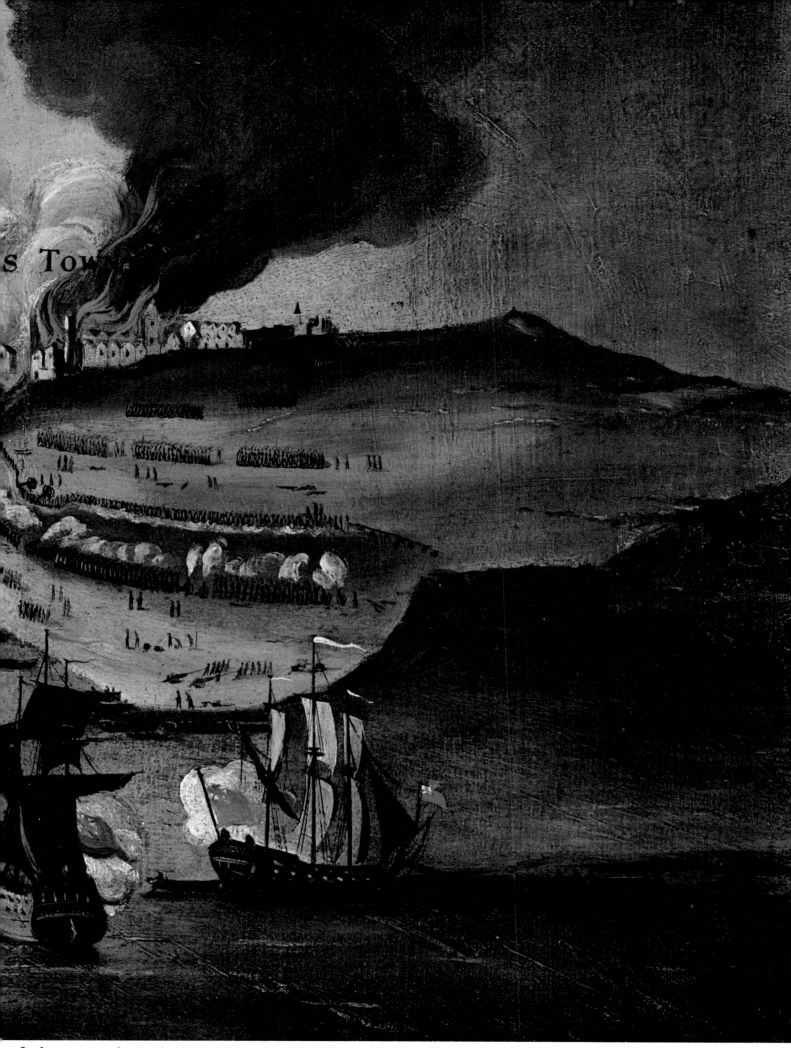

It has gone down in history as the Battle of
Bunker Hill, though it was actually fought at
Breed's Hill with the burning of Charles Town
depicted here as the most dramatic feature.

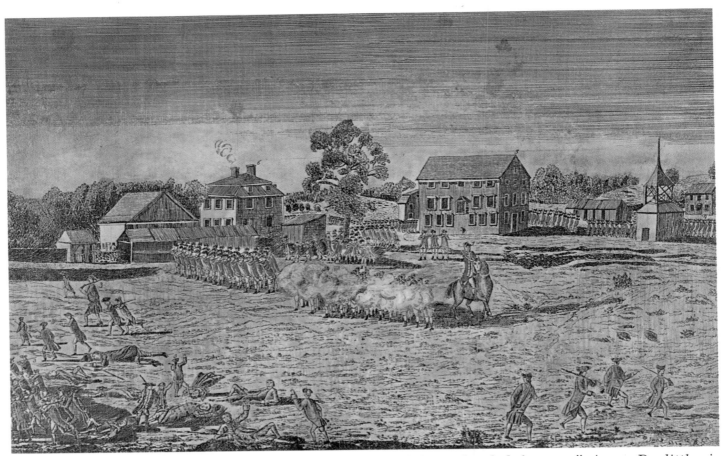

"And fired the shot heard round the world," the poet Ralph Waldo Emerson wrote, giving credit to *"the embattled farmers."* Amos Doolittle, in these engravings, showed the British firing.

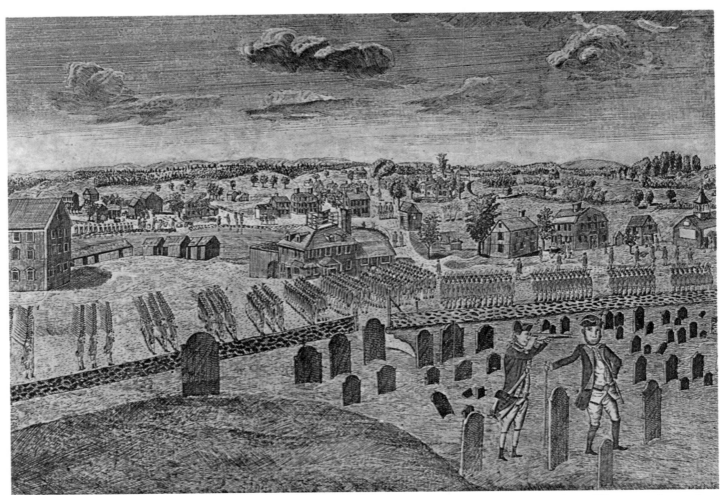

In the plate at top of page, titled The Battle of Lexington, *Doolittle shows Major Pitcairn* giving the command to fire. The regulars then marched on into Concord, as shown above.

76

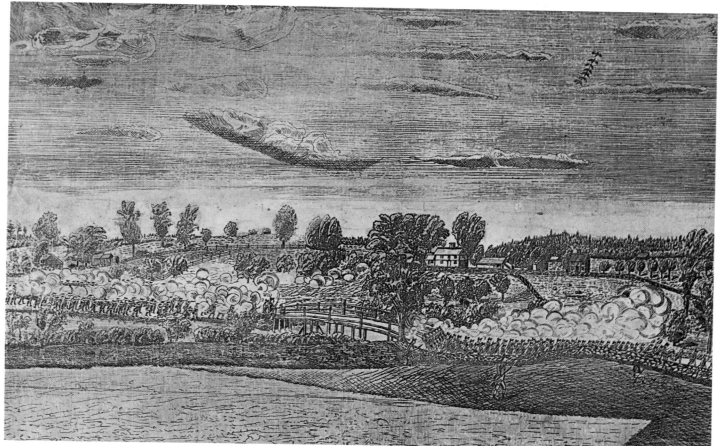

These "Regulars who fired first" were met at the North Bridge in Concord by the Provincials, *in Doolittle's explosive rendition, and then the rout of the British continued*

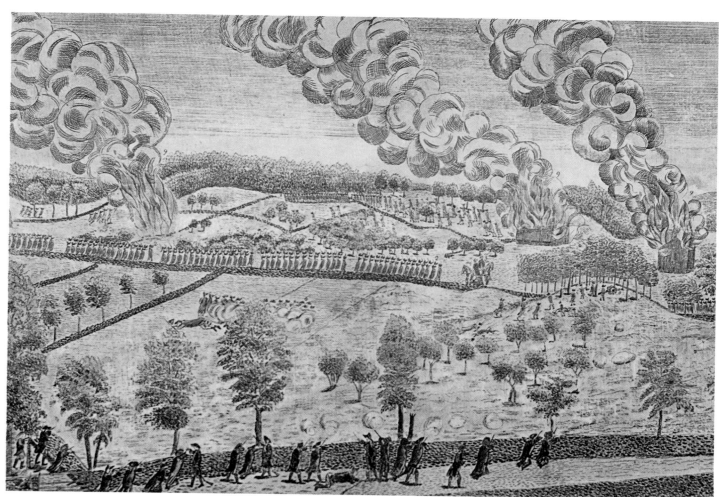

. all the way to Charleston, as the Minute Men fired from cover. The British lost 73 men *with 200 wounded, the Americans lost 49, with 46 wounded. And nobody knows who fired first.*

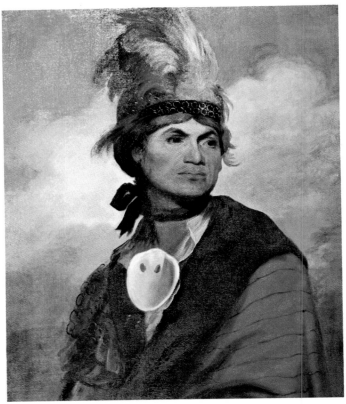

A Mohawk chief, Joseph Brant, led border raids so ferocious that he was dubbed "monster Brant."

Joseph Brant and Guy Johnson

Two-Sticks-of-Wood-Bound-Together was the meaning of the name Thayendangea. The name meant strength, for one stick breaks easily, but two bound together are strong. This tall Indian leader became better known as Joseph Brant, adopted son of the respected British Indian Commissioner and fur trader, Sir William Johnson. Johnson loved Brant like a son and indeed many believed he was Johnson's son. But the evidence points to an Indian father, a sachem or chief, known as Nickus Brant. Johnson, after the death of his wife, lived with Brant's sister, "Miss Molly," for the rest of his life and had at least three children by her.

When young Brant was in his teens he learned about war by taking part in some of the battles in the early days of the French and Indian War. He learned to read and write when Sir William sent him to the Reverend Doctor Eleazer Wheelock to be educated at the Moor Charity School in Lebanon, Connecticut. Upon the death of Sir William, Joseph Brant became the most influential Indian engaged in diplomatic affairs when he became secretary to Guy Johnson (Sir William's son-in-law), who became the new general superintendent of the Indian Department.

They were an unlikely pair. Guy Johnson, reared in England, of medium height and inclined to plumpness, considered himself an "English gentleman." He seems to have had little sympathy for or understanding of the Indians under his care. Brant was tall, slim, with hard etched features and a deep understanding of the problems of both the Indians and the whites. Both sided with England in the Revolution and, in the Six Nations, organized tribes that carried out punishing raids against settlements as well as formal battles against the Colonial armies. Brant, when asked why he fought for the British, said, "When I joined the English in the beginning of the war, it was purely on account of my forefathers' engagements with the King. I always looked upon these engagements, or covenants between the King and the Indian nations, as a sacred thing.

Both sides wooed Brant but he stayed with his covenant to the end and, when the British cause was lost, led his followers to Canada where he settled and lived out his life. On the occasion of meeting George III, he refused to kiss the hand of the King but said he would be delighted to kiss the hand of the Queen. And with their approval he did.

Guy Johnson, Indian agent, and Joseph Brant, his secretary, were painted by Benjamin West.

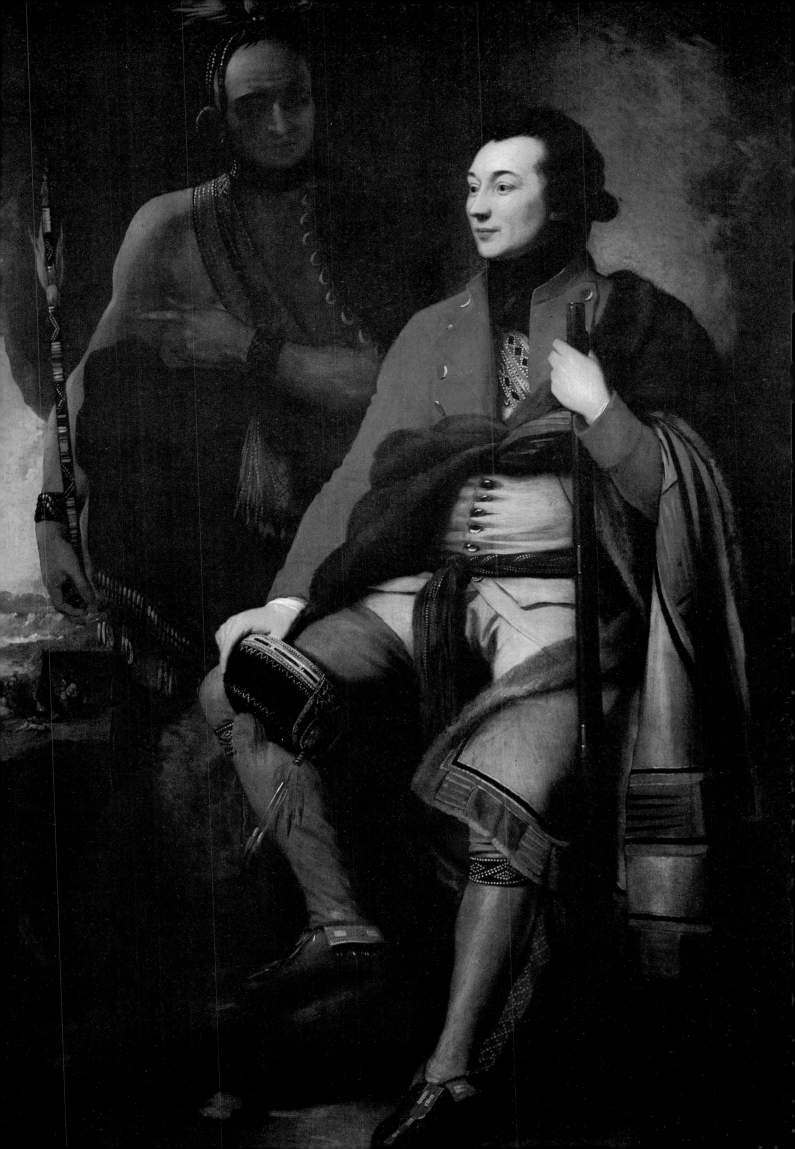

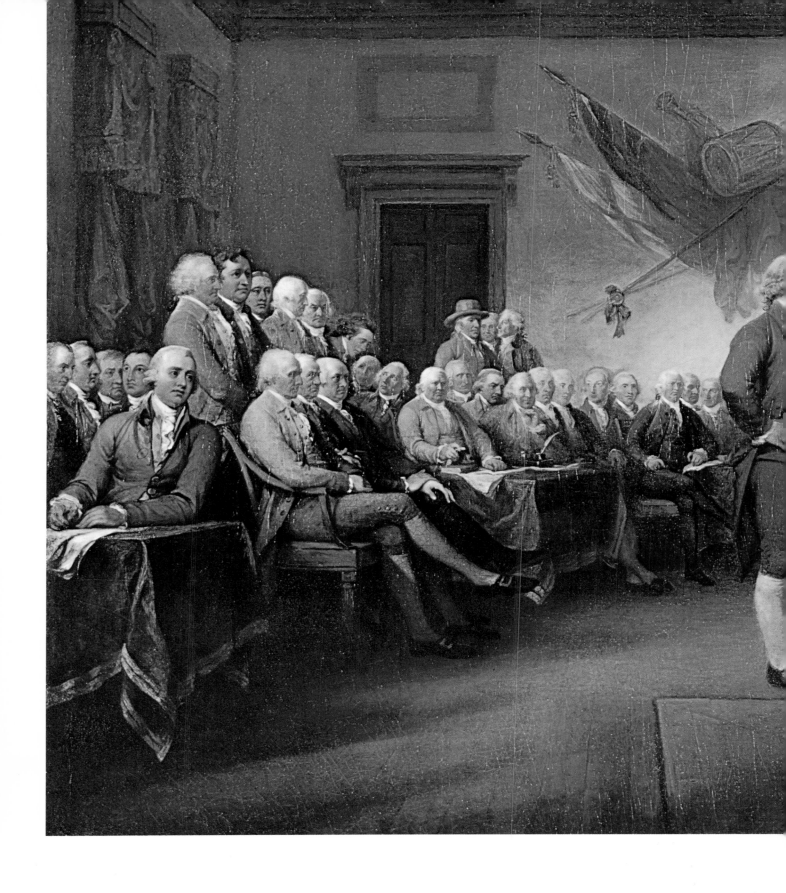

The Declaration of Independence

The Second Continental Congress went into session in May, 1775. On June 7, 1776, Richard Henry Lee introduced a resolution that read in part:

"That these United Colonies are, and of right ought to be, Independent States, that they are absolved from all allegiance to the British Crown, and that all political connection between them and the State of Great Britain is, and ought to be, totally dissolved."

While this resolution was being discussed, a committee was formed to draft a declaration of independence: Benjamin Franklin of Philadelphia, John Adams of Massachusetts, Thomas Jefferson of Virginia, Robert R. Livingston of New York and Roger Sherman of Connecticut. The committee proposed that Jefferson prepare the first draft. He reluctantly

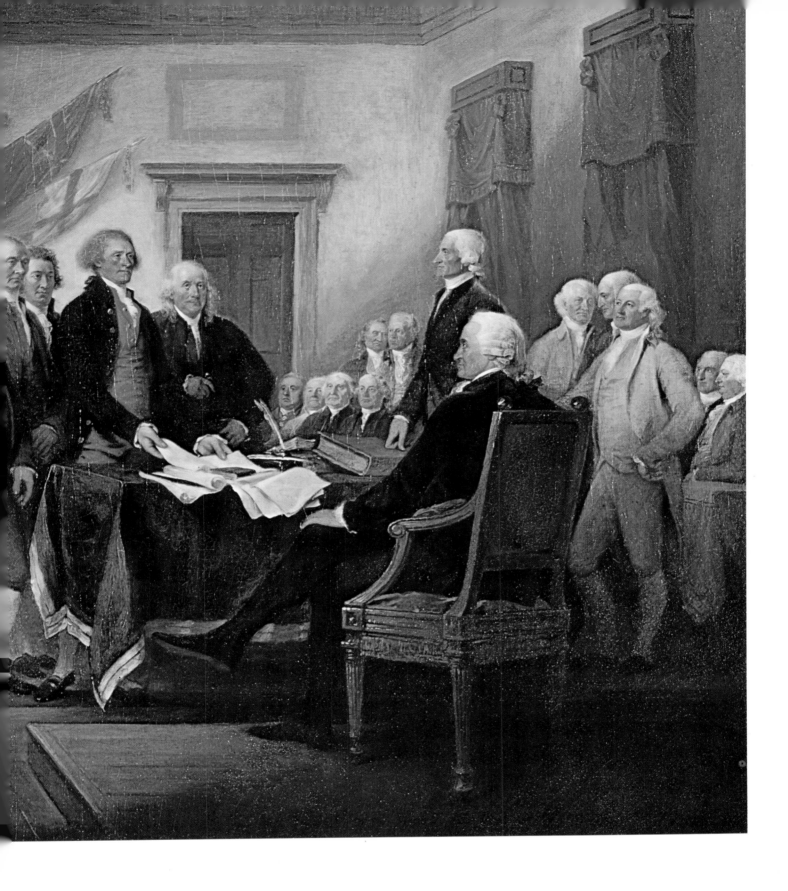

agreed to do so.

For 20 days Jefferson wrote and rewrote his draft. The committee members would from time to time suggest additions and changes but Jefferson was the primary author. On the first day of July ''A Declaration by the Representatives of the United States of America in Congress Assembled'' was presented. On July 2, the original resolution by Richard Henry Lee was adopted, and with that action the United States officially declared its independence from England. Two days later, on July 4, the declaration was adopted. It was signed "by order and in behalf of Congress" by John Hancock. The final version was not passed unanimously until July 19, when the New York delegation voted approval. Congress asked Thomas Jefferson, Benjamin Franklin and John Adams to design a seal of the United States, which they did. Then Congress ordered a copy of the declaration engrossed on parchment. Fifty members of Congress signed it on August 2, 1776.

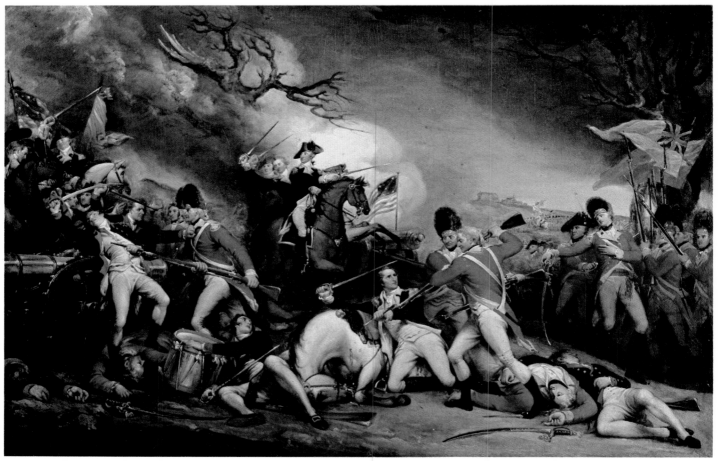

The victory at Trenton inspired the country and the depressed Colonial Army. Their success then *carried over to the Battle of Princeton where Washington's army again won valiantly.*

The War Is On

The Revolution was a new kind of war for the British. It was the most informal, unorganized conflict the generals of England had ever known. They were faced with too great an area, too many fronts to attack successfully, and too many patriots were under arms for all of them to be exterminated. The will to resist had been built up slowly but it rested on a solid base. The colonials could and would defend their political rights and their status as free men.

At first, only a small dedicated group believed that the Colonies could actually win a war against the assembled might of Great Britain. Yet they learned at Lexington and Concord, Ticonderoga, Moore's Creek and Harlem Heights that the British Army could be defeated. What began as an undeclared police action, with soldiers dispatched to the Colonies to punish insolence and defection, became a major conflict that covered thousands of miles.

Throughout the early days of the undeclared war the pen joined the sword culminating with the publication of Thomas Paine's *Common Sense* in 1776. This book argued emotionally and logically for independence from England. It appeared at exactly the right time and George Washington said, "It worked a powerful change in the minds of many men."

But the ultimate victory was to come from the spirit of amity that joined together the northern, middle and southern colonies in the common cause. Differences were forgotten in the defense of their land.

Beginning with Lexington and Concord, 83 battles were fought in six years. Forty-nine engagements were in the North, 34 in the South. In battles won and lost the British were overwhelmingly ahead; they won 41 to the Americans' 27. The other 15 were indecisive. But, as in every war, it is the winner of the last major battle who triumphs, and the Colonials, with the help of their French allies, won that fight at Yorktown on October 19, 1781. The British Army Band played *The World Turned Upside Down* as the British surrendered. The rebels had won their independence.

At the turning point in the Revolutionary War George Washington plotted the strategy for the entrapment and defeat of the British at Yorktown with Generals Lafayette and Tilghman.

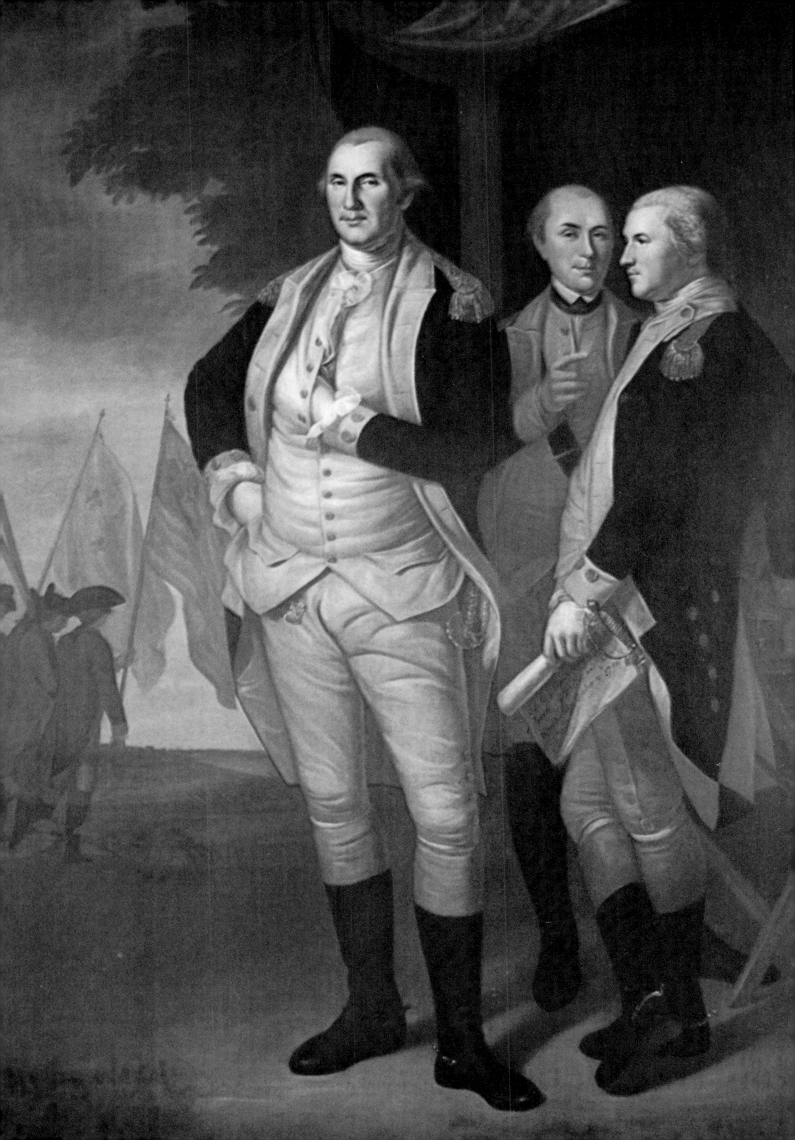

The War
Is Over

General Cornwallis and his British Army had taken over the village of Yorktown, just ten miles from Williamsburg, capital of Virginia. General Washington thought the chance of a badly needed victory would be possible either there or at New York, depending upon where the French would support him. If Admiral de Grasse, with his large fleet of 29 warships could keep the British fleet from relieving Cornwallis at Yorktown and patrol the rivers so that Cornwallis could not escape, Washington's chances, he believed, would be best at Yorktown.

Washington and his generals — Benjamin Lincoln, the Marquis de Lafayette and the newly promoted Tench Tilghman — laid careful plans to entrap the British Army. "Now or never," said

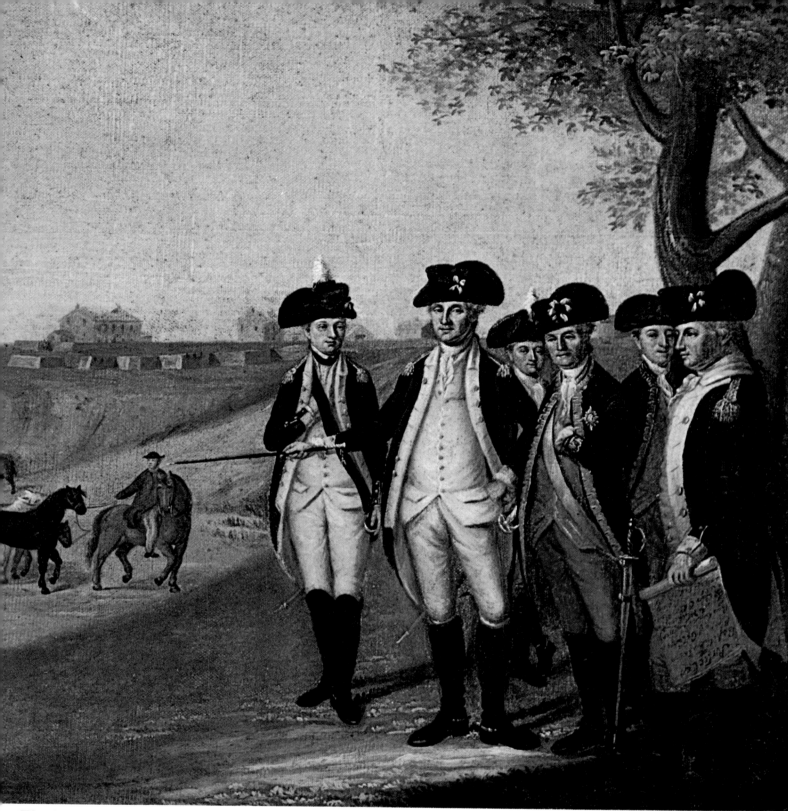

The battle of Yorktown was won. The victorious generals stand triumphant on the beach. Dead *horses and sunken ships give evidence of French naval superiority as their warships block the river.*

Washington, "our deliverance must come." For the first time since the beginning of the war he had, thanks to the French, adequate artillery, protective naval armament and two experienced armies: his Americans, plus the French under Comte de Rochambeau, Vicomte de Noailles, Baron de Vioménil and Marquis de Choisy.

The combined forces began the battle on the morning of September 28th, by October 16th at least 100 guns were pounding the British lines.

On the morning of October 19, between 9 and 10 a.m., Cornwallis asked for a cease-fire to discuss surrender. General Cornwallis was indisposed, so General Charles O'Hara officially surrendered to General Benjamin Lincoln.

Preliminary negotiations for peace, offering complete independence to the Colonies, reached the Congress on March 12, 1782, and at this time all hostilities ceased. On April 19, eight years after the Lexington/Concord battle, the war with England was ended by treaty, and independence was finally won.

Benjamin Franklin

Samuel Adams, the propagandist, probably started the Revolutionary War, but Benjamin Franklin, the diplomat, certainly ended it. This genius of invention and philosophy was able to terminate the conflict because of his political acumen and influence with the French: In 1778 they signed a defense treaty with the Colonies virtually guaranteeing the success of the Revolution by supplying men and arms, and leading to the French blockade of the British Navy.

It is fitting, then, that Franklin has assumed the stature of a founding father. He was the American personification of the Age of Enlightenment, his Yankee wit, wisdom and common sense advancing him from youthful obscurity to the role of internationally famous elder statesman. Along the way he showed that he was neither prudish nor dull.

Consider his success with women, for instance. The ladies of France adored him. He once played chess with a lady until late at night — while she was in the bathtub. John Adams, on Franklin's committee to ally with the French, was apparently jealous of the 70-year-old diplomat's popularity when he said, "The ladies of this country . . . have an unaccountable passion for old age "

But all that was secondary. French intellectuals considered him the embodiment of practical wisdom, and to many he summed up the justification of the American cause — justice, common sense, moderation, democracy and liberty.

Franklin was born in 1706, the tenth son of a tallow chandler, in a straitlaced Boston which still echoed to the preachings of Cotton Mather. Young Ben was economically established at 22 as a partner in a Philadelphia printery. Through friendships, which he made easily, and by operating his shop from dawn to 11 at night, his business prospered. He became official printer for the Assembly, made paper money for Pennsylvania and New Jersey, and acquired the floundering *Pennsylvania Gazette* from a former employer and transformed it into a financial and popular success.

He translated his philosophy of life into homilies which, in *Poor Richard's Almanac* (started in 1732), brought him fame and affection from much of the world: "Necessity never made a good bargain It is hard for an empty sack to stand upright The used key is always bright."

He married Deborah Read, even though her first husband, who had run away, was possibly alive; they had a son, who lived only four years, and a daughter, Sarah. With the cooperation of other ladies he produced at least two other offspring, both illegitimate. They were William, who became royal governor of New Jersey and a Loyalist during the Revolution, and a daughter.

Into the first half of his life Franklin packed an amazing array of accomplishments. He formed Philadelphia's first club (The Junto) devoted to the pursuit of scholarly knowledge. He organized America's first volunteer fire department; became America's first experimenter with the nascent science of electricity; overhauled the Colonies' creaking postal system and probed the mysterious current of the Gulf Stream. He invented the lightning rod and devised a stove which gave off more heat than an open fireplace and used less wood. He gained substantial wealth (obfuscated in his autobiography) through investments in land and as America's first business franchiser.

In 1754 Franklin was Pennsylvania's representative to the Albany Congress, devising plans for mutual defense by the Colonies against the menacing French and the Indians. As deputy postmaster general, he rode horseback up and down the Colonies, meeting with royal governors and political leaders, expounding his budding views on the advantages of political union. In 1757 he was sent to London as Pennsylvania's lobbyist in Whitehall. Between political business he was showered with honors.

Franklin returned to Philadelphia in 1762, but as tension mounted between the Colonies and the mother country he was sent back to London in 1764. He remained for ten eventful years, tangling with cabinet ministers, wooing friends for America, penning articles against the Stamp Act and enjoying London's society. On the eve of independence he sailed back to Philadelphia and was elected a delegate to the Continental Congress.

Then came his mission to France where he worked tirelessly to obtain French support. The Revolution over, Franklin returned home to be elected president of the Pennsylvania Council and serve in the Constitutional Convention, where with his diplomacy and wit he frequently smoothed tensions. To the end, he was the humanitarian. His last public act before his death in 1790 was to present to the House of Representatives a memorial advocating abolition of slavery.

In April of 1790, when Franklin was 84, George Washington wrote him:

"If to be venerated for benevolence, if to be admired for talents, if to be esteemed for patriotism, if to be beloved for philanthropy, can gratify the human mind, you must have the pleasing consolation to know that you have not lived in vain."

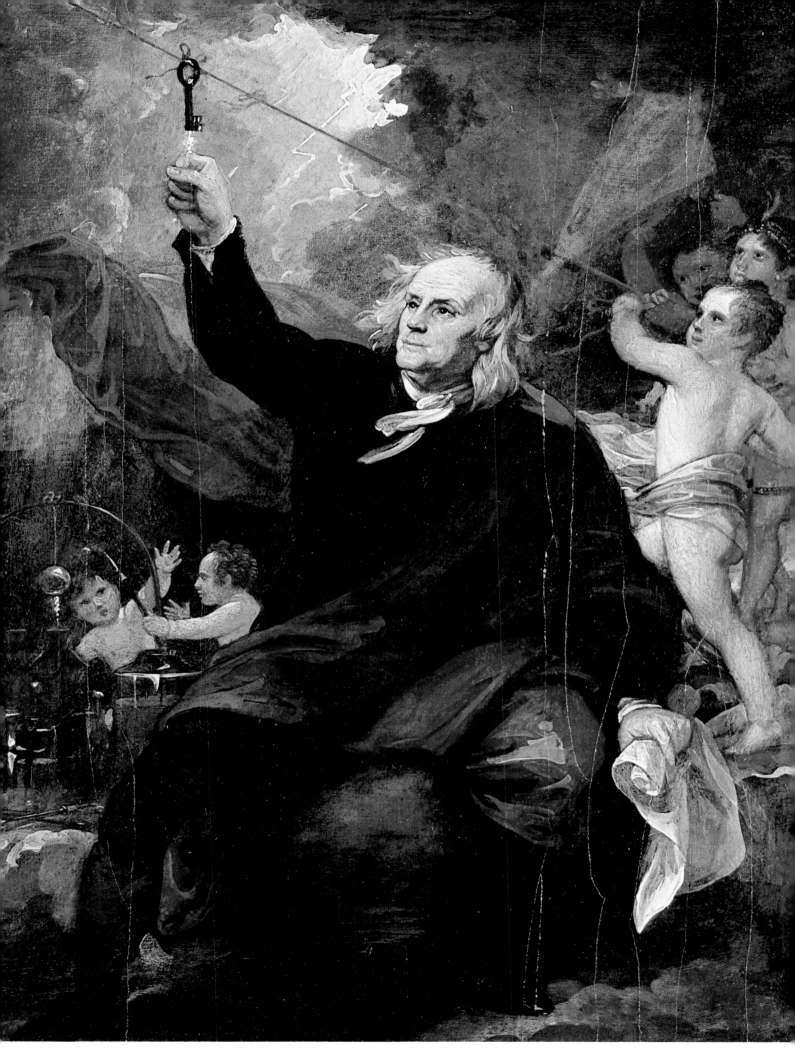

*An allegorical painting by Benjamin West shows
Benjamin Franklin as the god of the lightning.*

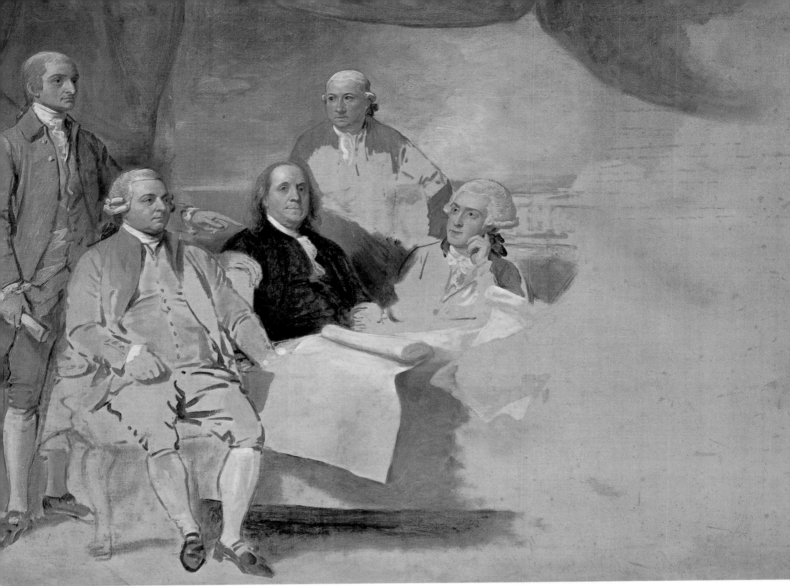

John Jay, John Adams and Benjamin Franklin met with the British in Paris to negotiate peace.

The third British Commissioner died suddenly before Benjamin West could complete the painting.

The Observers

Three distinctly different types of artists recorded the American Revolution and its leading characters. They were the European-influenced fine artists with backgrounds of an Old World painting tradition; then the primarily self-taught artists, men who felt a great urge to record their times and to make their living at it; and finally the amateur patriotic painters who combined propaganda with folk art and sign painting.

In the first group was Benjamin West. He grew to manhood in Pennsylvania, showed as a youth a great talent for painting, and received the first grant given in the Colonies to study art in Europe. When young West decided to move to Boston from Philadelphia because he was unable to obtain enough art commissions to make a living, Philadelphia merchants subscribed money for him to travel and study in Italy. Their investment paid off extremely well for West, if not for the developing Colonies, for after studying in Italy he traveled on to London and remained there. Yet his influence was felt by many American painters. He became affluent — his huge historical paintings brought in large sums of money — and he generously supported visiting American student painters in the years preceding the Revolution. Among them were Matthew Pratt, Henry Benbridge, John Trumbull, Ralph Earl and Charles Willson Peale, who studied with West between 1766 and 1767.

Benjamin West was not the only American artist who found it difficult to reach a position of wealth or importance by painting in the Colonies. John Singleton Copley, Boston-born, knew from an early age that painting would be his profession. He was influenced by the English rococo painter Joseph Blackburn who visited the Colonies when young Copley was only 17. But by then, Copley had already seen a great deal of the limited art world of Boston, for his stepfather was Peter Pelham, an outstanding engraver. As he grew up he was exposed to the artist's life.

Paintings, music and the engravings of his stepfather were part of his environment. In one of his letters he wrote:

"The people generally regard it [painting] as no more than any other useful trade, as they sometimes term it, like that of carpenter, tailor, or shoemaker, not as one of the most noble arts in the world, which is not a little mortifying to me. While the arts are so regarded, I can hope for nothing either to encourage or assist me in my studies but what I receive from a thousand leagues distance, and be my improvements what they will, I shall not be benefited by them in this country neither in point of fortune or fame."

Yet Copley continued to paint in America and made a fair living from it, although he never attained much fame. But as the tensions in Boston mounted and as fewer commissions came to him, he left for England. After he had made the Grand Tour and studied in Italy, he finally reached London, while the war was on. His sympathies were with the colonials but his dedication to his art was greater than his political concern. In England he was, like West, not confined to portrait painting and, like West, he contributed to the evolution of painting in Europe.

A partially self-taught, European-influenced fine artist of the time was Charles Willson Peale. He had a middle-class American upbringing and, having worked with saddles, silver and watches during his apprentice days, he was able to regard painting, too, as a craft and a trade. He exchanged a saddle for lessons with a noted painter, John Hesselius (son of the earlier Swedish-American baroque painter Gustavus Hesselius) and after selling a self-portrait he was launched. But although he became the most important painter of the Revolution (he painted at least 44 of the principal characters) art was only one of several interests. His enthusiasms included science, teaching, and collecting mounted birds and animals, bones of dinosaurs and mastodons, and related items for the new nation's first scientific museum, which he opened in Philadelphia and which remained popular for many years after his death. Also in Philadelphia, Peale founded the nation's first art school. He not only taught his large family how to paint but even found time to invent porcelain false teeth. At 81 he developed a new manner of painting, a soft natural-light technique.

The character and talent of Peale left an indelible impression on American art and artists. His younger brother, James Peale, became distinguished for his still lifes, and his work was surpassed only by Charles Willson Peale's son Raphaelle Peale. Another son, Rembrandt Peale, became one of the epoch's important portraitists. Other sons named Rubens and Titian left smaller

A remarkable illusion of reality was created by Peale in this trompe l'oeil *of two of his sons.*

The talented Peale family was painted by Charles Willson Peale – father, teacher, and artist.

but lasting bodies of work.

A painter whose works created a permanent vision of the heroes of the Revolution was Gilbert Stuart. When one visualizes George Washington with his straight mouth, firm jaw, noble nose and wide-set eyes, the image is evoked by one of Gilbert Stuart's paintings from life. Stuart became an outstanding portraitist not only in the Colonies but in Europe. He had the ability to see beneath the surface of the model and to define the character of his sitter. He was a natural artist, partly self-taught; in his teens he painted well enough to influence a traveling Scottish painter to take him to Edinburgh to study. Like Copley and West, Stuart spent 12 years in London but his extravagance put him in debt and he returned to America. In the new nation his fame had preceded him, and he had no difficulty obtaining commissions.

Stuart had considerable influence on another revolutionary artist, John Trumbull, who, like Stuart, was a natural painter who began with little training. Trumbull knew and painted the Revolution firsthand for he was aide-de-camp to Washington. Later, an accomplished artist, he went to London to study with Benjamin West. If Stuart and Peale were to paint the leaders of the new country, it was Trumbull who elected to paint great scenes from American history. These men were the classical recorders of the country at its birth.

Examples of the third category of artist include three talented men who found it necessary to engage in more than one trade. Both Paul Revere and Amos Doolittle were silversmiths and both were engravers. Peter Pelham, stepfather of John Singleton Copley, was another important engraver of the period and it was he who produced the first version of the Boston Massacre, a rendition Paul Revere copied and called *The Bloody Massacre*. It is not fine art; yet it is an excellent example of patriotic folk art. One cannot look for accuracy in the painting, for Revere was a patriot first and a documentarian second. The same problem exists with the historic engravings by Amos Doolittle for, while Doolittle showed a considerable amount of the engraver's skill in his four prints of the Battle of Lexington, he derived his material from sketches made by the young artist, Ralph Earl.

These three artist-patriots — Revere, Doolittle and Pelham — were visual journalists whose work was rapidly reproduced and widely distributed. None produced classical paintings. But the very crudeness, awkwardness and documentary quality of their mezzotints, etchings and lithographs contributed not only to the cause of the Colonies but became one of the factors in the foundation of an American art tradition. While factual inaccuracies occurred, the spirit of the colonials and their dedication to the cause of freedom was permanently recorded.

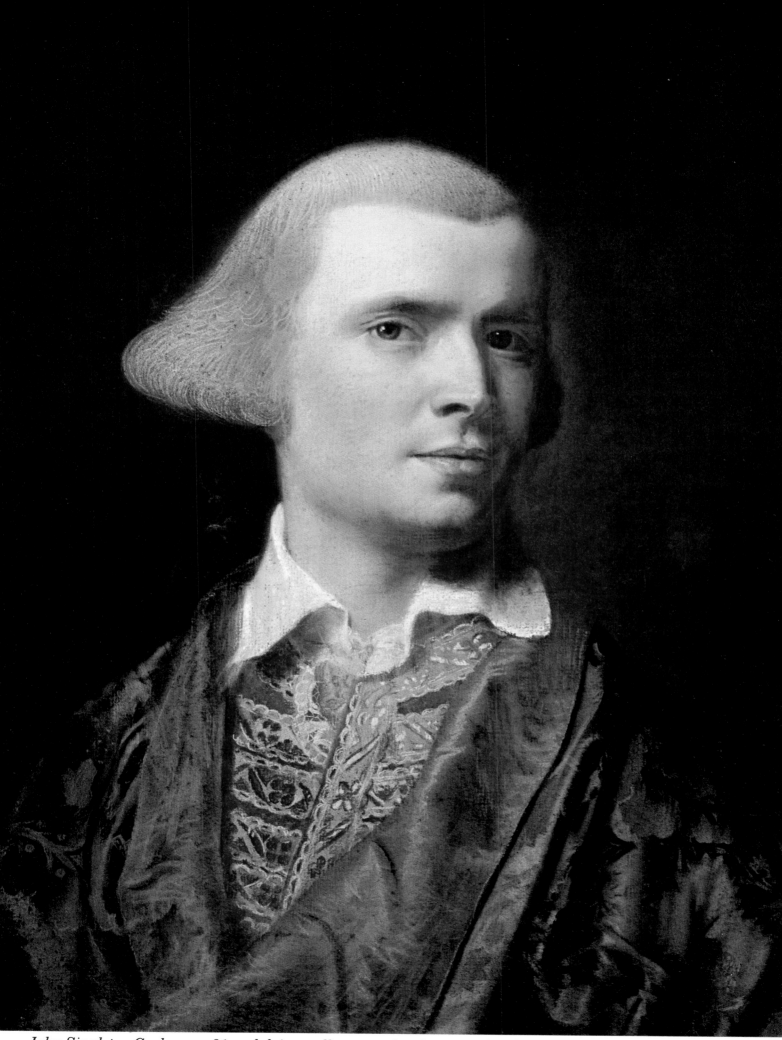

John Singleton Copley was 31 and doing well as a painter when he did this sensitive self-portrait, but he wanted to be more than a portrait painter so he moved – leaving America for England.

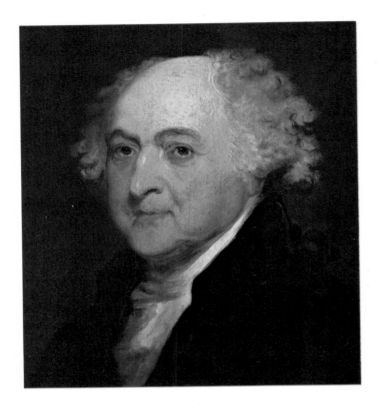

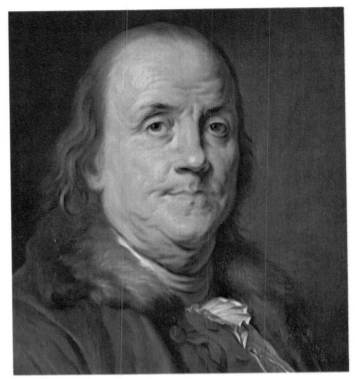

Surely the unlikeliest set of revolutionaries in U.S. history, the Founding Fathers were all very responsible citizens who proclaimed their views verbally and in writing. John Adams, a small town farmer and lawyer, opposed the Stamp Act in resolutions written as early as the year 1765.

Most reluctant revolutionary of them all, Ben Franklin remained in London until 1775 (when he was 69) advocating self-government within the empire. But his provocative articles, published in England, became more bitter and he returned home to militate for independence.

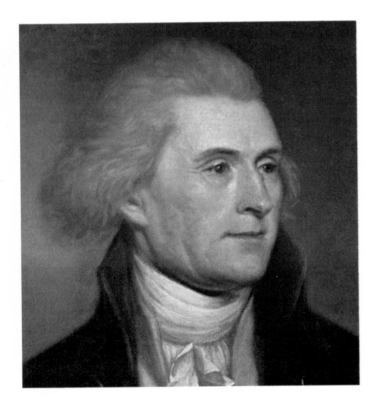

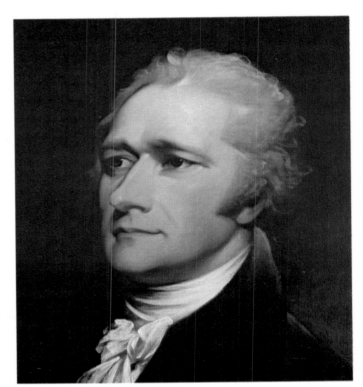

Aristocrat, intellectual, lawyer and slave owner, Thomas Jefferson wrote so lucidly on behalf of all colonists that he was assigned to draft the Declaration of Independence, although he would have preferred to be back home in Virginia writing his own state's new constitution.

Showing promise of his future brilliance as a conservative economist, Alexander Hamilton at the age of 20 wrote three pamphlets attacking British policy and defending the Continental Congress. In 1776 he became a captain, in 1789 Treasurer of the newly formed United States.

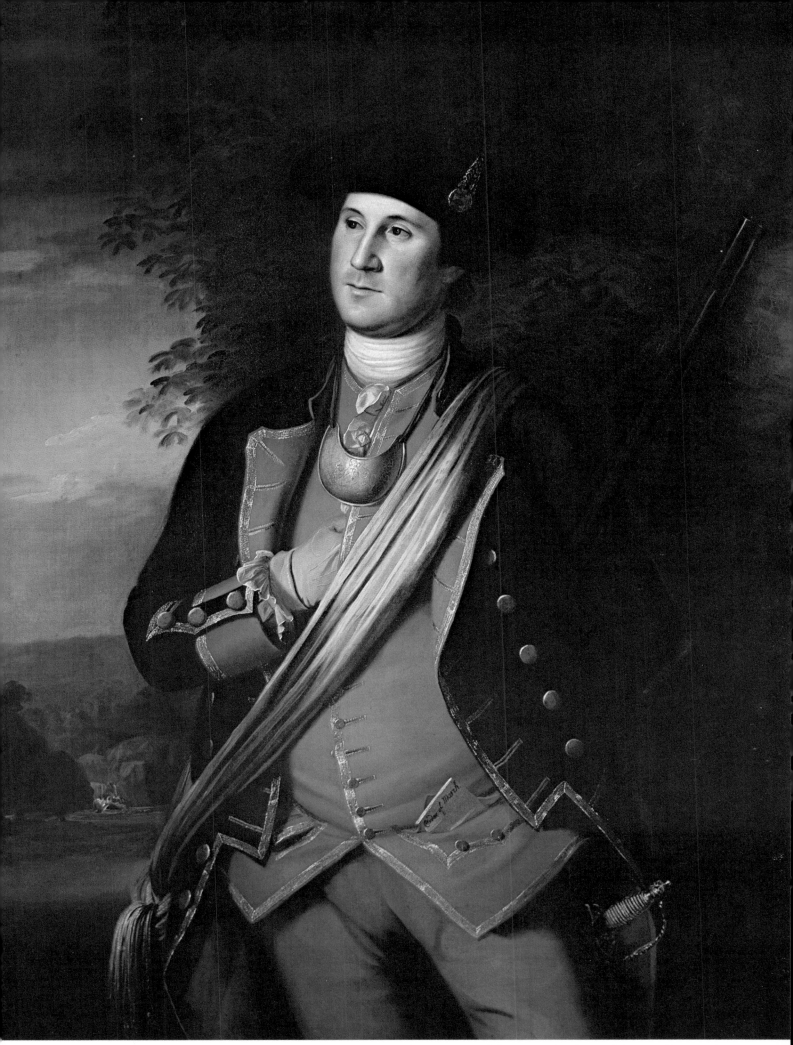

The most improbable revolutionary was surely Wash-ington, who since the age of 19 had loyally served the king. Peale's portrait shows him at 40 wearing his uniform from French and Indian War days.

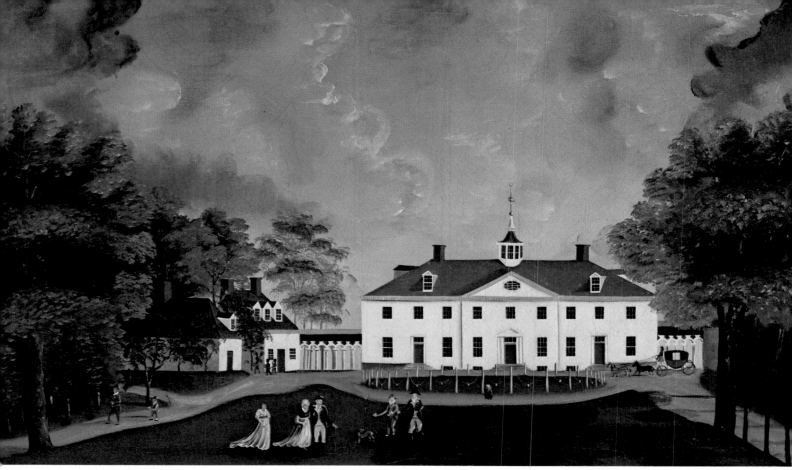

Mount Vernon was named after a British admiral and inherited by George from his brother Lawrence.

George Washington

In George Washington the United States has a unique example — the creation of its first aristocrat. His great-grandfather had been a mate on a British vessel that went aground off Virginia in the mid-17th century. On shore while the ship was being repaired, young John Washington fell in love with Anne Pope; they originated the Washington family in Virginia.

Their son Lawrence had three children, John, Augustine and Mildred. Augustine, known as Gus, was a tall, sturdy, good-natured fellow who married and had three children. Active in land management, Augustine became interested in an iron foundry and made a trip to Europe to discuss it with his partners. Upon his return home, he was shocked to find his wife had died. Within a year he was remarried to Mary Ball, an attractive young woman of 23 years; Augustine was then 36. Twelve months after they were married, on February 22, 1732, their first child, George, was born.

Young George Washington was a farm boy, more interested in the outdoors than in school. His father died when he was 11. He grew up helping to manage Ferry Farm which was worked by slaves. From a teen-age surveyor he became a youthful soldier, with service in the French and Indian War. The soldier became a general and the general a state legislator and President. With each change in status Washington, through his industry and sense of duty and his dedication to the cause of the Colonies, forced the admiration of more and more Americans, to the point where he could have become king of the United States. Indeed, some of the men around him voiced the opinion that, during Washington's second term as President, he would have liked to be king. But while his manners did become more aristocratic as he became increasingly more interested in the social intercourse in government circles, he retained an ultimate simplicity that was reflected in his statement when he was drafted into the Presidency: "I believe I cannot give a greater evidence of my sensibility for the honor they have done me, than by accepting the appointment." He had said many times that he would only hold office so long as his country needed him. He probably would not have accepted the Presidency had he not been the unanimous choice and had he not had John Adams for vice-president. He was sworn in by Chancellor Robert R. Livingston. "Do you solemnly swear," he said, "that you will faithfully execute the office of President of the United States and will, to the best of your ability, preserve, protect and defend the

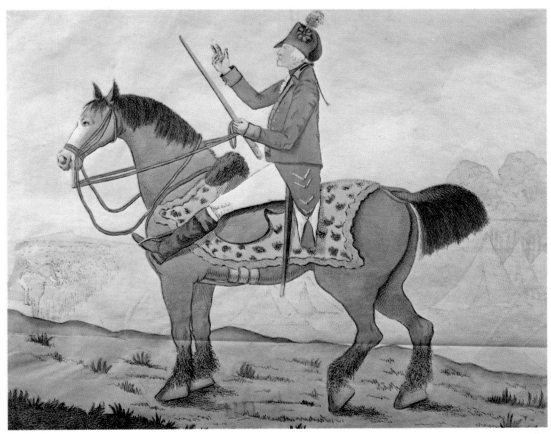

Revered throughout the nation, Washington was the object of ridicule in this 1796 British caricature.

A grim Washington faces a dour Martha in this classic family portrait by Edward Savage. Their mood seems to be reflected in the expressions of the two grandchildren and the liveried servant.

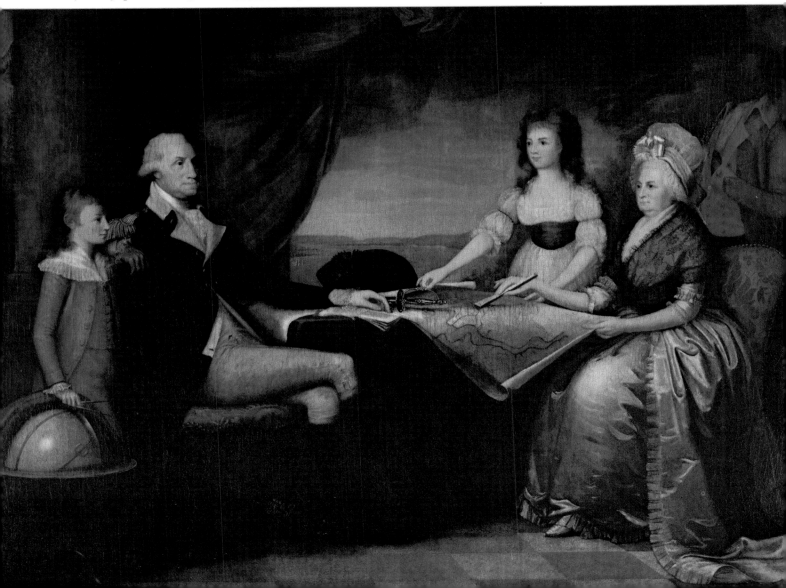

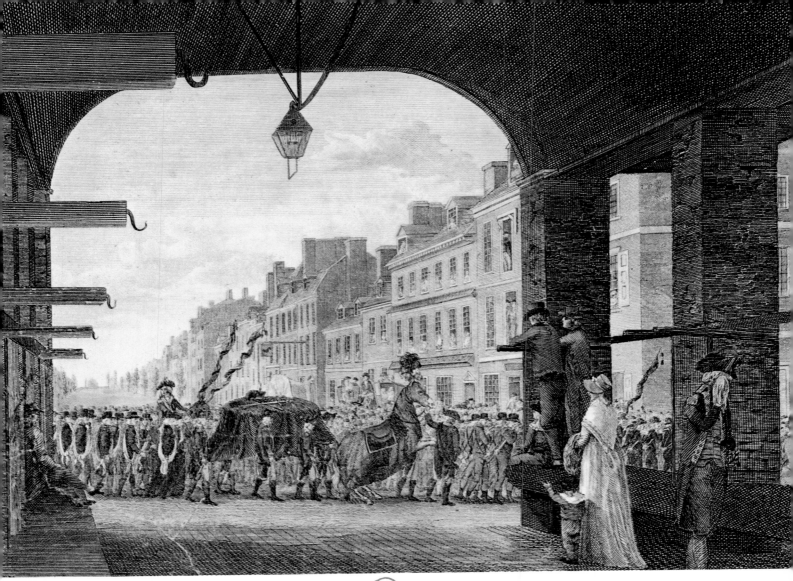

"I die hard," said Washington at the age of 69, feverish, after riding in a snow storm and being *bled a quart of blood. His death was mourned the nation over, as in this scene in Philadelphia.*

Constitution of the United States?" Washington answered, "I solemnly swear — so help me God," and bent forward and kissed the Bible. "It is done," Livingston announced.

It had been a long, rough road from barefoot farm boy to the Presidency. Now in his 57th year he was the unanimous choice of the people he had served. Although he had been a general with few victories to his credit, his defeats were forgotten, while his dedication to his country was remembered. His first administration brought little criticism and he was unanimously elected to a second term with Adams continuing as vice-president. His major opposition in the second term came from Jefferson and his burgeoning Republicans. The second term also brought criticism from other members of his cabinet. Yet it was generally held that Washington was by far the country's best choice as a leader.

He was derogated for his standoffishness, for his adoption of the role of aristocrat. Many thought his manner too kingly, that like European monarchs he had become intrigued

with power and relatively unapproachable. He returned to Mt. Vernon leaving John Adams President in 1797. Washington had returned to Mt. Vernon many times, but this time, in his 65th year, he returned to stay. He even remarked that he felt himself a permanent resident for the first time in 25 years. Immediately he set to work to make Mt. Vernon both the pleasant and profitable farm it had been when he left. He enjoyed his grandchildren, resulting from marriages of John and Martha Custis, who were six and four when he wed their wealthy, widowed mother, with whom he did not have children. And he liked visits by such friends as George Washington Lafayette, the son of the marquis. He rode over the farms, had leisurely dinners with a glass of madeira by his side and usually retired early. But he was not to have much more time. In 1799 he and Martha celebrated their 40th wedding anniversary. Then, while on his daily ride over the estate, he was caught in a storm of snow, sleet and hail. Two days later George Washington was dead. He was mourned throughout the country.

1800-1827
THE
RISING COUNTRY

Daniel Boone leads settlers from Virginia to Kentucky. Thomas Jefferson becomes President. Country is greatly extended by Louisiana Purchase. Hamilton killed in duel with Burr. Jefferson dispatches Lewis and Clark to explore the western territory and to find a western passage to the sea. In war with England the United States is again victorious. First nationwide depression as the paper money system collapses. The Missouri Compromise delays showdown on slavery.

HISTORICAL CHRONOLOGY	ART CHRONOLOGY
1801 *Thomas Jefferson, inaugurated on March 4th, moves into the recently completed White House.*	*1800* *Library of Congress founded.* *Rembrandt Peale paints* Thomas Jefferson.
1801-05 *War with Tripoli, occasioned by depredation of Barbary pirates on U.S. merchant ships.*	*1806* *Robert Fulton painted by Benjamin West.* *Noah Webster completes his* Compendious Dictionary of the English Language.
1803 *The United States purchases Louisiana from France for $15 million.*	*1810* *Boston Philharmonic Society founded.*
1804 *Alexander Hamilton killed in duel by then Vice-President Aaron Burr.*	*1811-13* *Artist Washington Allston introduces the Romantic movement into America with such canvases as* The Dead Man Restored to Life by Touching the Bones of the Prophet Elisha *and* The Poor Author and the Rich Bookseller.
1804-06 *Meriwether Lewis and William Clark explore lands from Upper Mississippi to the Pacific.*	
1807 *Robert Fulton makes first practical steamboat trip (from New York to Albany) in his* Clermont. *Aaron Burr tried for treason and acquitted.*	*1814* *Francis Scott Key writes words to* The Star Spangled Banner *during bombardment of Fort McHenry, near Baltimore, by British.*
1811 *Battle of Tippecanoe; William Harrison, then governor of Indiana Territory, defeats Indians under Tecumseh's brother.*	*1817* *William Cullen Bryant's poem* Thanatopsis *is published.*
	1819 *Thomas Sully paints his dramatic* Washington at the Delaware.
1812-15 *War with British over various forms of naval harassment.*	*1822* *Charles Willson Peale paints his self-portrait* The Artist in His Museum.
1820 *Missouri Compromise sets policy on slavery issue for territories west of the Mississippi.*	*1823* *Samuel F. B. Morse paints* The Old House of Representatives.
1823 *Monroe Doctrine recognizes independence of all countries in the Americas and prohibits further colonization in Western Hemisphere.*	*1825* *The Hudson River School of landscape painting is launched with the success of New York painter Thomas Cole.*
1825 *New York governor Dewitt Clinton opens the Erie Canal.*	*1827* *John James Audubon publishes first engravings of* The Birds of America. *Thomas Cole paints* Last of the Mohicans. *Death of Charles Willson Peale.*
1826 *Death of Thomas Jefferson and John Adams on July 4, exactly 50 years after the Declaration of Independence.*	

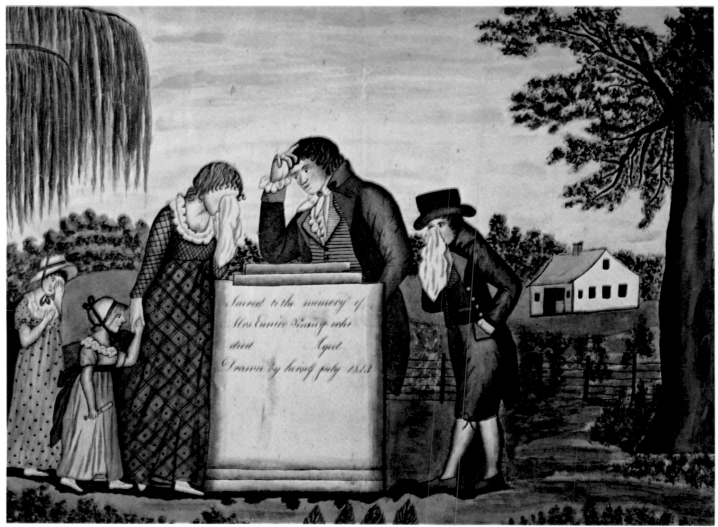

In a fresh naive style reflecting European Romanticism this amateur artist painted a touching memorial to herself. Children at this time were portrayed as miniature adults.

End of An Era

Stately, plump John Adams was the last Federalist president. His great-grandson, the historian Henry Adams, described Federalism as "the half-way house between the European past and the American future." The original Federalists, men like Benjamin Franklin and George Washington, were held together by the basic belief that the Constitution would make for a stronger federal government than would the Articles of Confederation previous to 1789. Comprising a faction rather than a true political party, this energetic minority of well-heeled conservatives who feared anarchy might sweep away the gains of the Revolution eventually formed the Federalist party.

Under Washington's administration there developed a split between those who favored rule by the "best men," for which read aristocrats, and those idealistic humanists who believed with Thomas Jefferson that men left to their own devices could govern themselves by popular vote. The power of the Federalists was broken when Jeffersonian Republicans triumphed in the 1800 election, but the Party lingered on until about 1816 in acrimonious opposition to the administration. Around the turn of the century Alexander Hamilton, Washington's great Federalist Secretary of the Treasury, recorded his personal experience of what was in fact the end of the Federalist era. "Every day proves to me more and more," he wrote, "that this American world was not made for me."

Yet Hamilton, though he thought the Constitution left too much power to the individual states, did a great deal to see that it was ratified, and then even more to make it work. The problem was a simple one: Without Great Britain as a common enemy, what common cause or interest would be strong enough to bind the 13 states permanently into one nation? Hamilton's answer was vested interests. He

arranged a marriage between government and money. At his suggestion, the federal government assumed the debt of the individual states' Revolutionary War expenses, which it would pay by levying customs duties on imports and excise taxes on items such as whiskey. This arrangement would give the states a direct interest in the nation's health and wealth.

Hamilton then persuaded President Washington and the Congress to found a federal bank, jointly owned by the government and by private citizens. Thus America's leading citizens would have a personal concern for their country's overall prosperity. As Federalist John Jay bluntly said: "Those who own the country ought to govern it." That some of the "Founding Fathers" were also "Funding Fathers" was nowise contrary to Federalist principles. Jeffersonians were wont to dub the Federalists pro-British, repressive and aristocratic. The Federalists responded with charges of French Jacobinism, rabble-rousing and fatuous idealism.

Yes, Adams was the last Federalist President, but before leaving office he assured Federalist thinking in the judiciary branch of government for many years to come. On his last day of office Adams sat late at his desk, ratifying the appointments of no less than 21 new judges, Federalists to a man. Jeffersonians were outraged, but helpless. The "Midnight Judges," as they came to be called, constituted an unassailable judiciary fortress of Federalist philosophy.

About a month earlier, Adams' last Senate had confirmed the nomination of Federalist John Marshall, currently Secretary of State, to replace John Jay as Chief Justice of the Supreme Court. For the next 35 years, through the compelling logic of his decisions, written with careful consideration of their long term effects as precedents, John Marshall so heightened the prestige of the Supreme Court that neither future Presidents nor Congress could challenge its autonomy. His conception of the judiciary's role was patently clear: "It is emphatically the province and duty of the judicial department and nobody else to say what the law is." The law was the Constitution, and the Constitution was what five out of nine Supreme Court judges said it was. Marshall's first great case, *Marbury versus Madison* (1803), established the important precedent of the Supreme Court declaring an Act of Congress unconstitutional; this power was not granted the court specifically by the Constitution, but is now generally recognized. *McCulloch versus Maryland* (1819) resulted in the annulment of a state law that conflicted with a federal law. Hamilton would have rejoiced to see this strengthening of the federal government.

The Supreme Court became increasingly important in its function of hearing appeals from

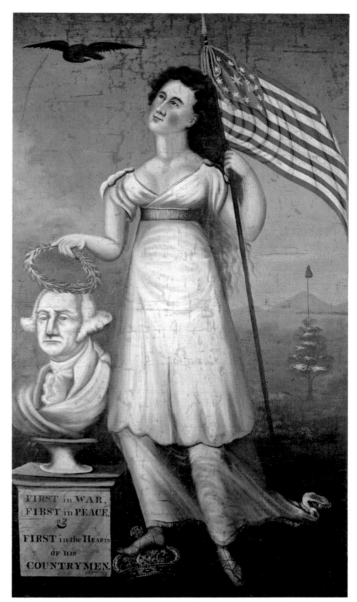

By this date (1810) George Washington had become the universally loved father of his country.

lower courts. By 1925, 90 years after Marshall's death, it was approximately three years behind in its work, and had to be relieved of part of its burden by the creation of Circuit Courts of Appeal. Adams' original Federalist appointees of the eleventh hour and Chief Justice Marshall stand, historically, at the slender base of a ponderous inverted pyramid, the upper part of which might represent the present-day magnitude of our federal justice system.

Long after the close of the Federalist era much of Federalist thought survived. Federalist-inspired concern for orderly government conserves the Constitution to this day, and many elements of Federalist thought have reappeared from time to time beneath the banner of later political parties, such as the National Republicans (1825-1834), the Whigs (1834-1854) and the Republicans (1854 to the present).

King George's Indians

Agrarian-minded President Jefferson, entering the White House in 1801, could not but have been pleased by the prospering homesteads spreading out into fertile prairies north of the Ohio river. But he would probably have found it less pleasing to admit that his political rivals the Federalists, and in particular Adams' special envoy to England, John Jay, had played a vital role in opening up this new soil to American settlement to make those homesteads possible.

Back in 1794, when America seemed again at the brink of war with Great Britain, Jay had obtained a treaty with the English which secured their withdrawal from the military posts they had retained at Niagara, Detroit and several other strategic points south of the Canadian border. These posts, theoretically maintained to protect Canada against American aggression, served the less publicized function of selling whiskey and firearms to the Indians and encouraging them to "rub out" all the American settlers they could. Soon, the Indians were assured, King George would return, chase the Americans away and restore their stolen lands. At one time a Canadian governor had gone so far as to propose setting up an Indian satellite state between the Ohio and St. Lawrence rivers.

While Jay was negotiating the British withdrawal, General Anthony Wayne won a decisive victory over an estimated 1,500 to 2,000 Indians and about 50 Canadian rangers in the Battle of Fallen Timbers on the shores of Lake Erie in what is now Ohio. The following year, after six weeks of negotiations with an assembled gathering of over 1,000 Indians, comprising delegates from all the major Midwestern tribes, Wayne concluded the Treaty of Greenville in the middle of a large forest clearing with the open sky for witness. In exchange for $10,000 worth of annuities, the "Fifteen Fires" (United States) would be permitted to settle certain designated areas between the Ohio, Mississippi and St. Lawrence rivers.

Clearly the Treaty of Greenville was but a first step in the settlers' westward march. During the period from the conclusion of the treaty until the end of Jefferson's last term of office (1809), the Indians of the Midwest were induced by fair means and foul to give up about 48 million more acres. After a brief but bitter period of resistance in 1811, General William H. Harrison (later to become President) defeated Shawnee leader Tecumseh's Indian confederacy in the Battle of Tippecanoe. During the War of 1812 Tecumseh,

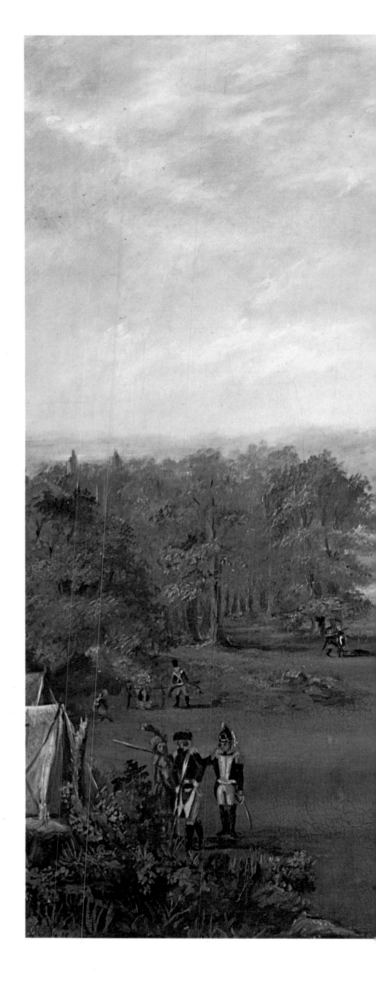

one of the Indians' truly great leaders, sided with the British. His confederacy was definitively crushed (and Tecumseh killed) in the Battle of the

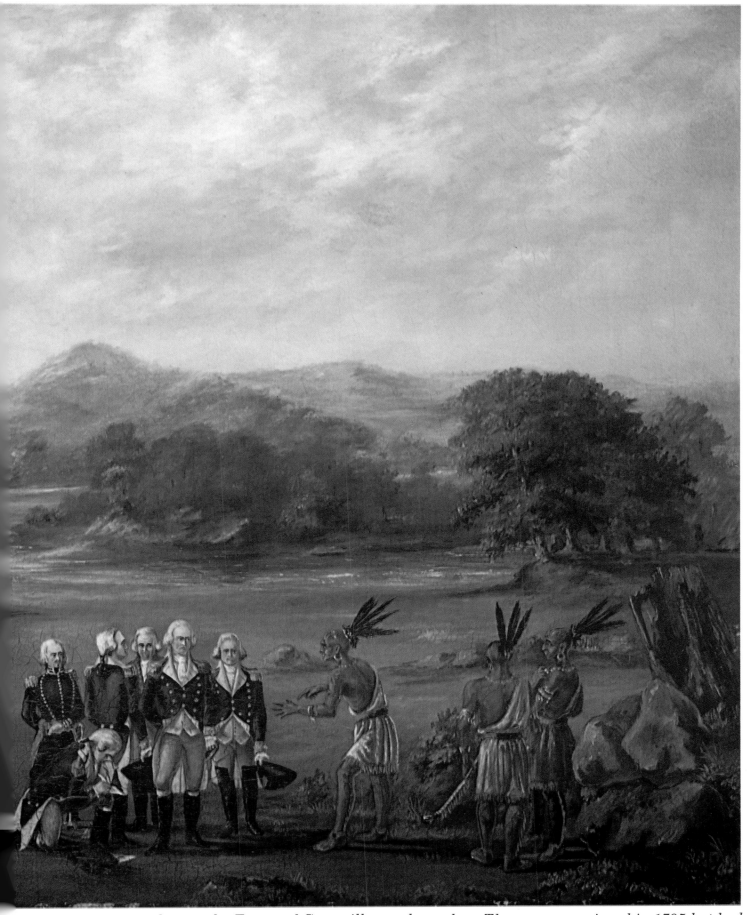

Between 1800 and 1805 the Treaty of Greenville protected Indian lands from further encroachment by settlers. The treaty was signed in 1795 but had become worthless to the Indians 10 years later.

Thames, near Lake Huron, during the second year of the war. The War of 1812 was a defeat for the Indians as well as for the British. The Redcoats went home for good, taking with them the Red Man's last hope of resisting the inexorable advance across the continent.

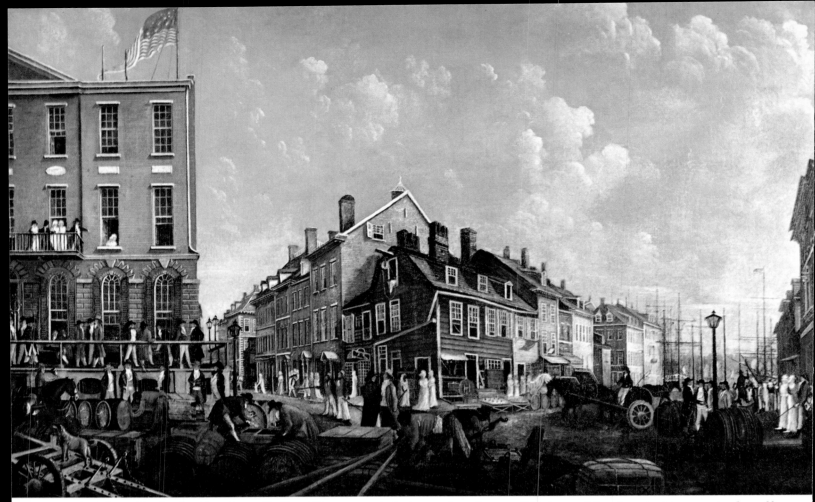

In New York the Tontine Coffee House, *painted by Francis Guy, was a social center for the* leading politicians. Merchant shippers took coffee *and liquor and listened to current gossip.*

City and Country

A new force began to make itself felt around the turn of the century — the sudden swelling of urban growth. Eastern seaboard cities sprawled inland as better transportation evolved, and new towns sprouted in the old Northwest. Cities and towns were growing at triple the rate of the nation as a whole. The urbanization trend troubled contemporary observers greatly. Thomas Jefferson wrote to his philosopher-physician friend Benjamin Rush in 1800: "I view great cities as pestilential to the morals, the health and the liberties of man." An excellent architect himself (witness his stately Monticello mansion, for which the President drew his own blueprints), Jefferson originated the "chequer plan" which alternated buildings with open squares of greenery in the enlargement of New Orleans.

But planned cities were the exception. What distinguished communities west of the Alleghenies was their sudden, improvised appearance in the middle of a wilderness. The analogy of the beehive, whereby a city develops slowly as a center for the storing, refining and redistribution of agricultural produce, fit European villages better than American frontier towns. They sprang up as forts and trading posts, spearheading the westward migration of the 19th century, preceding the tilling of soil.

Throughout the 18th century Philadelphia had dominated America both culturally and politically, with many municipal institutions,

An idyllic concept of country life done in needlepoint in New England by Mary Woodhull.

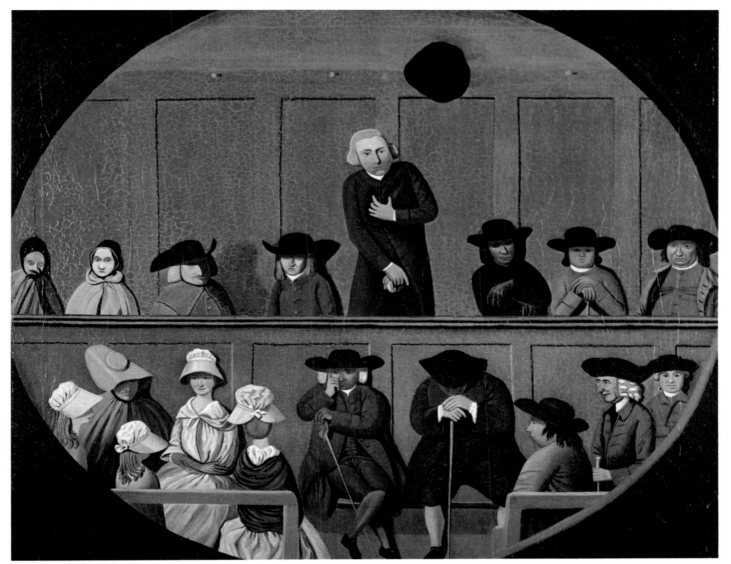

Porthole view of a Quaker meeting in 1790. Men and women sat in separate groups. Quakers normally kept their heads covered in protest against the sovereignty of terrestrial monarchs.

industries and shops. But by 1810 New York was larger, and 15 years later the opening of the Erie Canal, linking it to the entire midwestern region, gave it decisive economic hegemony over all other U.S. cities. Barges laden with passengers, agricultural produce, lumber and minerals from the environs of Lake Superior could enter the 363-mile canal at Buffalo, glide through its locks near Albany and Troy, and descend the Hudson River to New York Harbor.

Within five years of the opening of the Erie Canal the most significant transportation breakthrough of the century occurred, stimulating the growth of cities not situated on canals. In 1830, the famous race between the early *Tom Thumb* locomotive against a horse-drawn conveyance demonstrated the feasability of steam-powered railroad transportation, even though the horse did win the race. A few months later a steam locomotive, the *Best Friend,* went into daily service in Charleston, South Carolina.

New farming areas beyond the Alleghenies, largely cleared of hostile Indians by the end of the War of 1812, now had access to markets by one or more of a number of means of transportation — steamboat, railroad, a network of canals, and the "national pike" which penetrated westward through the Cumberland Gap. Thousands of homesteaders took advantage of the opportunity. The area between the Mississippi and the Alleghenies doubled in population from 1810 to 1820; the states of Ohio (1803), Louisiana (1812), Indiana (1816), Mississippi (1817), Illinois (1818), Alabama (1819), Maine (1820) and Missouri (1821) entered the Union. The interior towns of Pittsburgh, St. Louis, Cincinnati, Lexington and Louisville acquired the amenities of full-fledged cities. A worldly traveler, visiting Louisville in 1819, assures us that "there is a circle, small 'tis true" where one may, "whilst leading beauty through the mazes of the dance, forget that he is in the wilds of America."

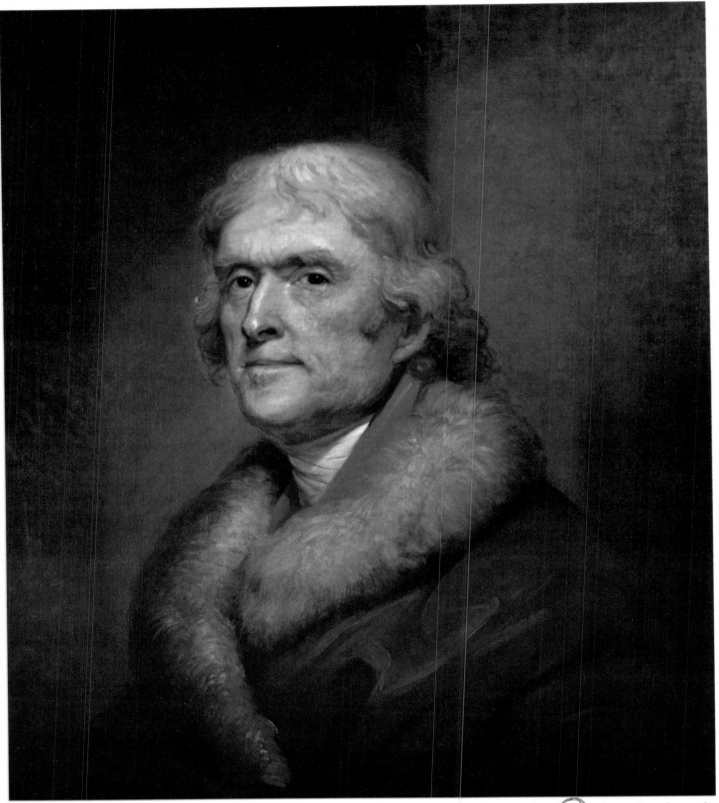

President Jefferson was 62 when Rembrandt, son of Charles Willson Peale, painted this portrait.

Thomas Jefferson almost did *not* become President. Under the original procedure of the Electoral College each member voted for two candidates, of whom the one receiving the most votes would be President, the runner-up Vice-President. The Republican ticket called for Jefferson to be President, Aaron Burr Vice-President, but there was no way for the electors to make the distinction and the two were tied. (The system was subsequently changed by constitutional amendment.) The election then went to the House of Representatives, where ballot after ballot ended in a tie. There was talk of civil war, and the Virginia Militia was all set to march on Washington. Finally, Alexander Hamilton, who had no love for either candidate, asked the New York delegation to resolve the election "for the public good," and thus, thanks to a man whose political philosophy was opposed to his own, Jefferson was elected.

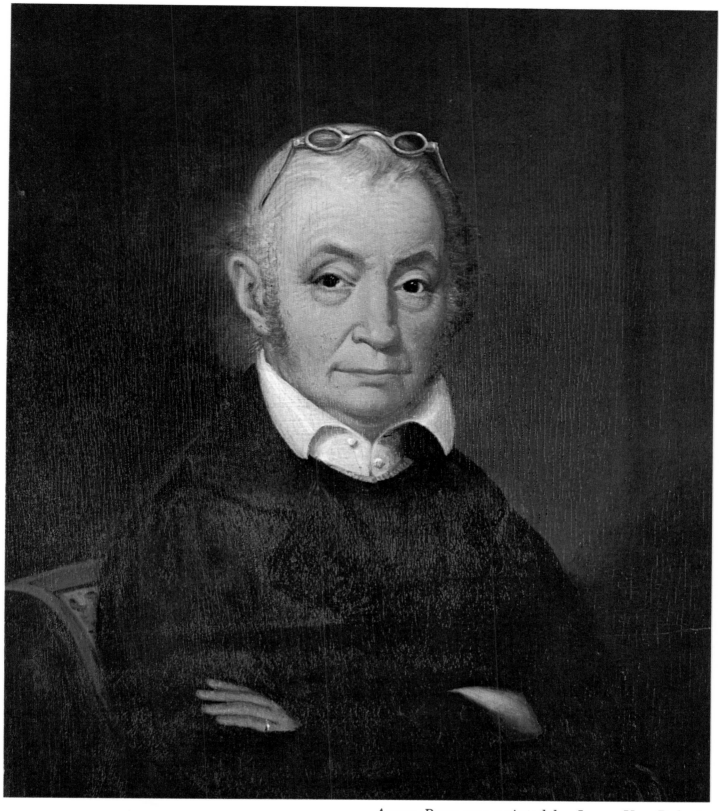

Aaron Burr was painted by James Van Dyke in his 78th year. He was Jefferson's Vice-President.

Aaron **Burr** almost *did* become President in 1800. It is impossible to speculate the course of empire had this most controversial man been elected, but as far as Burr himself was concerned, his political career was ended. Dropped by the party in 1804, he ran for Governor of New York, with a secret understanding that he would head the Northern Confederacy if New York and New England seceded. Again Hamilton thwarted his ambition,

and Burr challenged Hamilton to a duel and shot him dead. He then became involved in intrigues in the West, with dreams of becoming Emperor of Mexico or President of an independent Louisiana — which at that time extended to Canada and the Rockies. Jefferson personally ordered him tried for treason, but he was acquitted on technical grounds. Burr fled to Europe, then returned to New York to practice law until he died at the age of 80.

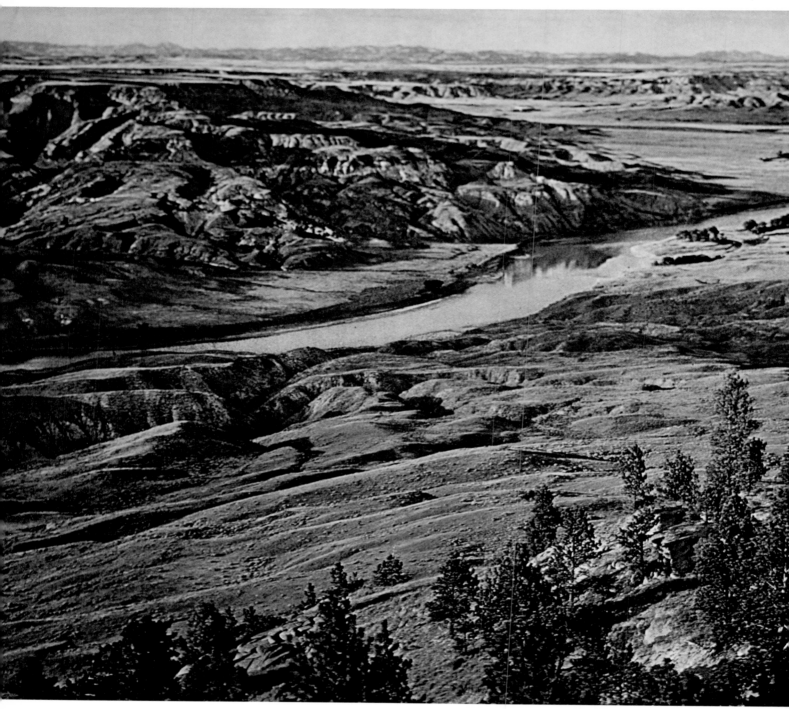

On Sunday, May 26, 1805, George Rogers Clark wrote in his journal "On the north side of the

Lewis & Clark Expedition and Louisiana Purchase

A true renaissance man, Thomas Jefferson thought with equal vigor on both theoretical and practical levels. While the Revolutionary War was actually in progress he proposed an exploratory expedition into the West, and ten years later when he was vice-president of the American Historical Society he again proposed an expedition "ascending the Missouri, crossing the Stony mountains, and descending the nearest

river to the Pacific." Jefferson was unashamedly lured by the sheer love of learning — an early form of pure research — in addition to the hope of discovering via inland waterways a passage to the Pacific, and thence to the Orient.

After 20 years Jefferson was finally able to carry out his plan; he was President of the United States. With the authorization of Congress he commissioned his private secretary, Meriwether Lewis, to command a small expedition of volunteers across the unexplored northwest region of the continent. Lewis, in turn, brought in his friend William Clark to share in the leadership. They thoughtfully kept the exploration secret, as most of the land belonged to France.

river Captain Lewis first caught sight of the Rocky Mountains, the object of all our hopes. . . ."

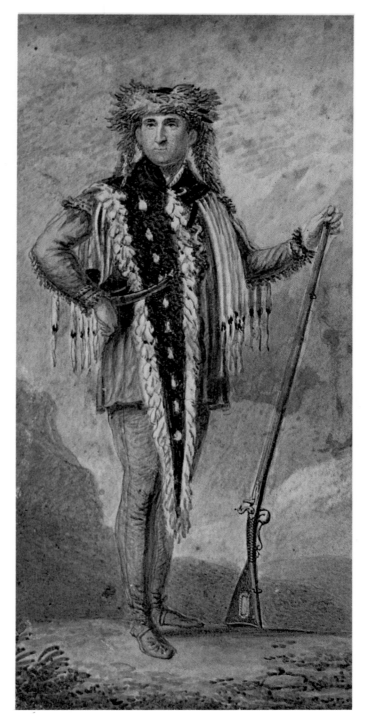

Portrait by Saint-Mémin of Lewis as he looked on his return from the great expedition.

Unexpectedly in the spring of 1803 came an opportunity that Jefferson's Minister to France, Robert R. Livingston, was quick to seize. Napoleon, badly in need of money to finance his forthcoming war with England, was willing to sell the entire Louisiana Territory to the United States for $11 million, plus other costs adding up to some $27,267,000. This was not only a good deal but relieved the country of the presence of Napoleonic France in North America and Jefferson made the purchase. He was now more anxious than ever to dispatch Lewis and Clark to take stock of the huge, uncharted acquisition.

Setting out from the junction of the Missouri and Mississippi Rivers in the spring of 1804, the orderly little expedition conducted one of the most successful and well-documented explorations in history. They reached the Pacific at the estuary of the Columbia River and were back in St. Louis by September, 1806, bringing with them a wealth of information: descriptions of flora and fauna, and geographical, geological and meteorological observations. Lewis' analysis of the relations between traders and Indians, and his astute recommendations for future government policy toward them ("The first principle of governing the Indians is to govern the whites. . . .") went largely by the board, but his writings remain one of the few reliable sources of information on Indian dress, customs and attitudes at the beginning of a century that was to prove fatal to that people's way of life.

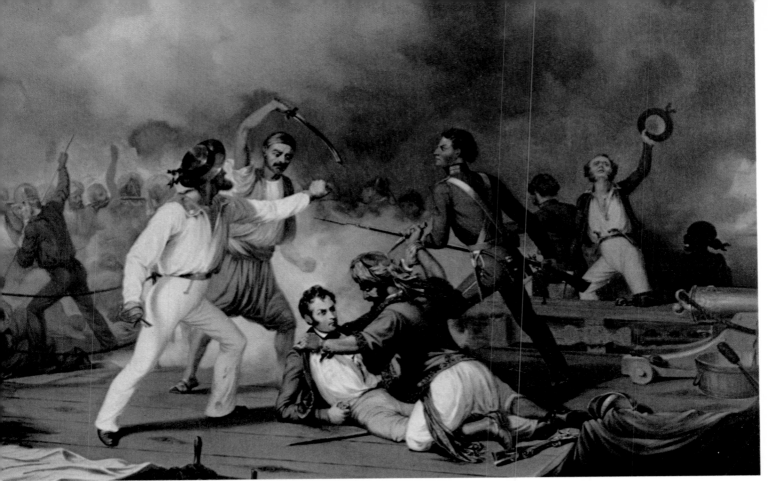

Despite his seemingly hopeless situation in this painting, Lt. Stephen Decatur killed his adversary and went on to wage and win the naval war that put an end to tribute to the Algerian corsairs.

Showdown with the Barbary Pirates

The young nation was hardly of age when it was faced with the decision either to continue paying protection money to pirates, or to police foreign waters. In one of its most exciting cases of foreign intrigue, the U S chose the course of direct action in initiating a minor war.

The Barbary Coast of North Africa had long been a haven of piracy. From its shores had come the ship that kidnapped young Julius Caesar — he swore he would catch the scoundrels and execute them when he grew up, and he did. By 1800 it was common practice among European nations to make regular payments to the pirates. The infant American Republic complied, but tribute and ransom costs were running higher every year. By 1801 the U S had paid out nearly $2 million — two-fifths of annual revenue — to the Beys, Deys and Bashaws who controlled North African piracy.

Back in the 1780's, Jefferson, then Secretary of State, had unsuccessfully urged Congress to expedite the construction of more warships to protect American vessels. Now, in 1801, he could act; he was President. The crisis came when the Dey of Tripoli, angry because the U S delayed in sending him his bags of gold (he did not like paper money), had the flagpole in front of the consulate in Tripoli chopped down, and declared war. Congress did not declare war, but granted the President a free hand. Jefferson sent four newly-built frigates to Tripoli for a show of strength, and followed them up the next year with an even larger force, but the pirates laid low.

William Eaton, the high-spirited consul whose flagpole had been chopped down, suggested a plan anticipating the finest efforts of both the CIA and Hollywood. The Dey of Tripoli, he reported, had usurped the throne of his older brother Karamanli. Eaton proposed finding Karamanli and restoring him to power in exchange for friendly relations with the United States. Jefferson discreetly encouraged the contentious consul with firearms and a vague title.

In the meantime the *USS Philadelphia,* blockading Tripoli, unfortunately ran aground in the harbor. Surrounded by corsairs, the 36-gun warship and its 307-man crew surrendered. The Arabs demanded a ransom of $3 million for this

The burning of the captured Philadelphia *was Decatur's most daring and successful exploit.*

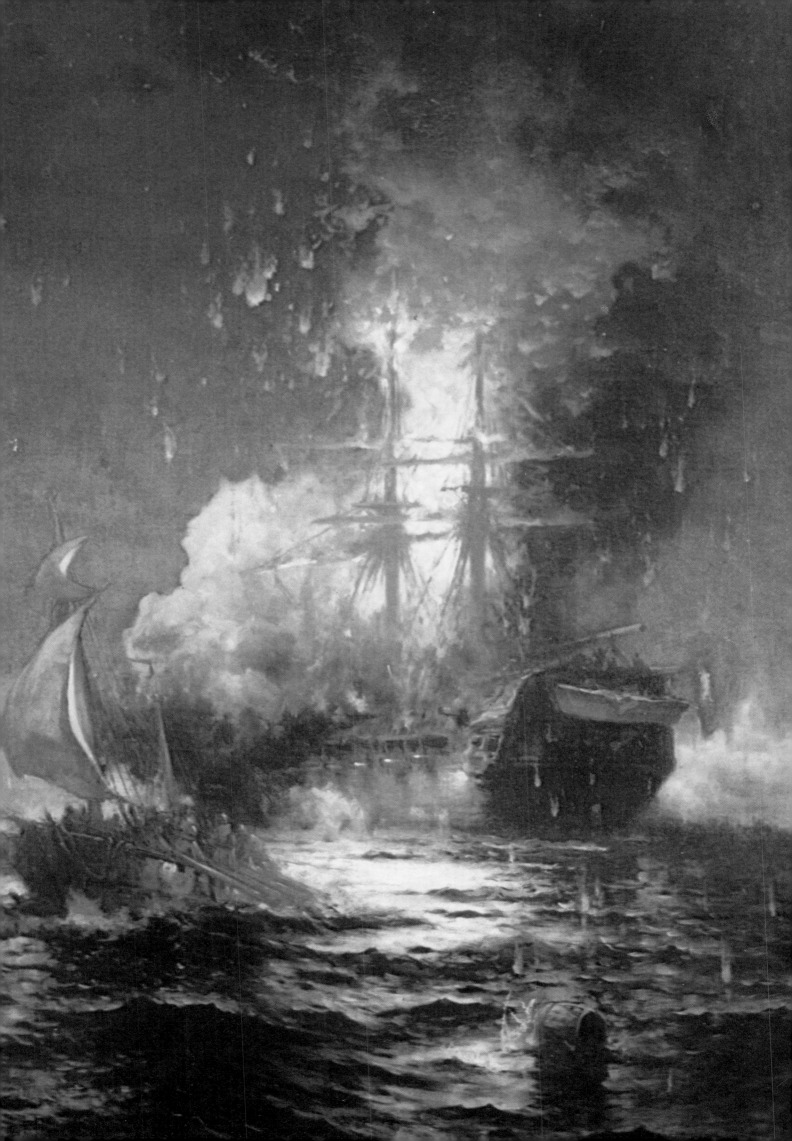

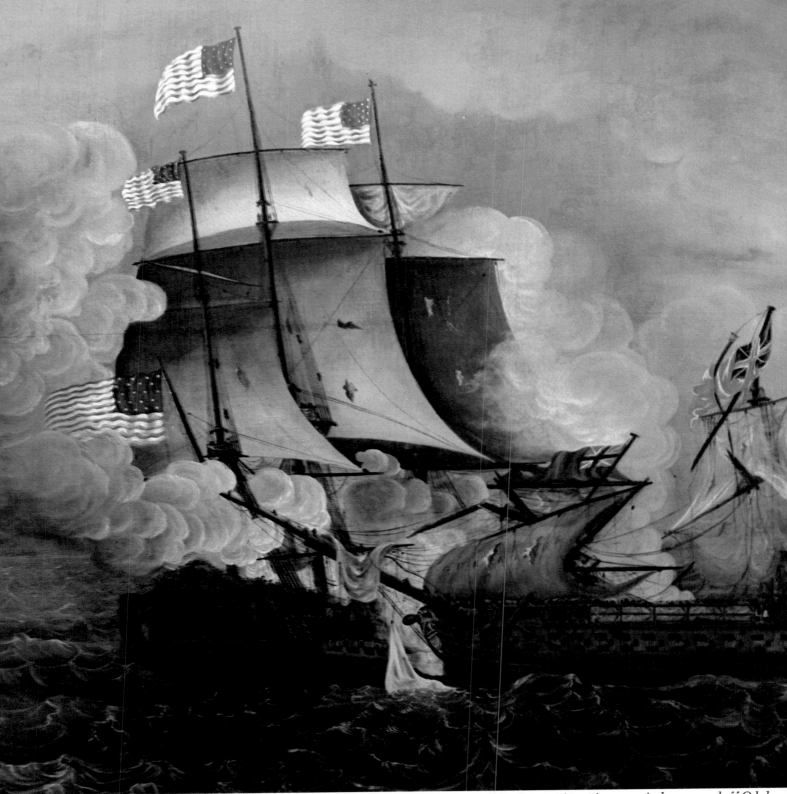

The USS Constitution, *nicknamed "Old Ironsides," defeated the British* Guerrière *after*

Allah-sent windfall. But Lieutenant Stephen Decatur, commanding a force of 62 Marines, surprised the guard, burned the ship, and got away with only one man wounded. The Dey reduced the ransom on the crew to $500,000. It was refused, and Decatur continued to harass the corsairs with their own techniques: grappling irons to board the enemy ship broadside, and hand-to-hand combat with swords, axes and pistols.

But the Dey still held the crew. The *USS*

Constitution moved in to within 600 yards of Tripoli and began pouring explosive shells into the royal palace. The Dey cut the ransom price in half, but again the offer was rejected. Meanwhile, out on the desert, Eaton was coming across Libya with Karamanli, eight U.S. Marines, and a motley following of Greek mercenaries and Arabs on camels. He reached Derna, west of Tripoli, and with the help of a naval attack captured the town. Before he could take on Tripoli, however, Jefferson made a deal

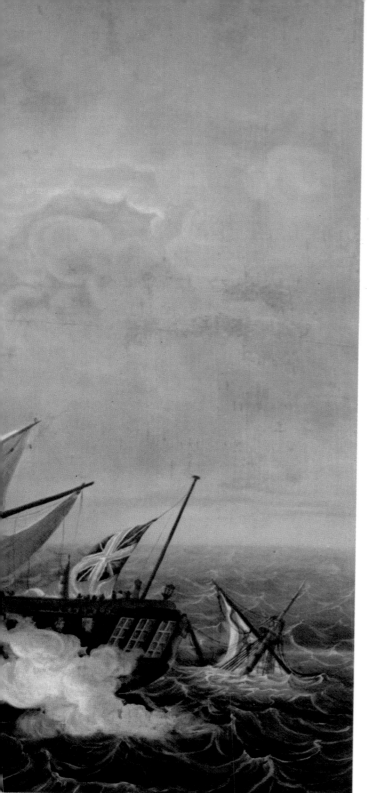

War of 1812

Only 30 years after the close of the American Revolution, Great Britain and America again found themselves at odds on land and sea, and again the American freedom to engage in foreign trade was a major bone of contention.

Great Britain and Spain had been allied against Napoleon's European empire in a struggle of mutual trade strangulation since 1806. Not only were all the ports of Europe blockaded, but both powers were becoming increasingly loath to recognize America's right, as a neutral power, to continue the normal shipping activity so vital to the New England states. France forbade all trade with or through England, and England in turn forbade all trade *except* through England. In addition, England required payment of tariffs, insisted on the right of search, and frequently impressed American sailors on the grounds that they were former British subjects.

Jefferson attempted to force England to respect American rights at sea by closing U S ports to all but coastal commerce. This policy was both unpopular and ineffective, for the British soon discovered they could do without American trade. As the sharp-tongued John Randolph of Virginia remarked, Jefferson's embargo was like cutting off one's toes to cure one's corns.

Just before ceding the Presidency to James Madison in March, 1809, Jefferson repealed the embargo. It was replaced by a milder Non-Intercourse Act, opening up trade to all countries except the two belligerents. The following year that restriction, too, was dropped. But unfortunately Madison, persuaded in 1811 by wily French diplomacy to resume the non-intercourse policy against England in exchange for normalized trade relations with all of French-controlled continental Europe, stumbled headlong into the War of 1812. Had it come earlier, when the Royal Navy was totally occupied in the war against France, America's fledgling fleet might have found a task more commensurate with its capacities. But France was weakening, and soon the English fleet was free to devote devastating attention to the United States.

On land the British, backing Tecumseh's confederation of Eastern Indian tribes, successfully resisted the American attack on Canada across the New York-Canada border and in the Great Lakes region. The Canadians, many of whom were descendants of the Colonial loyalists who had fled to Canada during the

two and a half hours of battle in 1812*. She demolished* HMS Java *about four months later.*

with the Dey, returning Derna, paying $60,000 for the American crew, and receiving in return a guarantee of permanent peace. Eaton, although his derring-do had unquestionably influenced the Dey to negotiate, felt cheated. He was convinced that he could have taken Tripoli.

Corsairs from neighboring Algiers continued to harass American shipping. Finally, in 1815, President Madison sent so intimidating a force that no further tribute was ever demanded of the United States by any of the Barbary States.

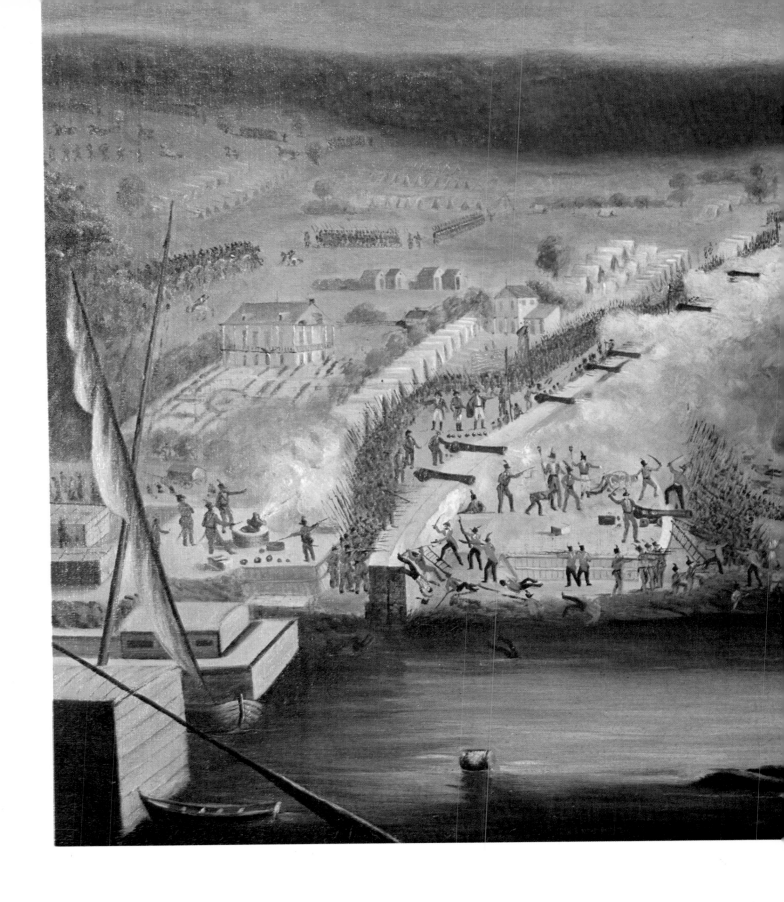

Revolution, began a successful counterattack. But by the end of 1813 Tecumseh had been defeated, the Americans had seized control of the Great Lakes and raided the town of York (now Toronto). To the south, after Napoleon's abdication in 1814, the British mounted a large scale offensive. A force of about 4,000 men sailed up Chesapeake Bay and burned as much of the Capitol and the White House as would burn (sending the Madisons and the Cabinet scampering to the nearest hills). It then shelled Baltimore and withdrew.

An even larger force landed near New Orleans and marched in unbroken ranks toward the city. In the battle that followed (January 8, 1815) American riflemen won an impressive victory,

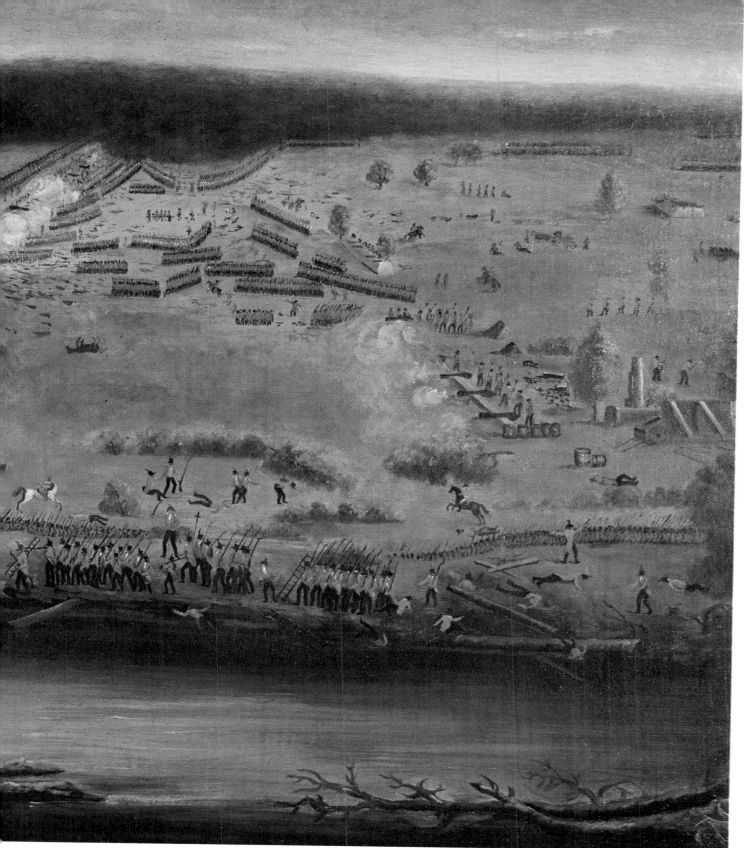

British tactics at the Battle of New Orleans had not improved since Bunker Hill days. Redcoats marched in formation, only to be mowed down from behind cotton bales by Jackson's riflemen.

with only about 70 men killed or wounded, as compared to more than 2,000 casualties on the British side. The slaughter could have been avoided had there been a transatlantic cable in those days — but neither General Andrew Jackson nor his opponent Sir Edward Pakenham knew that the Treaty of Ghent had been signed two weeks earlier, officially ending hostilities.

By the terms of the treaty, neither side conceded anything — no territory, no pledges of more equitable naval conduct. Nobody won the war. Yet it had two important consequences. England did not give up her right of search, but ceased practicing it. America discovered what older sovereign nations had long since learned: Sometimes the paradoxical price of peace is war.

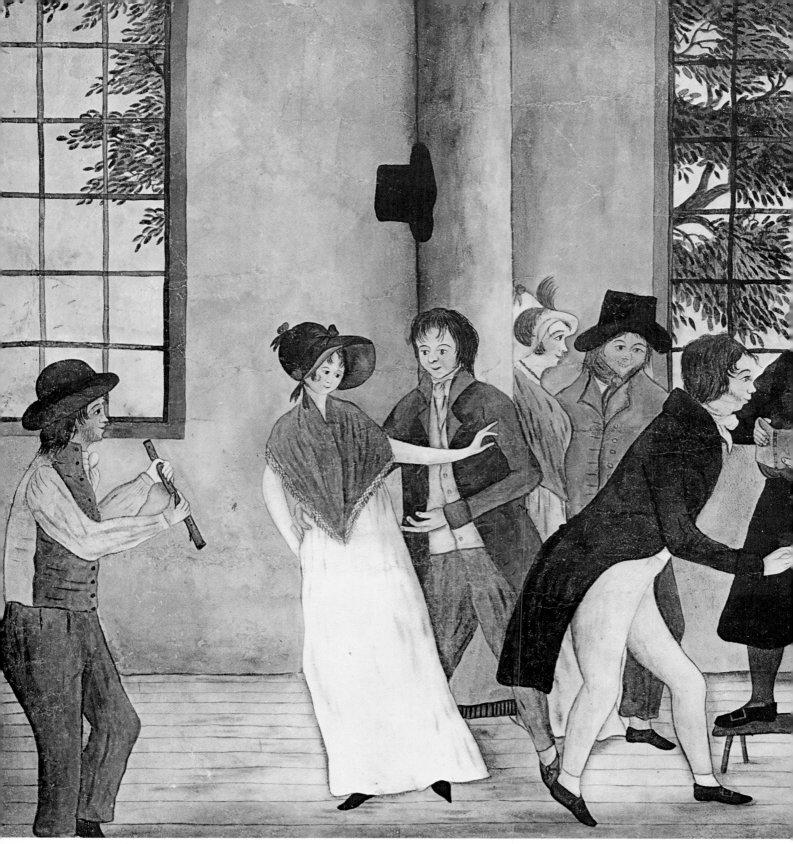

In Union There is Strife

The old Federalist Party, its hold on the nation already weakened during the Democratic-Republican administrations of Thomas Jefferson and James Madison, found itself irrevocably compromised by the War of 1812. So strongly had Federalist New England opposed the war that a convention in Hartford, Connecticut, seriously considered making a separate peace with England. The party was completely out of touch with the times. Alexander Hamilton, two days before his tragic death in 1804, put the Federalist feeling on democracy succinctly: "Democracy is our real disease." If true, the

elegance. The mood reflects the post-war spirit of détente typical of "The Era of Good Feelings."

currents of impending sectional conflict. Regional interests found expression in the eloquence of Daniel Webster and John C. Calhoun.

Daniel Webster spoke for New England. He had opposed protective tariffs because the shipping industry, still foremost, thrived on imports. But when British imports began to flood US harbors at the conclusion of long embargoes and the War of 1812, "Black Dan" discovered merit in a tariff of from 20% to 25% on the value of all dutiable imports, the very tariff he had opposed a few years earlier. Great Britain seemed to be launching a second attack on her former colonies, but this time in the form of endless manufactures. Manchester textiles led the assault. The tariff would shelter new power-loom mills along New England's streams long enough for enterprising industrialists like Francis Lowell and Samuel Slater to get on their feet. Cheap native cotton, made available thanks to Eli Whitney's invention of the cotton gin, combined with the cheap labor of Rhode Island's children, soon satisfied the bulk of the American market for cotton fabrics. Woolen and iron industries followed the flourishing cotton mills.

While Webster's initial opposition to protective tariffs gave way to enthusiastic support, the allegiances of John C. Calhoun of South Carolina produced an inverse volte-face, from support to violent condemnation of the tariffs. Cotton was not yet undisputed "King" in the South in 1816. But as it became clearer that the Southern states were destined to develop an agricultural economy, buying manufactured items, the tariff took on the character of a tax levied against the South to enrich Yankee industrialists. The issue came to a head in 1832, when Vice-President Calhoun's native state threatened to secede over the question, and President Jackson called its bluff by preparing to send a small army against the port of Charleston for having refused to collect the tariff. He promised to have Calhoun tried for treason, and hanged if found guilty. Bitterness resulted, but with it an unmistakable indication of the progress of national cohesion: Gone were the days when a state could make a peaceful withdrawal from the Union.

Sectionalism and states' rights were aroused by the slavery issue even more strongly than by hot-headed tariff debates. In 1819 Missouri asked Congress for statehood status, the first beyond the Mississippi river. Slavery already existed there, but the House of Representatives refused to grant admission without making legal provisions for the gradual emancipation of existing slaves, and prohibition against the growth of the institution in Missouri. The

disease's only victim was the Federalist Party itself, for it disappeared from the scene.

The years of Federalist and Democratic-Republican bickering ended with an easy victory for Virginian James Monroe in the presidential race of 1817. Then began a period of national consolidation and reconciliation, often referred to as the "Era of Good Feelings." But in fact below a surface of serenity flowed dangerous cross-

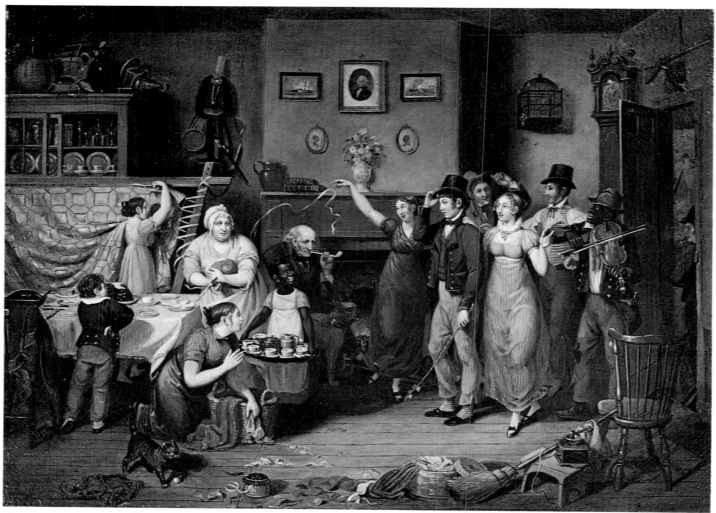

Genre painter Krimmel's Quilting Party *shows the harmonious blending of generations: reveling youth, mother cutting bread, grandpa with his pipe, and sisters occupied with their quilting.*

deadlock persisted until 1820, when Henry Clay of Kentucky proposed a series of bilateral concessions that would conserve the balance of slave states versus free states for another generation. To counterbalance the admission of Missouri as a slave state, Maine (formerly a part of Massachusetts) would enter the Union as a free state. As part of the bargain that became known as the Missouri Compromise, all unorganized territory north of the 36° 30′ parallel was to remain free soil forever.

America's military force, though still far smaller than that of any of the major European powers, had succeeded in imposing a stalemate on Great Britain. In the wake of popular enthusiasm and with an increased sense of security, foreign policy gained in firmness. James Monroe inaugurated the United States' emergence as a world power by calmly announcing a permanently closed season on colony-hunting in the Americas. Though cast in the impersonal language of general principles, the relevance of the message in 1823 was unquestionable. It meant that the newly independent Latin republics were not to be crushed by Spain, and that the northern Pacific

coast was not to be further colonized by Russia. Contemporary critics were quick to point out that the Monroe Doctrine (for which John Quincy Adams deserves at least half the credit) was no more formidable than the modest US Navy. But fortunately Great Britain, who valued her trade with the Latin American republics, was no more willing than Monroe to see King Ferdinand VII and his Holy Alliance regain his colonies.

Sharp-eyed US diplomats had been turning Europe's misfortunes into America's good fortune for some time. In 1819 Spain was too busy coping with anti-royalist factions at home and a rash of revolutions in her colonies to risk a war with the United States over Florida. She had long neglected her alligator-infested everglades, which over the years had become a haven for Cree and Seminole Indians fleeing the prospect of removal to land beyond the Mississippi, Negroes fleeing slavery, desperados of various races fleeing the law, and possibly a few British agents. As they all tended to band together and raid adjoining territories, General Jackson was dispatched on a punitive expedition. Highly successful, he hanged as many marauders as he could catch, and threatened war with Spain for

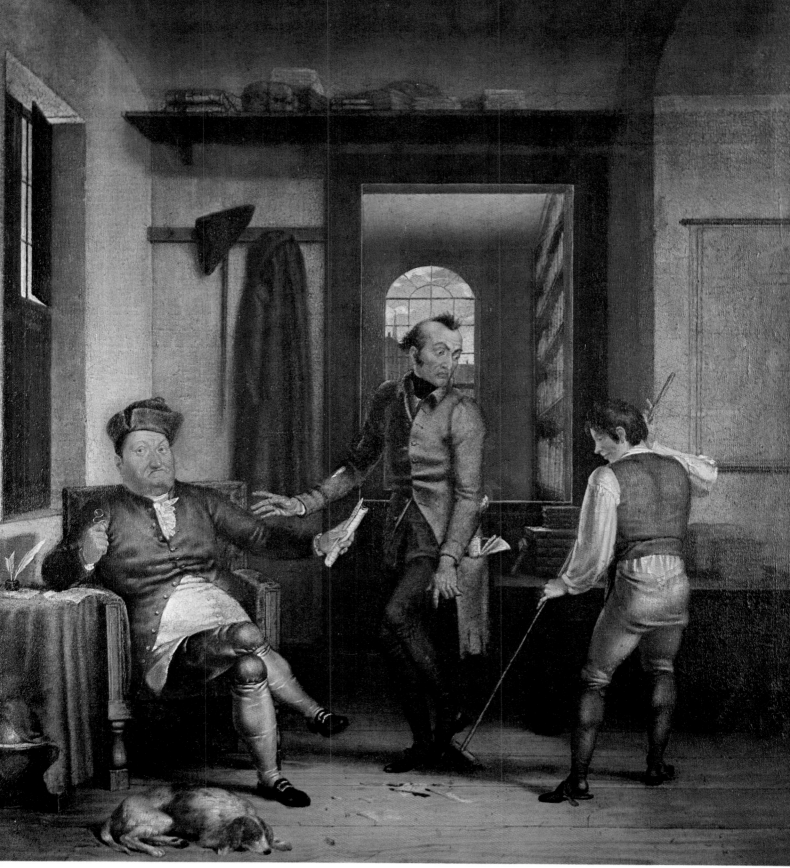

Authors of this period, without adequate copyright protection, did not have a leg to stand on. A saucy servant treats this one like so much dirt while his smug master rejects manuscript.

harboring spies and conspirators. Spain hastily agreed to swap the Floridas for some dubious concessions from the Monroe administration: the United States assumed payment of claims against Spain by U S citizens, and dropped all claims to Texas — for the time being.

(Overleaf)
Itinerant painters satisfied the constant demand for likenesses before the days of the camera.

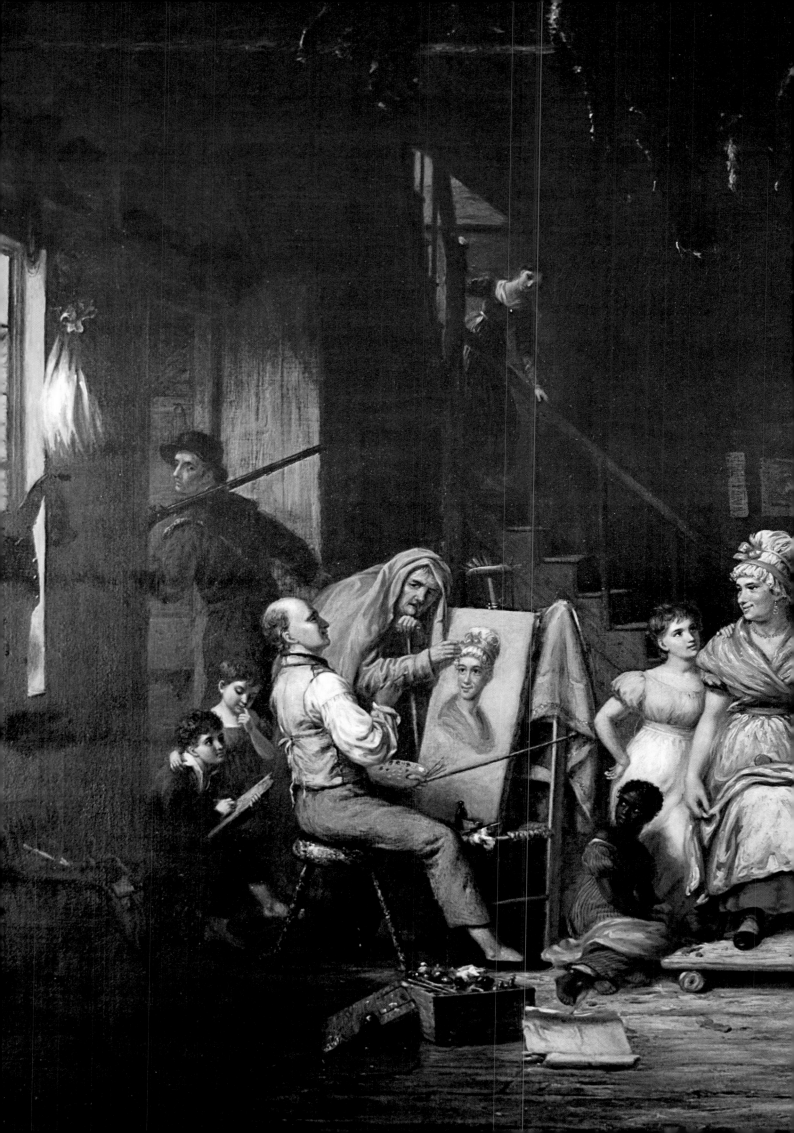

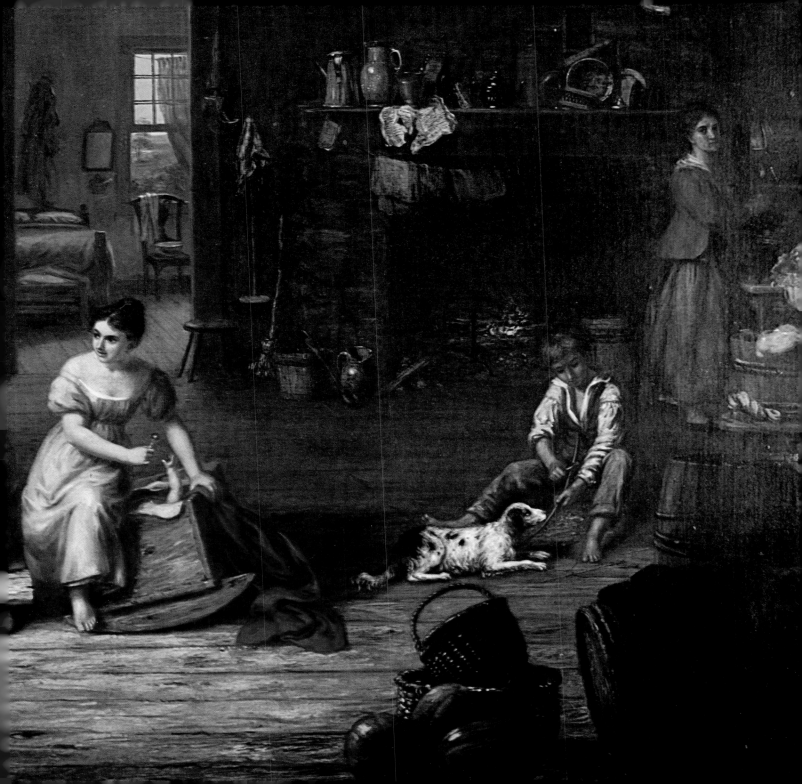

Padres, Mission Indians and Americanos

In 1800 the first American ship put in at San Diego's ample bay. The captain of the *Betsy,* out of Boston, stopped for wood and water on his way from the northwest California coast to Hawaii. From there he would set sail for Canton, China, where he would trade bales of sea otter pelts (far

California Indians at a mission painted in 1816. "Though all are Christians," wrote a guest, "they still keep many of their own beliefs, which the padres, from policy, pretend not to know."

more prized than seal by the Orientals) for tea, silk, "china," and other dainty Cantonese bric-a-brac. He had discovered a new and promising trade for Yankee shippers — a trade the Spanish would just as soon have kept secret from the rest of the world, so profitable was their erstwhile monopoly. Increasingly, Russian, British and American companies now would ply the coastal trade.

The California coast in those days was divided into four Spanish districts, extending only a few miles inland to the littoral mountain ranges.

From south to north, they were San Diego, Santa Barbara, Monterey and San Francisco. Franciscan friars held the land "in trust" for their Indian converts, raised sheep, cattle, horses and donkeys, and introduced olives, oranges and grapes. "The lack of wine for the Mass is becoming unbearable," wrote a padre in 1781. By the beginning of the 19th century the missions of San Diego, San Juan Capistrano, San Gabriel, San Buenaventura, Santa Barbara and San Luis Obispo were pressing wine.

The Indians, especially the Diegueños and Luiseños, were deceptively easy to convert. They combined Christian rites with their own native dance ceremonies, were moved to tears by the new religious chants and showed aptitude for learning Spanish. Apparently humble and submissive, they covered their nakedness, confessed and did light chores. Still, they stood in need of much reform, for according to a joint report by two Southern Californian padres in 1812, their dominant vices were "impurity, stealing and murder." Occasionally a throng of "gentiles" (Indians), taking exception to the disciplinary flogging of their brethren, would fall upon a mission under cover of night, loot and burn the buildings and plant the seeds of martyrdom; but by and large padres and Indians lived a life of humdrum harmony on the missions which lined El Camino Real (The King's Highway) from San Francisco to Baja California.

While New England tars were discovering these pleasant shores by sea (and not infrequently jumping ship), intrepid "mountain men" approached them by land. The earliest of these trapper-trader-explorers to leave a written account of his journey beyond the Rockies was Jedediah Strong Smith. In 1826 Jed set out from northern Utah with 18 men on a beaver trapping expedition. Beaver in the Rockies were already thinning out, so the party followed rivers toward the southwest, crossed the Mojave Desert and finally wandered wearily into the sanctuary of the astonished padres of San Gabriel. There the mountaineers rested for two weeks, until a suspicious provincial governor, convinced that no sane man would travel a thousand miles merely to look for beaver, ordered Smith disarmed and sent to San Diego for questioning. The governor could not prove Smith a spy, nor that he intended to claim California for the United States, so he elicited a promise never to return to California and sent the whole party packing. But most of Smith's men never did leave California, and Smith himself soon returned on a second journey. The trapping was excellent, but he lost an ear and half his scalp to a grizzly, and most of his men to hostile Indians. Upon arrival in California he was jailed in Monterey. This time he took the lesson to heart: he never came back to California. But the pass he had found across

the continental divide via the high plateaus of southern Wyoming was destined to play as vital a role in future westward expansion as Daniel Boone's Cumberland Gap through the Alleghenies had done decades earlier.

Other hunters and trappers pushed west to the Pacific. James Ohio Pattie, Ewing Young and Christopher ("Kit") Carson scouted out southern routes to California, the most frequented of which was called the Santa Fe Trail.

Mexico, having won its independence from Spain in 1822, inherited the California provinces. During the 1830's the missionary zeal was waning, mission lands were secularized and sold to cattlemen as ranchos, and rumors of revolution were in the air. It was said that the Russians, the French, the British and the Americans were awaiting the opportunity of

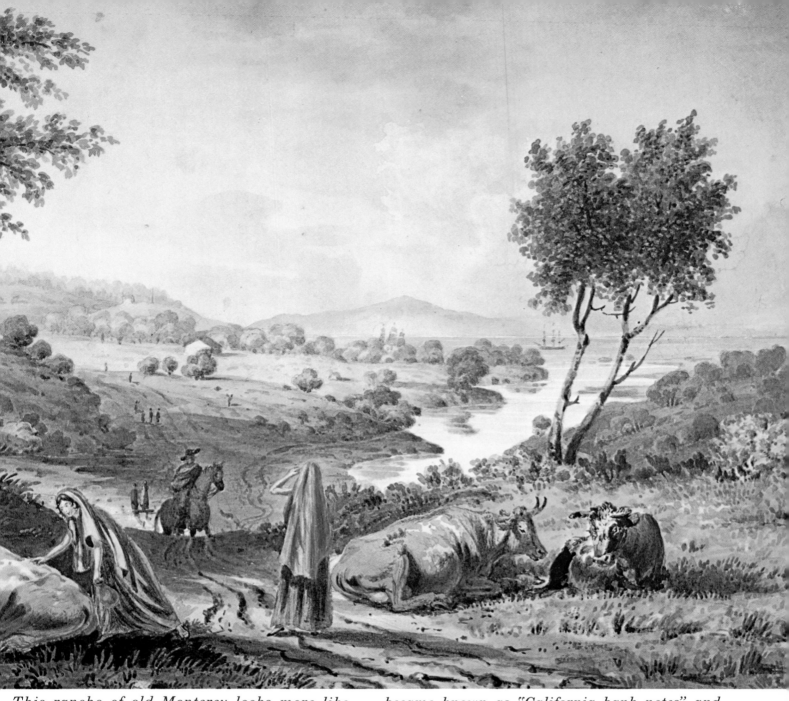

This rancho of old Monterey looks more like Spain than the California we know today. Hides *became known as "California bank notes" and replaced otter skins in the New England trade.*

takeover. Small wonder that the Mexican officials took a dim view of American sailors and mountaineers! And what they feared eventually took place. News of the mountaineers' successful passage soon attracted more trappers, then whole companies of traders, then (by 1841) the first organized overland pioneers. Well before the California gold rush dusty caravans of pioneers found California's rich farmlands. There were enough of them by 1846 to push for independence, and hoist the Bear Republic flag in Sonoma. Before the year was out the stars and stripes were flying over Monterey.

War dance costumes of the inhabitants of northern California by Login A. Choris, 1816.

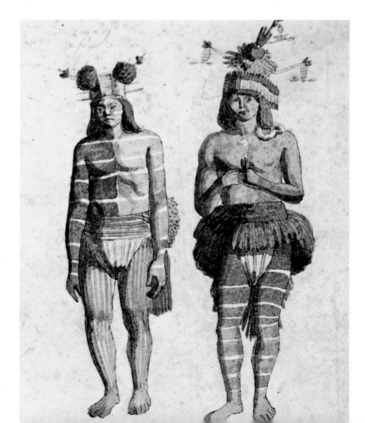

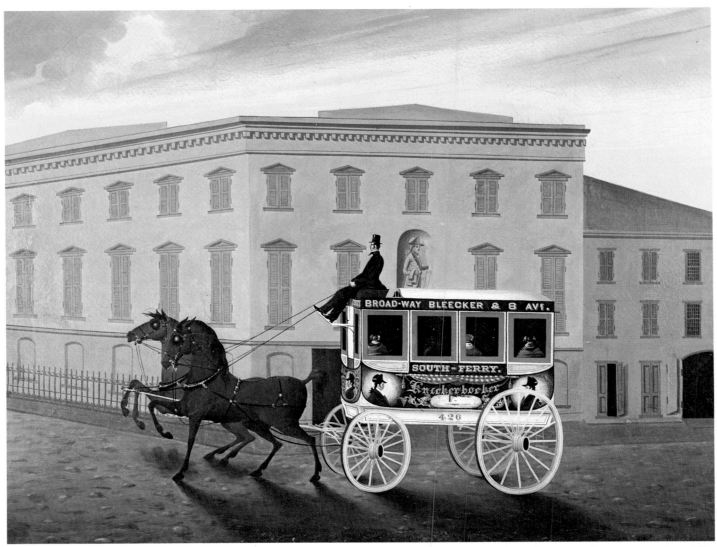

Portrait of a stagecoach, prevalent type of public conveyance in New York City in the 19th century.

Bright Lights and Busy Streets

New York, Boston, Philadelphia, Baltimore ("the risingest town in America, except the federal city," predicted George Washington), and the still very "foreign" city of New Orleans began to replace their oil lamps with gas lights in streets and public buildings, though not yet in private homes, in the 1820's. Philadelphia's Chestnut Street Theatre glowed with brilliant new gas lighting as early as 1816. American audiences warmed to the British Shakespearean actor Junius Brutus Booth, but were no less attracted by less sophisticated entertainment: Black comedians, ventriloquists, fencing masters, Punch and Judy shows and acting dogs.

The Atlantic cities were, according to one English visitor, full of "well-clad, plain-looking, serious-visaged men, and women in all the gaudiness of over-dressed pretension." American hack, cab and stage drivers appeared more skillful than their European counterparts, despite a "loose, awkward and unartist-like" way of holding the reins. And already there was an overabundance of "glaring signboards, gilding, and green paint." The uncomfortable and overcrowded "inns" on which turnpike travelers between cities had to depend were gradually being replaced by more gracious "hotels," introduced by upperclass émigrés from Revolutionary France.

Particularly surprising to Europeans was the sight of American ladies walking alone or in couples in the streets. There being "no corresponding class of females in Europe at all like them," our bewildered Britisher formed a "widely mistaken notion of them" and noted in his observations that "many awkward mistakes take place in consequence."

A farce at New York's Park Theater. Ladies did not sit in the orchestra in Dolly Madison's day.

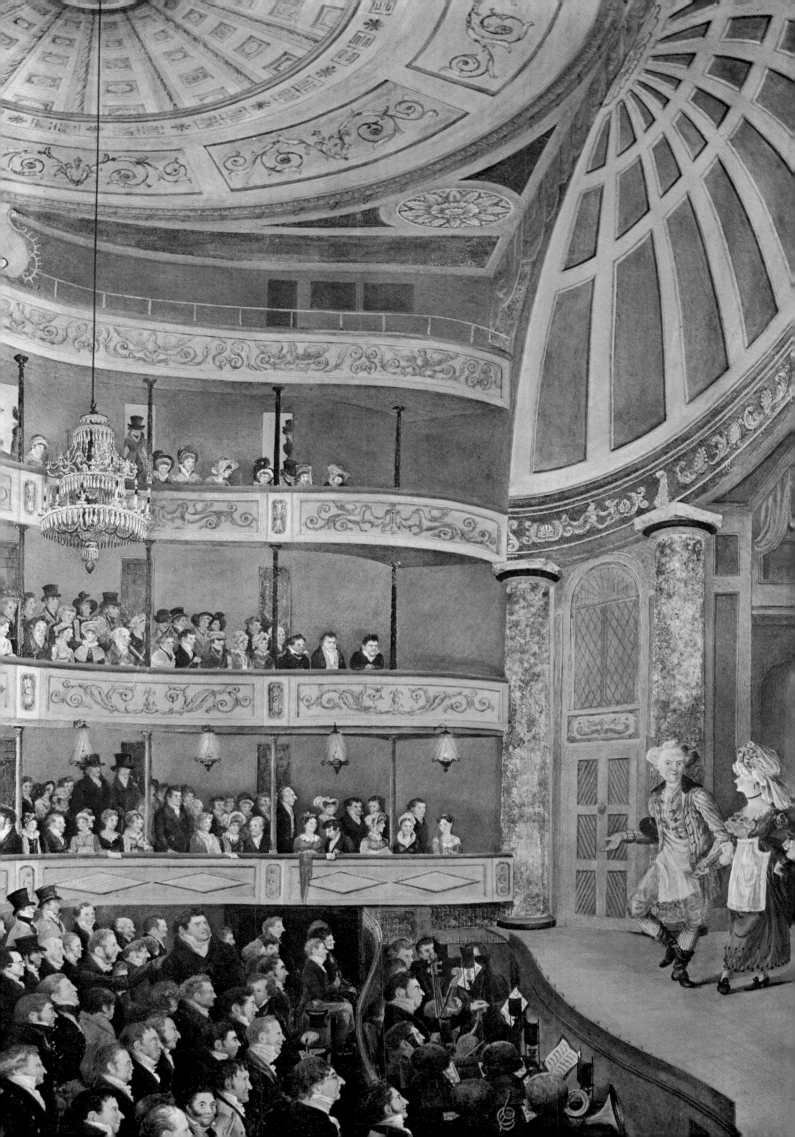

The subdued elegance of this dining room could vie with the best that Europe had to offer.

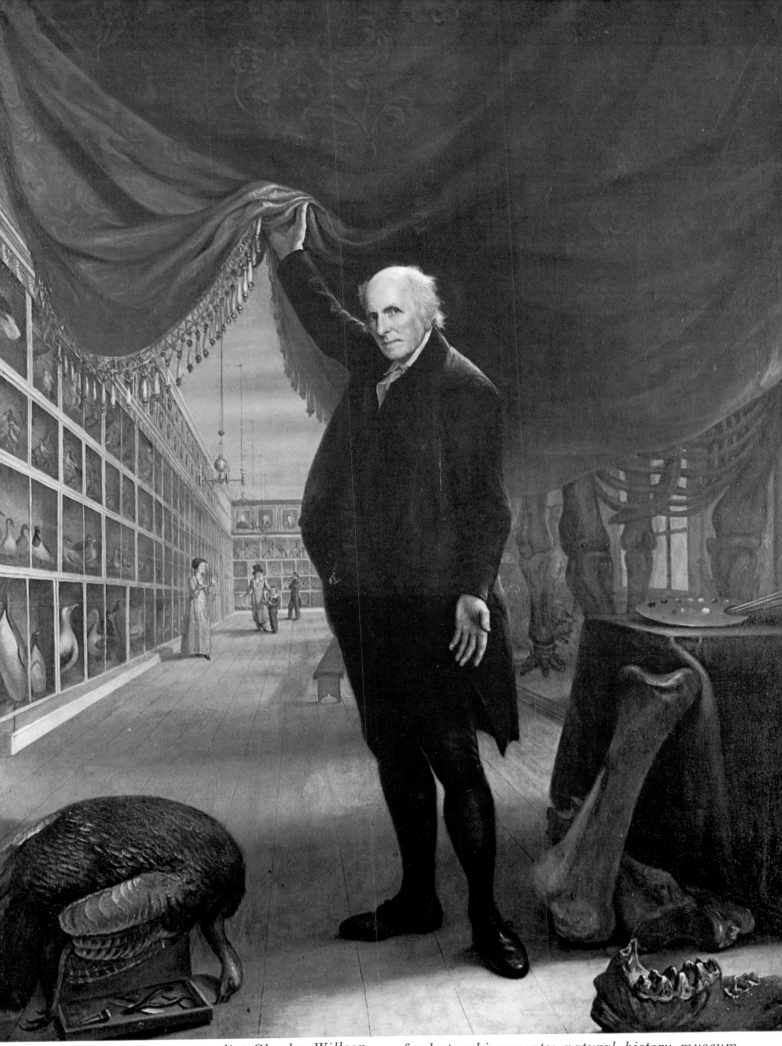

Octogenarian artist-naturalist Charles Willson Peale included in this self-portrait some of his fondest achievements: natural history museum containing a mastodon, and rows of stuffed birds.

Eli Whitney

When Eli Whitney died in 1825 the impact of his inventions was only beginning to be felt. They were to transform the economy of the entire country. A well-educated man of little means, Whitney went to Savannah, Georgia in 1792 to study law. In exchange for room and board at the home of the widow of General Nathanael Greene, Eli fixed things around the house. One evening when some of Mrs. Greene's acquaintances were discussing the impractability of growing green seed cotton — it took too long to clean — the lady blithely volunteered: "Mr. Whitney can make a machine to clean it." He dutifully invented the cotton gin, which made cotton "King" and slavery a vital institution in the South.

Whitney's contribution to manufacturing techniques is less well known. His musket factory in New Haven, Connecticut, not only supplied arms for the War of 1812, but also introduced the standardization of parts and division of labor. Whitney's portrait (above) was painted by Samuel Finley Breese Morse.

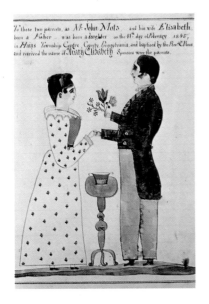

1827-1848
EXPANSION AND GROWING PAINS

Andrew Jackson organizes the "Kitchen Cabinet," the first powerful presidential advisory group. Jackson removes Government deposits from the Bank of the United States, causing its demise. Texans victorious at the Alamo, and new states are added to the Union. Daniel Webster becomes the spokesman for the Government. Compromise with England sets the northwest boundary of the United States. Californians fight to become independent as war begins with Mexico.

HISTORICAL CHRONOLOGY	ART CHRONOLOGY
1828 *Andrew Jackson defeating J. Q. Adams wins the Presidency.* 1829 *President Jackson introduces on a national scale the spoils system by which patronage is used for party purposes.* 1830 *Indian Removal Act.* *Reopening of West Indies trade which had been closed since 1826.* 1832 *Congress creates a Bureau of Indian Affairs within the War Department.* 1834 *The National Trades Union is formed, America's first national labor organization.* 1835 *Start of the Texas War of Independence which lasts for one year.* 1837 *US recognizes Texas as the Lone Star Republic.* *Stock and commodity prices break, creating general economic collapse – Panic of 1837.* *Telegraph invented by Morse and Cooke.* 1842 *Daniel Webster settles Maine boundary dispute with British.* *Beginning of large-scale immigration to Oregon.* 1845 *Florida and Texas enter statehood.* *John L. O'Sullivan's phrase "Manifest Destiny" justifies the "divine right" of American people to settle the continent.* 1846 *Settlers aided by Frémont proclaim the Republic of California in Bear Flag revolt.* *War with Mexico begins, ending in 1848, with US acquisition of most of what are now the Southwestern states, by treaty of Guadalupe Hidalgo.* 1848 *Gold is discovered at Sutter's Mill in California touching off the gold rush.*	1827 *First part of John Audubon's* Birds of America *published.* 1828 *Noah Webster publishes* An American Dictionary of the English Language. 1830 Book of Mormon *published and Church of Jesus Christ of the Latter-day Saints founded in New York by Joseph Smith.* 1831 *Tocqueville visits America.* America *is composed by Samuel F. Smith.* *William Lloyd Garrison publishes first edition of* The Liberator, *influential abolitionist newspaper.* 1832 *George Catlin paints* Four Bears, *one of a series of Indian Chiefs.* *Hudson River School painter Thomas Cole is commissioned to paint* The Course of the Empire *series.* 1833 *Founding of Oberlin, which was first coeducational college in the US.* *Boston Academy of Music opens.* 1834 *Currier & Ives begins printmaking.* 1836 *First editions of* McGuffey's Readers *published.* *American Temperance Union formed.* *Ralph Waldo Emerson publishes his first volume of essays,* Nature, *setting forth tenets of transcendentalism.* 1839 *Daguerrotypy, forerunner of photography, introduced in USA.* 1840 *Richard H. Dana's* Two Years Before the Mast *is published.* 1841 New York Tribune *is founded by Horace Greeley.* 1844 The Raven *by Edgar Allen Poe is published.* 1845 *Thoreau moves to Walden Pond.* Leonora, *first grand opera composed by a native American, William H. Fry, is produced.*

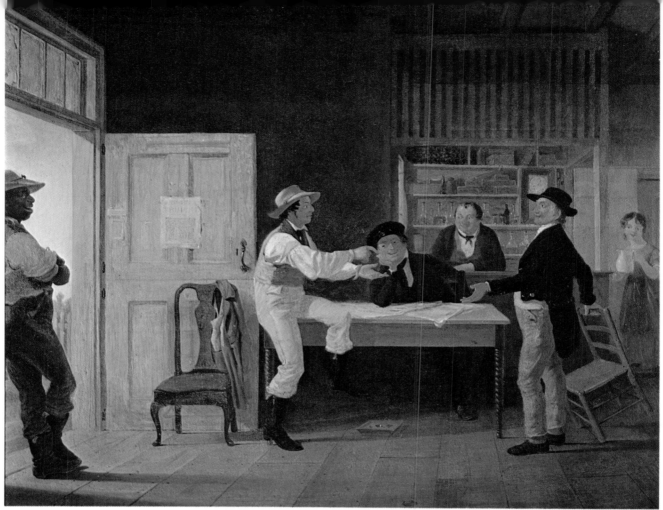

J. G. Clonney's Politicians at a Country Bar *displays the new Jacksonian spirit. Politics was* *everybody's business now. Americans began to keep an eye on those "rascal politicians."*

Jacksonian Democracy

A new force surfaced in the election of 1828 — the power of the popular vote. It carried Andrew Jackson into office and set the American Ship of State upon a course distinct from that of other nations. Old-guard Federalists decried the new "tyranny of numbers." How would the masses use their new-felt power, those droves of unlettered backwoodsmen, drifters, dockworkers, that unruly "people" whom skillful and dedicated Federalists, and even the more democratic-minded Jeffersonians, had thought to govern from a dignified remove? Jacksonian democracy was brash and sometimes blundering, but more importantly it was "the people's government made for the people, made by the people, and answerable to the people," as Daniel Webster aptly described it three decades before Lincoln improved the cadence of his phrase.

Four years earlier John Quincy Adams had just barely won the presidency. Andrew Jackson won more votes than any of the candidates, but failed to obtain a majority and the House of Representatives chose John Quincy Adams, a brilliant diplomat but mediocre President. Arousing resentments he did not trouble himself to quell, Adams was particularly unpopular in the West where five newly-formed states had written the public vote into their constitutions. The popular will had been thwarted. Four years later it arose with a vengeance, enthroned "King Andrew I" and surrounded him with office-hungry supporters. Few were disappointed: Jackson put so many former campaign workers on the public payroll that he has come to be known as the originator of the "spoils system," a lasting legacy to American politics.

True to his backwoods Tennessee origins, Jackson was an outspoken man with a short-handled temper — a combination of traits that involved him in several duels before becoming President. He repaid both goodwill and malice in kind. During his campaign days his opponents, seeking any lever with which to topple the popular idol, discovered that he had married a divorcee before her divorce was finalized. Jackson weathered the storm of political vituperation but his wife did not; she died before his inauguration. Jackson never forgave those who had attacked her.

These circumstances make it easier to

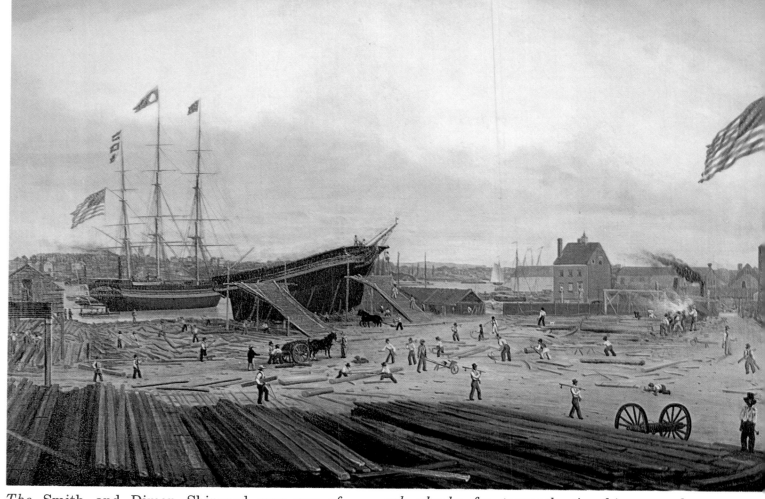

The Smith and Dimon Shipyard *was one of several along NYC's East River. Moving the solid* oak planks *for transatlantic ships was heavy work. Smoke at right is from caulking tar.*

understand why, in 1831, the President of the United States dismissed almost his entire Cabinet to defend a woman's reputation. The woman was Mrs. Peggy Eaton, then the wife of Jackson's friend and Secretary of War, but formerly a lowly boardinghouse keeper's daughter, the lovely blue-eyed Peggy O'Neale. Washington ladies would not speak to Peggy because it was rumored that she was a woman "with a past," and that she had had an affair with Eaton while married to her former husband. When he either died or committed suicide at sea in 1830, Eaton immediately married her. The snubs and slander persisted. The chief executive then called a special meeting of the Cabinet to settle the affair. He pronounced Mrs. Eaton "as chaste as a virgin" and invited any Cabinet members who did not agree to leave the White House permanently. As a result of this "Petticoat War" the Cabinet was purged of husbands whose wives had boycotted Peggy in 1831, and the following year John C. Calhoun, whose wife was the main instigator of the slander, resigned the vice-presidency.

Sometimes history's byways lead to crossroads. In the case of the "Eaton malaria," as contemporaries called it, two major consequences

resulted. The first was that Jackson's Secretary of State, Martin Van Buren who, being a bachelor, was not involved in the ostracism of Mrs. Eaton (in fact he found her both intelligent and attractive), became the President's confidant and chosen successor in office. The second

New Yorkers of the Jacksonian era could pause for a plate of oysters on many downtown streets.

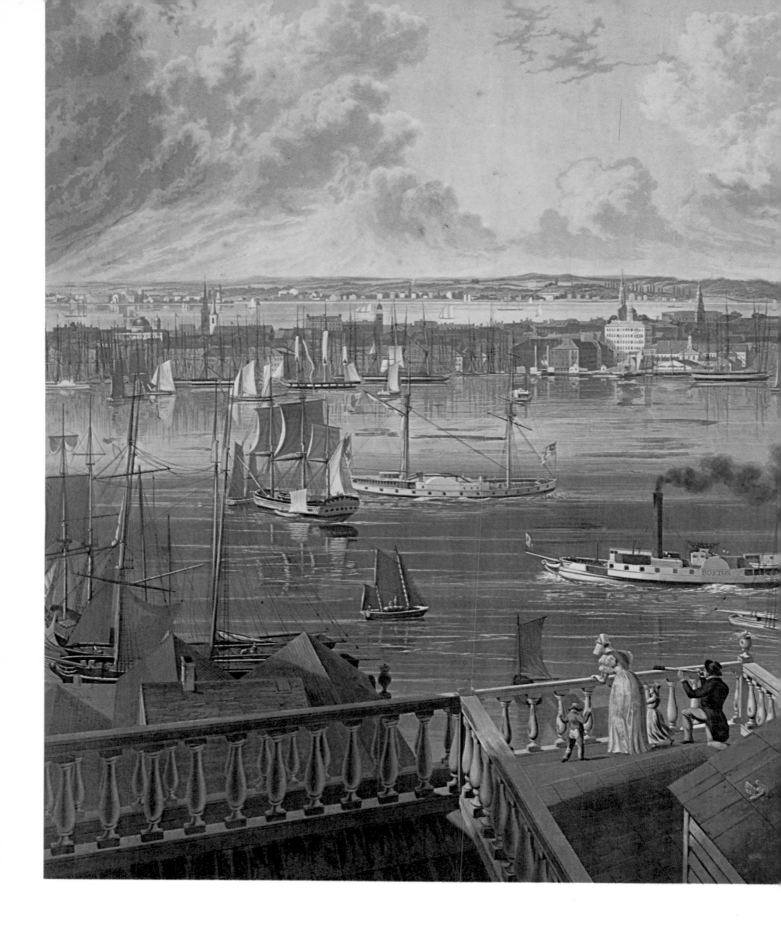

consequence was that Calhoun, falling back on his South Carolina constituency for a seat in the House of Representatives, openly opposed the President, espoused the cause of states' rights, and called for nullification in his native state of the federally-imposed tariff on imports.

Calhoun argued, not without reason, that the tariff favored New England and penalized the South. Though New England's ports were crowded with ships, the section now had a developing industrial economy as well. The high protective tariff made British imports slightly more expensive than local manufactures. Without it Southerners could have bought their

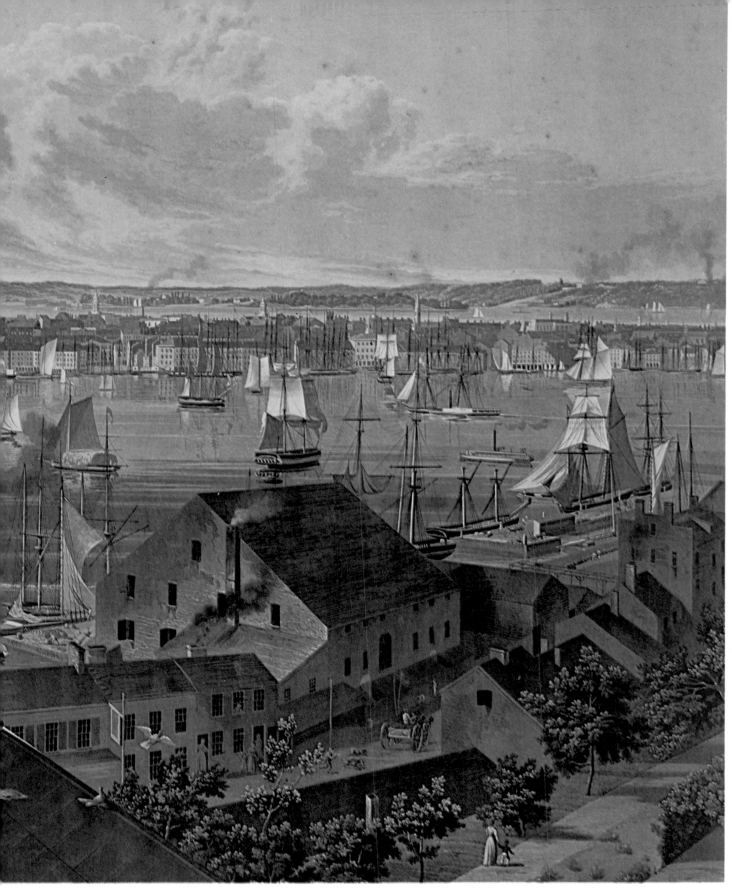

A strikingly accurate portrayal of Manhattan and the East River, seen from Brooklyn Heights in 1837. That early steamboat's peaceful puff of smoke announced the Industrial Revolution.

cloth cheaper from England, and British merchants would have paid a good price for their cotton rather than return to Liverpool with empty holds. Why should the South, Calhoun argued, economically the least successful region in the United States at that time, be forced to subsidize Yankee industrialists? The West sided with the North, because from tariffs came the federally-funded bridges and roads it needed into the interior. The Southerner was beginning to feel alone, excluded from the land-boom of Western expansion, and a resentful witness to Northern prosperity during the springtime of the Industrial Revolution.

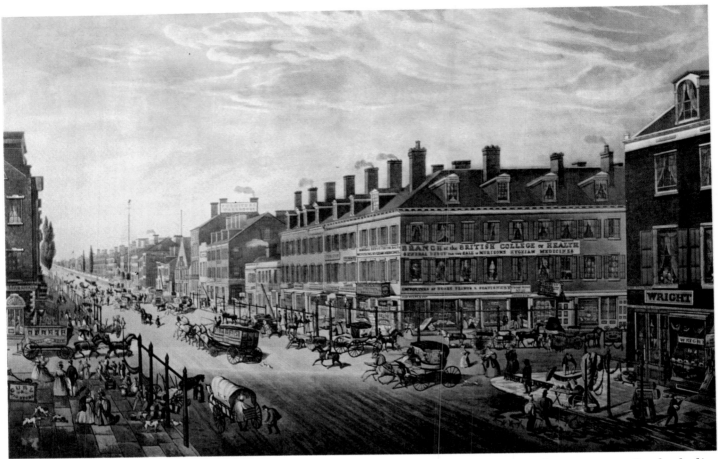

This Thomas Hornor lithograph of a busy Broadway street corner in 1836 is alive with movement: horses trot, dogs scamper freely, ladies with ankle-length dresses attempt a safe crossing.

The City and Its Institutions

Inland cities in the 1830's were growing rapidly. Speculators planned vast new towns in the West; sometimes they lost, sometimes they won. In Chicago, for example, one lot on Lake Street, purchased for $300 in 1834, was resold two years later for $60,000. Meanwhile, the older Eastern cities were continuing to grow, their economic success established to the point that cultural institutions could take root and flourish.

The first penny newspapers came out in New York. James Gordon Bennett's *Herald* was published in 1835, in time to cover The Great Fire which destroyed most buildings east of Broad Street. The *Sun* published what is believed to be the first illustrated "extra" when the steamboat *Lexington* burned and sank in Long Island Sound with a loss of 120 passengers. The paper came out only three days later with lithographs by Nathaniel Currier illustrating the "melancholy occurrence" of the "awful conflagration." The following year Horace Greeley founded the *Tribune,* a more liberal paper for the Workies, abolitionists and

"Fanny-Wrightists." "A newspaper can send more souls to Heaven, and save more from Hell, than all the churches or chapels in New York," pontificated Bennett of the *Herald* in 1836 "— besides making money at the same time." He raised the price of his paper to two cents a copy.

The municipality itself was rich enough to carry out a number of community projects, including water supply. Jubilant parades marked the completion of the Croton Aqueduct.

The Astor House, with its 309 guest rooms and running water even above the ground floor, was America's finest hotel. Outside its majestic facade waited the first cabs, lighter and more convenient than the older public Broadway stagecoaches. "The most convenient things imaginable" reported the *Mirror.*

Further south along the Atlantic seaboard, urban life proceeded along less hectic lines. The leisurely arabesques of wrought-iron balconies and gates translated a different time sense. Charleston's focal point of activity was not in the narrow streets but in the porticos and gardens hidden behind brick walls. Beneath the branches of oleanders and olive trees Southern gentlemen discussed Jackson's unpopular "tariff of abominations" while ladies compared the latest muslin gowns and silk-lace shawls. To bring in

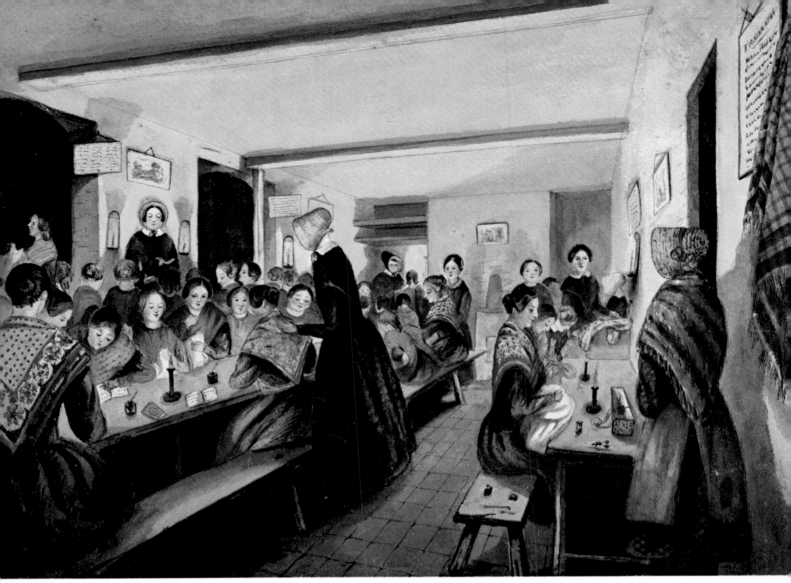

Penmanship and needlework were still the main items on the curriculum in girls' schools in an age *when women had at most an unobtrusive role. Most did not go beyond grammar school.*

more light and air in the sultry climate, houses retained their majestically-high ceilings beneath characteristically steep red roofs. The sons of plantation owners could go north to the University of Virginia, Thomas Jefferson's great intellectual legacy; young ladies might acquire the social graces at a "finishing school."

In cosmopolitan New Orleans' Canal Street, planted with a double row of trees down the middle, echoed the Creole voices of milk criers, butter criers and brightly-dressed hawkers of sundry items, skillfully balancing huge baskets on their heads. Along the levee, trading ships put in from Mexico, Texas and Florida, while steamers, flatboats and keelboats from Indiana, Ohio and adjoining states awaited their turn. Some Blacks, the "gens du couleur," free people of color, were themselves slave owners and had considerable social advantages; the Civil War was to obliterate the distinction between *free* men of color and *freed* men of color. Tulane University, originally the Medical College of Louisiana, was founded in 1834, other faculties added in 1847.

Over the country, higher educational institutions were largely considered an adjunct to the churches. Great emphasis was laid on memorization of theological works. Women, being considered unfit for strenuous mental disciplines, did not continue formal schooling beyond the grammar school level. True, Rutgers Female Institute of New York, built in 1838, offered a few substantial courses for girls, but emphasis was primarily on needlework, embroidery, painting and drawing. In New England, Amherst, Holyoke, and Adams Female Academies offered three-year programs in religious and moral training, domestic skills and the "ornamental accomplishments" of music, dancing, penmanship and painting.

New York merchants probably felt easier knowing their daughters were quietly preparing their minds for the duties of future domestic life or missionary work beneath the elms of tranquil Massachusetts or Connecticut, rather than in the big city. For despite its brighter aspects, the growing metropolis was not always a safe place to be, especially after dark.

The unsolved Jewett murder as it appeared to the mind of an anonymous artist. This version shows the fiendish villain making his escape in the dark after setting the lovely Helen Jewett's bed on fire.

Crime in the City

In 1836, the year New Yorker Martin Van Buren was campaigning for Jackson's office, Knickerbocker newspapers gave less ink to politics than to police reports. A murder case that has remained unsolved to this day intrigued the city's fast-growing population of nearly 200,000 and stimulated newspaper sales. But it did not improve the reputation of the constabulary.

The victim, 23-year-old Helen Jewett, had the gracefulness and beauty of the leading ladies of the day, though she was not a lady, in fact, and her real name was not Helen Jewett but Dorcas Doyen. Her landlady, Mrs. Rosina Townsend, usually addressed simply as "Madam," discovered her talented "Queen of the Pave" dead in a flaming bed. Horrified, she uttered a shriek that sent respectable lechers and dishevelled trollops scampering in all directions.

During the initial phase of the investigation all suspicions pointed to Richard Robinson or "Frank Rivers," as he was known when he was where he should not be, which was generally case after eight o'clock in the evening. Madame

swore he was the man. Could it have been anyone *but* Frank Rivers she saw through the half-opened door to Miss Jewett's room when she brought up that bottle of champagne at eleven o'clock? And was it not Frank's dark mantle that was found in the next-door neighbor's garden? And the murder weapon, the hatchet found in the backyard — did it not come from Mr. Hoxie's store where Frank worked? Of course!

But the longer Robinson sat in gloomy Bridewell Prison, the less positive the public became about his guilt. True, Robinson had been known to quarrel with his too-popular favorite. But he certainly did not act like a criminal, and his roommate testified that he had noticed nothing unusual in Robinson's demeanor the evening of the crime. Several witnesses for the prosecution became less sure of what they had seen. Another suspect, a female rival for Robinson's attentions, was found poisoned in bed two weeks after the murder. A remorseful suicide perhaps? And a grocer came forward with an alibi; he said he was selling Robinson cigars at the putative time of the crime.

Robinson was acquitted, although there was some suspicion of bribery. The grocer subsequently jumped in the bay, possibly to drown a perjury-laden conscience. It was even rumored that Robinson had been seen at a

distance handing one of his former jurors what looked like a package.

The tantalizing case remained a mystery, though for years thousands of Americans went on solving it, to their own satisfaction at least, in innumerable ingenious ways. Five years later it was eclipsed by an equally intriguing murder case, that of Mary Cecelia Rogers, whose body turned up on the shore of Hoboken, New Jersey, then still a relatively quiet rural town.

The Rogers murder found lasting literary fame for it was transposed into an intricate detective story, cast in a French setting and called *The Mystery of Marie Rogêt,* a sequel to *The Murders in the Rue Morgue.* It was literature's first whodunit, by Edgar Allen Poe.

City dwellers appear to have been more intrigued than frightened by these famous unsolved cases, which were merely a token of the prevalence of violence in the dimly lighted sidestreets of the larger cities. The anonymity of urban life, combined with an influx of poor Irish and German immigrants crowded into unhealthy slum areas, made living in the city appear to some to be more hazardous than the Western frontier. Police protection did not exist in the form it does today. Constables were little more than night watchmen who shouted out the hour, presumably to warn evildoers to desist. The day men, called roundsmen, were not salaried. In theory they received their income from the fees they were authorized to charge for serving warrants and eviction notices; in practice they sometimes collaborated with thieves. The roundsman would overlook a robbery, then be given the stolen sum to return to the victim in exchange for a reward to be split between the co-workers. This was the forerunner of the grease that would one day lubricate the machinery of corruption on a much larger scale.

Another version shows her as found after the crime. A hatchet wound, just visible on right temple was the cause of death, not burning. The killer's motive seems to have been jealousy.

Washington Irving's haunting short stories soon inspired plays and paintings. John Quidor did this scene from Irving's Rip Van Winkle. *Rip comes home to news of American Revolution.*

Myths, Legends and Stories

Some of the folk heroes of American legend have historical roots, others are of unknown origin, still others are fictional through and through. But whatever their source, several have won their place in the American imagination.

The legend of Johnny Appleseed is based on the actual life of John Chapman (1774-1845), who planted seedling apple nurseries from the Alleghenies to central Ohio. It was his business, but he approached it with a quasi-religious zeal. The saga of Paul Bunyan, the giant bearded lumberjack with a blue ox named Babe, on the other hand, probably grew out of tall tales told around the campfire by loggers in the old Northwest. He has become the hero of a series of stories involving superhuman size and strength. John Henry, who "died with his hammer in his hand," has been called the Negro Paul Bunyan, although he did exist in person. The ballad of John Henry symbolizes man's struggle against the machine. John Henry and his hammer could not defeat the steam drill.

In literary form, Washington Irving, upper New York State author of quaint histories and haunting tales, called on the timeless atmosphere of legend in *The Sketch Book* (1819), which contains *Rip Van Winkle* and *The Legend of Sleepy Hollow*. The characters of these two stories provided popular themes for painters and playwrights in the succeeding decades and are still well-known. Irving presented the material, tongue in cheek, as being of "scrupulous accuracy, which indeed was a little questioned on its first appearance, but has since been completely established." He reinforced the mood of his stories, in which the real and the supernatural blend harmoniously, by recurrent references to dreams and sleep. In the dead of night the frightened pedagogue Ichabod Crane encounters the Headless Horseman in "the drowsy shades of Sleepy Hollow." Rip Van

Ichabod Crane, the terrified schoolmaster, hero of Irving's Legend of Sleepy Hollow, *flees for his life before the Headless Horseman. Artist opposes Crane's white horse to monster's evil black one.*

Winkle's adventures take place during a profound and protracted slumber from which not even the American Revolution could rouse him.

Historical novelist James Fenimore Cooper, first to present a large-scale treatment of the frontiersman and the Indian, was immensely popular in Europe as well as America. In eulogizing the heroic, vanishing Red Man he borrowed the "noble savage" mystique which originated with French writers, but added much authentic observation. Cooper's legendary Indian heroes are idealized, but the high literary quality of *The Last of the Mohicans* and other novels of the *Leatherstocking Tales* preserved his work.

So, too, did the distinctive meter of *Hiawatha* help to preserve Henry Wadsworth Longfellow's epic poem of an Indian brave. Longfellow also preserved in poetry early heroes and heroines like Captain Miles Standish and Evangeline.

During the early 40's, Southern-born Edgar Allen Poe's Gothic tales of terror met with immediate success. A consummate craftsman, Poe's choice of words and cadenced prose projected mystery, suspense and sometimes sheer terror in short stories like *The Pit and the Pendulum*. He wrote what is considered generally to be the first detective story, *The Murders in the Rue Morgue*. In prose and poetry Poe thematized anxiety, dread of death, delicately beautiful heroines, ill-boding black cats and ominous ravens. Though his personal career was overshadowed by neuroses and alcoholism, his works were acclaimed at home and abroad. Baudelaire translated his work into French, and with Mallarmé helped gain recognition for their American contemporary.

While Poe was fading away another American literary figure was sailing the seven seas, gaining the experience which would help to make *Moby Dick* one of the great novels and even greater allegories of all time. Herman Melville served on a whaler himself, and the realism enhanced the story of Captain Ahab against the whale, man against his destiny.

European influences upon these American literary figures are not difficult to trace, but the legends of characters have a definitely American flavor and stand on their own.

A Great Day A-Comin'!

Western central New York State had already become known as the "burnt-over district" in the days of Andrew Jackson, because it had been swept by so many waves of fire-and-brimstone revivalism. In the 1830's and 40's, it again began to generate revivalist, utopian and spiritualistic stirrings, some of which reached far out across the continent. One of America's most powerful religious groups, the Church of Jesus Christ of Latter-day Saints, was born there.

The founder, Joseph Smith, Jr., grew up in Palmyra, New York, amid a maze of denominational controversy. Who might baptize? Was infant baptism authorized by scripture? Was fasting mandatory, penance without grace redeeming? How was the unity of the trinity to be understood? How was the church to be governed? Young Joseph Smith's mind cast about for certitude, coherence. "Who of all these parties be right? Or are they all wrong together?" he queried. On September 22, 1827, according to the history of the church, it was revealed to him that they were all wrong together. Divinely led to a hillside near the town of Manchester, he dug up a book composed of thin, golden plates engraved with characters in the reformed Egyptian tongue. Over the next three years Smith translated the *Book of Mormon* into English. It prophesied Columbus' discovery of America, the fate of the Indians (Jews from one of the Lost Tribes of Israel), and the American Revolution.

Smith formed his first church, originally called the Church of Christ, at Fayette, New York, in 1830. It moved to Ohio, where it recruited Brigham Young, its great future leader. The Mormons pushed farther west, into Missouri, where the people, fearing the Mormons would buy up all the land, took up arms and chased them east to Illinois. Further tribulation came their way when Smith announced that polygamy was authorized by God. Joseph Smith and his brother Hyrum were arrested and members of a mob shot the brothers in their cells.

Their new leader, Brigham Young, led the Saints across the Rockies to their "Zion in the Wilderness," on the shores of Great Salt Lake. By 1870 their group was 140,000 strong, and rapidly making converts both in America and abroad.

While Joseph Smith was translating the *Book of Mormon,* another rural New Yorker, a shy Baptist farmer named William Miller, was calculating from biblical clues, particularly the Book of Daniel 8:13-14, the exact date of Christ's Second Coming. He confided to neighbors in 1831 that the Millennium, a period of 1,000 years during which Christ would reign on earth, was to begin sometime in 1843. A New England minister with a rare talent for publicity management, Joshua V. Himes, joined Miller and, in camp meetings under a huge tent, promoted Millerism through pictures, songs and the printed word. They built up a following of at least 50,000 souls, but 1843 came and went. Recalculation set October 22, 1844, as the true date of Christ's return, but to the consternation of thousands gathered expectantly on hilltops, He did not appear. Out of Millerism grew the Seventh-day Adventist Church.

Camp meetings and prayer meetings were extremely successful all along the frontier. In the course of a few days, during intensive preaching,

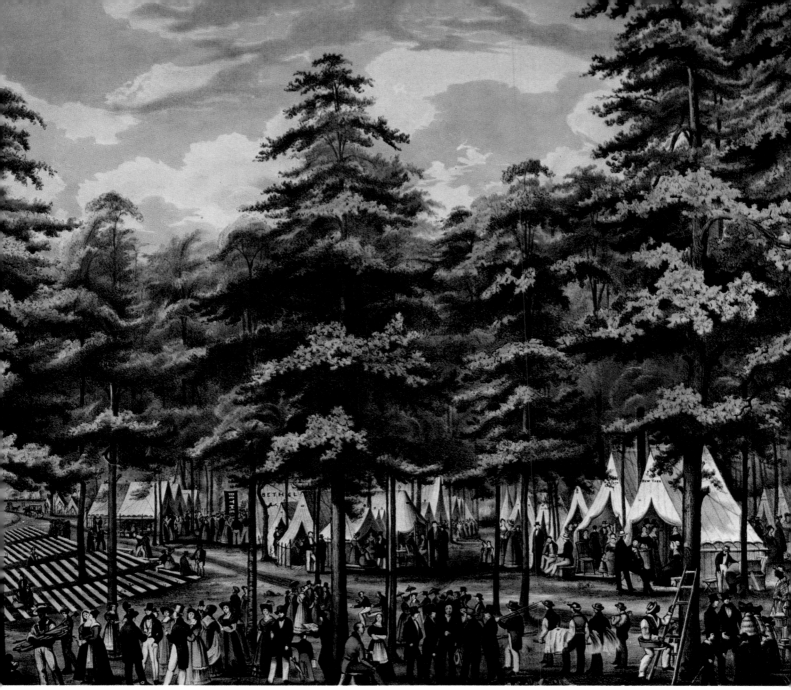

This camp meeting, held at what is now Ossining, New York (the name was formerly Sing Sing), is quieter and better organized than were most. The Hudson River is just visible in background.

a backwoods man or woman might undergo an accelerated cycle of guilt, atonement and forgiveness accompanied by the physical manifestations of jerking, weeping, and laughing attendant upon so rapid a conversion.

In comparison, a more intellectual approach to spirituality was taken by the New England Unitarians. They had little use for doctrines of repentance or atonement, because they took an optimistic view of man's nature. Urban, generally in easy financial circumstances, the Unitarians were described by outsiders as believing in "the fatherhood of God, the brotherhood of man, and the neighborhood of Boston." A group of New England Unitarians, initially under the leadership of Pastor Ralph Waldo Emerson of the Second Church of Boston, drifted away from the church and formed the

Transcendentalist Club in 1836. It was numerically a small group, but included such noted individuals of the intellectual world as W. H. Channing and Henry David Thoreau. Their only real affinity was their common insistence upon free thinking and a tendency to value intuition as much as logic in the quest for enlightenment. Their attempted intellectual commune, the Brook Farm Association, founded in 1841, disbanded after seven discordant years.

Other communes of the period were more lasting. The Oneida Community, for example, founded in New York in 1847, was destined to prosper, although along somewhat different lines from its original purpose, the sharing of all property and sexual freedom. The Amana Church Society came to the US in 1843, and later moved to Iowa where it, too, prospered.

The Artist as Inventor

Few young men have known so well what they want, and worked so hard to achieve it. When he was 23 years old, Samuel Finley Breese Morse wrote his mother with seriousness and conviction: "My ambition is to be among those who shall revive the splendor of the fifteenth century, to rival the genius of a Raphael, a Michael Angelo, or a Titian; my ambition is to be enlisted in the constellation of genius . . . I wish to shine the brightest."

Morse, born in Boston in 1791, was the conscientious son of a minister. He importuned his father to send him to London to study with the aging American master, Benjamin West, and returned with training to match his talent. Artists at the time could earn money by getting commissions to paint scenes for public buildings, by painting a huge allegorical or historic scene and charging admission to see it, or by painting portraits. Young Morse had no choice but to paint portraits, and after five years, portraying his subjects the way they paid him to paint them, he became very good at it. For the big painting on which he staked his future, the House of Representatives in session, he made 88 individual portraits. Exhibits were going out of fashion, however, and it did not draw crowds. Because beauty burst out of him, he painted landscapes, too, but there was no market for them, either. One of the founders and president of the National Academy of Art, he failed to get a government commission for political reasons. His pretty young wife died after childbirth in New Haven; she had been buried several days by the time word reached him in New York and he arrived there. That is when the bottom dropped out. Compassionate friends raised $3,000 and sent him to Europe to recuperate.

On the voyage home (six weeks at sea) Morse and another passenger discussed the possibility of using the newly-developed electromagnet to send messages over long distances. He took a one-room studio, sleeping on the floor, and eked out a living teaching while he worked out the telegraph. A personable, honest man with many friends helping him, he put a system together, complete with a code still known by his name. After ten years, in his fifties he finally began receiving a comfortable income.

A man of great energy, physical and mental, Morse had also visited Louis J. M. Daguerre in France and become interested in daguerrotypy, the forerunner to photography. Using a heavy, complex camera he designed and built, he set out to reduce the time required for exposure — some

20 minutes sitting motionless, eyes closed, in full sun. With mirrors to increase the light intensity, and improvements in the materials, he was able to get the posing time down to 60 seconds or less.

At last, with his telegraph earnings, Morse

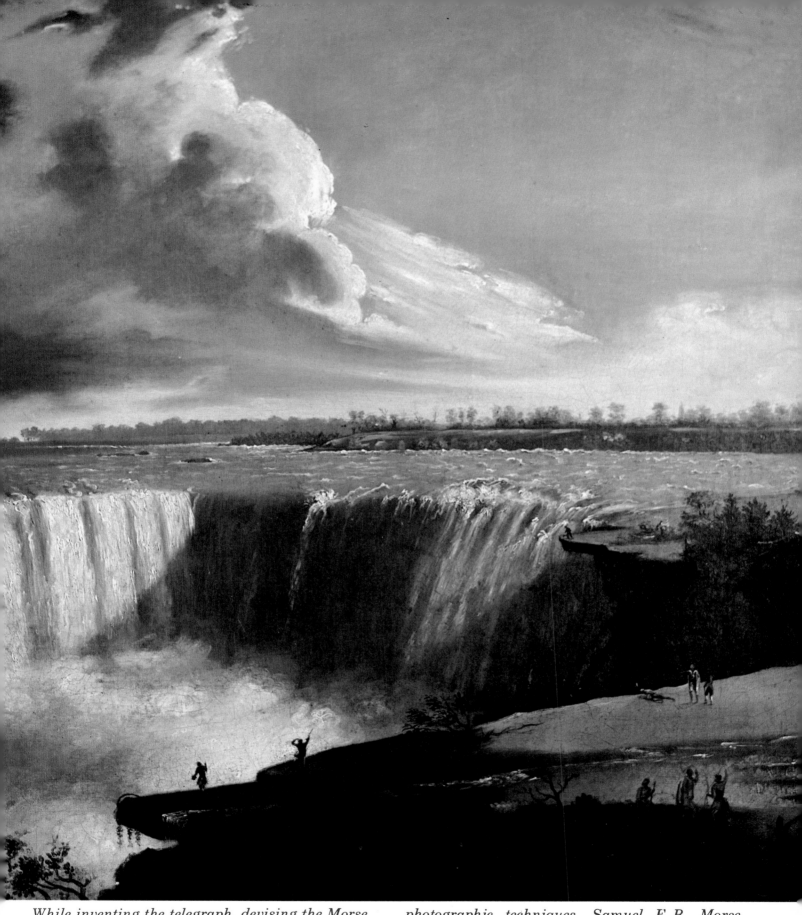

While inventing the telegraph, devising the Morse code, teaching art, and working with new photographic techniques, Samuel F. B. Morse managed to find time to paint Niagara Falls.

could afford to paint, but he was no longer interested. He had turned out some 300 works, and he knew that many of them were good. Yet they had brought him little recognition or money. He was through with art.

And so today Samuel D. B. Morse is known as the inventor of the telegraph. If, with his talent and dedication, he had lived at some other period, he might instead be known, as he would doubtless have infinitely preferred, as an artist.

The Artist as Naturalist

Jean Jacques Fougere Audubon, the illegitimate son of a French naval officer, naturalized American in 1806 at the age of 21, was destined to become the world's leading ornithologist before the century reached midpoint. He was not, at 21, what would normally be termed a bird lover, for his leisure hours were devoted to waging a noisy war on all the colorful wildfowl of eastern Pennsylvania, where his father had purchased an estate. John James, as he was called in America, rode the delightful countryside with gun and bird dogs.

It took John James about ten years to run through his share of the estate, and by 1819 he had gotten himself jailed for debt in Louisville. He had also acquired a wife, the former Lucy Bakewell, and two sons. Lucy must have been a remarkable woman, for she was not unduly perturbed when her husband, soon after his release, said that he felt called "by the rivers and the forests" of the Mississippi Valley, and boarded a flatboat at Cincinnati headed west. For the next seven years she supported herself and the children by working as a governess, first in Cincinnati, then in New Orleans, where she joined her husband in 1821. Audubon had arrived there with a rich array of bird sketches and careful notes on the song, habits and preferred habitat of each species. While he taught fencing and dancing and sold an occasional portrait, Lucy ran a private school.

As always, Audubon's best hours went to painting. He developed a method of wiring dead specimens in lifelike poses. But the coquetry of his Carolina wren, the histrionics of his catbird, the redstart's alarm, the heron's poise, came less from the model before his eyes than from vivid memories — insights gleaned during months spent in lonely marshes, fields and forests. Over the years he brought to realization his fondest dream, the compilation of a complete pictorial portfolio of American birds. When he at last succeeded, he was unable to interest American publishers in so expensive a venture, which would necessitate hundreds of copperplates and the laborious hand coloring of each engraving.

By 1826, with the help of his wife's savings, Audubon was able to sail from New Orleans to Liverpool with his life's work. He sketched sea gulls on the way. He obtained letters of introduction to Sir Walter Scott and other European notables, and his works were displayed throughout Europe. The French Academy of Sciences hailed them as "the most magnificent monument yet erected to ornithology." At last Audubon was extended credit to publish his *Birds of America*. The process took years. Each of the 435 life-size prints was over three feet long and two feet wide. They were made up into four-volume sets and sold for $1,000 a set by private subscription. One perspicacious admirer remarked that the energetic poses of certain species reminded him of the flamboyant gesticulation of excited Frenchmen.

Audubon returned to his family in Louisiana in 1829, and took them with him on later trips to Europe. Though Lucy once said she had a "rival in every bird," she understood and encouraged his lifelong mission. She won her reward when the income from his books enabled them to move to New York and purchase a three-story house in a quiet spot along the Hudson River.

Audubon's journals reveal the contentment of a man who succeeded in making a profession of his passion, painting birds. Less introspective and more scientifically inclined than another great nature lover of that era, Henry David Thoreau, his spirit bears a greater affinity to the early 20th-century entomologist, Henri Fabre. Both men seem to lose (and find) themselves in the investigation of the outer world. As a visitor to Audubon in his last days remarked: "His enthusiasm for facts made him unconscious of himself. To make him happy you had only to give him a new fact in natural history, or introduce him to a new bird."

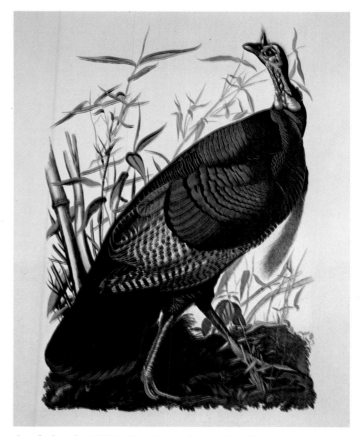

Audubon's Wild Turkey *shows bird's habitat and vigilant attitude as well as detailed plumage.*

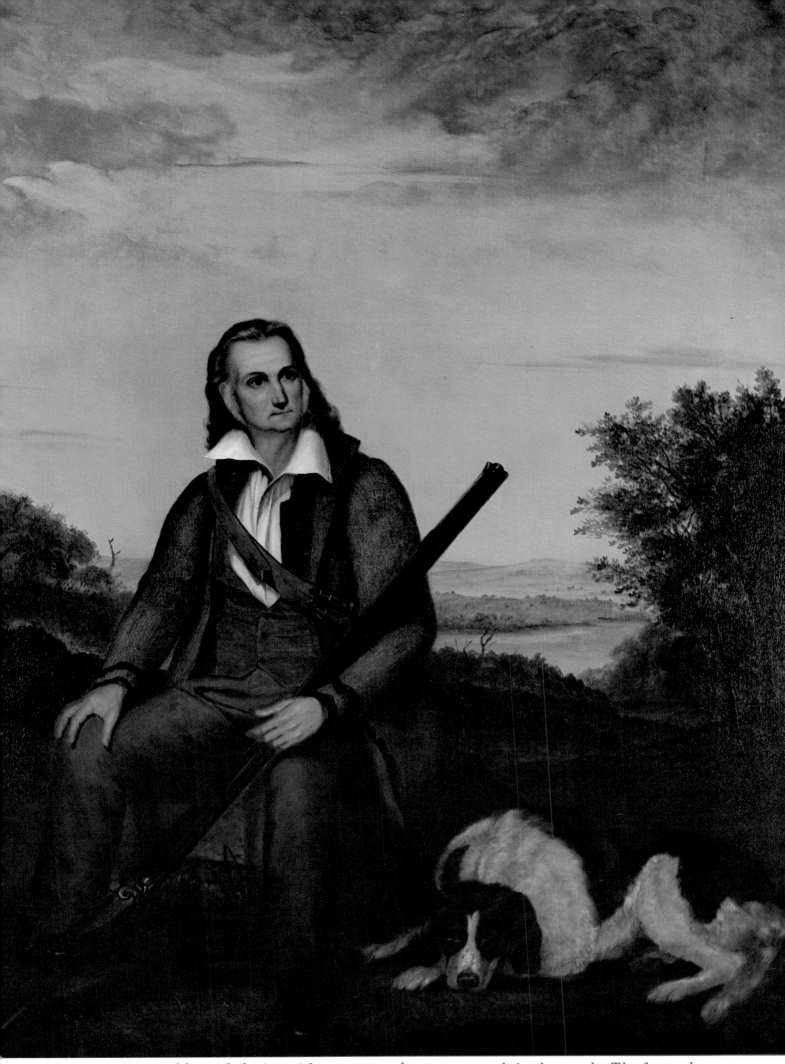

The celebrated 56-year-old <u>ornithologist</u>, with gun and faithful bird-dog, right back where the whole *adventure started, in the woods. The four-volume* Birds of America, *his life work, was finished.*

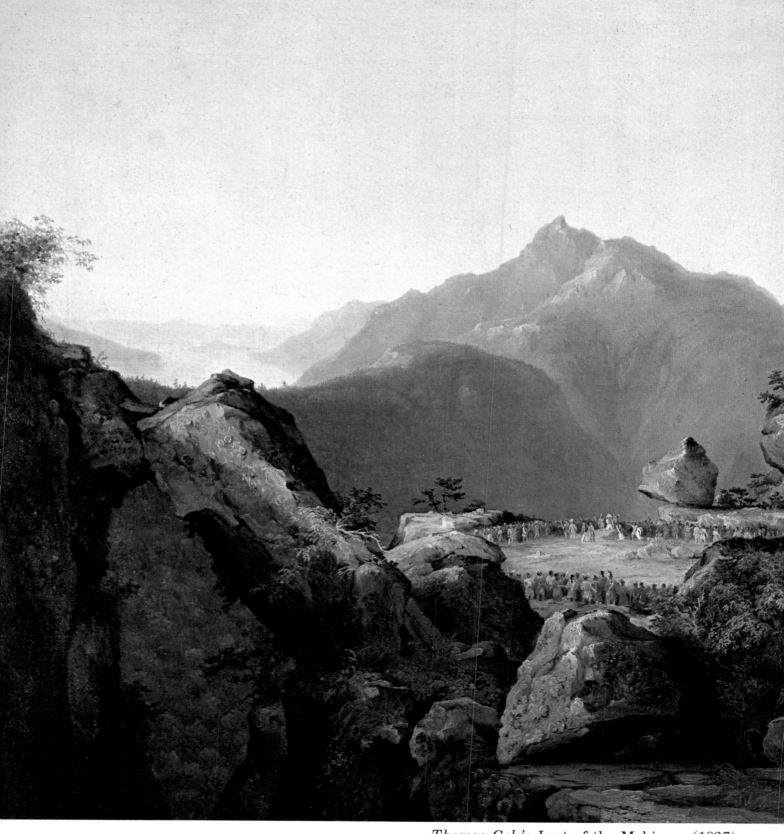

Thomas Cole's Last of the Mohicans (1827) was
inspired by Cooper's novel which appeared the

preceding year. The real Mohicans, long since dispersed, once peopled the lower Hudson Valley.

Removal of the Eastern Tribes

Soon after assuming office in 1829 President Andrew Jackson was handed a Supreme Court decision which he did not like. Chief Justice John Marshall ruled, in *Worcester versus Georgia*, that the laws of Georgia had no jurisdiction over the Indian lands in the state. This could have foiled the plan of the state to dispose of the lands by lottery — had not Georgia gone ahead and done it anyway. "John Marshall has made his decision," Jackson is supposed to have said, "now let him enforce it." The next year Congress ordered the Eastern tribes moved beyond the Mississippi. During the ensuing decade about 100,000 Choctaw, Creek, Chickasaw, Cherokee and Seminole Indians were herded west to the newly-created Indian Territory of Oklahoma.

The pros and cons of the Indian removal policy, which Jackson supported but did not originate, have been hotly debated. Some politicians backed the removal purely because of self-interest or pressure from their constituencies. Others did so out of the conviction that it was to the benefit of the Indian to shield him from white society, to which he appeared unwilling or unable to adapt. In any case, no one could have stemmed the tide of white settlement in 1830. Ironically, of all the Eastern tribes the Cherokee had been by far the most successful in integrating European institutions into its society. The Cherokee built roads, schools and churches, and cultivated their own cotton. A young warrior named Sequoya invented a writing system for the Cherokee language and in 1828 published the first Indian newspaper.

In the Midwest, the Shawnee, Delaware and Wyandot were pushed across the Mississippi by advancing ploughshares. Sauk and Fox Indians who dared recross the river east into Illinois were defeated by the militia of that state, in which a Lieutenant Jefferson Davis and a Captain Abraham Lincoln fought side by side.

The situation facing all the Eastern tribes was reflected in the sad but realistic view expressed by a third party, Alexis de Tocqueville. After visiting the Southeast, he wrote:

"Whilst the savages were endeavoring to civilize themselves, the Europeans continued to surround them on every side, and to confine them within narrower limits They were isolated in their own country, and their race only constituted a little colony of troublesome strangers in the midst of a numerous and dominant people."

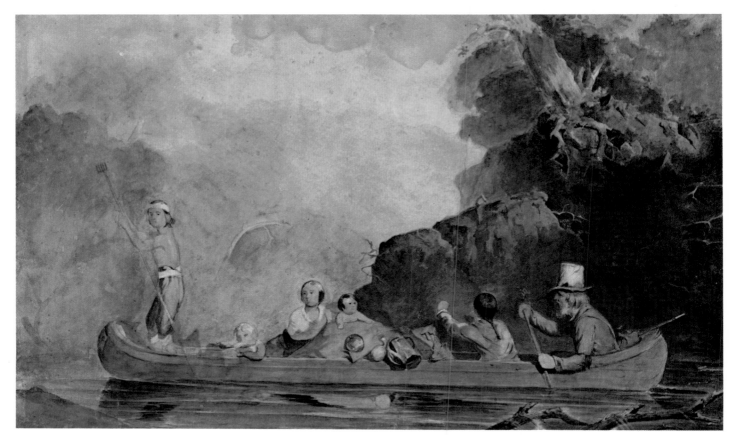

Trappers lived among the Indians, shared in their lifestyle. Both fled west before the plow's advance.

Painters of the Painted Indian

To the settler and the politician the Indian was a problem, to the soldier a wily enemy. To the novelist James Fenimore Cooper he was a noble savage. But there was one group of Europeans who had occasion to meet the Indian on his own terms and in his own territory, and who knew him as a human being: the trapper.

The trapper and the Indian had a common basis for understanding. Both knew that settlement and the spread of agriculture in the West was a threat to their common means of livelihood, the hunting of wild animals. True, the trapper depended upon the civilized world's demand for furs, but he also depended upon the bounty of the unspoiled wilderness in which furbearing animals thrived. He had to know how to live for extended periods with no other resources than his musket, the scant provisions he could carry on his back or in his canoe, and, above all, his store of wood lore. Under these circumstances, Indian and trapper developed mutual admiration, and sometimes friendship formed. Many trappers learned several Indian languages, some became tribal members, and a few married Indian women. Indians, for their part, frequently found employment with fur trading companies. Unfortunately, as the Indian had no written language, and the trapper, by his very mode of life, seldom had occasion to commit his knowledge to writing, neither left much written description of life among Western tribes.

However, following the rivers, streams and portages of the trapper, resting at his trading posts and profiting from his friendly relations with the Indians, an occasional painter would travel into the Far West. To such adventurous seekers of new subject matter we owe much of our knowledge of the physiognomies, costumes, dwellings and mores of the Plains and Rocky Mountain Indians before they had extensive contact with white settlers.

In the early 1830's George Catlin and Karl Bodmer, two important painters of Indians whose works will be discussed in the next chapter, visited the Dakota, Mandan and Ojibway tribes, located near the headwaters of the Mississippi. Bodmer's portrayal of the Mandans' earth-dome villages was especially timely, for only five years after his visit a smallpox epidemic decimated their tribe.

A young and talented artist named Alfred Jacob Miller had just returned to New Orleans from art study in France when he made the acquaintance of an eccentric Scotsman, Captain W. D. Stewart. The captain, a Waterloo veteran with a castle in the Highlands, commissioned

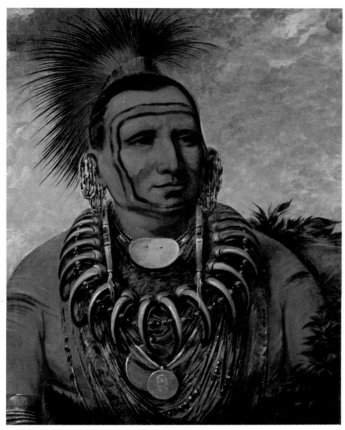

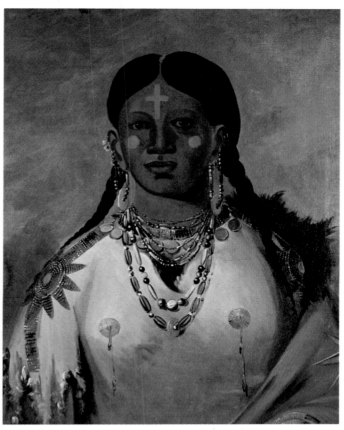

Three portraits by George Catlin: above, <u>Little</u> <u>Wolf</u>, *chief of the Cheyenne Bow String society.*

She Who Bathes Her Knees, *a Christian convert, looks justly proud of her rich ornamentation.*

Travels Everywhere, *a warrior of the Plains Ojibwa (<u>Chippewa</u>) tribe. Note hand motif on*

horse. Such markings were part of a symbolic "medicine" for protecting oneself during battle.

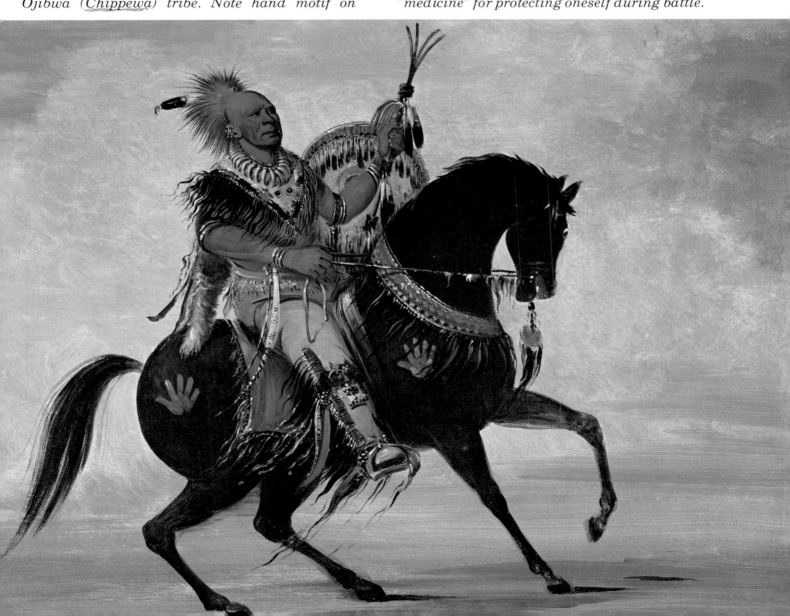

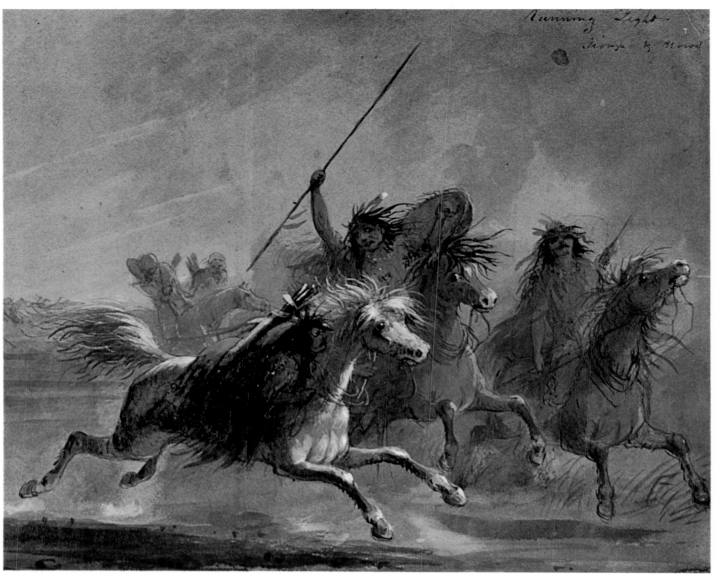

Alfred Jacob Miller's Running Fight, Sioux and Crows *depicts an Indian riding skill verified by* *other observers: clinging to the horse's side without a saddle to avoid enemy blows.*

Miller to accompany him on his fifth excursion into the Rocky Mountains. They traveled as far as Fort Laramie on the Platte River with the American Fur Company, then on to the Green River and beyond on their own. Miller produced a rich portfolio of watercolors and sketches from which he later worked up more elaborate paintings in Stewart's Perthshire Castle.

Catlin, Bodmer and Miller were artists by vocation. Lieutenant James W. Abert, though he had received instruction in draftsmanship at West Point, was primarily an army surveyor. He was appointed "artist extraordinary" in 1845 and assigned to accompany a detachment of topographical engineers for the purpose of sketching whatever Indians, flora and fauna they might encounter on their overland journey from Fort Bent on the Arkansas River to St. Louis. He left portraits of southern Comanche and Kiowa Indians and a rather mundane journal punctuated by an occasional rhapsodic reverie on the beauties of nature in the language of early 19th-century romanticism.

Father Nicolas Point, a French-born Jesuit missionary with no prior artistic training, executed hundreds of paintings and drawings of northern Rocky Mountain Indians before 1850. The garish colors of his primitive illustrations illuminate the pages of six beautifully-penned manuscripts. These journals, the *Souvenirs des Montagnes Rocheuses,* hidden away in the archives of Montreal's Collège Sainte-Marie for 125 years, have been published only within the last decade. In them Father Point describes the life of Coeur d'Alene, Flathead and Blackfoot Indians during the period of his mission, from 1840 to 1847. Naturally the good Father could not view Indian medicine, witchcraft, religion or polygamous practices objectively. He expresses his indignation at "the excesses of which women are capable, who prefer half the heart of a man to

Snowshoes, an Indian invention, enabled hunters to catch up with buffalo floundering in the drifts.

Catlin was one of the last Europeans to see this type of Indian dome-shaped dwelling. Mandan and Hidatsa villages (in what is now North Dakota) were soon to be decimated by epidemics.

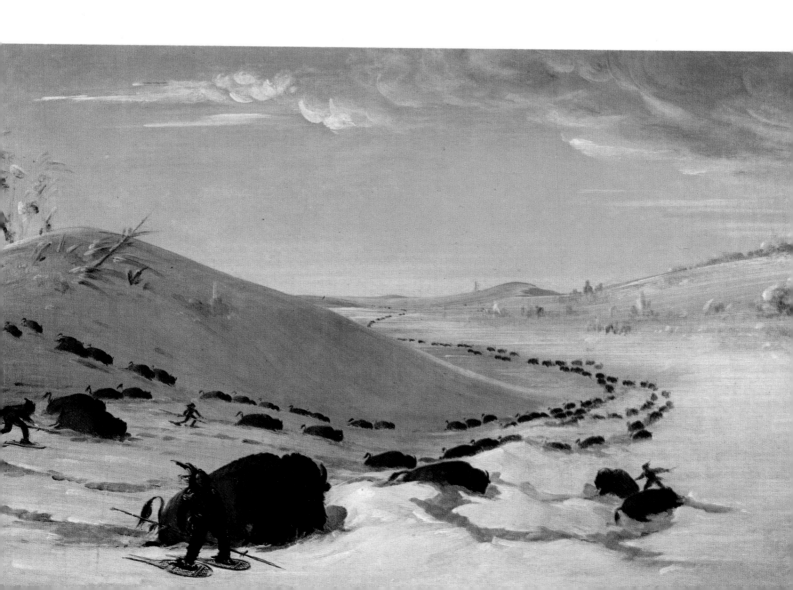

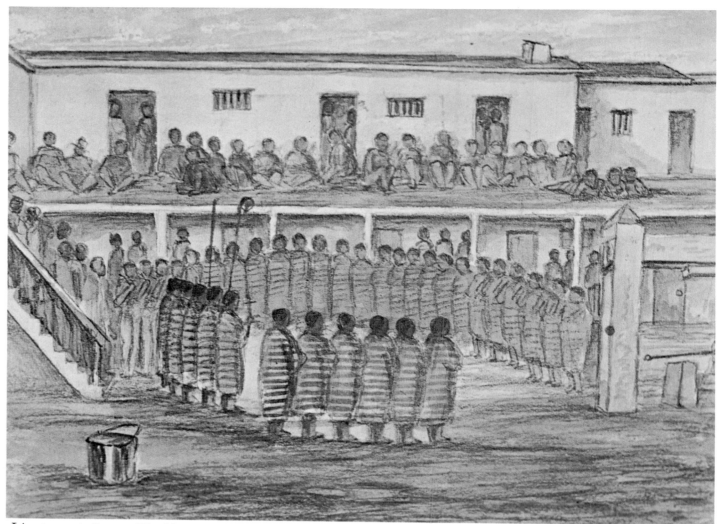

Lieutenant James W. Abert painted this dance of the Cheyenne Indians at Fort Bent, near what is now Pueblo, Colorado. They are celebrating a victory over their enemies, the hated Pawnee.

the friendship of God." Point founded his mission, Sacred Heart, on the western side of the Rockies, south of "New England," as Canada was designated on maps of the period. He accompanied his neophytes on their semiannual buffalo hunts, and recorded, from direct observation, their methods of stalking, attacking and trapping the bison. Trapping was resorted to exclusively by Indians who had no horses. Point describes a method by which posts were driven into the ground to form a triangular enclosure, with an opening at one apex. One Indian, disguised in a buffalo skin and horns, would lure the herd into the triangle, where the animals were slaughtered. Though Father Point deplores the Indians' addiction to gambling, he describes their sleight of hand games, lacrosse, the joyous spinning of tops on iced-over ponds, and their horse racing.

The visual and written records of the Western tribes during this period are particularly important from the historian's point of view, for the relocation of the Eastern tribes west of the Mississippi precipitated intertribal warfare and disrupted the complex social structure and traditions of indigenous tribal life.

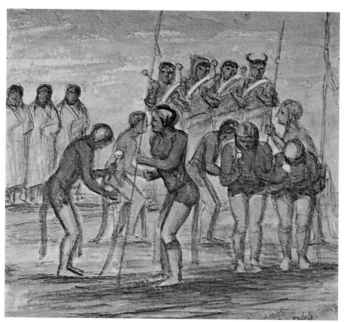

Women in most Indian dances merely shuffled. The men usually had more spectacular steps.

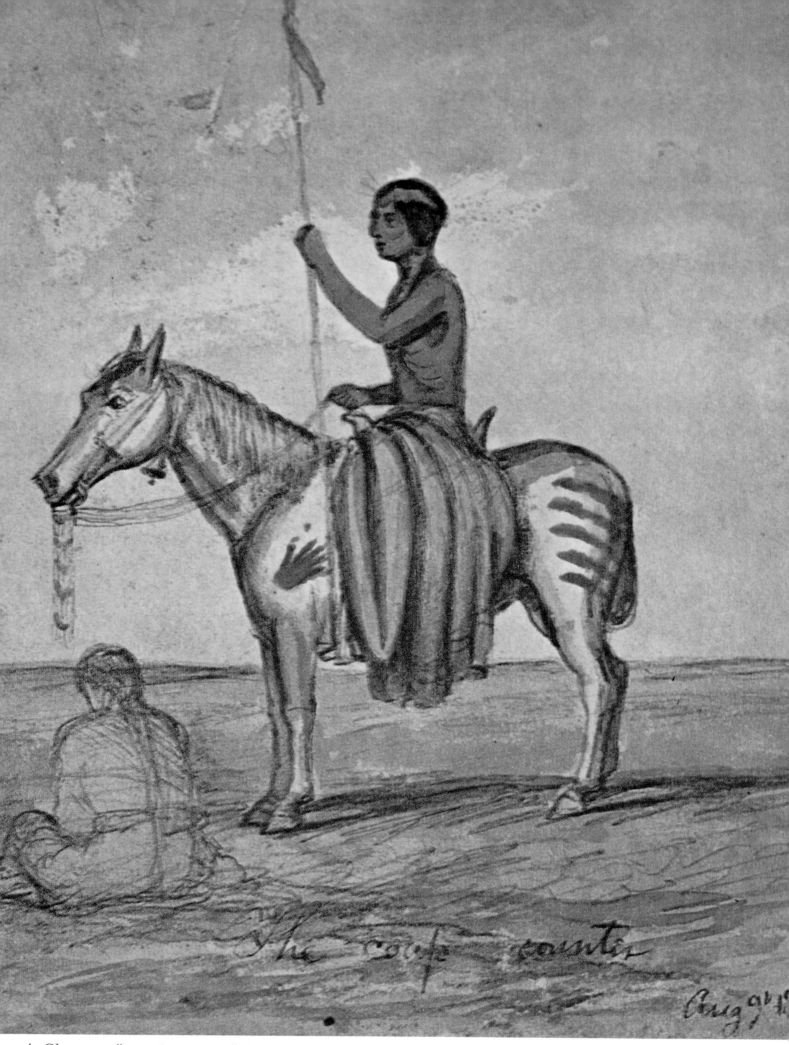

A Cheyenne "counting coups." In the words of Lieutenant J. W. Abert, the artist, "he rode off a few steps whilst the rest joined in the dance, giving the hero time to recall some other exploit."

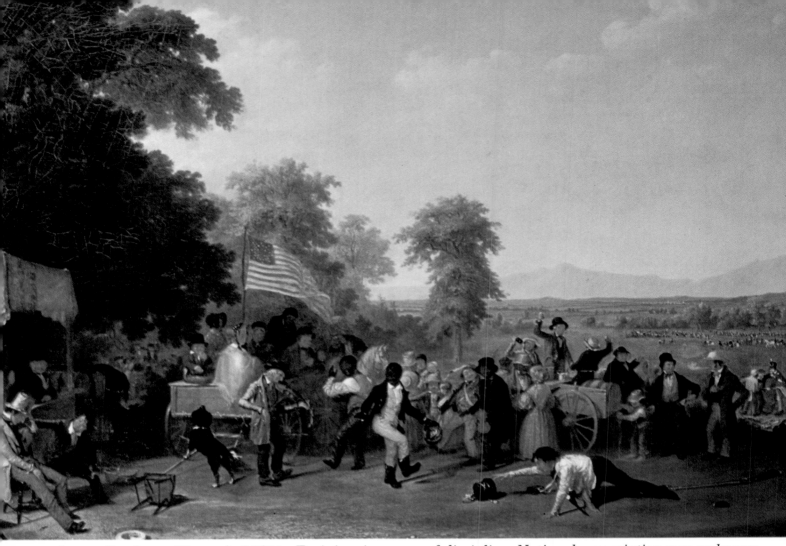

James Goodwyn Clonney's Militia Training *is a joyous satire on the state militia's notorious lack* *of discipline. National conscription was unknown in America previous to the Civil War.*

"Tippecanoe and Tyler Too!"

Much to the surprise of the Democrats, whose success in 1829 was based on broad appeal to the common man with a touch of rusticity thrown in, a disparate opposition party, the Whigs, outdid all precedent for demagoguery in the tub-thumping, stump-speaking, horn-tooting, cider-guzzling campaign of 1840.

The Whigs, who carried the day, had no platform. They filled the void with catchy phrases like "hard cider," and "log cabin." They shouted down the Democratic party's overtures to speak to the issues with jeers at the incumbent Van Buren — "little Van, a used-up man" — and raised their mesmerizing chant: "Tippecanoe and Tyler Too!" — sometimes shortened to "Tip and Ty." Their "Tippecanoe" was William Henry Harrison, a 67-year-old general whose reputation was based on his defeat of Tecumseh's warriors in that famous battle, followed by other military

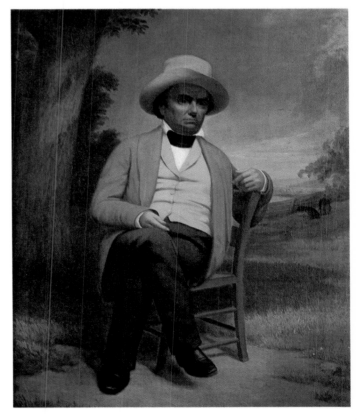

Daniel Webster, a stern-faced New Englander, was easily the greatest orator of his era.

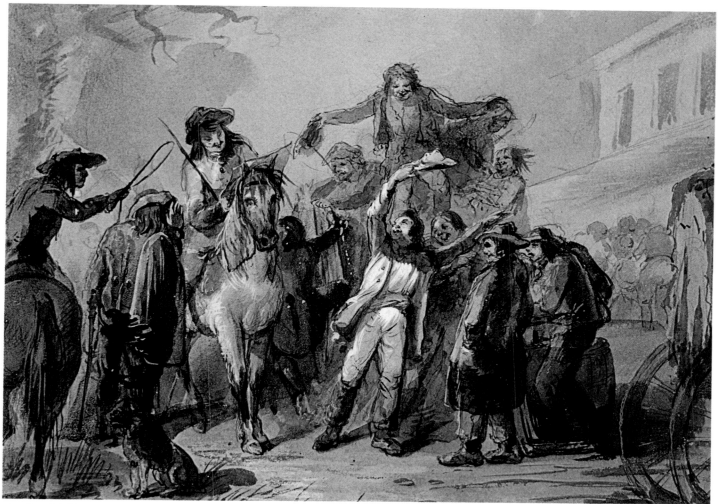

A. J. Miller's Election Scene at Catonsville *conveys the fervor of the national conventions held* *in Baltimore in mid-19th century by Whigs and Democrats. Catonsville is a Baltimore suburb.*

achievements during the War of 1812. He conformed to the specifications for the selection of presidential candidates which both parties seemed to have adopted: a nationally-known figure, preferably a military leader, with generally unclear opinions on controversial issues. Only ambiguity could keep a heterogeneous opposition party together long enough to win office.

Upon election Harrison was hounded by scores of office-seekers. He said their constant importunities would kill him, and perhaps they did. More directly his demise, only one month after inauguration, was ascribed to a cold he contracted while delivering a long, boring inauguration speech on the White House steps. Suddenly the public was set to wondering who "Tyler Too" was. It soon became apparent that their new President, John Tyler, an afterthought on the Whig ticket and a concession to the anti-tariff Southern constituencies, was an aloof Virginian who felt no particular party ties. "His Accidency" was formally expelled from the party by a Whig caucus. He ruined the plans of Daniel Webster and Henry Clay to run the government behind a presidential figurehead, the role for

which Harrison had been slated. As he used his veto time and again to block congressional legislation his entire Cabinet, except for Daniel Webster, resigned, and the House of Representatives tried vainly to impeach him.

In retrospect it may be easy to lament the extreme emotionalism and lowbrow tenor of politicking during and after the election of 1840, but it is also a fact that the new trend forced political parties to take the nation's pulse and follow its changing states attentively. By 1844 America's interests and political center of gravity were shifting westward. The Democrats chose a candidate who seemed likely to satisfy the desire for westward expansion: General James Polk. As the election returns indicated, most people thought Polk would fulfill America's "manifest destiny," which meant anything from taking over the entire continent of North America to merely extending the US frontier to the Pacific. The incumbent President Tyler read the election results as a mandate to annex Texas, which he did, just before stepping out of office. It remained for Polk to square that arrangement with Mexico. It was all over but the shooting, which soon began in earnest.

The Lone Star and the Bear

The acquisition of four western regions was necessary in order to extend the USA across the continent to the Pacific. Three of these regions, Texas, California, and the Arizona-New Mexico area connecting them, comprised the northern reaches of Mexico. The fourth, the Oregon Territory (which included Washington), was claimed by both the US and England.

Texas came first. After the Louisiana Purchase American pioneers began pushing west from Louisiana into the huge fertile Mexican northern frontier. It had been called *Techas* by the Caddo Indians of the area, a word meaning friends or allies. After their independence in 1820 the Mexicans welcomed Americans into the sparsely-settled region. Moses Austin, of Missouri, was given a grant of hundreds of thousands of acres of fertile farm and grazing land. His son, Stephen F. Austin, directed the colony of 20,000 settlers and 2,000 slaves.

Other Americans continued to trickle over the border without bothering to secure grants. The Mexicans paid little attention until the trickle became a steady stream. Among the migrants were Tennessee's former governor, Sam Houston, Davy Crockett, woodsman and politician, and James Bowie, with his deadly knife.

In 1830 the Mexican Government, observing that the American colonists were becoming too independent, changed the rules, giving them less autonomy. The Texans, as they called themselves, did not like it. They revolted, organized a small army and took San Antonio. Though these first Texans died at the Alamo, others regrouped, defeated the Mexicans and founded the independent Republic of Texas.

American leaders did not want trouble with Mexico, but they did want California, Arizona and New Mexico — and Texas was a bridge between that region and the USA. Texas was recognized. Andrew Jackson tried to buy California for $10 million; when he failed he suggested that Texas extend its territory in that direction.

England, meanwhile, was taking a real interest in these proceedings. If Mexico recognized Texas, the English hoped, it would keep that great land out of the Union. England was also afraid that if Texas joined the USA, California might come next, then the disputed territory of Oregon — and England's fears were justified. For ex-President Jackson assured presidential candidate Polk that he could win the election of 1844 with a platform of "all of Texas — all of Oregon." The voters agreed. Polk was elected, and after nine independent years the Lone Star State joined the Union. The boundary

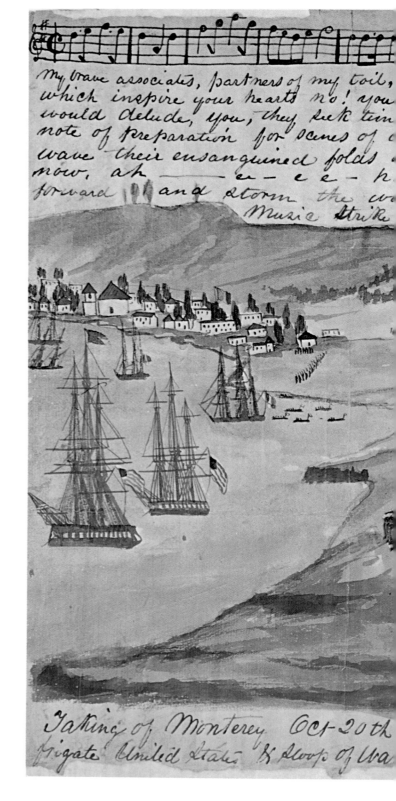

line between the USA and Canada was set and America took over the Oregon Territory.

In California the American settlers were becoming increasingly restless. Mexico insisted that California continue as a Mexican territory, but dreams of independence persisted. A group of settlers, who were called *osos*, or bears, by the Spanish, made a homemade flag with a grizzly bear facing a big red star over the words California Republic and a red stripe, all on a

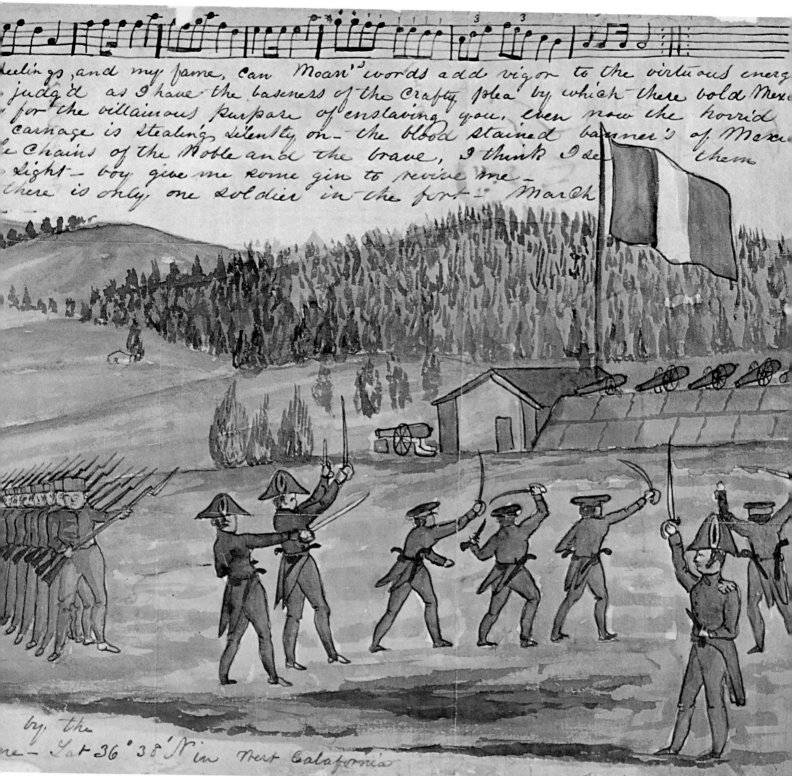

Commodore T.A.C. Jones of the US Navy taking Monterey, California in 1842. When he found out he was misinformed, and his country not at war with Mexico, he left with warm apologies.

field of white. Thirty-four strong, they rode into the sleepy village of Sonoma near San Francisco Bay and bloodlessly captured a small fort. The Mexican commander, after breaking out his own wine and brandy, agreed to surrender without further resistance; the Californians, in turn, promised not to seize any property or harm anyone. On July 4, 1846, they celebrated the independence of the Bear Flag Republic; the Declaration of Independence was read, followed by the Spanish fandango, general dancing, and gun salutes to the new republic.

Three US fighting ships arrived, Commodore Matthew Sloat in command, with momentous news: America and Mexico had been at war for almost two months. Commodore Sloat's forces occupied Monterey; Captain John C. Frémont, the California leader, secured San Francisco Bay. On July 9th, the Bear Flag was lowered and the flag of the United States raised.

While Californians were fighting independently for their freedom, three thousand miles to the east President Polk, as commander in chief, was deploying his forces in a four-point strategy to win the war against Mexico.

In the westernmost operation, General Stephen Watts Kearny was dispatched westward from Fort Leavenworth with 1,600 men and orders to take Santa Fe, then continue west to meet up with the naval squadron off California and consolidate the territory. A middle thrust was consigned to General John Ellis Wool who would push his attack south into north central Mexico. To the east of that movement, Polk selected "Old Rough and Ready" Zachary Taylor, hard-drinking, hard-talking, hard-fighting veteran of the Indian Wars, as his spearhead and battering ram. And on the eastern flank, aging but efficient General Winfield Scott commanded the amphibious forces which would invade Mexico from the Gulf of Mexico, attacking Tampico and Veracruz, then Mexico City.

Backing up this formidable array of generals were junior officers Ulysses S. Grant, Robert E. Lee, George B. McClellan, Thomas (later Stonewall) Jackson, George G. Meade and Jefferson Davis, in an important rehearsal for their later military exploits.

For 17 months, from April, 1846, until September, 1847, the battles raged throughout Mexico. The Mexican foot soldiers fought well and bravely, their cavalry magnificently. But Polk's four-point strategy steadily wore them down. Zachary Taylor handily won the first engagement at the Battle of Palo Alto on May 8, even before war was officially declared, and immediately pushed on to win the hard-fought Battle of Monterey.

While Polk's three armies were moving into Mexico, Kearny marched his men westward, pausing to take the Mexican capital at Santa Fe without firing a shot. Meeting up with Kit Carson, he learned of the naval landing in California and, taking the California trapper with him, hurried west. Deploying his men along the Santa Fe Trail, by the time they reached

General Zachary Taylor, center, with suspenders showing, was known as "Old Rough and Ready," *for being a bit casual in his military dress. The message is probably from President Polk.*

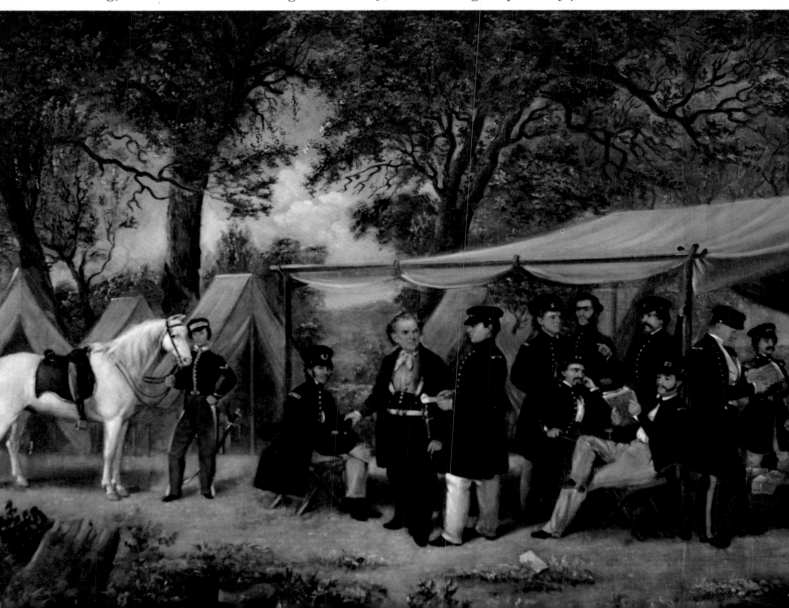

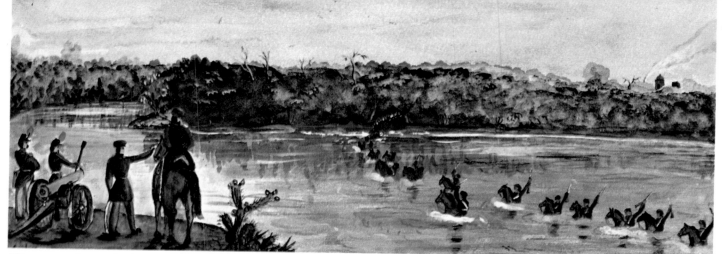

The crossing of the Rio Grande, soon after the first shots of the Mexican War had been fired.

Artillery stands ready to shell the Mexican shore in case of counterattack, but none came.

California, Kearny had only a hundred left. He nevertheless took them into battle, fighting a draw at San Pasqual, near San Diego, and winning the last battle at San Gabriel. California was secured, and the men Kearny left in New Mexico completed the conquest.

The war in Mexico ended with the final capitulation of the Mexican Army in Mexico City to General Winfield Scott. But it was Zachary Taylor who won the glory. He rode it to victory in the election of 1848 to continue his rough and ready ways as President of an expanded nation.

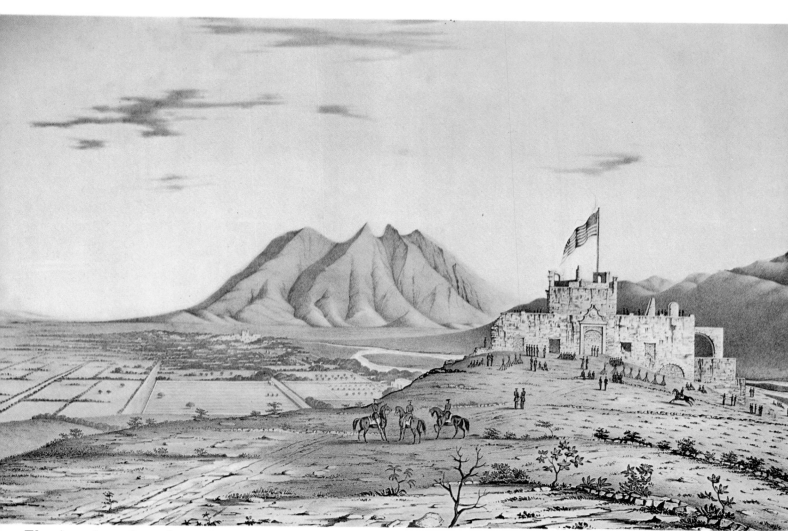

The American flag above the Mexican fortress of Monterrey. Victorious General Taylor soon moved on to take the fortress of Buena Vista. It made "Old Zack" a hero, and eventually President.

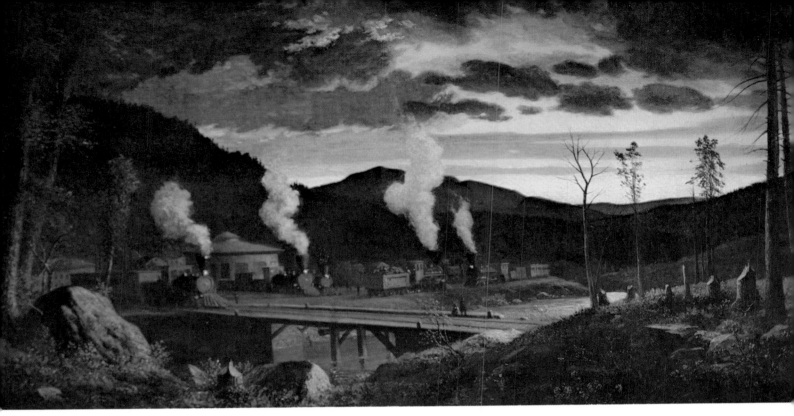

Thomas P. Rossiter, an American historical and Biblical painter who had studied in London and Europe, was obviously enthralled by this early railroad terminal: Opening the Wilderness.

The Romance of the Rails

For a long period the USA was a two-speed nation. Westward expansion was proceeding at one rate, further expansion in areas already settled at another. In the westward movement Conestoga wagons swayed, crunched and jolted overland, flatboats moved with the current of the Ohio. The slowest pace of all, but the surest, most comfortable and most popular, was the mile-and-a-half an hour rate of the horsedrawn boats on the Erie Canal. Tens of thousands of settlers went westward by means of that magnificent ditch, the largest engineering work completed by any government to that time. Freight, livestock and passengers could proceed the length of its 363 miles in ten days. And so reasonable was the cost that, in shipping goods from Philadelphia to Pittsburgh, it was cheaper to go via New York and Buffalo than direct. The canny Pennsylvanians got the message and built their own canal system.

But as many Americans inched westward, others, established in cities and communities of the East, began showing that dominant American characteristic, the desire to get places in a hurry. For now they had the means to do it, the steam locomotive running on rails of iron. The American love affair with the railroad began around 1830 and intensified with locomotive speed. There was the *Best Friend* of Charleston, the *DeWitt Clinton* out of Albany, *John Bull* at Camden, *Old Ironsides* at Philadelphia, the *Pontchartrain* at New Orleans, all by 1832. Existing lines grew longer — Charleston was connected to Hamburg, 136 miles away, by 1833 — but most of the growth was in purely local service between nearby towns. A passenger could get to Buffalo from New York in 1840, but with many changes. By that time there were 2,800 miles of railroad in the USA. Over the tracks chugged wood-burning engines with their balloon-like smokestacks, huge and powerful and beautiful. A major event of the day, then and for many years to come, was to watch the train go by.

The railroad, Daniel Webster said in 1847, "towers above all other inventions." Four years later, in his 70th year, the venerable statesman was as happy as a kid when he rode the inaugural train of the world's longest railroad, from the west bank of the Hudson above New York to the shores of Lake Erie. President Fillmore and other dignitaries made the trip, too, but in the regular coach. Webster would have no part of that — he wanted to see the countryside. The railroaders were happy to oblige, coupling a flatcar to the end of the train and securing a rocking chair to the floor. At one stretch the powerful engine pulled the train at speeds of a mile a minute, and when it reached Lake Erie the following afternoon cannons were fired. It was not just business, not just transportation, not even the extension of empire, but thrilling, exciting, exhilarating adventure. And Americans were going to have a lot more of it for many generations to come.

1848-1861
FROM SEA
TO SHINING SEA

Victory in the Mexican-American War adds the territories of California, New Mexico, and Utah to the growing country. The gold rush stimulates a population movement westward. But as new territories are annexed, the precarious balance between slave and free states is upset, resulting in national dissension, violence, and the possible dissolution of the Union. The Compromise of 1850 holds the country together temporarily. Perry opens commerce with Japan.

HISTORICAL CHRONOLOGY	ART CHRONOLOGY
1848 *War with Mexico ends. Brigham Young reaches Utah with Mormon settlers. Gold discovered at Sutter's Mill in California. Women's rights convention in Seneca, New York, declares "all men and women are created equal."*	*1848* *American Art Union founded, counts over 5,000 subscribers in 2 years, sponsors annual exhibits.* *"Oh! Susanna," first of many popular songs written by Stephen C. Foster, is published.*
1849 *Zachary Taylor, hero of Mexican War, becomes President.*	*1849* *Civil Disobedience written by H. D. Thoreau.* *The California and Oregon Trail written by Francis Parkman.*
1850 *California is admitted into the Union as a free state, under the Compromise of 1850. President Taylor dies and is succeeded by Vice President Millard Fillmore.*	*1850* *Harper's Magazine founded.* *Hawthorne's Scarlet Letter published.* *Jenny Lind, the soprano "Swedish Nightingale," begins American career with impresario P. T. Barnum.*
1853 *Mexico sells southern Arizona and New Mexico to U.S. for $10 million (Gadsden Purchase).*	*1851* *New York Daily Times founded, becomes New York Times six years later.* *Moby Dick written by Herman Melville.*
1854 *"New" Republican Party formed, opposed to any extension of slavery. Commodore Matthew C. Perry opens trade relations with Japan.*	*1852* *Harriet Beecher Stowe publishes Uncle Tom's Cabin or Life Among the Lowly.*
1855-56 *Violent disorders in Kansas between pro- and anti-slavery groups.*	*1853* *Crystal Palace in New York City opened to show American industrial inventions.*
1857 *Dred Scott Decision by Supreme Court.*	*1855* *Walt Whitman's Leaves of Grass published.* *Longfellow writes Song of Hiawatha.*
1858 *President Buchanan communicates with Queen Victoria via the first transatlantic cable.* *Lincoln and Douglas debate the slavery issue.*	*1857* *First Currier and Ives lithographs.* *The Atlantic Monthly founded.*
1859 *John Brown leads abortive slave uprising.*	*1860* *Emerson's essay The Conduct of Life written.*
1860 *Pony Express inaugurates 10 day mail service between Missouri and California. Abraham Lincoln is elected President.*	

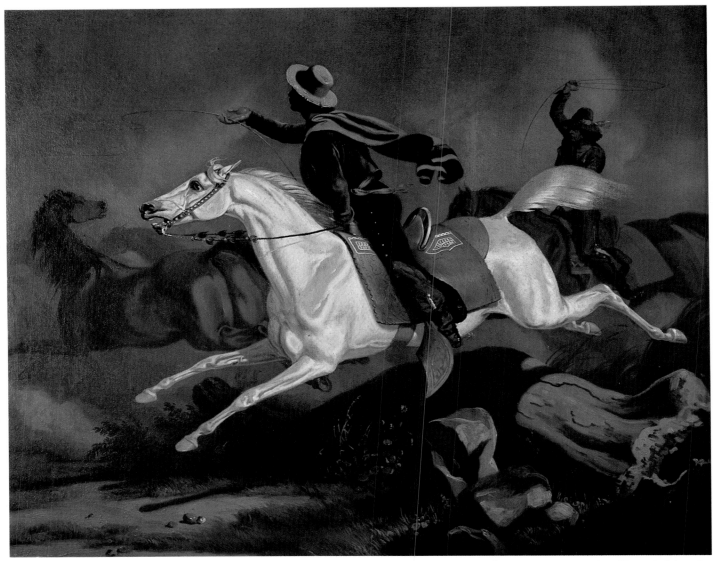

Vaqueros ("vaca" means cow in Spanish), the West's first cowboys, were skilled horsemen.

California, Here We Come

The restless years between 1848 and 1861 brought a burst of territorial growth. The citizens of the germinating nation were too impatient to stop and consolidate their gains. President James K. Polk, the Congress and the people had begun to experience the freedom of living in an ever-expanding country and were intent upon occupying the entire continent including Mexico, Canada and even Cuba.

The catch phrase "Manifest Destiny," which had been used so successfully as a slogan during the annexation of Texas, and was equally useful in mustering support for the war with Mexico, continued to be persuasive. By 1849 a high percentage of citizens firmly believed that the United States had God's sanction for unlimited territorial increase.

First the Whig Party and then the Republican Party adopted this conviction. Only the foresight of a small group of congressmen, President Polk and a number of citizens who had lost their taste for war, prevented the United States from annexing all of Mexico. Canada was not considered worth an all out war with Great Britain, so the government happily settled for California and the territories of New Mexico and Utah. These new territories — plus the addition of northwest regions which had been disputed with Great Britain — were prize enough. After all, the Continental United States, in less than a hundred years, had been developed from the 13 eastern colonies to a country larger than all of Europe — and with a population speaking the same language. It was the largest national territorial expansion in history.

The time had come to pause and allow the rapidly growing population to reap the benefits of the lands won by the pioneers. But one more

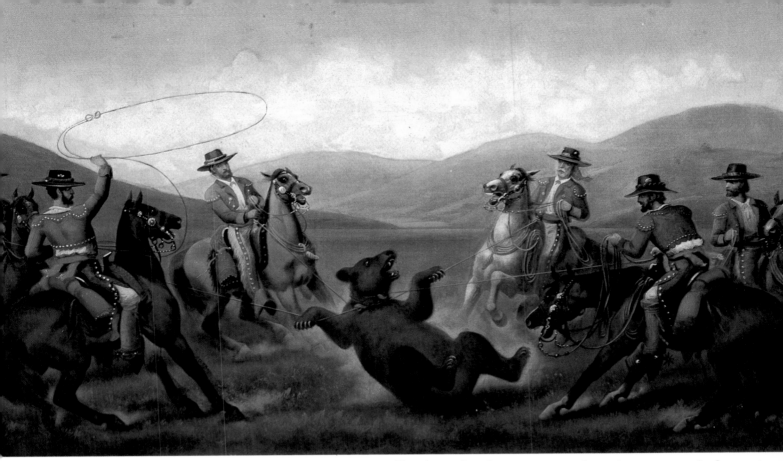

Roping the bear was a favorite sport of the danger loving Mexican Dons of early California.

expansionist venture almost took root. The annexation of Cuba, through war with Spain, was seriously considered in 1850. Why not? The earlier territorial schemes of Aaron Burr, Andrew Jackson, James Long and Sam Houston were now a reality. Again, cooler heads in Congress prevailed. The end of the Mexican War on February 2, 1848, with the treaty of Guadalupe Hidalgo, put a period, at least temporarily, to further plans for immediate expansion. Out of a feeling of guilt the United States paid Mexico $15 million — and everyone felt better. Six years later the United States paid Mexico $10 million for 29,640 square miles of land south of the Gila River, most of which was later incorporated into the state of Arizona.

Exactly what did the US get out of the peace terms with Mexico? The total territory included California, Nevada, Utah, New Mexico and Arizona — most of what we know as the West and the Southwest.

When Arizona was admitted as the 48th state in 1912 it took in 113,909 square miles. It included the awesome Grand Canyon, the colorful Painted Desert, the ever-flowing Colorado River, the Petrified Forest, endless fertile river bottoms and the great Arizona Desert, belying a report to Congress made after the purchase from Mexico. "The region is altogether valueless. After entering it there is nothing to do but leave." Later settlers in the territory found the warm dry climate salubrious

and farming and ranching a prosperous pursuit.

New Mexico offered even more territory than Arizona — 121,666 miles of spectacular countryside that offered mountains, valleys and deserts as well as the oldest Spanish civilization in the United States. Many of the Spanish citizens stayed on at the capital in Santa Fe to add their ancient culture to the newcomers.

California was, however, the magnet that brought pioneers, many of whom settled on the way to the West. At this time it was the second largest of all the states (Texas was first) and had its publicists as early as 1840 when John Marsh wrote to friends in the East greatly praising the fertile land and benign climate — and adding that it would not be too difficult to reach California. This resulted in the first organized group, the Bidwell-Bartelson party of settlers, to cross the Rockies.

Its harbors from San Diego to San Francisco could take hundreds of ships. Its mountains contained the highest in the US, Mount Whitney, at the time it was admitted as the 31st state in 1850. It also boasts the lowest point in the U.S. In the days before the war with Mexico, elk, deer and antelope were plentiful. Fortunes were made by trapping the beaver. Its enormous virgin stands of timber included redwood, giant Sequoia, pine, cedar, fir, aspen and hemlock.

Now all of this new territory was waiting for settlers. All that was needed was a good reason for skeptical eastern farmers, confined factory

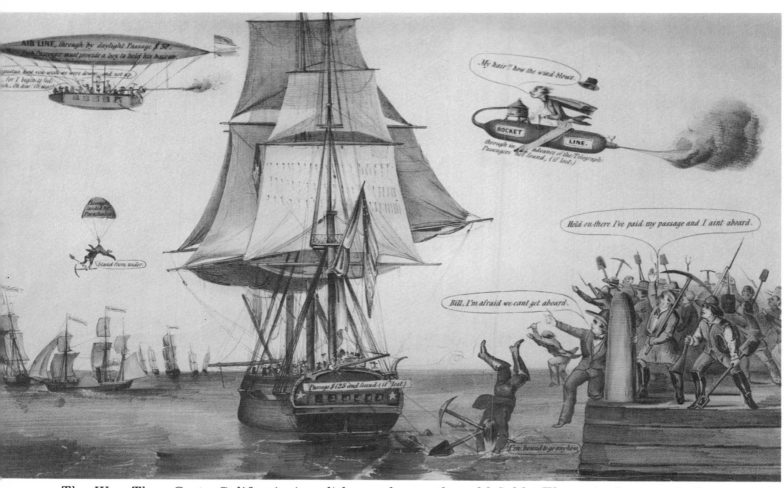

The Way They Go to California *is a lithograph caricaturing Easterners' burning desire to reach* the gold fields. The artist foresaw the later use of rockets, balloons, and parachutes.

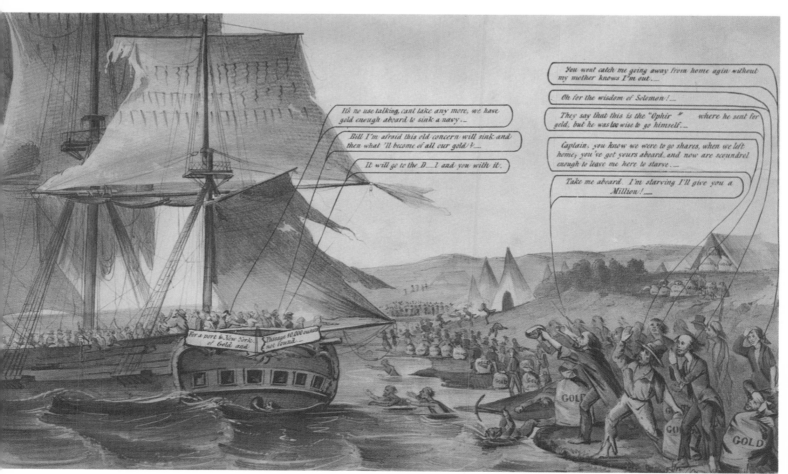

The Way They Come from California, *another caricature, discloses the haste of gold seekers to* return home. Few found gold, and living costs were prohibitive for those who did.

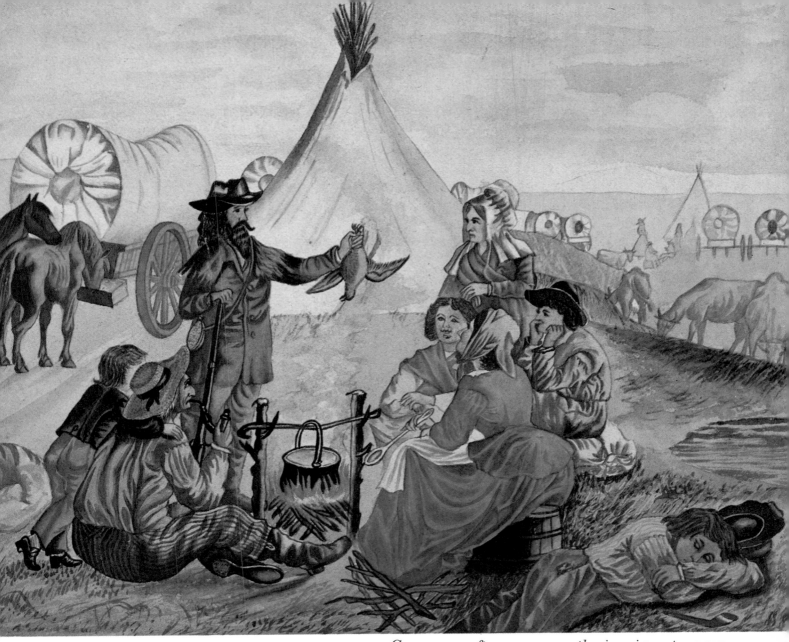

Game was often scarce as the immigrant wagon trains followed each other across the prairies.

workers or poor southern gentlemen to pack their belongings and move west.

Just nine days before the war with Mexico ended, James Wilson Marshall, a 38-year-old wheelmaker, was building a sawmill for John Sutter, located 48 miles north of Sutter's Fort. There he found some small pieces of gold and reported it to Sutter. They planned to have subsequent miners pay a fee to mine in the area. But the newcomers took the position that there was no Mexican law and no American law forbidding them to prospect for gold where they wished. They dug where they pleased.

At first the gold rush was only a trickle. Because the news of the strike traveled east slowly, it was nearly a year before President Polk officially confirmed the discovery and Easterners started West to prospect. Before then, only small groups of Mexicans had worked their way up to California and staked claims around the town that later became Sonoma. And several

ships of settlers had arrived from Hawaii; in those days of sailing vessels, California was a lot closer to the Islands than the East Coast.

The rush began in earnest in the spring of 1849. The population of the United States was on the move again, but this was nothing new — citizens of the 70-year-young United States had always been on the move! Now they streamed into the gold country by the thousands. California's population rose in two years from an estimated 15,000 to more than 75,000. Four years after the discovery of gold a special census disclosed that the population had swollen to 223,856. At least 80 percent of these new Californians came from other parts of the United States. The rest migrated from Europe, Australia and Asia.

Not all the people who started out for California arrived there. Many found the farmland they had been looking for along the overland route. There were almost as many non-gold seekers moving slowly west as those

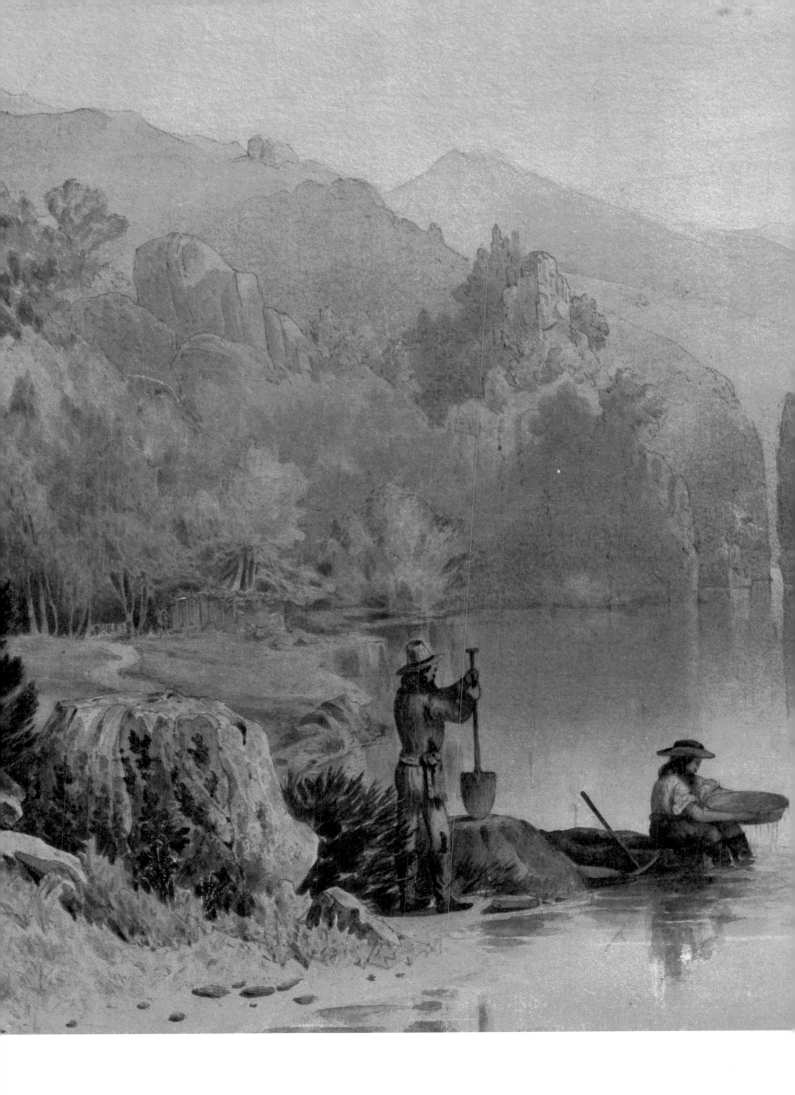

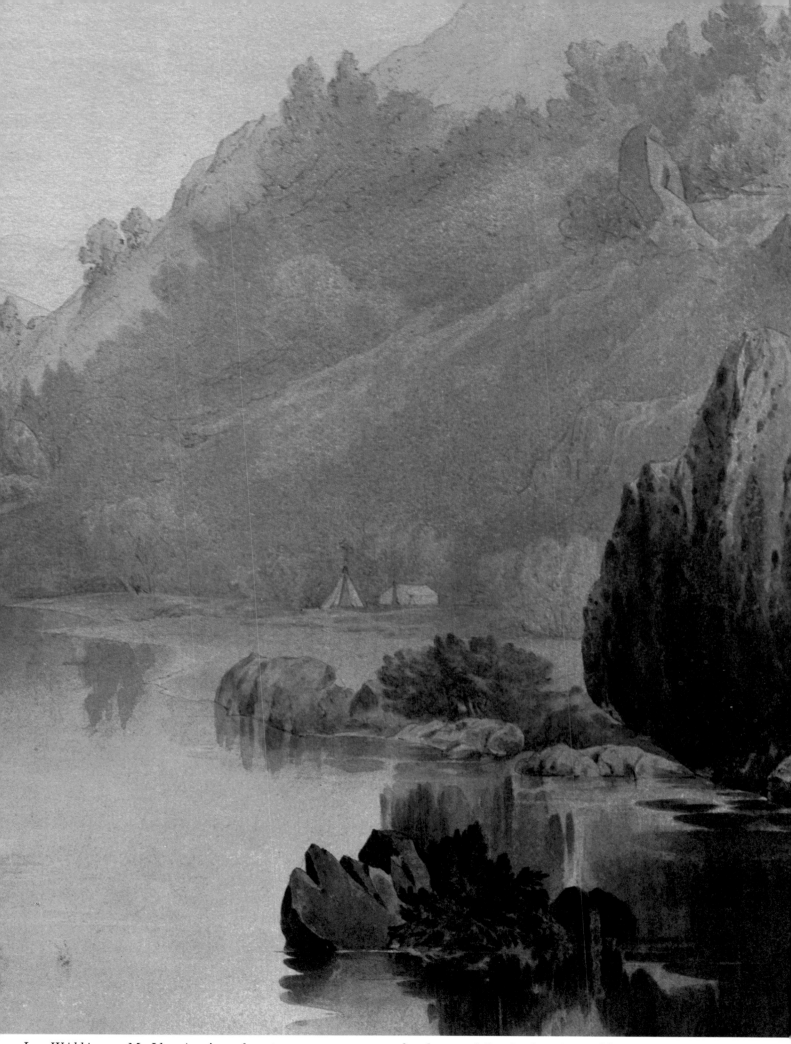

In William _McIlvaine_'s glowing sunset watercolor, one miner rotates pan swishing out the dross while the heavier gold particles remain, and his partner looks on.

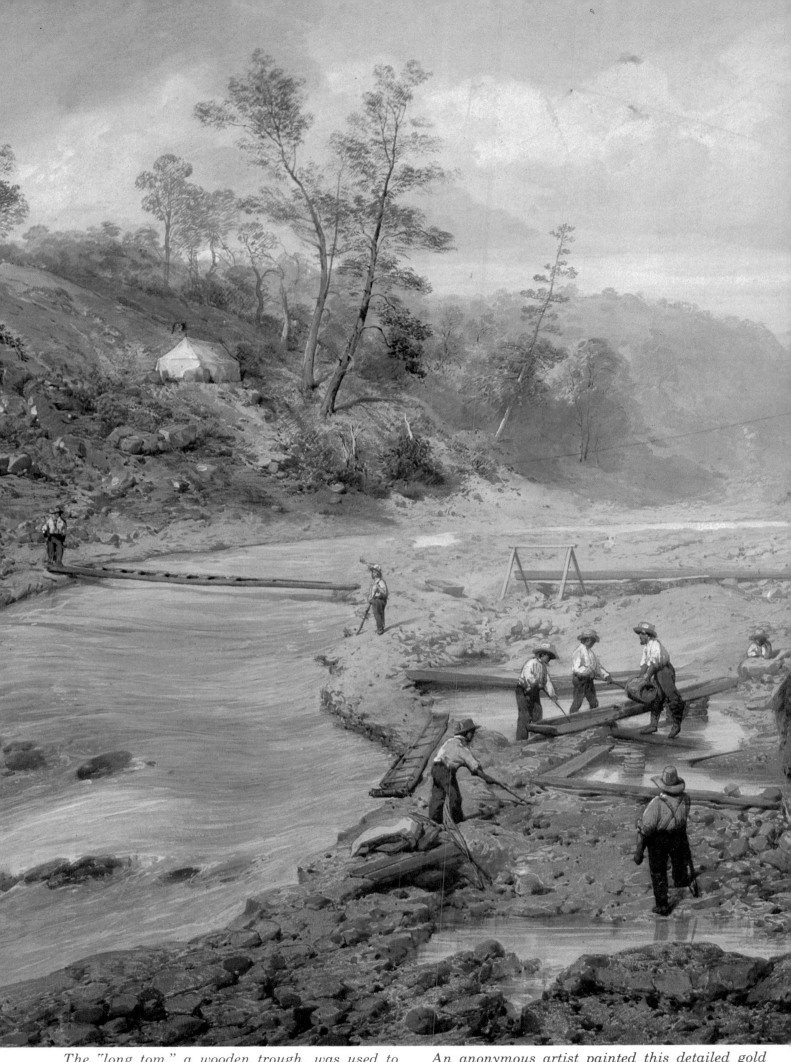

The "long tom," a wooden trough, was used to sluice away sand, leaving only the gold deposits.

An anonymous artist painted this detailed gold rush scene in Calaveras County, California.

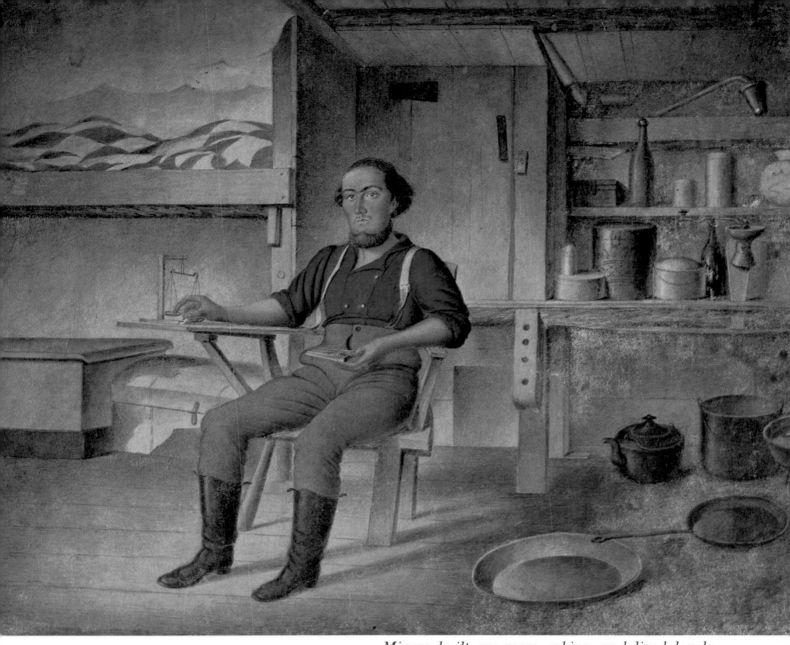

Miners built one-room cabins, and lived lonely, tenacious lives panning for gold.

after a quick fortune. These were the descendants of the men and women who had crossed the Atlantic risking the dangers of the New World. Forming settlements, they had moved up the Virginia coast and down the Massachusetts coast, inland to the Alleghenies and the Great Lakes and south into Louisiana. After crossing the Mississippi, many of these pioneers, gold rush or no gold rush, kept right on going. They were a people born and bred in motion who continued their locomotion. They believed the land they traveled belonged to them. They had little or no feeling about moving the previous settlers, the Indians, out. They were tenacious and became immovable.

In the early days of western expansion the Indians, whether nomadic or settled, were not always opposed to sharing their land with the newcomers. It was not until the newcomers became plentiful, the game began to thin out and the buffalo herds were decimated, that the Western Indians began to see their food supply dwindle and the land, that they had moved across freely, fenced. So there were few Indian uprisings during the late '40s and early '50s. This is understandable if one keeps in mind that the Indian's view of life was pantheistic. Reality was related to the supernatural. His beliefs were in the things that were both tangible and intangible. The land that was to be overrun, plowed up and later fenced, was to him a part not only of his day to day living but a part of his spiritual existence. Neither the early settlers nor the later ones understood the deep realistic yet spiritualistic relationship of the Indian to his surroundings. The trees, the grass, the animals, even the rocks, were essential parts of his daily existence and his future spiritual sustenance. Therefore, as long as the pioneers were moving through the lands, neither changing nor occupying them to any large extent, the Indians had no quarrel with them.

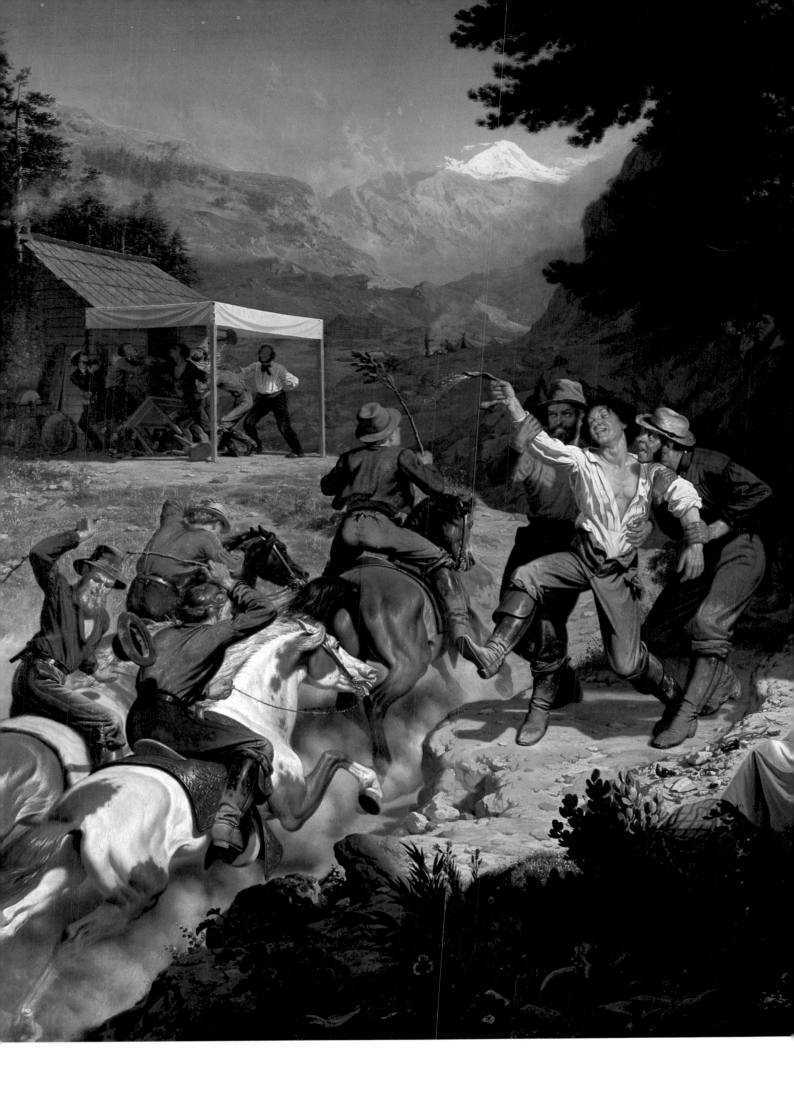

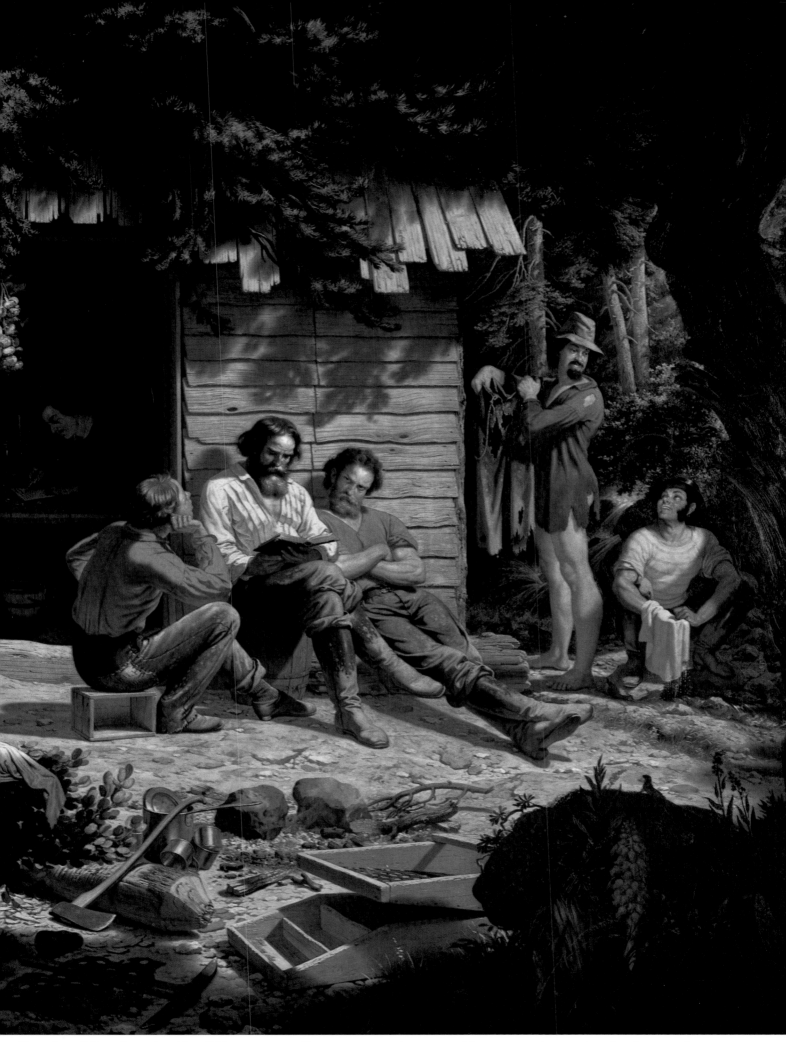

Sunday Morning in the Mines, *an allegory, shows evil on the left, good on the right. The* cigar smoking man in center background may *represent the <u>artist, Charles Nahl</u>.*

171

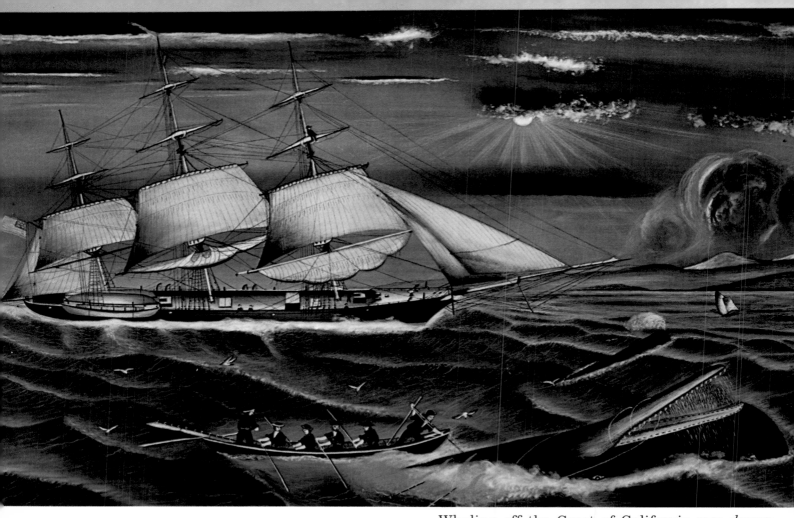

Whaling off the Coast of California was drawn by the ship's mate of the Joseph Grinnel.

The Fastest Way West

The Isthmus of Panama was the route taken by many easterners in a hurry to reach the mines before all the gold was exhausted. When the news first arrived in the East, a few ships had already set out for California, sailing around Cape Horn and stopping on the West Coast of Panama enroute. Hurriedly, hundreds of anxious gold seekers took whatever shipping they could find to the port of Chagres on the eastern side of Panama, then made their way across the Isthmus, first by small uncomfortable, crowded local steamers, then by Indian hand-built rafts called *bungas*. After moving as far as they could by water, they had to switch to muleback through the jungle to Panama City. The first post gold rush ship around the Horn was *The California,* which arrived late in Panama because it stopped in Peru, where a group of Peruvians, who had somehow heard of the gold find, were taken aboard. At Panama City, the shipmaster found some 1500 men camped out on

Master craftsman Donald McKay was the world's most famous designer of fast sailing clipper ships.

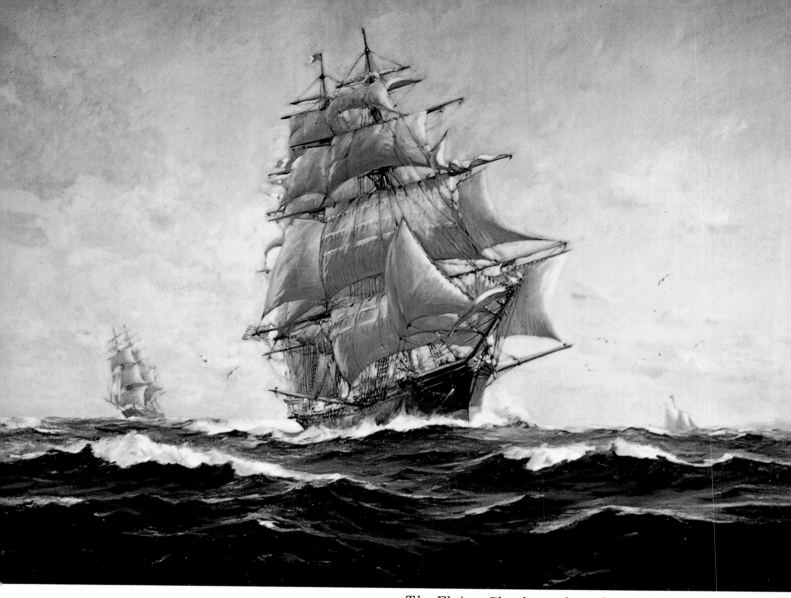

The Flying Cloud *was launched in 1851. She set two world records during the gold rush.*

the beach waiting for him and ready to riot. Most of them had to wait for later ships. Nevertheless 400 were crowded aboard *The California* which had a normal complement of 200. Food and water were rationed and many passengers were taken ill. *The California* had the dubious honor of being the first to arrive with its half-starved, scurvy-ridden passengers. A few weeks later, *The Oregon,* which had picked up passengers at Panama, and later *The Panama,* the third of the Pacific mail ships, arrived.

Clearly old side-wheeler ships like these would not meet the need to get to California fast. A voyage around the Horn in a bark or brigantine — even a primitive steamship — averaged just over five months, and could take as long as eight in bad weather. The lure of gold called for faster ships, which meant more voyages per year, and more profits for their owners.

And so Yankee ingenuity evolved a lean, graceful, streamlined sailing vessel whose rakish concave bow parted the seas like a pair of clippers, and whose sails bent to wide spars on

tall masts, could drive her at speeds of 20 knots. The clippers cut the New York to Frisco passage to just over 100 days. In 1851 the *Flying Cloud* set a record of 89 days, and established her designer, Donald McKay of Boston, as America's foremost shipbuilder. His busy yard launched 32 clippers, many of which set sailing records that last to this day. His *John Baines* sailed from Boston to Liverpool in 12 days, and his *Champion of the Seas* logged 465 nautical miles in 24 hours. One round-trip voyage west often paid more than the cost of the clipper.

These noble ships enjoyed only ten years of glory. But during that decade they were the symbol of the pride of the young nation and the envy of their foreign competitors. The first of them, the *Rainbow,* was designed and built by John W. Griffiths in 1845. The *Great Republic,* launched in 1853, was at that time the largest sailing ship in the world. The clippers did not die out because speed to the gold fields was no longer a prime objective in the mid-1850's; they lost out to newer steam powered ships.

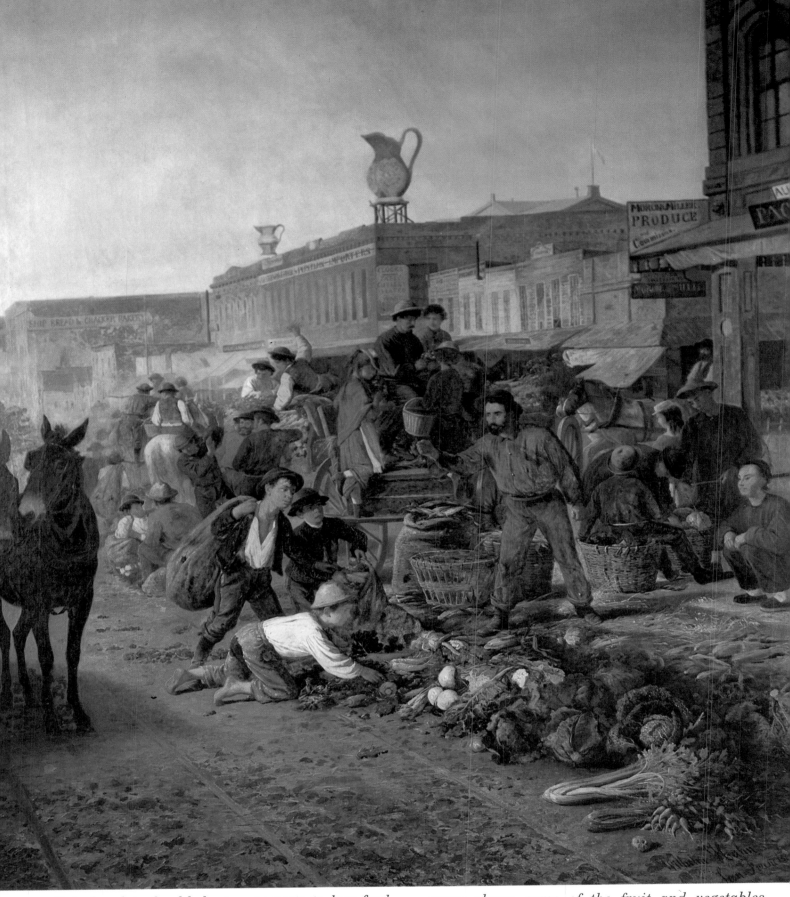

It took a lot of gold dust or nuggets to buy food in booming, _overcrowded San Francisco_. This scene shows some of the fruit and vegetables offered at the open air Sansome Street Market.

San Francisco
Boom Town

When gold was discovered at Sutter's Mill in 1848, the population of San Francisco was reported to have dropped from 820 to seven. Everyone rushed to the American River about 100 miles northeast of the city. Hundreds of ships were abandoned by their crews in the middle of San Francisco Bay. The exodus was short-lived, however, for a multitude of people swarmed to the gold mining area, an estimated 40,000 by 1849. San Francisco became the port and distribution center for food, clothing, hardware and liquor. Newcomers and old residents rushed into the city to provide services for the burgeoning prospecting population. Some of the hulks of the abandoned ships were beached and converted into hotels, stores and saloons; others were used as floating warehouses.

Theaters, night clubs and business establishments began transforming the mining town of shacks and tents into a city. In 1852, Adams & Company's San Francisco branch office was sending as much as $600,000 in gold dust and nuggets in a single New York shipment. In keeping with their thriving affairs, the company began construction of a magnificent new bank building. They used imported stones from China, and when the Chinese laborers, who were hired to sort out and lay the stones, struck for higher wages, the Asians knew they held the ultimate trump card: no one else could read the Chinese descriptions on the granite blocks indicating where they were to be placed! The strike was quickly settled to the workers' satisfaction. But more serious financial problems soon plagued officers of the Adams & Company's western branch, and they were forced to cede the newly completed, sumptuous stone structure to their rivals, Messrs. Wells and Fargo.

Thereafter Wells Fargo & Company monopolized banking and transportation in the West. They used horses, mules and even sleighs drawn by dogs to deliver the mail in the mountainous mining areas. They used a steamboat to transport goods and mail between Sacramento and San Francisco. Gradually the company converted to rail transportation, but until late in the century, they continued to use stagecoaches in the High Sierras.

San Francisco grew up unplanned, lawless, a prey to incessant fires that left whole quarters of the city in ashes. When Wells Fargo took over the Adams & Company offices, they came up with the most reassuring advertising campaign imaginable: "Offices in Sam Brannan's new fireproof block, Montgomery Street . . ."

In 1846 Sam Brannan had sailed into San Francisco Bay with a following of 200 Latter Day Saints. Brannan brought with him a printing press on which he rolled out the *California Star,* the first California newspaper. He was one of the first people to find out about James Marshall's discovery of gold, and he staked out a claim calling it Mormon Island and settled his followers there to work it.

As church elder, Brannan exacted the traditional tithe from his workers, and when they asked the civil authorities whether he had a right to take their money, the answer was yes, if the workers were fools enough to give it to him. When Mormon leader, Brigham Young, back in Utah, heard about Brannan's doings, he sent messengers and then gunmen to recover the tithe money. But for every one of Young's "destroying angels," Brannan found an "exterminator" to meet him on the desert. Young struck back by excommunicating the recalcitrant Brannan.

Brannan then embarked on a career in financing and land development that soon made him one of the richest men in the country By 1855 he owned about one-fifth of San Francisco and one-fourth of Sacramento. To clear the city of robbers and cutthroats, he instigated the first vigilance committee in 1851, and backed the second in 1856.

Author Bret Harte arrived in San Francisco in 1857, drove for the Wells Fargo Express for a time, edited the *Overland Monthly,* and after the war, took young reporter Samuel Clemens (Mark Twain) under his wing and, according to Twain, taught him to write "paragraphs and chapters that have found a certain favor in the eyes of even some of the very decentest people in the world."

Twain poked around in the gold mining area of Calaveras County, and came upon the richest vein of humor Americans had ever known. An old-timer told him a story about a race between two frogs. Twain wrote it down, called it *The Notorious Jumping Frog of Calaveras County, and Other Sketches,* and a New York publisher offered him $100,000 outright for the story. But Twain turned him down, and wisely held out for royalties. The story has become a classic, and sells well even today.

All in all, San Francisco, a rich admixture of crime, culture and cataclysms (fires, earthquakes, and sudden monetary booms and busts) was a fast-growing cosmopolitan city. It was favored with a mild year-round climate and an exceptionally well-sheltered harbor. Thanks to the gold fields and the nearby silver mines of Nevada (discovered in 1859), the city by the Golden Gate had already claimed hegemony in the West in the mid 1800's.

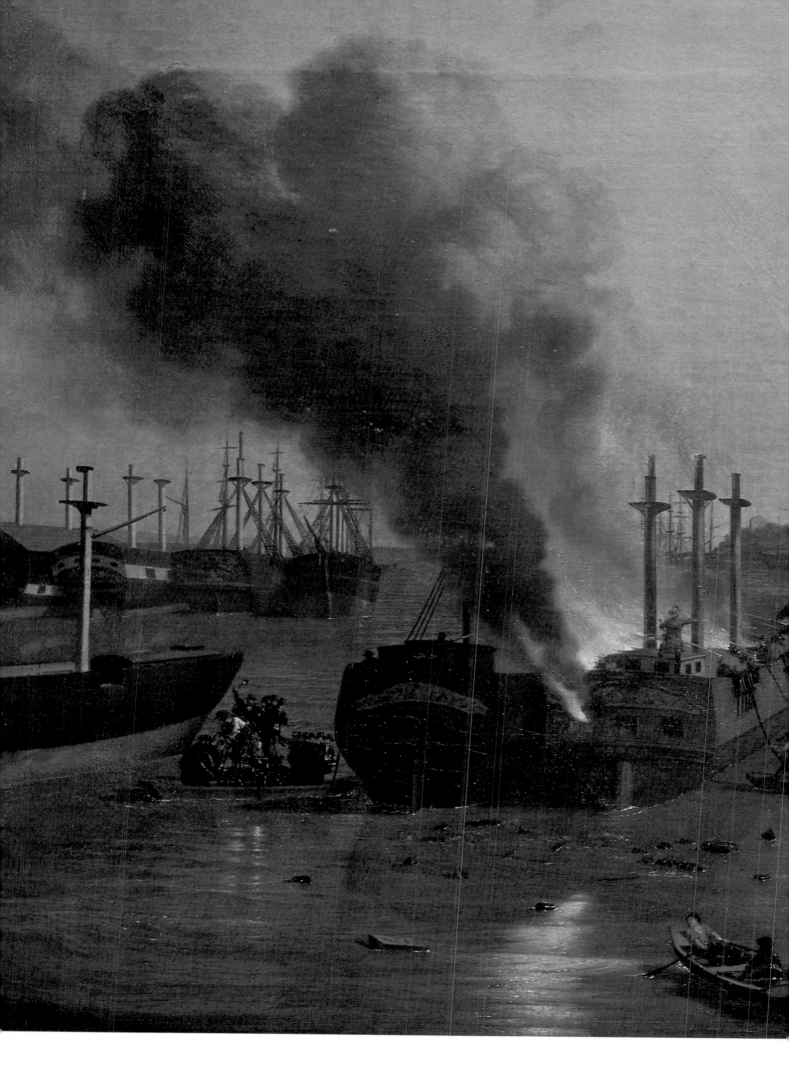

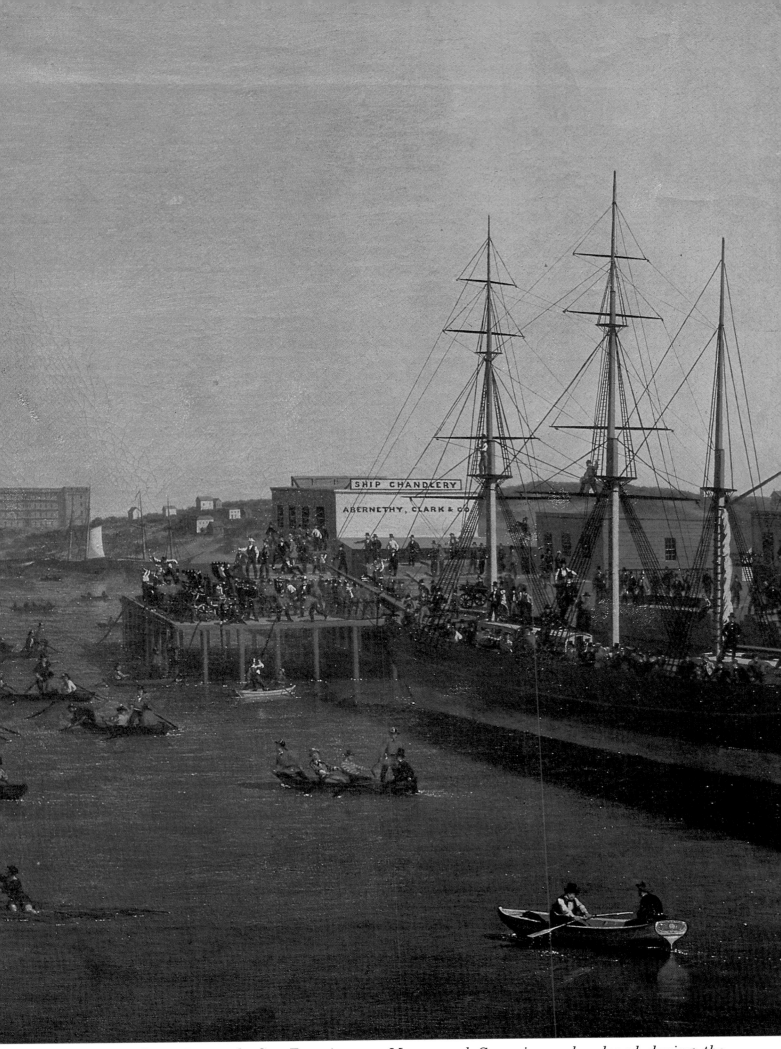

SHIP CHANDLERY

ABERNETHY, CLARK & CO

A spectacular conflagration on the San Francisco waterfront in 1853 was caused when the ships

Manco *and* Canonicus, *abandoned during the gold rush and used for storage, caught fire.*

Painters of the
Western Scene

The history of 19th-century America is the saga of an ever expanding and changing western frontier that was difficult to locate at any one time. It swept unevenly westward according to topography and shifted with each passing decade. Whereas some settlers remained in populous urban regions, others continued westward as civilization pushed the frontier further west.

Daniel Boone's father, for instance, found Pennsylvania too crowded by 1750, so he moved his family to the wilds of North Carolina. By the time the Revolutionary War broke out, the

Boones had pushed into the uncharted Kentucky woods. Before the end of the century, because Kentucky no longer gave Daniel Boone enough "elbowroom," he moved his family to Missouri, the new frontier.

Wherever it was, the frontier evoked certain constants: excitement, exoticism, danger, gold mining and of course the presence of Indians. Charles Nahl and William McIlvaine went West with the gold miners. The latter's *Sketches of Scenery and Notes of Personal Adventure in California and Mexico,* as well as his paintings, are among the most important records of the gold rush. There were other painters, some amateurs, who remained anonymous, and painted the passing scene in styles ranging from primitive through realistic to romantic. In these early paintings are reflected the life-styles of Mexican

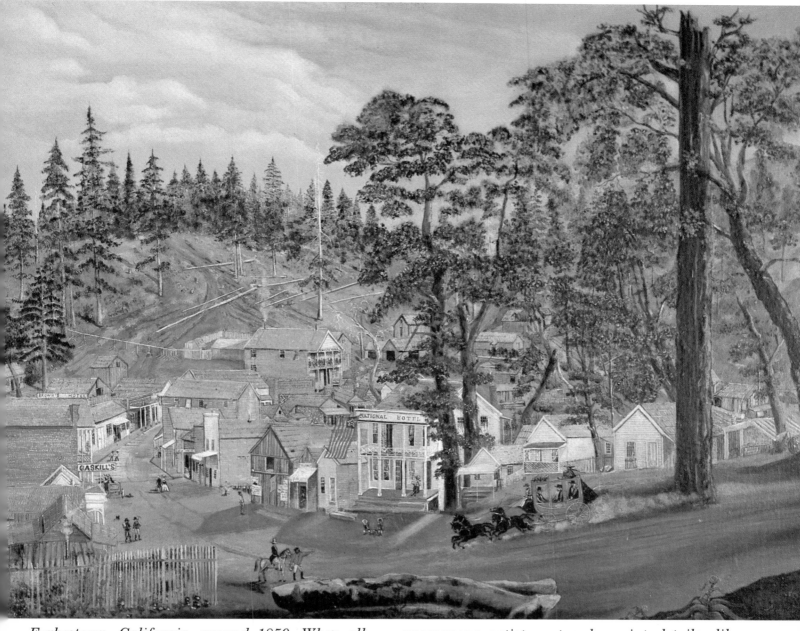

Forbestown, California, around 1850. When all gold was mined out, it became a ghost town. The anonymous artist captured quaint details, like the Indian onlookers peering over fence.

Dons, vaqueros and Indians. Many of the best paintings of Indian life during the first half of the century were by George Catlin, Karl Bodmer and Seth Eastman.

Catlin (several examples of whose work we have seen previously) was in his mid-thirties before he found his vocation. Born on a Pennsylvania farm, he made good as a lawyer in Philadelphia, and he was skilled enough at painting portraits to be allowed to paint President Madison's wife. But when he saw a delegation of Indians passing through Philadelphia on their way east to Washington, he was struck by the "silent and stoic dignity" of those "lords of the forest," and he decided to devote his life to portraying Indians in the wilderness of North America.

In 1832 Catlin made his first trip up the Missouri to live among the Plains Indians and paint them in their natural surroundings. The word catlinite, the technical term for Minnesota pipestone, is derived from his name and honors him as the first white man to see the Dakota Indians' sacred quarry of red rock.

In 1837 Catlin opened an art gallery in New York where he displayed 494 paintings of Plains, Woodlands and Southeastern Indians.

Catlin was a writer and lecturer as well as a painter. He wrote and illustrated *The Breath of Life*, a curious book of 19th-century health lore. In it he described how sleeping with an open mouth is almost sure to cause "Curvature of the Spine — Idiocy — Deafness ... Toothache — tic-douloureux — Rheumatism — Gout ..." because it "lets the enemy in that chills his lungs — that racks his brain — that paralyses his

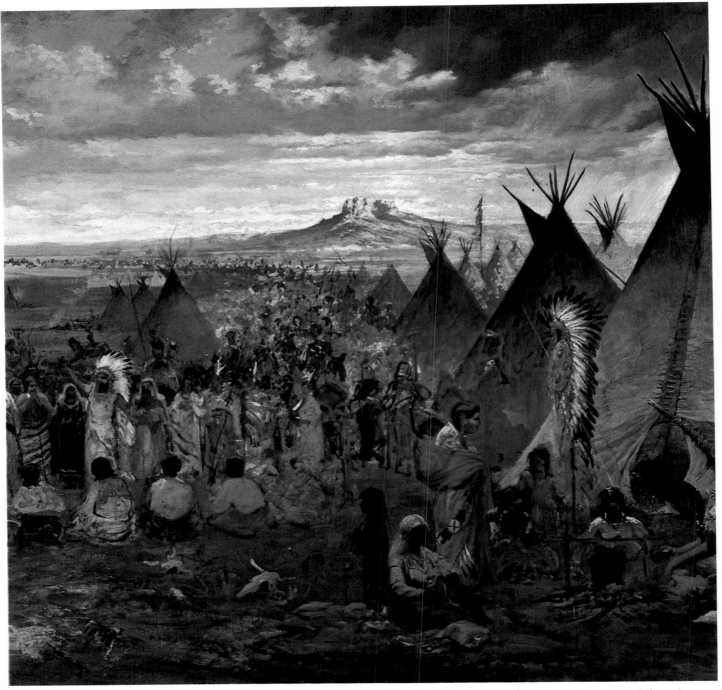

Large Sioux encampment painted by pioneer artist Tavernier, shows buffalo in background.

stomach — that gives him the nightmare — brings him Imps and Fairies that dance before him during the night." The book, published in England in 1862, sold more than 40,000 copies, and it is said that Lewis Carroll used Catlin's style of drawing and hand penned script as a model for his *Alice in Wonderland.*

One year after Catlin's return from his visit among the Plains Indians, Swiss artist Karl Bodmer accompanied the German Prince of Wied, Alexander Phillip Maximilian, and other scholars on a two-year expedition into the wilderness of the upper Missouri River. Later he made engravings from his drawings and paintings of the trip to illustrate the Prince's account of the journey which he entitled *Reise in das Innere Nord-Amerikas in den Jahren 1832 bis 1834* (Voyage into the North American Hinterland in the Years 1832-1834).

Easterners soon developed a taste for scenes from the rugged far western frontier. *Harper's Weekly* ran a lengthy series of sketches of the West by French-born Jules Tavernier and Paul Frenzeny. Previous to the paintings' appearance in the *Weekly* the editors titillated their audience with this teaser about the painters:

"These gentlemen will not restrict themselves to the ordinary routes of travel. They will make long excursions on horseback into regions where railroads have not yet penetrated, where even

the hardy squatter, the pioneer of civilization, has not yet erected his rude log cabin; and the pictorial record of their journeying will be a most valuable and entertaining series of sketches."

By a felicitous conjunction of circumstances, it occurred in 1833 that the military academy at West Point attracted the distinguished British artist Charles R. Leslie to teach drawing. Though many of his pupils, (among them Generals Lee, Grant and Sherman), are better known for their martial art than for their graphic art, one of them, Seth Eastman, became an outstanding painter of Indian life. Eastman's artistic career never hindered his career as an army officer. In fact, it was through the military that he became illustrator for the Bureau of Indian Affairs' report, *Historical and Statistical Information Respecting the History, Condition and Prospects of the Indian Tribes of the United States,* in which *Scalp Dance of the Dacotahs*

and *Fort Defiance* first appeared. Later Eastman illustrated some of his wife Mary Eastman's books on Indians.

Professor A.E. Church, Eastman's biographer, stresses the artist's close association with the Indians. While among them, Eastman painted "a large number of pictures of the beautiful scenery which surrounded their homes, and of the wild exercises in which they engaged, and an invaluable collection of the portraits of their most distinguished chiefs."

American art critics all too frequently echo the ill-founded notion that the "picturesque" quality of the frontier artists' subject matter somehow detracted from the quality of their work. Naturally the 19th-century frontier artist did not always produce masterpieces. Some West Pointers, detailed to illustrate reports on the flora, fauna and Indians of the frontier, were scarcely more than competent draftsmen who

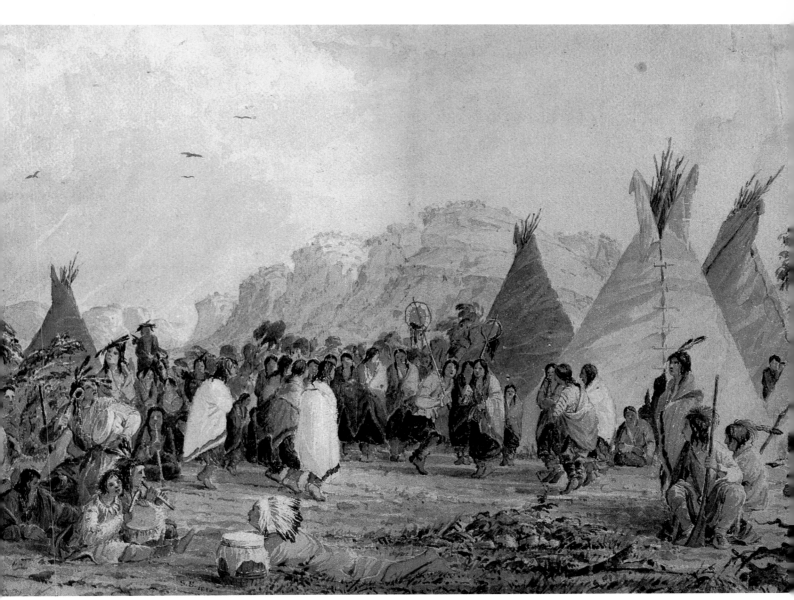

Dakota Indians (also called Sioux) of the North Central Plains perform a scalp dance.

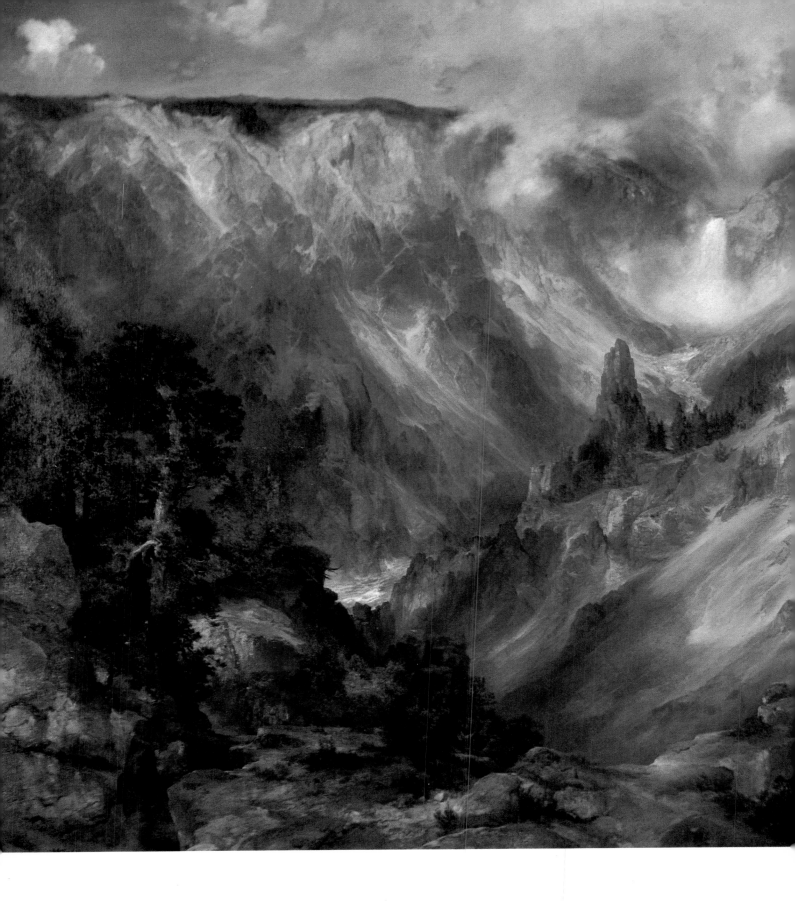

have, at best, left some record of Indian dress and life-style long since vanished. Others were dedicated and highly sensitive artists whose work, much in demand by Eastern publications, transmitted the living breath of the untamed continent; not just as something to look at, but also as a way of seeing: a style.

Another frontier artist from the military was Edward Meyer Kern, who went west in 1845 as a topographical artist with Frémont's third expedition to the Rocky Mountains, and later served in a California battalion commanded by Frémont, who named the Kern River after him. Kern was a talented artist who covered a great deal of territory. In the fall and winter of 1848 and 1849, he was in Colorado and made an

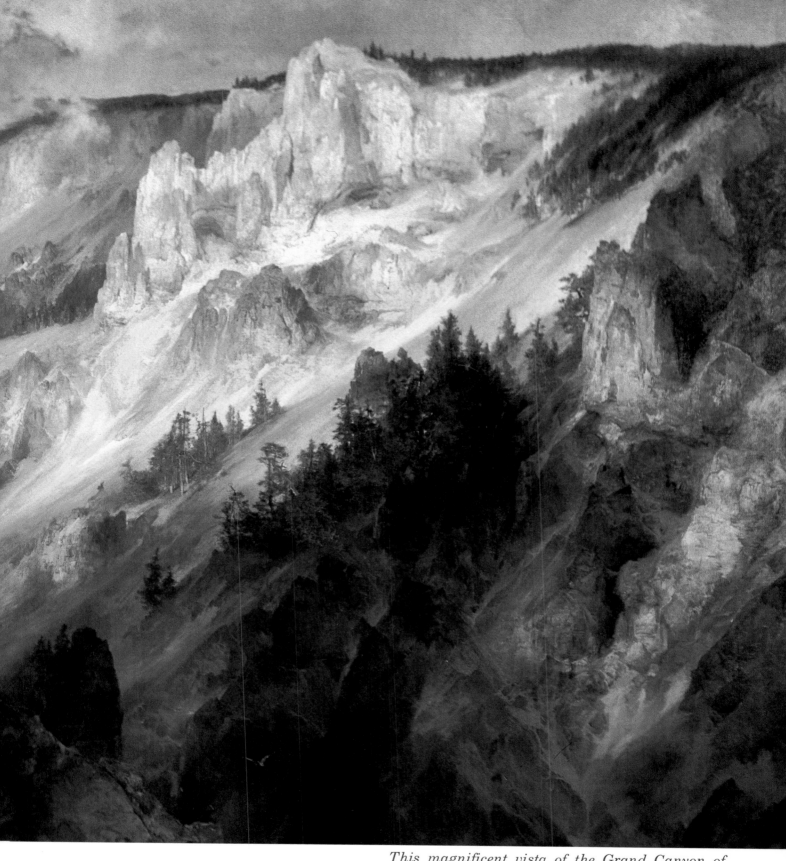

This magnificent vista of the Grand Canyon of the Yellowstone was painted by Thomas Moran.

expedition into the Navajo country. Later he was involved in exploring the North Pacific area; then he continued to sketch and draw as he sailed along the route followed by American whalers and trading ships between California and China. His was one of the great contributions to the visual records of the West.

Of all the frontier painters, George Caleb Bingham (1811-1879) had the distinction of being both a pioneer, and an artist who had studied and assimilated the techniques of classical European artists. He used classical lighting and composition in his work, which is reminiscent of Poussin. Bingham's West was not the dramatic Wild West of the later Remington, but it was vigorous art depicting young

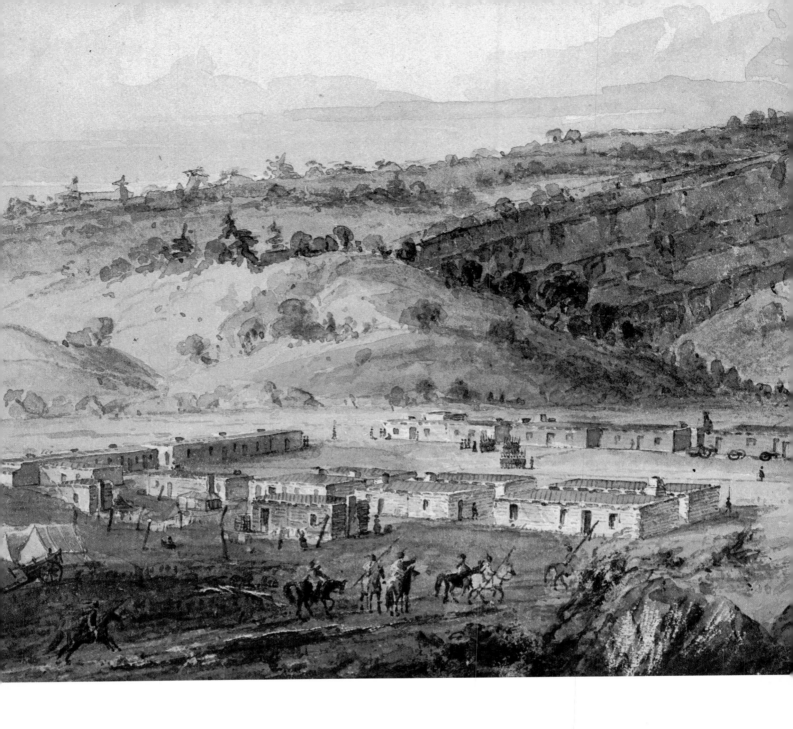

American life. The mood of his canvases is not frenetic, rather it is pensive and monumental.

Frederick Remington was, and is, undoubtedly the most popular painter of the western frontier, even though some art critics find him facile, superficial and melodramatic. Although he was born in the East, Remington devoted his life from age 19 on to portraying what was then clearly perceived to be a vanishing world: Indians, cowboys, horses, trappers and hunters. Remington's paintings are both dramatic and accurate, and they represent the image of the Far West that has triumphed and stuck in most of our minds. Remington was prolific; he produced thousands of sketches and paintings in his short 48-year life.

Similar in style and subject matter, but not as polished as Remington's work, was the painting of Charles Russell, a Montana cowboy and self-taught artist and sculptor. Among his better-known works are *Lewis and Clark at Ross' Hole,* which he painted for the Montana House of Representatives.

As the contrast became more marked between crowded Eastern cities and the unspoiled beauty of nature further west, landscape painters found enthusiastic and often wealthy buyers. The term "Hudson River School" had come to designate not a geographically defined group of artists so much as a grandiose style of depicting mountain scenes of clouds, dramatic outcroppings of rock and dwarfed mountain fir, with a certain "oceanic feeling," a yearning for infinity.

Some of the most romantic painters of the School broke off and developed a more modest, tranquil style of painting. These "luminists," as

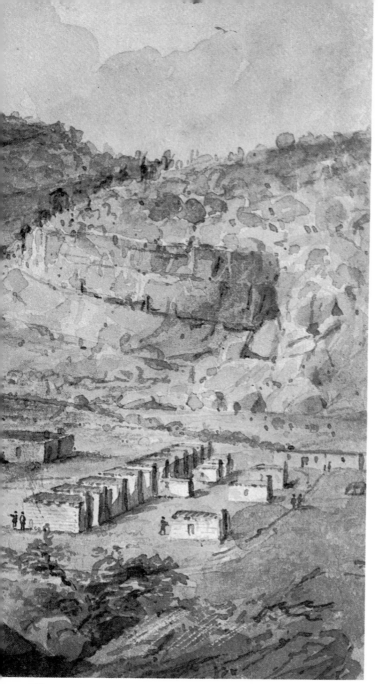

West of Fort Defiance (about 150 miles west of Albuquerque) settlers were on their own.

Hudson's Bay Company

With the exception of French colonies on the East, the area of what is now Canada was once held by a British fur-trading company whose original charter dates back to the 17th century. Charles II had granted the "Governours and Adventurers trading to Hudsons baye" exclusive trading rights within the territory of North America in which the rivers flowed into Hudson Bay. Since this vast area was largely unexplored at the time, neither the King nor his intrepid merchants knew how much land was involved.

In the course of the company's long and colorful history it came into conflict with the French colonies, Canada's North West Company, Astor's American Fur Company and, in the final phase of its operation in the mid-19th century, with local governing bodies in the United States.

The employees of the company numbered about 1,500 at the beginning of the 19th century. The Indian did most of the trapping. Upon entering a Hudson's Bay trading post, the value of his pelts would be assessed according to the "made beaver" unit, defined as being either an actual beaver skin or a fixed number of less valuable skins. Ten "rats" (muskrats) equaled one "made beaver," for example. The trader gave the Indian specially marked wooden chips equal to the number of "made beavers". In the adjoining storeroom he would trade his chips for such items as guns, flints, knives, blankets, traps and mirrors, each having a recognized "made beaver" value. A gun would cost 20 chips, two paid for a knife. In the early days a tot of rum was offered to trappers, but in the 19th century this practice was only maintained in areas where the Company needed to furnish a bonus to woo Indians away from rival traders.

During the 1840's, the United States border with British territories in the Northwest became a political issue. President Polk sensibly settled on the 49th parallel as an acceptable compromise, despite the aggressive "Fifty-four forty or fight" slogan of his democratic electorate, which would have put the boundary 5 degrees and 40 minutes further north. Even so, England's Hudson's Bay Company was found to have several outposts in the American territories of Oregon and Washington. Trade continued as usual on the Flathead and Kootenay outposts but settlers and local authorities resented the presence of a foreign company on American soil. The Hudson's Bay administrators, realizing that the influx of settlers along the Oregon trail would diminish wildlife and strain white-Indian relations, relinquished their U.S. claims for a payment of less than one million dollars.

they were called, put subtle variations of light and shade on canvas, executed sensitive paintings of secluded woodland haunts. Two of their most famous members were Martin J. Heade and Worthington Whittredge.

The early masters, such as Thomas Cole and his younger friend and admirer Frederick E. Church, painted landscapes primarily of Eastern scenes. But later disciples turned for inspiration to the unspoiled nature of the West. Such was the case of Thomas Hill, Thomas Moran and William Keith, who began specializing in natural wonders like the Grand Canyon, the Yosemite Valley, the redwoods of California, and the Sierra Nevadas. Keith and Hill settled in California, and became the nucleus of a group of painters who formed a school of California artists.

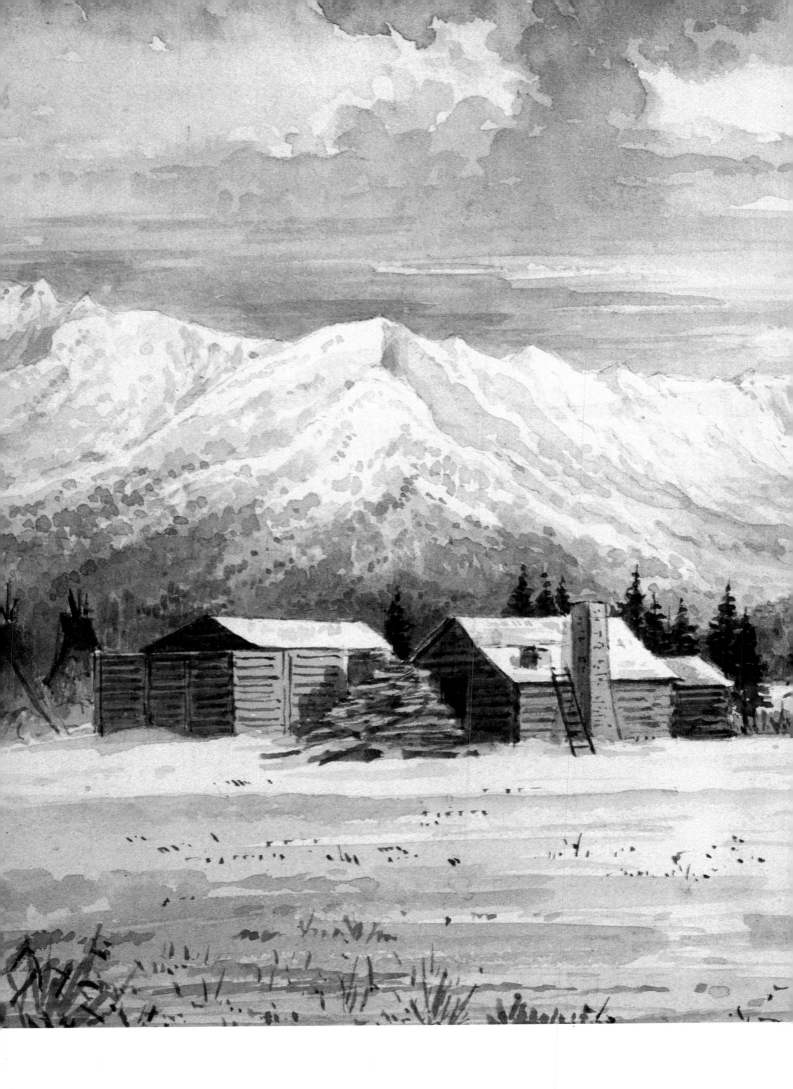

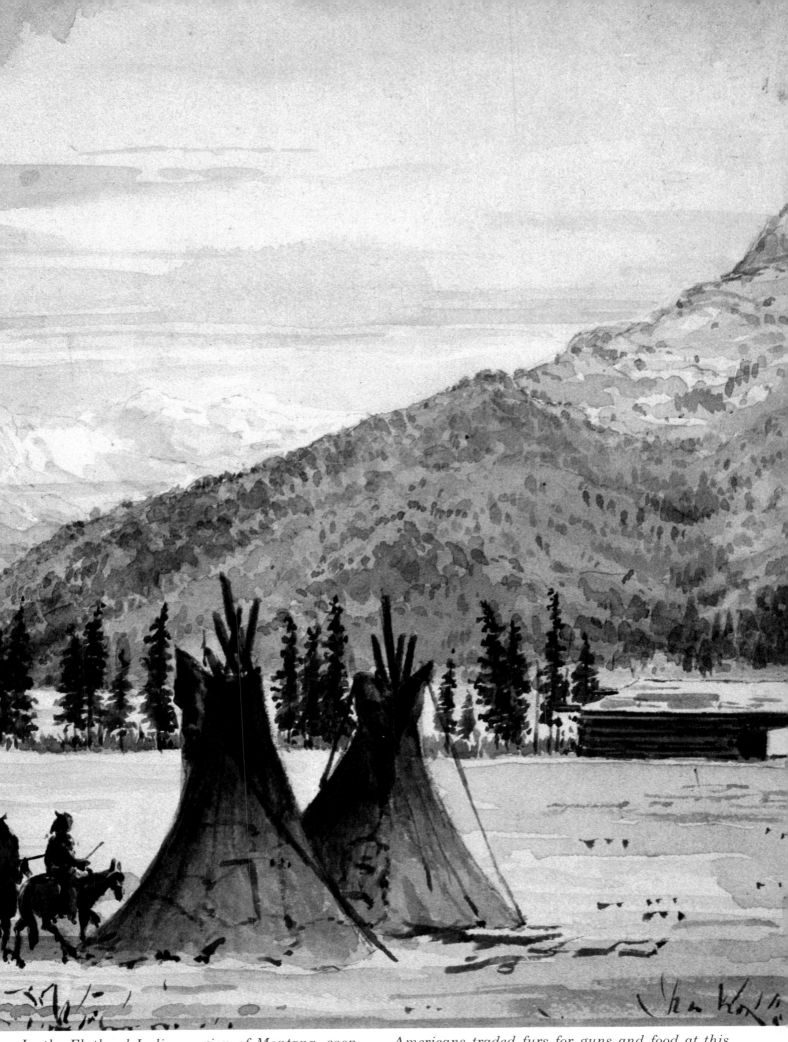

In the Flathead Indian region of Montana, soon to become the Montana Territory, native

Americans traded furs for guns and food at this log cabin outpost of the Hudson's Bay Company.

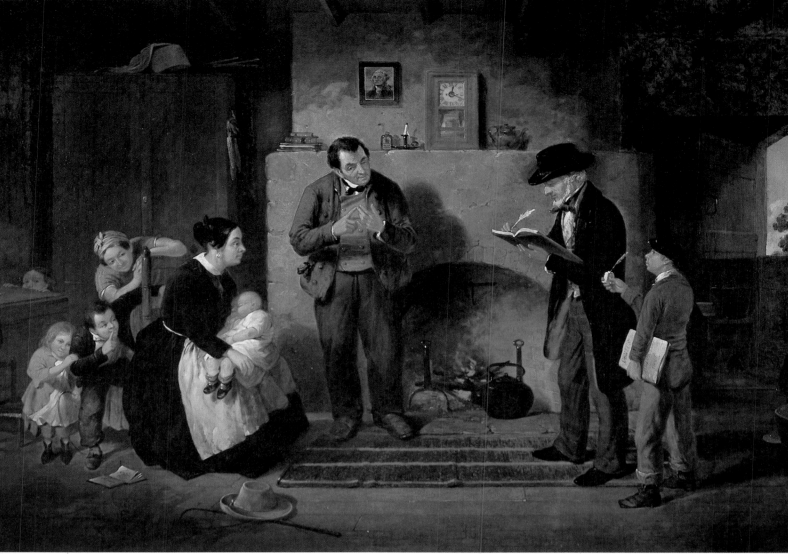

The population was 23.2 million when Francis William Edmonds painted The Census Taker.

A Literary Tradition Begins

The literary community of the times was based almost entirely in the Northeast, and these literati viewed the Indian problem and the slavery problem sympathetically but, on the whole, romantically. It was the time of the popular poems of Henry Wadsworth Longfellow, including his *Hiawatha,* written in 1855; and of James Fenimore Cooper, whose *Leatherstocking Tales* dealt sometimes romantically and sometimes realistically with the Mohican Indian. Richard H. Dana shipped out on a whaling vessel that allowed him to visit the West Coast; hence he probably knew more about Western Indians and treated his material more realistically.

According to Graham's *American Monthly Magazine* and *Godey's Lady's Book,* people were reading books imported from England. *Robinson Crusoe,* printed a century earlier, and *The Arabian Nights,* in a special edition adapted for family reading, was still admired, as was the poetry of Goldsmith and Robert and Elizabeth Barrett Browning. Popular magazines touched on a wide variety of literary endeavors. Novels were reviewed, essays on ancient history and modern morals were popular, and biographical sketches appeared routinely. But most in demand were the romantic short stories and the sentimental poems. Women poets were as esteemed as men, and no less than eight women writers were listed on the masthead of Graham's *American Monthly Magazine* although their names would not be recognized today. Among the male writers were William Cullen Bryant, Henry Wadsworth Longfellow, James Russell Lowell, James Fenimore Cooper and Richard H. Dana.

The most widely read of the foreign writers was Charles Dickens but almost as well read were the works of native son Washington Irving. Travel was a favorite subject, and when Francis Parkman published his work *The California and Oregon Trail or Life on the Praries and in the Wigwam,* it was immediately popular. It was also the first detailed travel book to describe the western territories and the routes to get there. This epic of the western wilderness was made up of firsthand accounts by a man who was an expert woodsman, a superior horseman and an excellent rifle shot. In addition to traveling the

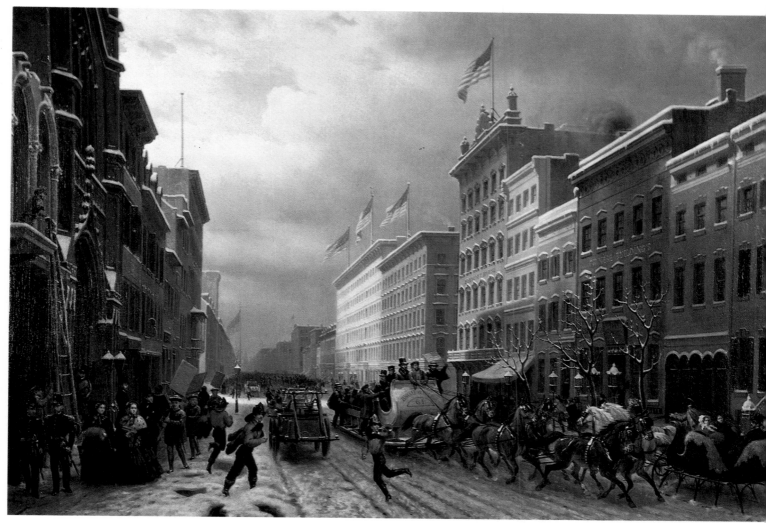

Sleighs, horse cars, foot traffic and fires caused major traffic jams on Broadway in 1855.

trails he described, he spent several months living with an Oglala band of Sioux Indians.

Manners and morals were also favored features in magazines and there were numerous books dealing with etiquette, temperance, marriage and motherhood. Two such books, *Letters to Young Ladies* and *Letters to Mothers,* appeared in 1850. Also in the best seller class was *Morals of Manners and Facts and Fancies for Young People* by a Miss Sedgwick. A new book by a little known author, Herman Melville, *Mardi* was excerpted in the *Literary World Magazine* of April 7, 1849. Two years later Melville's masterpiece *Moby Dick* appeared with little critical notice. Indeed, it did not even go into a second edition. Only a few hundred copies were sold during its first year of publication.

The most widely read poem of the day was William Cullen Bryant's *Thanatopsis.* Every schoolchild was able to quote:

"So live, that when thy summons come to join
The innumerable caravan, which moves
To that mysterious realm, where each shall take
His chamber in the silent halls of death,

Thou go not, like the quarry-slave at night,
Scourged to his dungeon, but, sustained and soothed,
By an unfaltering trust, approach thy grave,
Like one who wraps the drapery of his couch
About him, and lies down to pleasant dream."

During this period Longfellow wrote *Hiawatha* and *The Courtship of Miles Standish.* Nathaniel Hawthorne published *The Scarlet Letter* and *The House of Seven Gables.* Henry David Thoreau's *Walden* appeared. In the South, William Gilmore Simms, who was also published widely by northern magazines, remained popular. He was indeed the most prolific writer of his time publishing a total of 82 books.

Writers were beginning to lay the foundations that would become, in time, American traditions. Ralph Waldo Emerson composed his memorable essay on self reliance in which he said:

"Trust thyself, every heart vibrates to that iron string . . . who so would be a man must be a nonconformist . . . nothing is at last sacred but the integrity of your own mind . . . the objection to conforming to usages that have become dead

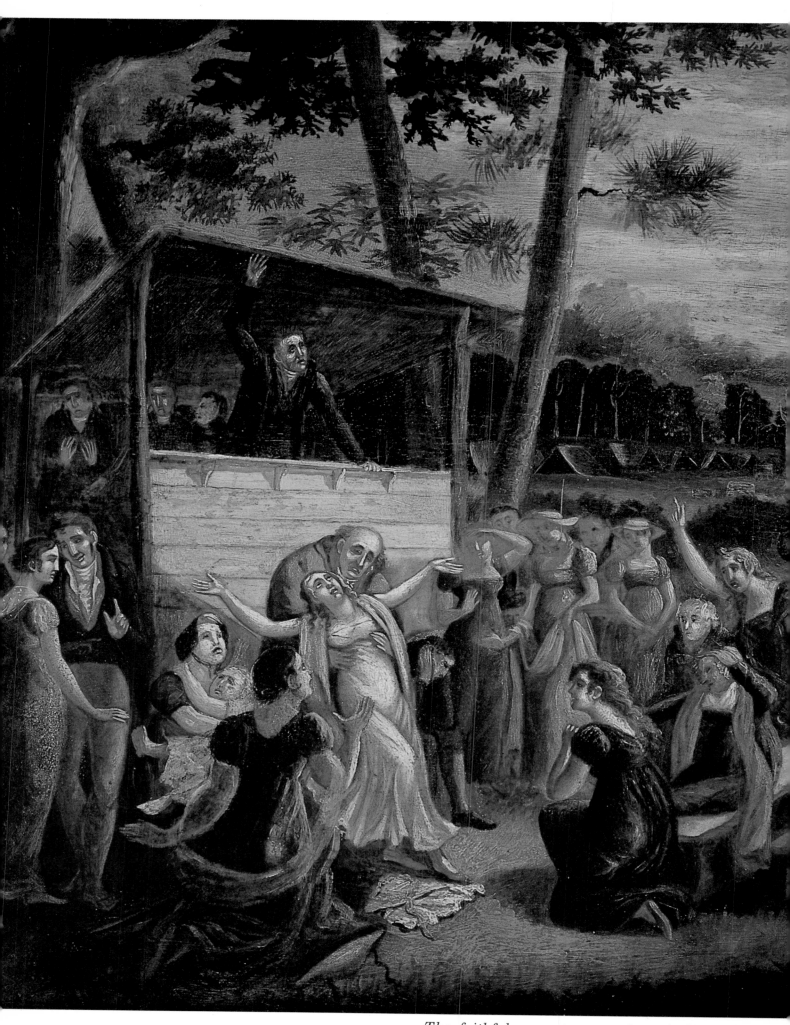

The faithful came to open-air revival meetings where they were both saved and entertained.

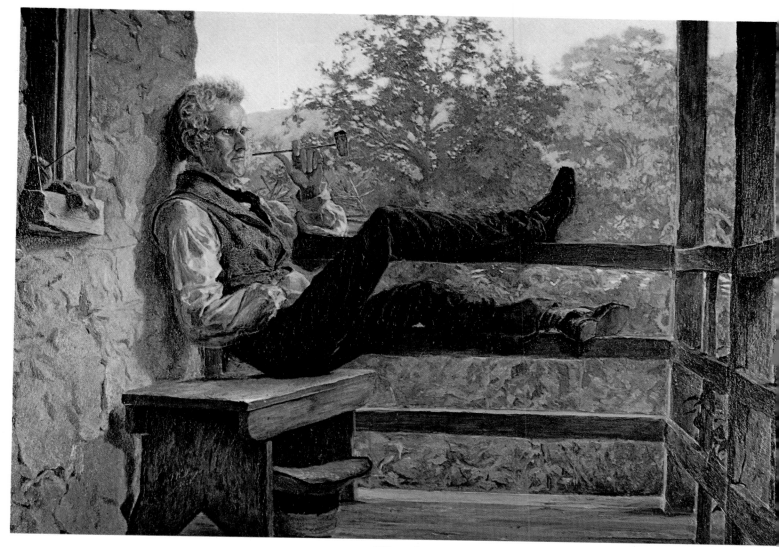

The demeanor of this American-style country squire bespeaks Emersonian self-reliance.

to you is that it scatters your force ... every true man is a cause, a country and an age; requires infinite spaces and numbers and time fully to accomplish its design; and posterity seems to follow his steps as a train of clients ... the intellect is a vagabond, and our system of education fosters restlessness ... our minds travel when our bodies are forced to stay at home ... it is only as a man puts off all foreign support and stands alone that I see him to be strong and to prevail."

Thoreau's *On the Duty of Civil Disobedience,* a profoundly though not stridently revolutionary appeal to the individual conscience, lashes out against slavery and the Mexican War: ". . . When a sixth of the population of a nation which has undertaken to be the refuge of liberty are slaves, and a whole country is unjustly overrun and conquered by a foreign army, and subjected to military law, I think that it is not too soon for honest men to rebel and revolutionize. What makes this duty the more urgent is the fact that the country so overrun is not our own, but ours is the invading army." Thoreau was briefly jailed for not paying the poll tax, in protest to government policy on these two issues.

Emerson was to become the very spirit of the youthful, vigorous, enthusiastic United States. He inspired Henry David Thoreau and Walt Whitman with a positivistic spiritualism that has come to be designated "transcendentalism." Whitman's *Leaves of Grass,* though not an immediate success, went through numerous editions during the author's lifetime, swelling in content from a thin volume to the voluminous work it is today.

Whitman, Longfellow, Whittier, Oliver Wendell Holmes, James Russell Lowell, all, to a greater or lesser degree, opposed the institution of slavery that was rapidly becoming a more and more insoluble issue. But their influence was relatively negligible compared to that of the dedicated, diminutive author, Harriet Beecher Stowe, the sister of the outspoken abolitionist Henry Ward Beecher. She called her book *Uncle Tom's Cabin or Life Among the Lowly* and, like many novels of the time, it first appeared serialized in *The National Era.* When the book came out copies could not be printed fast enough to keep up with the demand.

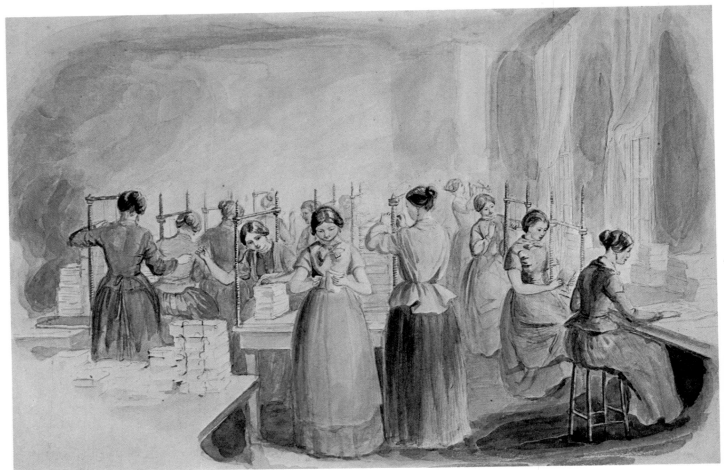

Women were employed in book binderies where most of the sewing was still done by hand.

Women at Work

In the mid-19th Century a gradual but distinct change began to take place in the field of women's work and women's rights. Industry created jobs women could do as well as or even better than men. This prompted changes in attitudes toward women in the industrial centers of the East. Changes, brought on in part by broader educational opportunities for women, also began to occur in women's legal status. Oberlin College in Ohio, became co-educational in the year 1837. Higher educational standards were developed in schools attended in Middlebury, Vermont and Watertown, New York.

In the Eastern cities, working-class women were forced into the factories and sweatshops. In the absence of legal regulations on working conditions — maximum hours and minimum wages — women and children were exploited.

The state of women in the West and South, however, was far different. Both of these areas continued to practice the traditional form of chivalry in which the "weaker sex" was defended, fed and clothed, and given only those rights that men felt women were ready for. This attitude may have served as a buffer in the West against the pioneer environment of physical hardship, violence and shotgun "justice."

One of the early advocates for women's rights and temperance was Amelia Bloomer who added the word "bloomers" to the English language. She and other dedicated women led the early temperance movement that, after the Civil War, became the National Christian Women's Temperance Union. With the help of barroom-wrecking, hatchet-carrying, keg-busting Carrie A. Nation, the Union finally succeeded in bringing about national prohibition in 1919.

Women slowly began to move into politics, focusing public attention on their cause. Only four years after the Civil War, the National Women's Suffrage Association was strong enough to oppose (but not defeat) the 15th Amendment to the Constitution that, while granting the vote to Negro men, did not extend the same right to women. In that same critical year of 1869, the territorial legislature of Wyoming granted women suffrage. By the 1890's three states would follow Wyoming's lead. But these states contained only a fragment of the national electorate, and women's suffrage, which was not introduced by constitutional amendment until 1920, had a long way to go.

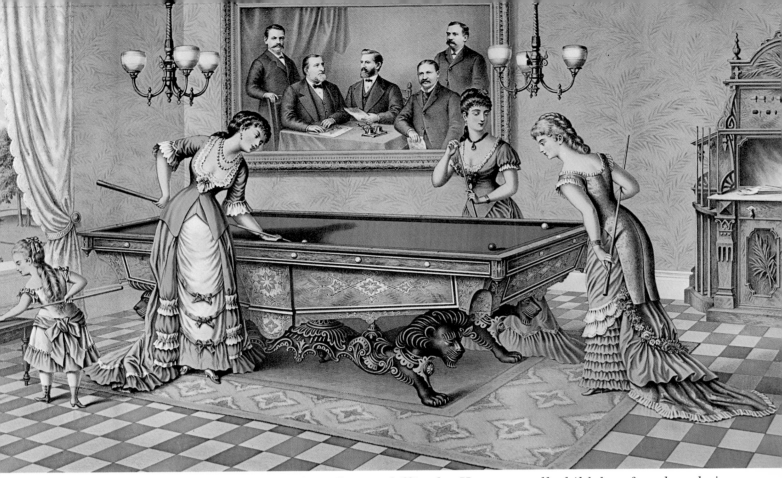

Although playing pool was considered to be vulgar, both men and women enjoyed playing billiards. Here a small child has found a chair on which to practice her shooting.

L. J. Levy & Company's dry goods store in Philadelphia was built in 1857. Its grand interior and appointments make it an aristocratic ancestor of our department stores.

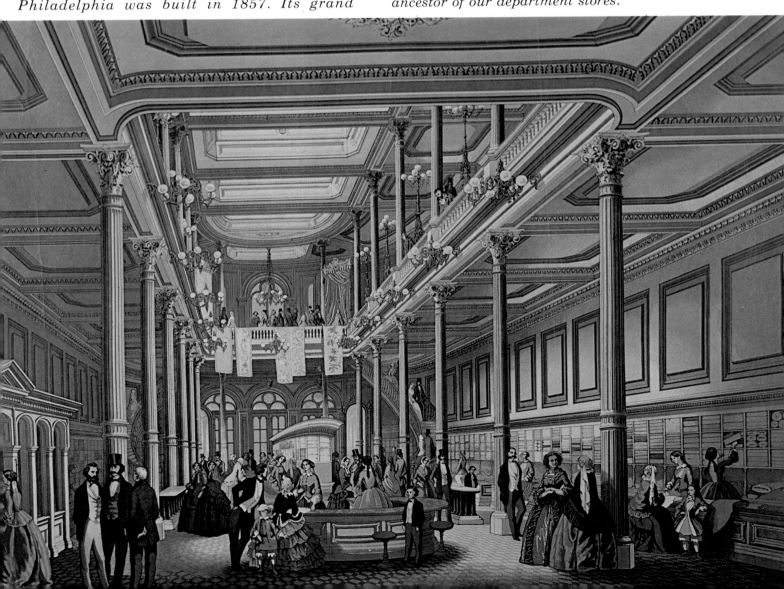

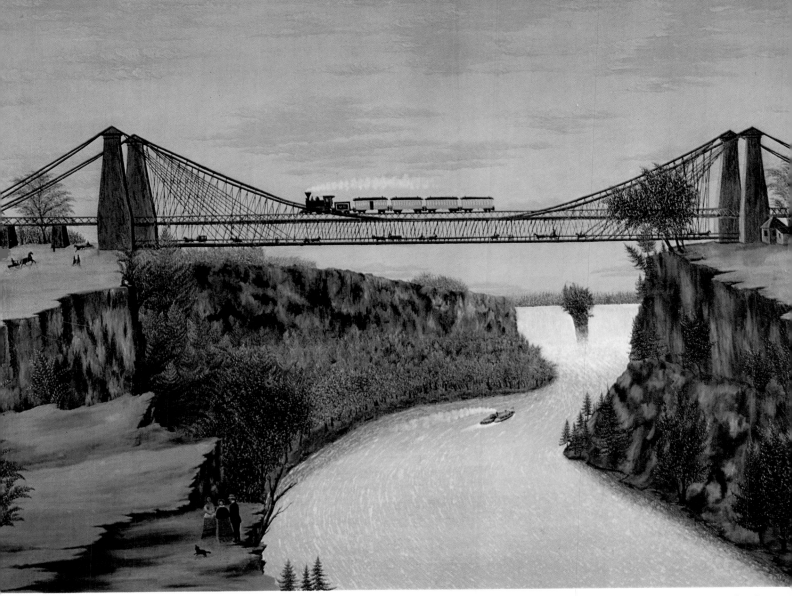

Spectacular two level bridge designed for horses and carriages above and trains below spans the Niagara chasm. Internationally acclaimed, it was built by John Roebling in 1855.

Transportation and Technology

There were two overall characteristics of the 1848 to 1861 period. One was the westward movement of the center of population; the other was the influx of people into the cities. Neither of these population shifts could have taken place without the continuing progress in transportation and technology.

The digging of the Erie Canal by the State of New York had given rise to a rash of canal construction. Philadelphians attempted a canal system in which boats would be hoisted over the Alleghenies by portage railroad. British capitalists who had invested heavily in the booming construction were hurt financially when technology took an unforeseen turn. Transportation by rail, which had the important advantage of not being ice-locked in winter, as

were canal barges, began to supplant transportation by water. Advances in locomotive and rail construction soon shaped the vehicle that was to help the North win the Civil War and later open up the West.

Two-thirds of the thirty thousand miles of railroad in operation in 1860 was in the North. And the combination of northern rail and canal transportation made it possible for the fast growing Midwest to develop and to prosper throughout the Civil War even when the Mississippi River was closed to northbound vessels. New York City had become the gateway to the Northwest, to northern Ohio, Indiana and Illinois. The frontier towns of Cleveland, Detroit and Chicago began to swell.

Some politicians predicted that unless overland transportation to and from the newly acquired territories of California and Oregon was provided, those spoils of the Mexican War might soon break away. Various routes were discussed, and Secretary of War Jefferson Davis, hoping a southerly route would help populate and

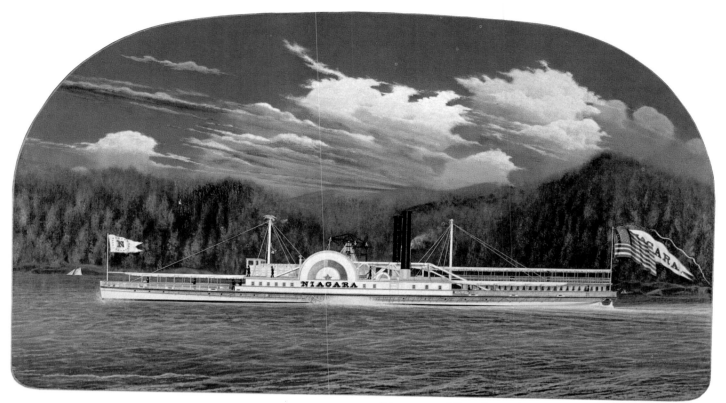

Steamers like this classic paddle-wheeler offered pleasant, popular and cheap transportation.

strengthen his native southland, pushed for a Houston-Tucson-Los Angeles itinerary. Davis quickly started to lay the groundwork for his southern crossing.

Through the intermediary of James Gadsden, minister to Mexico and prominent railroad man, Davis succeeded in negotiating a treaty with Mexico in which the United States agreed to pay its southern neighbor $10 million to extend the Territory of New Mexico southward to include the Gila River region. Because the Gadsden Purchase land offered the least mountainous access to California, Davis now felt confident that the southerly route would be adopted. But Davis's hopes were dashed when the Civil War broke out in 1861, and President Lincoln later chose a more northerly path for the nation's all important artery.

In agriculture, Cyrus H. McCormick's mechanical horse-drawn mower-reaper, which he patented in the Thirties, had become a truly revolutionary machine a decade and over 12,000 patents later. With the McCormick mower-reaper and the freight car, at their service, American farmers in the 1850's were supplying enough wheat to satisfy the domestic market, and they were exporting large shipments to Europe.

About 1,000 steamboats sailed the Mississippi by 1860. Some were veritable floating palaces. Today we think of them as sedate, slow-moving paddle-wheelers, but by 1855 the picturesque paddle-wheel had been replaced by a propeller,

and the new compound engine made greater speeds possible. Steamboats linked the cities of the eastern seaboard, and penetrated inland via the Chesapeake Bay and the Potomac River, Long Island Sound and the Hudson River. Describing the view from the Brooklyn ferry in 1856, Walt Whitman noted:

"On the river the shadowy group, the big steam-tug closely flank'd on each side by the barges, the hay-boat, the belated lighter,

On the neighboring shore the fires from the

This curved line drawing of a spirited horse later was done in metal, used as a weather vane.

foundry chimneys burning high and glaringly into the night."

Whitman was able to celebrate these presages of the Industrial Revolution rather than bemoan them because the conquest of iron and steam was gradual, compared, for instance, with its progress in England. There it had produced societal upheavals, health hazards and urban ugliness. There was no significant amount of iron ore east of the Alleghenies, and Pennsylvania was so far behind England in its iron-puddling methods that importation still gave cheaper and better quality iron. The first oil well was not drilled in Pennsylvania until just before the Civil War, and the usefulness of that new power source was yet to be realized. Animals, horses in particular, were still the mainstay of agriculture and transportation in 1850.

There were as yet few secondary railroad lines. The horse and carriage were still the normal means of local conveyance. There were as many types of carriages and harnesses, with shades of stylistic differences and corresponding implications for prestige and social standing, as there are types and styles of automobiles in our own time. Broughams, cabriolets, landaus, ladies phaetons, sulkies, surreys and victorias were but a few among dozens of models in the New England carriage maker's repertoire. A retail harness shop in 1860 listed a large variety of bits, whips, saddles and "horse clothing" for winter travel, and because the recently invented sewing machine (1846) was still mistrusted, the store concluded its advertisement with the assurance: "No Stitching Machines used in this Establishment." The cobbler's art also remained entirely manual until after 1860.

Steam power did not drive the wheels of very many industries in the Fifties. The abundance of fast-flowing streams made water wheels the principal source of power for a number of industries, including the vital textile mills and sawmills. The depression of 1857, followed by the Civil War, slowed down the advance of industrialization in some areas, but the invention and perfection of Winchester's repeating rifle (1860) and of Gatling's machine gun (invented in 1862, but not used until the siege of Petersburg in 1864) were undoubtedly hastened by the impending war between the states.

In After a Long Cruise, *an oil painting done by John Carlin in 1857, three drunken sailors,* *home from a cruise, upset an old woman's cart of fruit and accost a well-dressed black woman.*

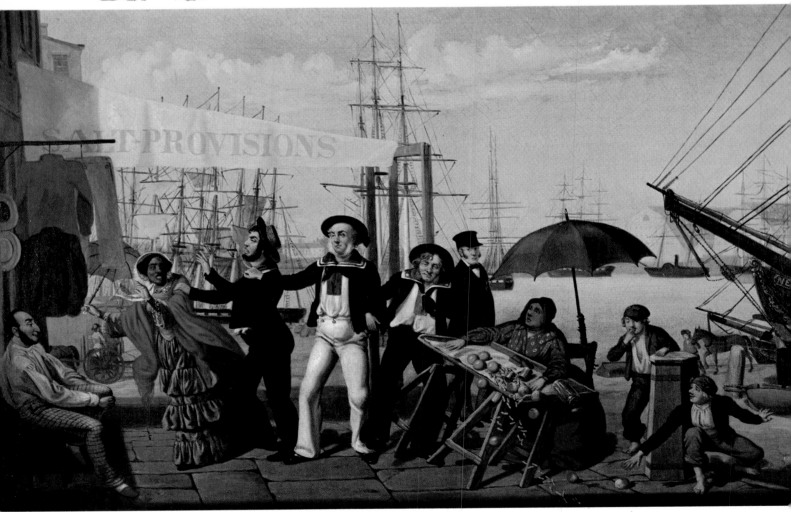

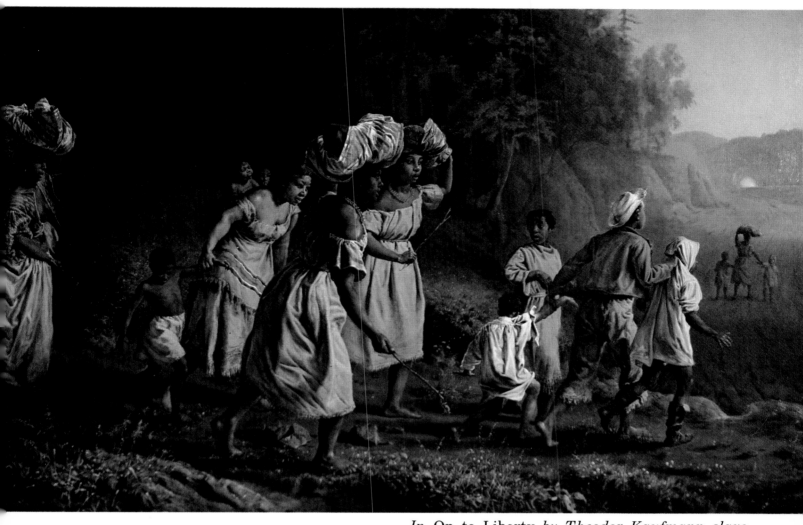

In On to Liberty *by Theodor Kaufmann slave women are leading their children to freedom.*

Dissension and Division

The country was prosperous. New England clocks were sold widely throughout Europe. The clipper ships and early steamers carried as much cotton, sugar cane and tobacco as the South could produce. But the issue of slavery hung over the country, and the 12 years between 1848 and 1860 became the most critical in the future of the Union since the dissension over the Constitution in 1788. Expansion became inextricably entwined with slavery. Would the new territories scheduled to become states be slave or free?

Congressman David Wilmot, a "free soil" Democrat from Pennsylvania, introduced a proviso to Congress to prevent slavery in any territory acquired from Mexico. It was defeated but the sentiment that newly acquired territories should be free of slavery was intense throughout the North and Middle West.

The democratic way of life was on trial. Instead of a single, united nation, relations between Northerners and Southerners finally eroded to the point that most southerners thought of Northerners as residents of another country. Northerners had no comprehension of either the economic or social problems of the South. A peculiar kind of regional nationalism slowly settled over both North and South as the gap in understanding widened. For there was no real concept of a United States, but rather a concept of an association of individual states or regions free to move in any direction they wished. To the Northerners, Southerners were effete, unrealistic romantics who did no work and who led lives of languid luxury. Southerners looked at northerners as greedy, money-grubbing sweatshop owners intent on destroying civilization with their hell bent industrialization.

For a time it looked as though there would be no way for the Union to continue. The North was not willing to offer the South an economically feasible alternative to slavery; the South, without slavery, feared complete economic and social chaos. Yet the Union was to be saved temporarily for at least the next 10 years, by three remarkable old men who worked out the

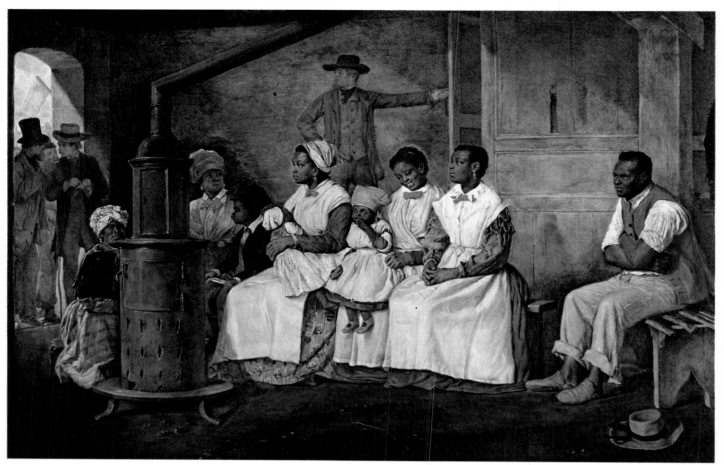

Dressed in their best, slaves sit waiting to be sold in this romanticized scene by Eyre Crowe.

Compromise of 1850. They were Henry Clay, John Calhoun and Daniel Webster. All three spoke for the preservation of the Union and their willingness to compromise became a stopgap. Under it, the state of California was admitted as a state free of slavery, and the slave trade was abolished in the District of Columbia. But the new territories of New Mexico and Utah were free to make their own decision as to whether they would be slave or free states at the time that they would be admitted into the Union. These provisions were reluctantly accepted by the South and were made palatable only by the final provision: a strong fugitive slave law. In effect, the North admitted that the South had the Constitutional right to own slaves who would be treated as property and returned to their rightful owners should they escape and be found in a northern state. President Zachary Taylor was opposed to the compromise although he was a slave owner. But he died suddenly on July 9, 1850, and his successor Millard Fillmore went along with the compromise.

But this compromise brought more rather than less dissension. The Kansas-Nebraska Act in 1854 allowed those two territories to make their own choice regarding slavery. This act brought a direct confrontation between the pro-slavery and anti-slavery legislators.

Although the slaves themselves knew little of what was going on, many remembered the Nat Turner insurrection of 1831. While there was almost no further organized resistance to slavery in the South, thousands of slaves did manage to escape from plantations and southern cities to make their way north over what became known as the underground railroad. It was not a railroad but rather a long chain of abolitionist-operated way-stations, with secret signals and passwords, that harbored, fed and clothed slaves as they made their way north. Not even the Fugitive Slave Act was effective against the multitude of anti-slavery advocates who were convinced that slavery was an evil that must be fought with either legal or illegal weapons.

In the South, slavery had become a well-defended, solidly based economic and social institution. The southern states, almost without exception, believed their present existence and future survival depended largely on the plantation system, which had earlier resulted in prosperity in the West Indies.

The South maintained that there were no

Bloodhounds close in on runaways in this detail from an 1863 painting by Thomas Moran.

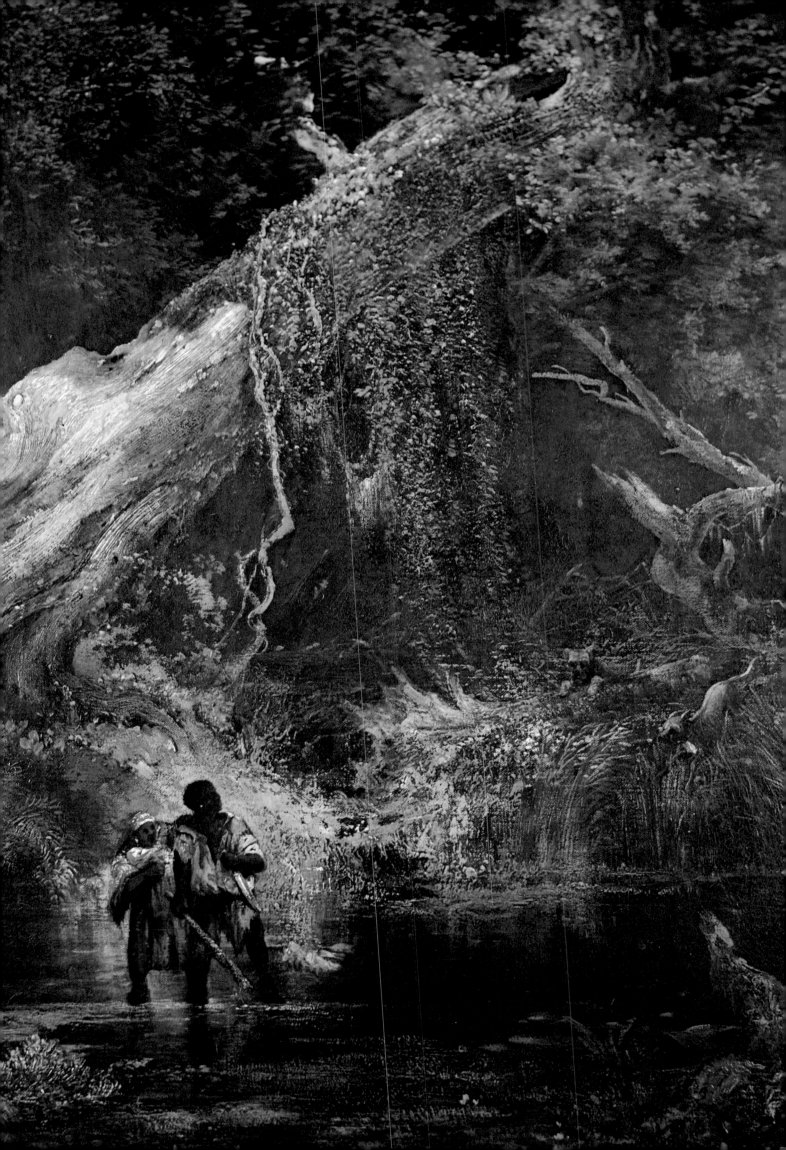

religious reasons advanced in either the Old or New Testaments against slavery, and quoted the Bible as authority that Abraham had more than 300 slaves; that when Israel conquered Canaan, they enslaved one whole tribe and made them "hewers of wood and drawers of water." Southern apologist Thomas R. Dew, a professor at William and Mary College in Virginia, also pointed out that at no time did Christ speak out against slavery, and then went on to explain that George Washington and Thomas Jefferson, both kindly men and great presidents, had been slave holders, and that not only were the slaves of great men treated well and abundantly fed, but this was true throughout the South. He went on to expound that a "merrier being does not exist on the face of the globe than the Negro slave of the United States." The argument of many intelligent southerners was that the institution of slavery allowed for all white mankind to mix on one common level; that because the menial offices were all performed by the blacks, the whites could freely intermingle as equals whereas in the North, where whites occupied menial positions, a caste system had developed.

But none of these arguments, nor the songs, poems or pamphlets turned out by the South, had any effect on the rising tide of opinion in the North against the institution of slavery.

Much of this controversy could have been avoided if the framers of the Constitution had been willing to practice what they preached. In theory, they believed that all men were created equal and should have equal opportunity — and so they stated. Yet they sanctioned the doctrine that allowed a property right in human beings. The South, as it grew into an agricultural area, made more use of this doctrine of human property than did the North. Yet it was the founding fathers who set up the principle — and that is where the potential dissolution of the Union began. It was not helped by the Supreme Court's Dred Scott Decision in 1857. The Court upheld the Constitution, pointing out that the Missouri Compromise violated the Fifth Amendment because it deprived persons of their property (slaves) without due process of law. The newly formed Republican Party violently opposed this decision and Abraham Lincoln, as their spokesman, became a champion of the anti-slavery movement. His series of debates with Stephen Douglas brought the issue into even sharper focus.

Crusading newspaperman William Lloyd Garrison pointed out that the Declaration of Independence itself guaranteed equal treatment and equal rights. He insisted that it would not be possible to have a gradual change of slave status but that they must be freed absolutely. Garrison's speeches and especially the newspaper, *The Liberator*, carried great weight

as did an earlier book published in 1839, called *American Slavery as It Is* by Theodore Dwight Weld. This was largely a compilation of clippings from southern newspapers detailing advertisements revealing that families were separated, that escaped slaves were punished and informers rewarded, that men ran away to be with their wives and wives escaped to be with their husbands and children. This documentation had wide distribution. Over 100,000 copies were sold within the year.

But could slavery have been eliminated in the South without secession and the resulting war between the states? It would seem that the North gave no consideration to the economic chaos that would follow the freeing of the slaves in the South and the resettlement of the large slave population. Few voices were raised suggesting that the Federal Government indemnify slave owners for the labor force that they would be losing. Nor was any plan advanced to support, with federal funds, the new black, independent wage earners. The question was only considered morally not realistically; nor were the economic problems considered. It would seem that, as a way of preserving the Union, short of war, a gradual program including subsidies to allow the South to develop a new economic base might have peacefully preserved the Union.

The Constitution specifically allowed the states freedom to secede. The South reacted against northern pressure and avoided secession as long as possible hoping for some other alternative. No one wanted a compromise to phase out slavery, and the Northern lawmakers saw no need to provide money for an economic changeover from a slave-based to a free economy.

England freed the slaves in her colonies in 1833. The slave owners were compensated and legislation passed that made the transition, although difficult, at least possible. But the United States had become too disunited to consider another compromise. Slavery must go, said the North. We will and must secede and form our own confederation of states, replied the South.

It is possible that the British saw the problem more clearly from a distance, for in 1849 one of the editors of England's *Fraser Magazine* wrote: "The consequence of the federal government not having reserved such power (to outlaw slavery), is that slavery in the South is outgrowing all conceivable possibility of abolition, and that it is probably destined within the next quarter of a century to lead to the dismemberment of the republic." A very clear view indeed.

The entertainer who posed for The Bone Player *by Mount was a successful freeman of color.*

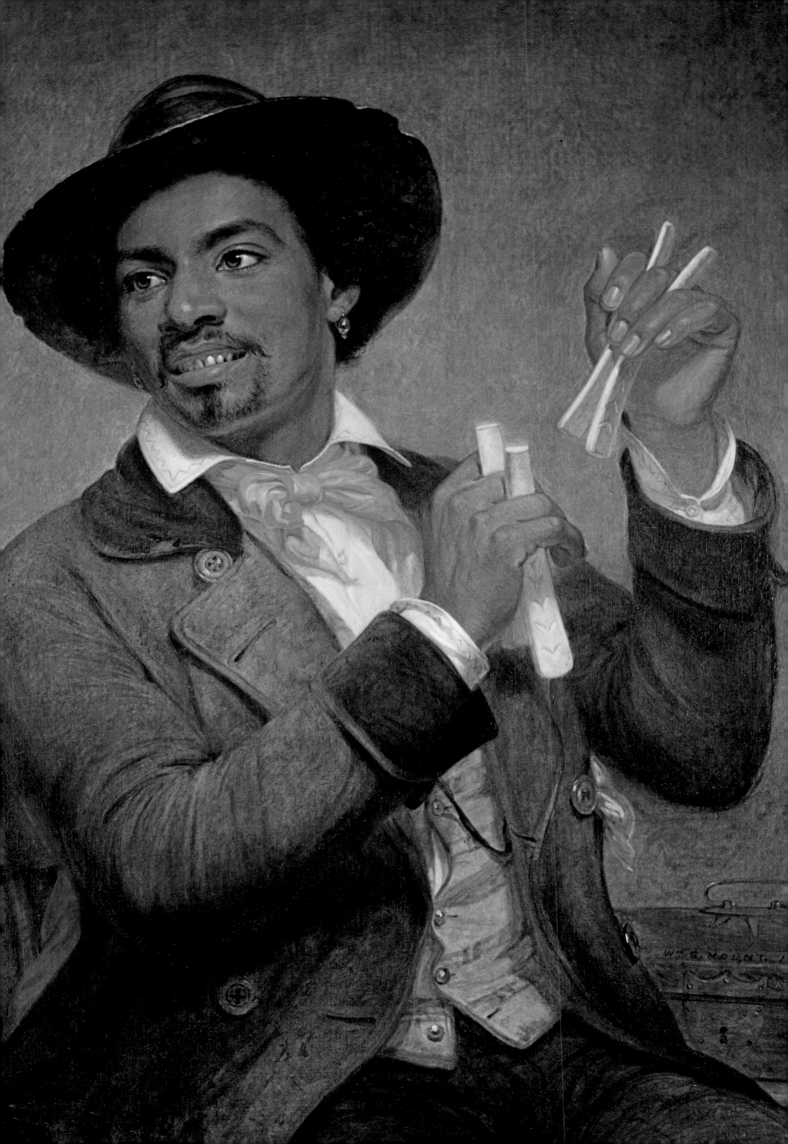

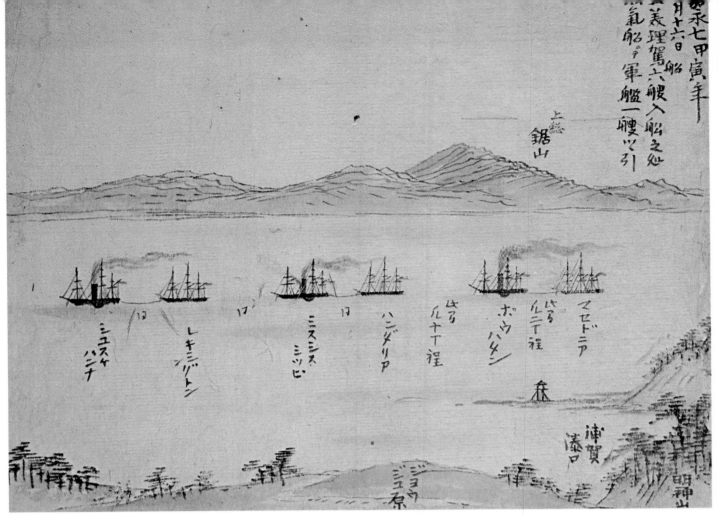

Isolation ended for Japan when Commodore Matthew C. Perry sailed his six threatening black ships along the unprotected coast. A Japanese artist recorded the historic scene in this watercolor.

Formal trade relations began between the United States and Japan when the first commercial treaty was signed between first U.S. Consul Townsend Harris and the Shōgun Iesada in 1858.

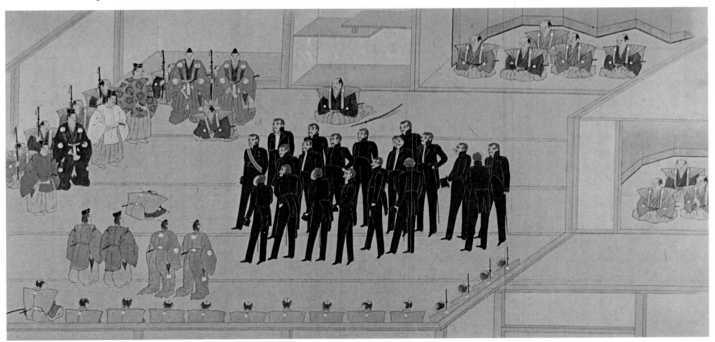

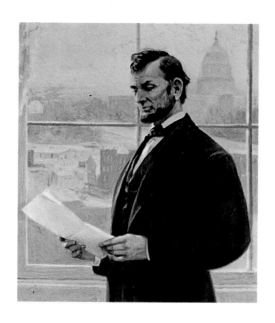

1861-1865
THE WAR BETWEEN THE STATES

Lincoln's election speeds the dissolution of the Union. South Carolina secedes, followed by Florida, Mississippi, Alabama, Georgia, Louisiana and Texas to form the Confederate States of America. The Confederates fire on Fort Sumter. Lincoln calls for troops. Virginia, Arkansas, Tennessee and North Carolina join the Confederacy. Emancipation Proclamation becomes effective January 1, 1863. At first victorious, the South falls before the manpower, armaments and industrial production of the North. Lincoln dies from assassin's bullet.

HISTORICAL CHRONOLOGY	ART CHRONOLOGY
1861 *Confederate States of America formed with Jefferson Davis as President and Alexander H. Stephens as Vice-President. Confederates fire on Fort Sumter, South Carolina. Civil War begins.* *President Abraham Lincoln proclaims blockade of Southern ports.* *The Union loses first battle of Bull Run.*	1861 *Winslow Homer records life on the battlefront for* Harper's Weekly. *George Innes paints* Delaware Water Gap, *an early example of Impressionism in America.* *Mathew B. Brady photographs first battle of Bull Run. (Brady and his photographic team documented nearly every phase of the Civil War.)*
1862 *Lincoln issues Emancipation Proclamation, freeing slaves in Confederate States.* *Naval duel of Merrimac and Monitor.* *The Union levies troops by national conscription.*	1862 *Julia Ward Howe's* Battle Hymn of the Republic *published in the* Atlantic Monthly.
1863 *General Robert E. Lee's invasion of the North stopped at Gettysburg.*	1863 *Publication of the popular Civil War song* "When Johnny Comes Marching Home." *Lincoln delivers* Gettysburg Address *on November 19th.*
1864 *General Ulysses S. Grant placed in command of all Northern forces.* *Lincoln re-elected President.* *Sherman marches through Georgia.*	1864 *David Gilmour Blythe depicts the hardships of the war in painting* Libby Prison.
1865 *Lee surrenders to Grant at Appomattox Court House, Virginia, on April 9th.* *End of Civil War.* *Lincoln is assassinated in Ford's theater in Washington on April 14th.* *Andrew Johnson becomes President.*	1865 *Winslow Homer paints* Prisoners from the Front. *James Russell Lowell expresses American patriotism in verse with his* Ode at the Harvard Commemoration.

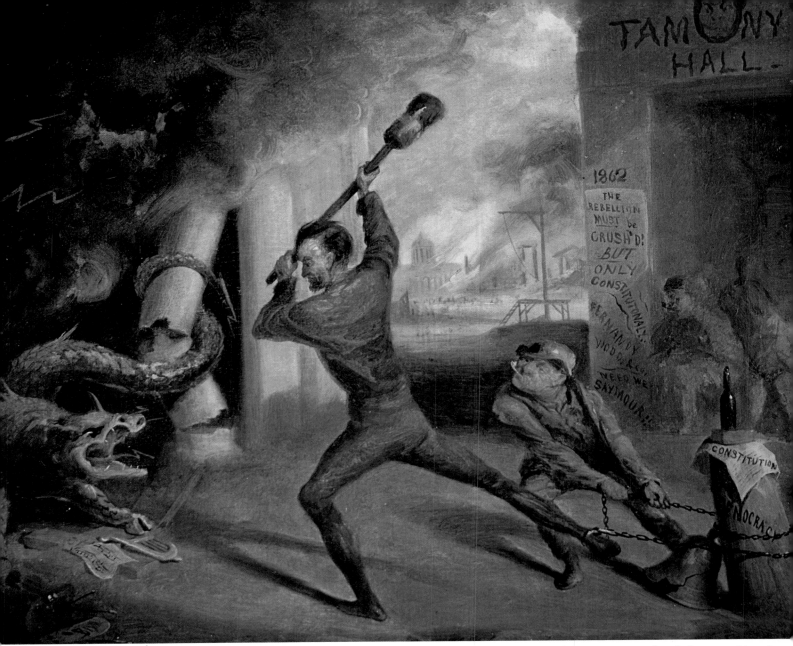

When David Blythe painted this allegory of Lincoln Crushing the Dragon of Rebellion, *the* *President was being attacked by radical Republicans and Tammany Hall Democrats.*

55 Days
of Decision

Fifty-two-year-old Abraham Lincoln from Kentucky and Illinois, 16th President of the USA, said, in his inaugural address on March 4, 1861: "In *your* hands, my dissatisfied fellow-countrymen, and not in *mine,* is the momentous issue of civil war. The government will not assail *you.* You can have no conflict without being yourselves the aggressors. *You* have no oath registered in heaven to destroy the government, while I shall have the most solemn one to 'preserve, protect, and defend it.'"

On April 29, 1861, 52-year-old Jefferson Davis, from Mississippi, provisional President of the Confederate States of America, said, in his message to the Confederate Congress: ". . . so

utterly have the principles of the Constitution been corrupted in the Northern mind that, in the inaugural address delivered by President Lincoln in March last, he asserts as an axiom, which he plainly deems to be undeniable, that the theory of the Constitution requires that in all cases the majority shall govern. . . . This is the lamentable and fundamental error on which rests the policy that has culminated in his declaration of war against these Confederate States."

In the tense 55 days between the statements of these two leaders, as Southern sympathizers in the North and Northern sympathizers in the South agitated against the imminent outbreak of hostilities, Fort Sumter, in South Carolina, was fired upon on April 12, 1861, while Federal ships, loaded with supplies and reinforcements lay outside the range of Southern guns. The attack was directed by Major General P. G. T Beauregard of the Confederate Army, recently of the United States Military Academy. The fort

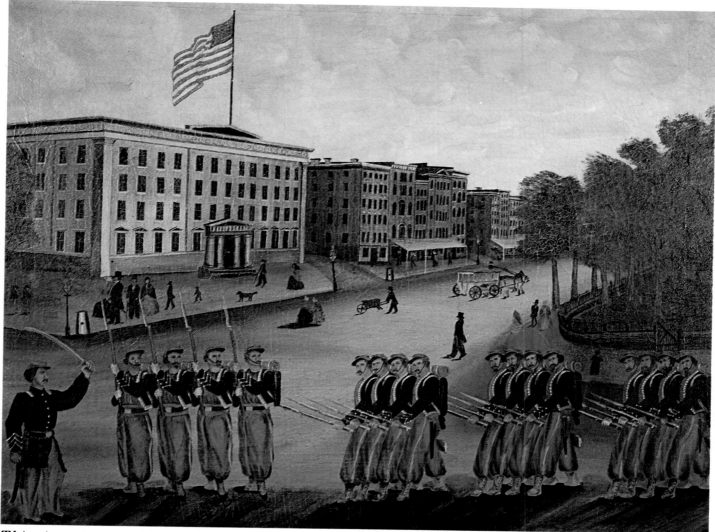

This American regiment of Zouaves wore the uniforms of a popular French Army company famous in Africa. They are seen drilling in front of New York's Astor House.

was defended by the Union Army's Major Robert Anderson, also of West Point. It was an almost bloodless battle. After the men in the fort surrendered, Major Anderson ordered a 50-round salute to the flag. The last charge exploded killing one soldier. It was an engagement that both sides anticipated, for both sides were eager for a showdown. Though the South fired the first shot, the North provoked it.

As Lincoln may have foreseen, the firing on the United States flag brought the divided North together. Two days later he declared that a state of insurrection existed, and called upon the Union to provide 75,000 militia for three months' service, a most optimistic estimate even for an insurrection.

Jefferson Davis had no doubts that this was no insurrection, but that the war was on. He called for 100,000 volunteers for a year's service to defend the cause of independence. The sides were now set, for Lincoln's declaration influenced the final decision of Virginia, Arkansas, Tennessee and North Carolina to secede and join the Confederate States of South Carolina, Georgia, Florida, Alabama, Mississippi, Louisiana and

Texas. A solid block of Southern states extending from Virginia and across the Southern borders of Kentucky, Missouri and Kansas and reaching as far west as the Rio Grande River had declared themselves a new and independent nation.

West Virginia withdrew from Virginia to form a new state in the Union. Four states, Maryland, Kentucky, Delaware and Missouri, were split, but they were largely dominated by the Federal Government. Of these slave states still in the Union, however, only Maryland responded to Lincoln's call for troops.

It was during these critical days that the leaders of the secession movement organized rapidly toward the formation of a self-sufficient Southern nation based upon states' rights, the right to hold or not to hold slaves, and the right to self-government. The Southern leaders believed that the original constitution of the Thirteen Colonies gave them the right to secede. They were a survival-motivated, nationalistic people, fiercely united in a cause. The Northern states began the war with less unity, but the determination to unite the entire nation through victory would develop.

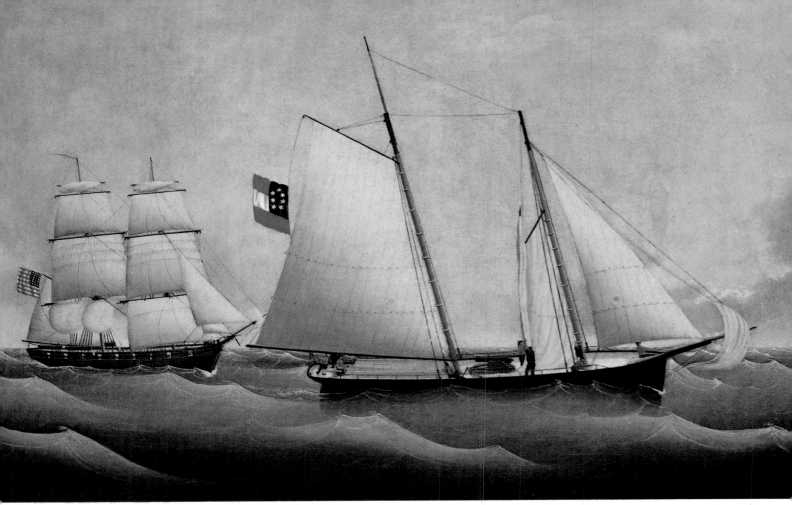

A swift-sailing Confederate blockade runner pulls ahead of a larger Federal man-of-war.

Many Confederate ships were captured but some got through to harass coastal shipping.

The View from the South

In the statements of its leaders and the speeches of its Congress, the South maintained that secession was an act of peace; that the Southern states, like the American Colonies in pre-Revolutionary days, were being oppressed without representation by a federal government that violated their constitutional rights. Most Southern leaders agreed with their President, Jefferson Davis, in his insistence that the Union should be subservient to the states that formed it. Strong in the belief that they were in the right, the leaders of the Confederacy set out to create a new nation on the foundation of states' rights. They felt the South would be secure economically, for was not cotton king? With the revenue from this major crop they believed the South could produce or purchase all the armaments it needed. And its two major customers, England and France, would surely grant recognition immediately. As it turned out, however, King Cotton was not enough on which to build either a nation or an alliance, for the

South received neither recognition nor aid.

The South also believed in the spirit, courage and dedication of its fighting men, and in the quality of its military leaders. The South was right, too — to an extent. Certainly generals like Robert E. Lee, Thomas J. "Stonewall" Jackson, Albert Sidney Johnston, Joseph E. Johnston and P. G. T. Beauregard were exceptional, but they were handicapped in making critical military decisions. When the military wanted to move into Union territory, for example, Jefferson Davis, as commander in chief, insisted upon taking the strategy into his own hands and fighting a defensive war instead. Robert E. Lee, one of the greatest military strategists of all time, would probably have won more victories had he been commander in chief of the Confederate Armies, but he was not given this authority until the very last days of the war.

Nationalism played a strong role in the minds of Jefferson Davis and the Southern leaders, but in actuality it was diluted by loyalty to each individual state. The South believed itself to be united, yet it badly miscalculated the effect of its own credo, states' rights, which worked against that unity. Major battles might well have been won instead of lost had it been possible to use

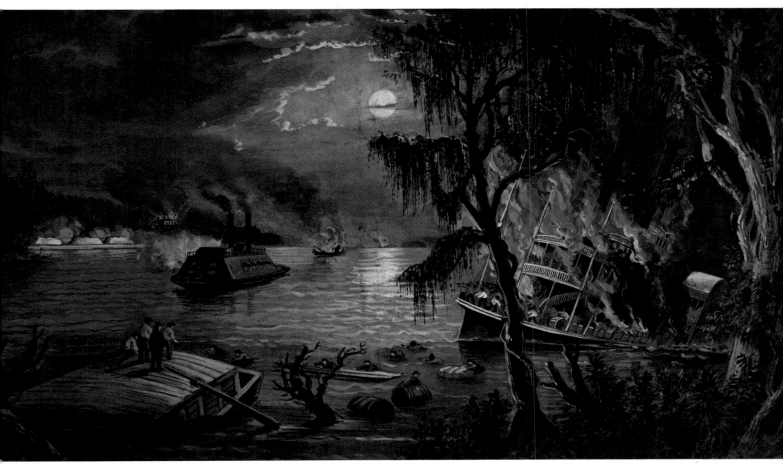

In its first battle the captured ironclad frigate CSS Virginia, formerly the Union's Merrimac, sank two Union warships, the USS Congress and the USS Cumberland, at Hampton Roads.

state armies where they were most needed. But each state wanted to defend itself as much as it wanted to defend the Confederacy, and each state was sovereign. As the war progressed, President Davis drew closer to the concept of a federal government with more authority over its members, but by then it was too late.

The real heroes of the South turned out to be Generals Robert E. Lee, Stonewall Jackson, and the less well-known George Gorgas, the West Pointer who created the Confederates' arms and munitions factories, and Brigadier General Joseph R. Anderson, owner and director of Tredegar Iron Works of Richmond which built the South's cannons, mortars, armor plate, torpedoes, and even a submarine.

These leaders, strong as they were, were in turn dependent upon the soldiers, those poorly equipped, underpaid, hungry foot soldiers of the Confederacy. Many were the Southern soldiers who showed by their actions that death was preferable to domination by the North. Yet as the war progressed, as the Confederacy was divided within, as conscription cut across states' rights, as fighting men were reduced to semi-starvation and makeshift equipment, the bravest were forced to lay down their arms.

The South was defeated by a bigger, stronger, better supplied and, ultimately, a more united army. It was also defeated by slavery itself, for slavery made international recognition difficult to obtain, and intensified the Northern effort. Toward the end of the war Jefferson Davis promised to arm the Blacks of the South and to emancipate them when the fighting was over, but the offer came far too late.

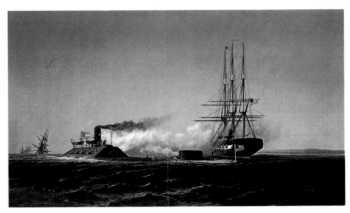

The Confederate ironclad CSS Virginia *battled the revolving-turreted* USS Monitor *at the mouth of the James River in Virginia. Neither vessel could sink the other, the battle was a draw.*

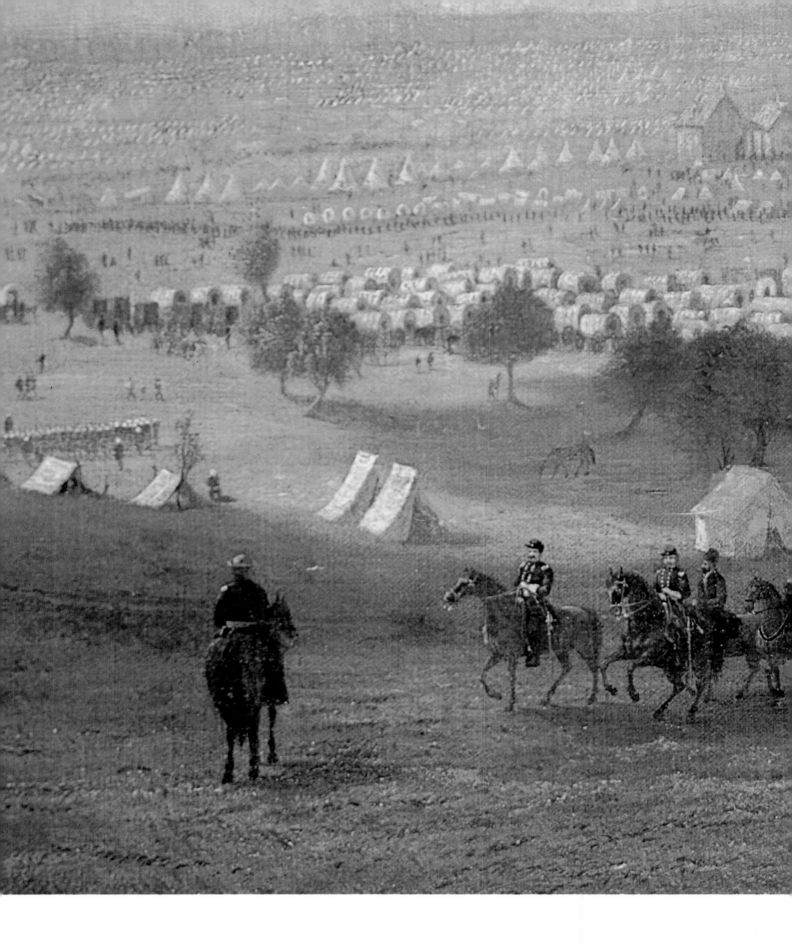

The View
from the North

When the war began, neither Lincoln, his Cabinet, nor the population at large could believe that the effete Southern gentlemen and indolent slave-holding plantation owners, with less than half the population of the North, with no army,

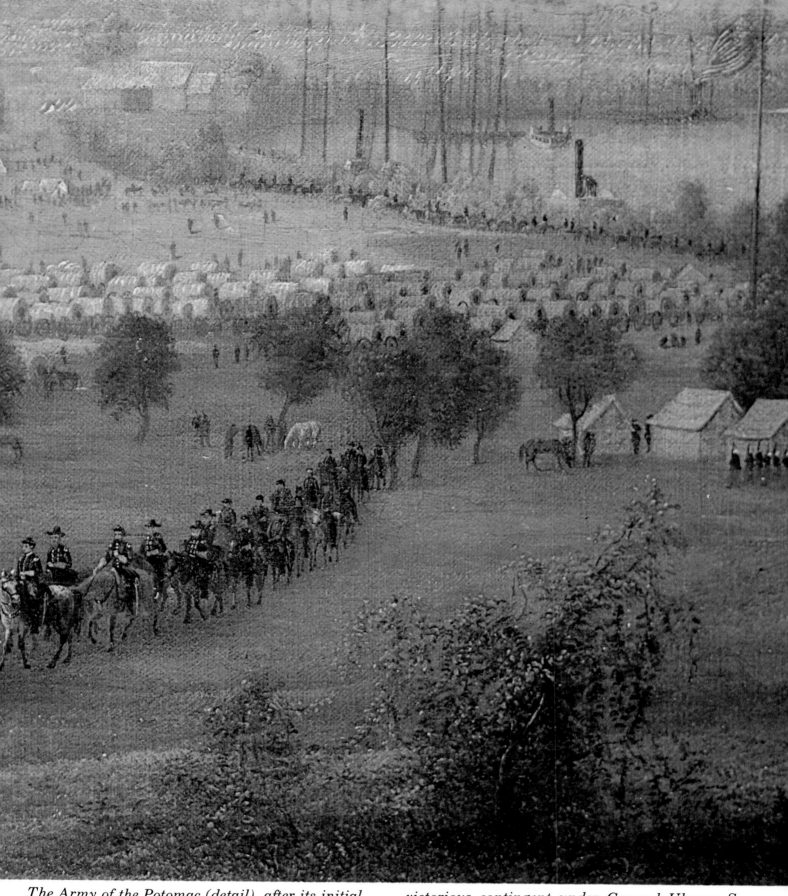

The Army of the Potomac (detail), after its initial defeat at Bull Run, recovered to become a victorious contingent under General Ulysses S. Grant. To this army General Lee surrendered.

no navy, no arsenals nor munitions plants, could possibly offer anything but a token resistance. Union politicians expected a quick and inexpensive victory for what appeared to be sound reasons. They believed that the Confederacy could quickly be squeezed into submission by blockading its eastern and southern ports, and by sending an expedition down the Mississippi River to cut off its Western states. Both of these plans ultimately worked —

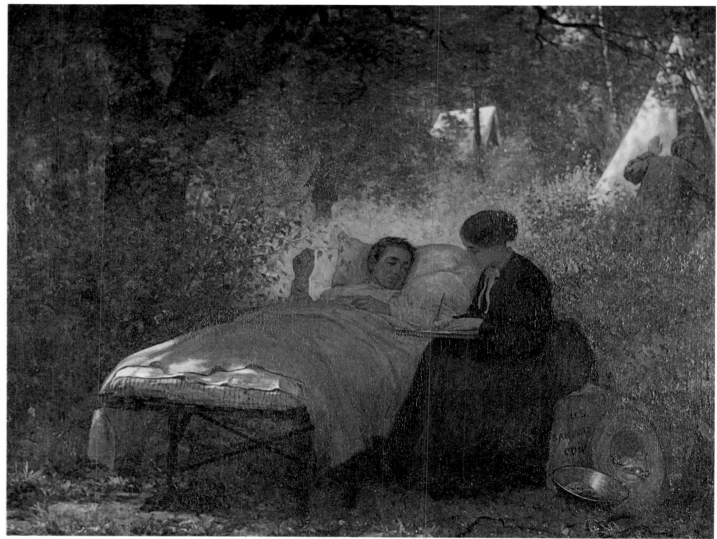

Winslow Homer painted this wounded soldier dictating a letter home in a romantic woodland locale. Women were rarely allowed as nurses, they visited the wounded to read and write letters.

but only after three years of a deadly war.

The North learned quickly that the South could raise as large an army, and as capable as its own, and it also learned, the hard way, that the South could develop a navy. Two major incidents in the early days of the war awakened the North to reality. As the war began the Confederacy made a series of daring raids, seizing the U S Navy's southern installations. The Norfolk, Virginia, yard yielded the beginning of the Confederate Navy, for here the South appropriated the steam frigate *Merrimac*, at least 52 new nine-inch Dahlgren guns and a huge quantity of naval stores and ammunition.

The second lesson was learned only three months after the war began. The Army of the Potomac, numbering 36,000 men, marched out of Washington, D.C. on their way to win the war. Washington society turned out in their coaches to go along to view the battle. A carnival atmosphere was in the air. Onlookers brought picnic baskets and planned to sit on the hillsides for the spectacle that would mark the end of the Confederacy.

But at a pleasant little creek called Bull Run the Federal forces ran into an obstacle. It was a

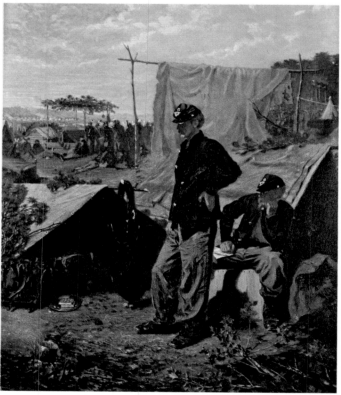

Two soldiers appear bored with army life in this scene by Homer called Home, Sweet Home.

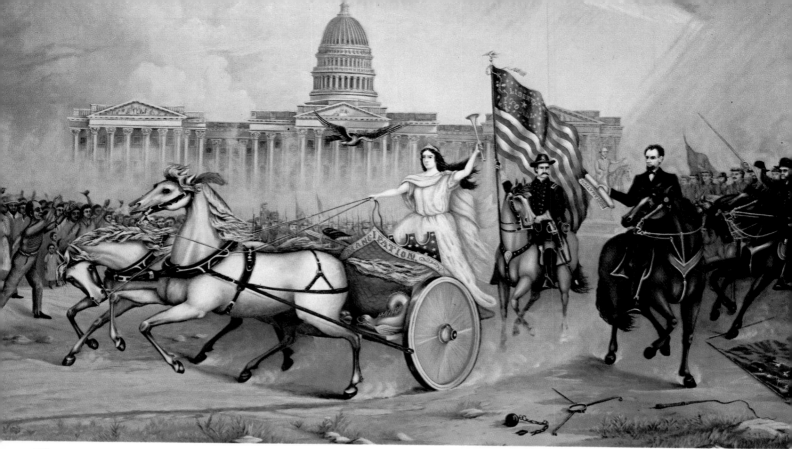

The Union's patriotic emblems are included in this painting of the Emancipation Proclamation.

Slavery was not abolished until the 13th Amendment was ratified in December, 1865.

Confederate force of some 30,000 men, not quite as many as their Army of the Potomac, but led by Generals Beauregard, Albert Sidney Johnston, Kirby Smith and Stonewall Jackson. The Southern generals had worked out a strategy with which to greet the Union Army on its first foray south. Stonewall Jackson waited until the last minute before allowing his hotheaded Southerners to fire point-blank into the Northern ranks, then follow up that advantage with cold steel and the terrifying rebel yell. More troops came in on their flanks, and, then hit from three sides, the Army of the Potomac collapsed. The retreat became a rout. What was left of the Army straggled all the way back to Washington overrunning the panic-stricken civilians in their carriages, with the Confederates close behind. In that one battle the North learned that it was not going to be a quick and easy war. President Lincoln set about finding generals to match the military strategists of the South.

Those strategists, luckily, were not permitted to press their advantage and enter the undefended Northern capital. With breathing space, the North realized that the war was going to be prolonged and bloody. Lincoln called up more men for longer periods of time. He found not one general but three. The first was George B. McClellan whom he assigned to take the demoralized Army of the Potomac and make a first-class fighting force out of it. This McClellan

did, but he also made major errors, lost some important battles and was ultimately removed from command. Later Lincoln found Ulysses S. Grant and William Tecumseh Sherman, and with superior manpower and superior materiel they would finally overwhelm the South.

But the North had other resources. The Union was slow to realize that its greatest asset in the war against the South was the continuing institution of slavery. There were four slave states still in the Union and, even after the defeat at Bull Run, Congress gave notice that the Federal Government would not interfere with slavery. One great molder of public opinion, Horace Greeley, owner-editor of the widely circulated *New York Tribune,* reflected the popular view when he printed a critical letter attacking Lincoln's slavery policy under the title *The Prayer of Twenty Millions.* It was well argued and read in part: ". . . the rebellion, if crushed out to-morrow, would be renewed within a year if Slavery were left in full vigor — that army officers who remain to this day devoted to Slavery can at best be but half-way loyal to the Union — and that every hour of deference to Slavery is an hour of added and deepened peril to the Union."

Four months later Lincoln had made his decision. On January 1, 1863, the Emancipation Proclamation become effective. But it freed only those slaves in states that were rebelling against the authority of the Union.

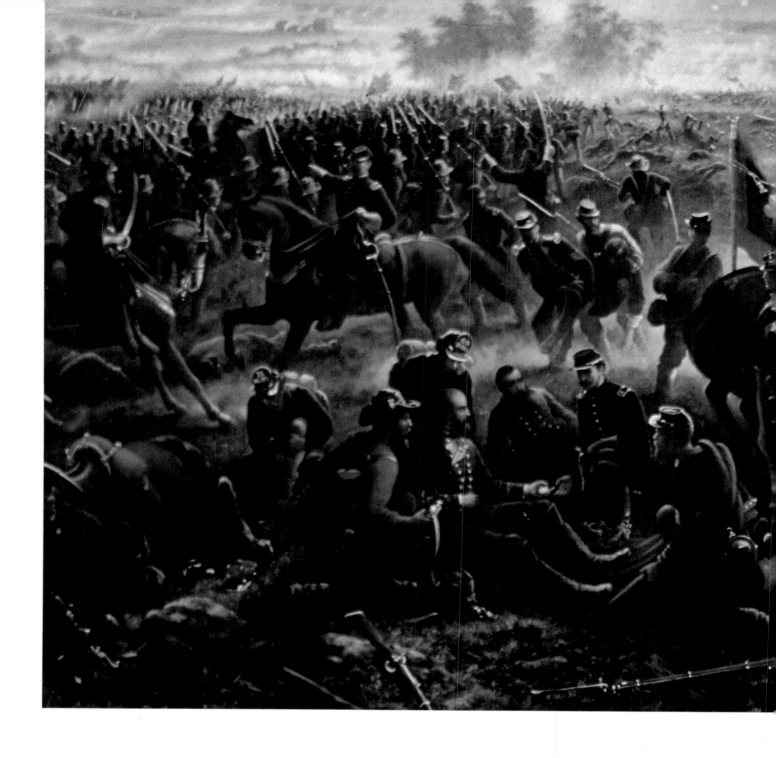

Gettysburg!

In England government leaders were impressed with the Confederate victories at Fredericksburg and Chancellorsville. Napoleon III of France was pressing them to join him in recognizing the Confederacy. But the English hesitated. The Southern emissaries drew the inference that one more major victory would swing the balance.

In addition to these foreign considerations, General Lee believed that a deep thrust into Pennsylvania, if successful, would have powerful effects in the North. President Davis gave permission for the venture, though without the number of troops that the general requested.

As reports reached Lincoln of Lee's northward move, he named General George Gordon Meade to head the Army of the Potomac. The two forces were drawn as though by fate to the pleasant little town of Gettysburg. And there what has become one of the most-studied battles in the history of warfare began on July 1, 1863.

For three days the battle raged. Fire fights erupted in peach orchards, on hilltops, behind old stone walls and up and down grassy hills. On the second day the Confederates made significant advances, and on the third General Lee, taking the calculated risk to win the victory, ordered a frontal attack on the Federal troops on Cemetery Ridge. Led by General George Edward Pickett, ten brigades of some 15,000 men advanced across open country. The Union Army was ready for them. First artillery fired point-blank at the

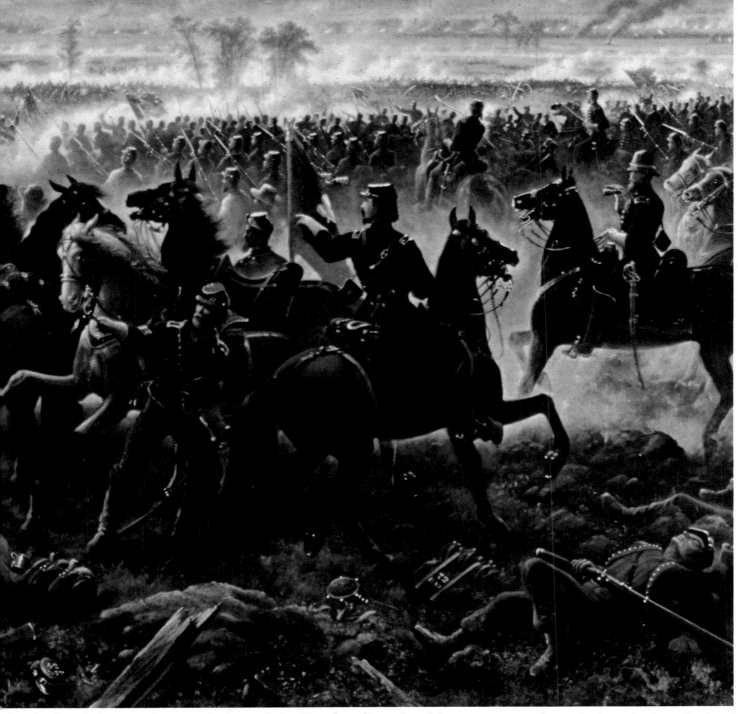

A detail from a huge painting of the Battle of Gettysburg by James Walker shows some of the *battle's carnage and confusion during General Pickett's disastrous charge toward Cemetery Hill.*

advancing gray uniforms, but even as Southern soldiers fell dead and wounded, others pressed on. Now the Union troops on the hill poured small arms fire into the oncoming bodies. So great was the slaughter that two generals and 15 regimental commanders were killed, but still the Confederates advanced. A hundred or so did indeed reach the Union lines, vault a stone wall, and engage the Yankees in hand-to-hand combat. But the effort was as futile as the men were brave, and they were wiped out.

The charge had failed. The Union Army maintained its position, and the Confederate Army, what was left of it, had no choice but to retreat. The most dramatic battle of the Civil War was over, and with it the South's last and greatest chance for victory.

The drama of Gettysburg is effectively captured in this classic war painting by David Blythe.

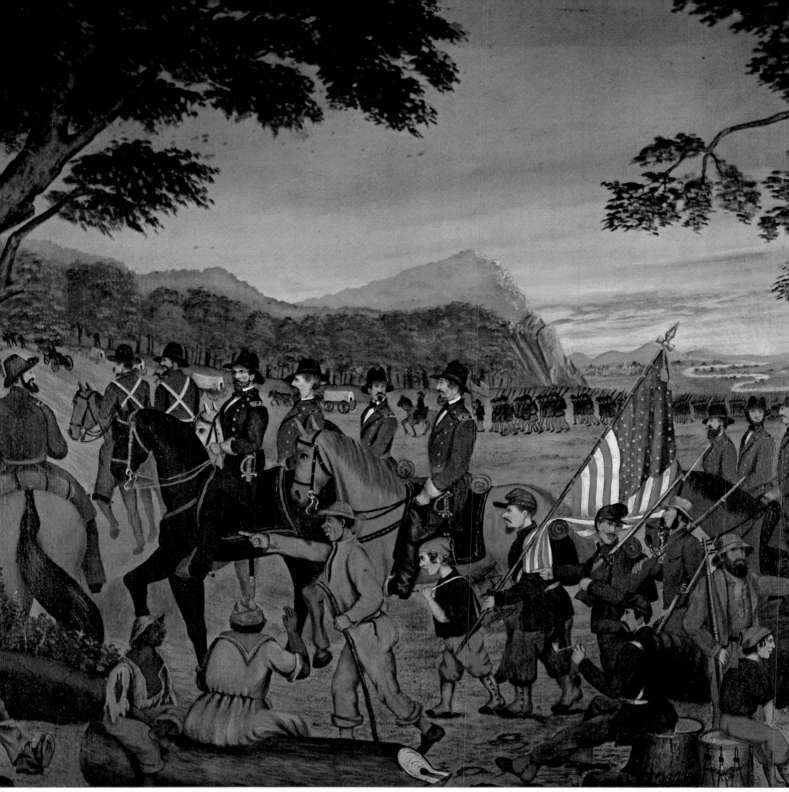

A frowning General William Tecumseh Sherman, mounted on a black horse, marches peacefully through Georgia in this naive painting which shows none of the horrors of war.

The End and the Beginning

The Confederacy was being systematically dismembered as state after state fell before the ever-advancing Union forces. Its ports were blockaded and occupied. Sherman had cut a wide path of destruction through Georgia and burned Atlanta — still the Confederate Army fought on. Some lost ground was regained, but the odds were hopeless.

Now, finally, Davis appointed General Lee commander in chief. Two months later, trapped between Grant and Sheridan, Lee surrendered.

Generals Johnston, Richard Taylor and Kirby Smith also surrendered. President Davis fled, but was captured, and President Andrew Johnson, who had replaced the assassinated Abraham Lincoln, granted amnesty to all who had taken part in the war against the Union.

Lincoln, though he did not live to see it, had kept his promise. He had preserved the Union.

1865-1900
THE GILDED AGE

The South struggles with Reconstruction as radical northerners set up military districts and force new constitutions. The Black Laws are obliterated and the 14th Amendment gives full-scale citizenship to Negroes. The Ku Klux Klan agitates to restore white supremacy. United States buys Alaska from Russia for $7,200,000. Peace and prosperity end in war with Spain. The country is extended when the Philippines, Hawaii, Puerto Rico and Guam are annexed.

HISTORICAL CHRONOLOGY	ART CHRONOLOGY
1865 Ku Klux Klan first formed in Tennessee.	**1865** First Department of Fine Arts in a U S college opens at Yale.
1866 Civil Rights Act grants citizenship to all born in U S except Indians.	**1867** Horatio Alger publishes his first boys' rags-to-riches book, Ragged Dick.
1866-69 14th and 15th Amendments guarantee Blacks civil rights and the vote.	**1868** Louisa May Alcott publishes Little Women.
1867 U S purchases Alaska for $7.2 million.	**1868** Susan B. Anthony founds suffragette newspaper, The Revolution.
1868 President Andrew Johnson impeached and acquitted by one vote. 14th Amendment grants citizenship to Negroes.	**1870** Thomas Eakins returns from Europe to begin his painting career in Philadelphia.
1869 First transcontinental railroad completed.	**1876** Mark Twain's Adventures of Tom Sawyer is published.
1871 Election of reform candidates breaks up the Tweed Ring in New York City.	**1877** Thomas A. Edison patents the phonograph, followed in 1891 by motion picture camera.
1872 Grant defeats Horace Greeley for President.	**1879** Boston Museum of Art opens.
1876 General George Custer and his entire force killed at Battle of Little Big Horn.	**1880** Joel Chandler Harris publishes Uncle Remus: His Songs and Sayings.
1881 President James A. Garfield, assassinated less than four months after inauguration, is succeeded by Chester A. Arthur.	**1885** Winslow Homer begins painting in Maine.
	1886 The Statue of Liberty is unveiled.
1882 Chinese Exclusion Act prohibits immigration for ten years.	**1888** George Eastman perfects Kodak hand camera, making possible first amateur photography.
1886 Capture of the Apache chief Geronimo ends the Indian Wars.	**1890** Poems of Emily Dickinson published. William James' Principles of Psychology revolutionizes field.
1889 Oklahoma land rush.	
1896 In Plessy vs. Ferguson, Supreme Court upholds "separate but equal" doctrine.	**1893** Stephen Crane, at 23, publishes Red Badge of Courage.
1898 Spanish-American War begins with explosion of battleship Maine in Havana harbor. Theodore Roosevelt and his "Rough Riders" capture San Juan Hill enroute to other victories. War ends same year.	**1896** Frederic Remington paints Indian Village Routed.
	1900 Theodore Dreiser publishes his first novel, Sister Carrie.

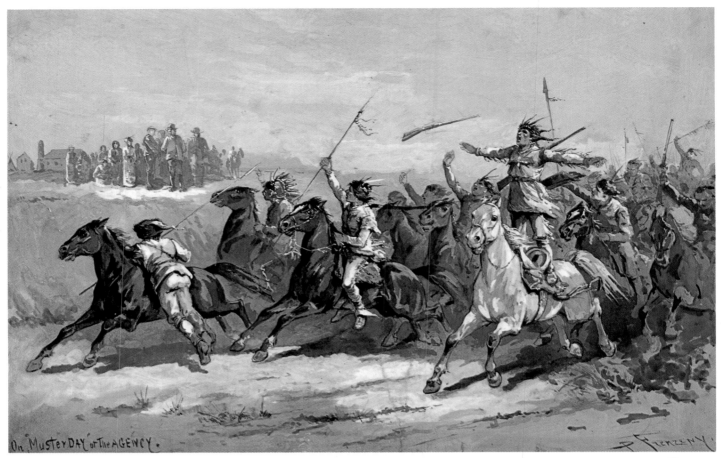

All was not war and reprisal. On Muster Day at the Agency *illustrates a peaceful display.*

Black Kettle's camp is shown under attack by Custer, inside the circle; outside, Arapaho,

Kiowa and Commanche launch a counterattack. The soldiers at upper right were all killed.

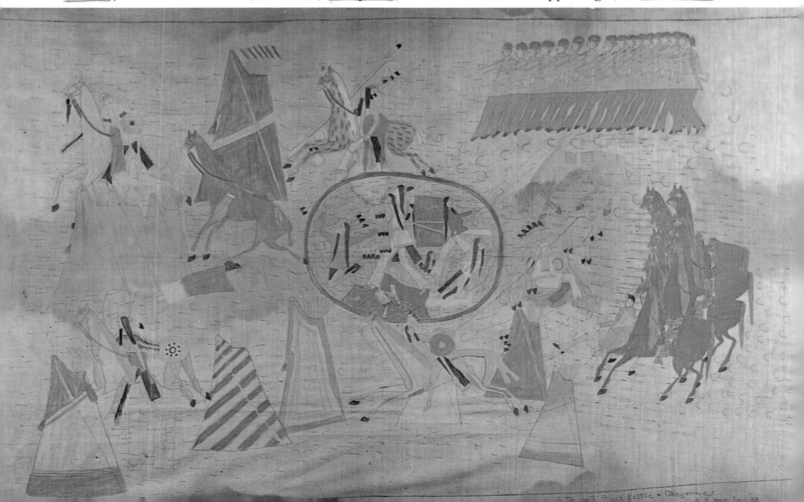

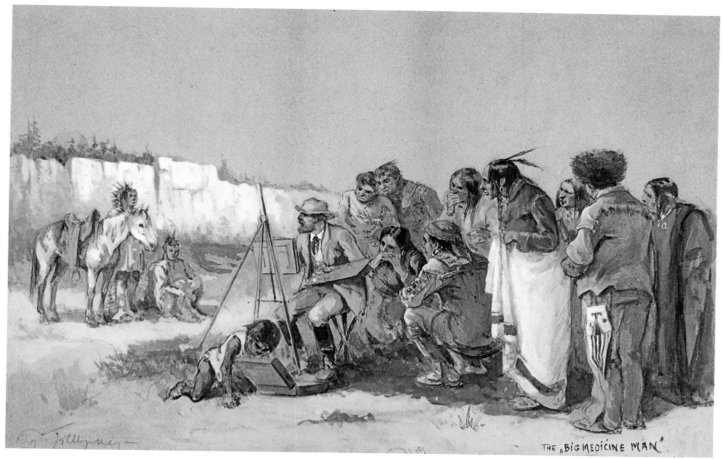

Artist Paul Frenzeny found the Indians made always interesting and usually willing models.

Fall of the Indian Nations

The destruction of the Indian nations was not the result of preplanned colonization and exploitation by a foreign country as was the European colonization in Mexico and South America. It was a massive, historic movement of peoples seeking escape from various forms of oppression and personal failure which they had experienced in the Old World. Its distinguishing marks were the rapidity of the influx of newcomers (especially in the latter half of the 19th century), and the great contrast between their values, customs and technology and those of the Indians. These were some of the factors that made assimilation impossible, and brought about the bitter Indian Wars.

The history of Chief Joseph and his leadership of the Nez Percé is not particularly significant from a numerical point of view, for the entire tribe consisted of only about 3,000 Indians, but it illustrates the total misunderstanding by the whites of the Indians' needs.

The Nez Percé had refused to participate in the 1863 treaty that ceded the Wallowa Valley (located at the intersection of the present states of Idaho, Washington and Oregon) to white settlement. But as pressure increased for the tribe to vacate the area, Chief Joseph reluctantly agreed, in the spring of 1877, to move his people onto the Lapwai Reservation. As they were preparing to leave, white settlers stole several hundred Appaloosa ponies, the Indians' most-prized possessions. The pacific leader was unable to restrain his people any longer; they killed 18 settlers, and war began. Fighting a running campaign over 1,000 mountainous miles for four months, consistently outmaneuvering several Army generals, Chief Joseph and his braves got to within 30 miles of the Canadian border before they were forced to surrender in the fall of 1877.

In the terms of the surrender, Chief Joseph was promised he would be allowed to return to the Lapwai Reservation, a promise the Government failed to keep. Instead, the chief was sent to the Indian Territory of Oklahoma where his six children and most of his band died. In 1885 the chief and the remaining members of his tribe were sent to northern Washington.

During the Civil War years, troops who were stationed at frontier garrisons to protect settlers against Indians were transferred to duty in the national conflict. This meant that some frontier posts were left without sufficient protection. In 1862, for instance, more than 350 whites

(continued on page 222)

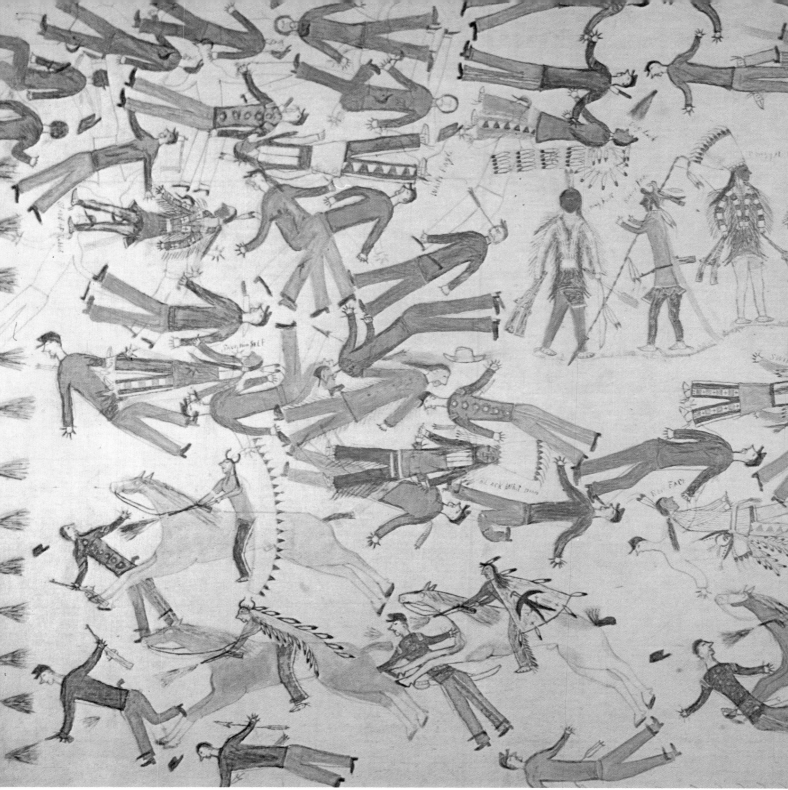

End of Battle of Little Big Horn, June, 1876.
Custer, in yellow buckskin, lies beside hat. There
were no white survivors. Lower right, women
prepare ceremony for returning warriors.

Custer's Last Stand

Six years elapsed between what might be called Lieutenant Colonel George Armstrong Custer's first stand and his last. In 1868 he was under orders to attack the village of Cheyenne chief Black Kettle on the Washita River in southern Oklahoma. Black Kettle was killed, but warriors from nearby Comanche, Arapaho and Kiowa villages engaged in a fierce counterattack.

Custer withdrew, leaving behind 19 men whom he had dispatched to take prisoners. Cut off from their retreating comrades, all 19 were killed.

The Indian Wars reached a climax after the discovery of gold in the Black Hills of South Dakota, for although the region had been granted to the Sioux, the Government wanted to buy it back for $6 million. The Sioux knew what they could do with the land and its game, but not what they could do with the money. They refused, but white miners were venturing into the hills on their own, and getting themselves

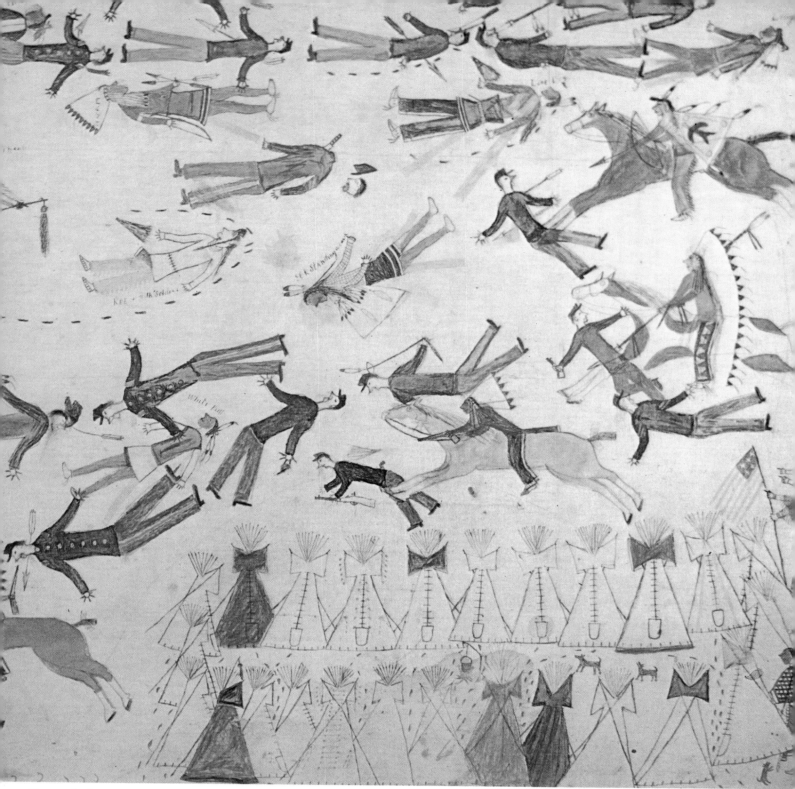

From left to right the four standing men are: Sitting Bull, Rain-in-the-Face, Crazy Horse, *artist Kicking Bear. Gall, deemed unworthy due to friendship with whites, was left out.*

killed. They appealed to the Army for protection. After a number of small battles, the Indians won a victory against General George Crook.

Meanwhile, Custer's success as an Indian fighter had become almost legendary among whites and Indians alike, but each group has its own version of his final defeat. The Indian version has it that two major tribes, the Hunkpapa Dakota (Sioux) and the northern Cheyenne, led by Crazy Horse and Sitting Bull, met for a peaceful powwow to locate and follow the buffalo on their fall migration. While the

Indians were gathered together, they were attacked by Long Hair (their name for Custer) and 215 of his men. The Indians, according to their account, defended themselves and wiped out the small Custer troop.

The white version says Custer divided his men into units in an attempt to surround the Indian village. The Indians, flushed with their previous victory over General Crook, surrounded their "undefended" village to ambush Custer when he attacked. In any case, there were no survivors in Custer's party to verify either story.

(continued from page 219)

were killed in the Minnesota Uprising of the Santee Sioux.

Similar events took place in the Arizona and New Mexico territories with the Apaches regaining almost complete control of the region. In 1863 a campaign against the Apaches began. The usual white man's strategy of rounding up and imprisoning all the Indian warriors, burning the Indian crops and slaughtering their livestock was useless against the Apaches who were expert guerrilla fighters. Raiders led by Geronimo terrorized the settlers and escaped to the inaccessible hills of Mexico.

Finally in 1886, General Nelson A. Miles captured Geronimo and the remaining hostiles. They were sent to Florida as prisoners, then transferred to Alabama, and finally to Oklahoma. Those who were still alive in 1913 were set free.

In 1889, the Ghost Dance was introduced on the Pine Ridge and Rosebud Reservations in South Dakota. The dance was performed to bring about the return of dead ancestors and the vanishing buffalo, and to make the white man disappear. White reservation officials forbade the Indians to perform the dance, and when they persisted in the ritual it brought on further conflicts that led to the arrest and shooting of Sitting Bull, and to the flight of Big Foot's Band. The desperate group (over 200 men, women and children) was captured and massacred by 500 soldiers at the now famous Wounded Knee Creek in South Dakota. The massacre seems to have occurred following a skirmish that took place when an Indian refused to give up a rifle hidden beneath his blanket. The 500 soldiers opened fire with four Hotchkiss guns sighted on the captives. The grotesque shapes of the frozen corpses that protruded from the Wounded Knee snows of 1890 were a grim postscript to the defeat of the American Indian.

The Indians, as a major group of organized warriors, were defeated. Now the Government, possibly with good will, passed the Allotment

Remington painted mostly in the 80's and 90's. This one was called Indian Village Routed.

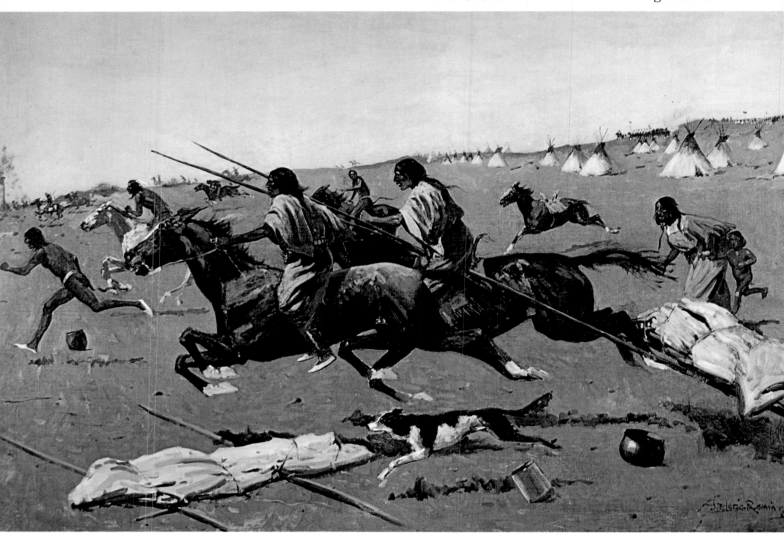

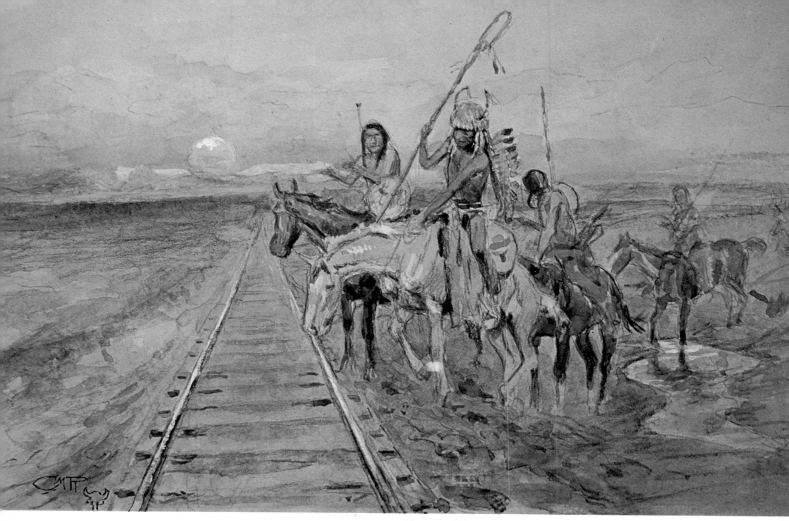

Russell's Trail of the Iron Horse *contrasts whites' progress with traditional Indian ways.*

Act. This Act, simply stated, meant that tribes were to return their reservations to the Government; the reservations would then be cut into single farm sizes of from 10 to 640 acres, to be allotted to individual Indians. After these divisions were finished, the acreage left over was to be purchased from the tribes and opened to white ownership. The purpose was to transform Indians into small farmers and thus assimilate them into the economic and social systems. But the Indians had no experience in farming, no economic resources, and it was not long before many of them had sold or leased their land to white farmers. The system turned out to be a windfall for land speculators and the ever-increasing number of white settlers. It was 1934 before the Indian Reorganization Act reversed these policies.

The coming of the railroads destroyed the Indians' hopes of ever regaining their traditional hunting grounds. For the railroads brought first hundreds, then thousands, of new settlers, many of them immigrants just arrived from the Old World. At first the Indians reacted by attacking railroad workers, but the trains went through; farms, villages and cities grew up along the tracks, and the Indians' hunting grounds faded away.

Spanning the Continent

The purchase of Alaska from Russia in 1867 marked the end of the era of large scale territorial expansion; now efforts were directed toward linking the newly settled areas with the East. Although both transportation and communication continued for some time to be dependent upon the horse, the locomotive and telegraph line gradually became predominant during the latter half of the 19th century.

The locomotive had been in use in the East since 1830, but did not have the speed to outdistance a good stage team, nor the power to mount steep grades, which were both prerequisites for the use of the railroad in the West. Trains were slow enough to inspire Samuel Clemens' ironic suggestion that the cowcatcher should be attached to the caboose to keep the animals from running into the train! But technology was advancing rapidly, and shortly before the turn of the century *Locomotive 999* would make the world's first 100-mile-per-hour run. Given a viable locomotive, the long and

223

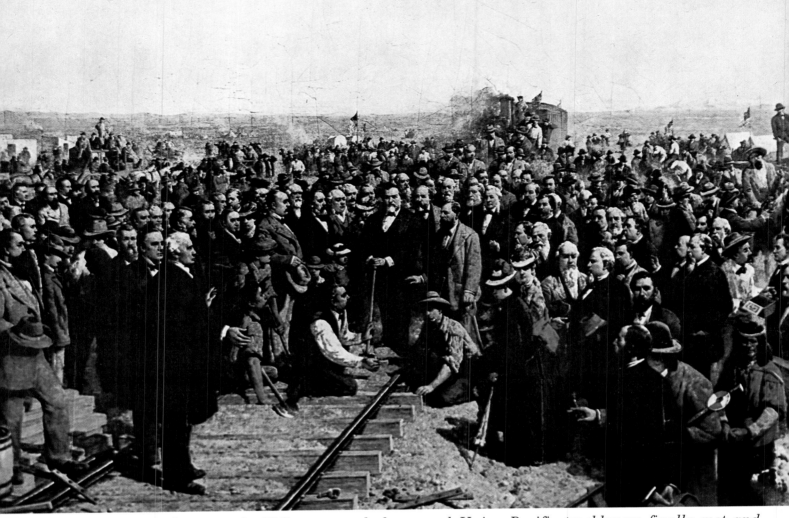

The first railroad across the U.S. was marked by the driving of a golden spike when Central *and Union Pacific tracklayers finally met and joined their rails at Promontory Point, Utah.*

expensive task of purchasing land, blasting through mountains, grading hillsides, constructing bridges and transporting thousands of ties, rails and spikes could begin.

Within three months after the final shots of the Civil War were fired, the first rail of the Union Pacific had been laid in Nebraska. As its workers, consisting mainly of discharged soldiers and Irish immigrants, advanced westward, the Central Pacific built eastward from Sacramento with its crew of Chinese tracklayers. The two lines met at Promontory Point, Utah, on May 10, 1869.

Private investments in railroads doubled every decade from 1860 until the end of the century, and both the Federal Government and municipalities encouraged railroad construction. By 1890, four railroad lines spanned the continent, and local lines multiplied.

Railroad construction produced large fortunes. Cornelius Vanderbilt, who had already made millions in steamboating, did not turn to railroad investment until his late sixties. He accumulated a fortune of $100 million. A number of scandalous cases of fraud and graft were connected to railroad construction in the 60's and 70's. Jay Gould, Jim Fisk and Daniel Drew printed and sold $6 million worth of illegal stock

for the Erie Railroad. Gould bribed the Albany Legislature to legalize the transaction. William Marcy Tweed, better known for his large scale theft of public monies and bribery of leading New York politicians, was an asset to the unscrupulous direction of the Erie Railroad. He supplied his associates with corrupt judges. With the combined loot from the Erie affair and from a successful attempt at controlling the price of gold (with the help of President Grant's brother-in-law) Gould pooled $23 million. He then plunged heavily into the transportation and communication business, buying the Union Pacific Railroad, Western Union, and the elevated railroad of New York City.

The Crédit Mobilier Railroad Construction Company tapped the Treasury for $23 million with the help of several congressmen. Obviously, although the cost of congressional graft was high (lobbyists for the Central Pacific Railroad spent from $200 to $500 thousand per legislative session) profits from the financial-legislative "entente cordiale" were even higher. Vice-President Schuyler Colfax was bribed to ward off investigation into the Crédit Mobilier affair, in exchange for free stock that paid 625 percent dividends yearly.

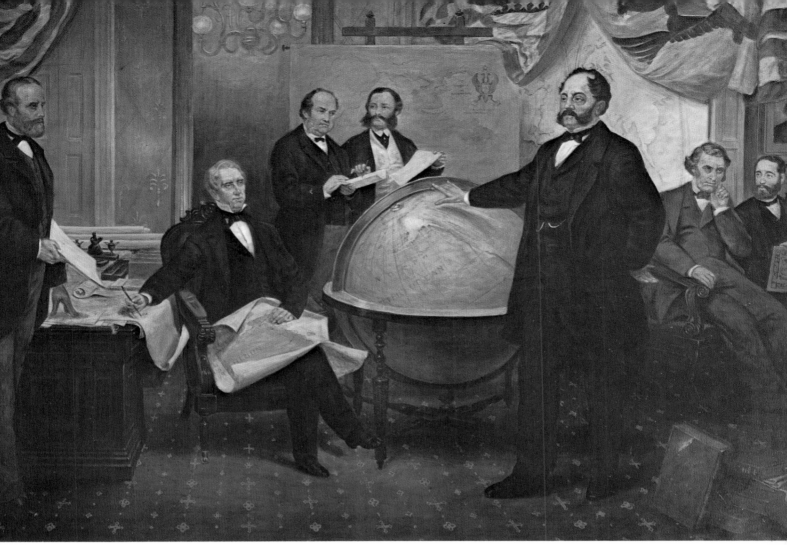

Seward, American Secretary of State, holds pen inviting Russian, touching globe, to sign the con- *tract of 1867 selling Alaska to the United States for $7,200,000 – under two cents an acre.*

The telegraph had proved its usefulness during the Civil War. The first transcontinental telegram, sent in 1861, had assured President Lincoln of California's loyalty to the Union. In 1866, by laying the first successful transatlantic cable, Cyrus Field extended the telegraph's range to Europe. Ten years later, Alexander Graham Bell was working on an instrument he thought would make it possible to send several telegrams at the same time. He failed, but accidentally hit upon the device that was to become the world's first telephone. Perhaps as significant as any of the technological improvements made on the telephone was the substitution of females for males at the switchboard. The latter were less efficient, and tended to shout impatiently at customers.

Not until the concluding decade of the century did the first gasoline-powered automobiles make their appearance; first came the Duryea, then the Ford and finally the Packard. But the electric car was more popular than the noisy gasoline-powered vehicle because it did not frighten horses, required no cranking and was faster. The *Electrobat* won a race against the Duryea brothers' automobile in 1895, by attaining a speed of nine miles per hour. Vermont's law of

Seasonal seal hunting in the Aleutian Islands was profitable enough to engage a small fleet.

1894 scarcely hindered the automobile's progress; it stated that no car could be driven on a public highway unless someone else walked ahead to warn oncoming traffic.

Because electricity was presumed to be a more promising source of transportation power than gasoline, by 1890 fifty cities were using F. J. Sprague's electric trolley, and New York City boasted 300 electric battery-powered taxicabs.

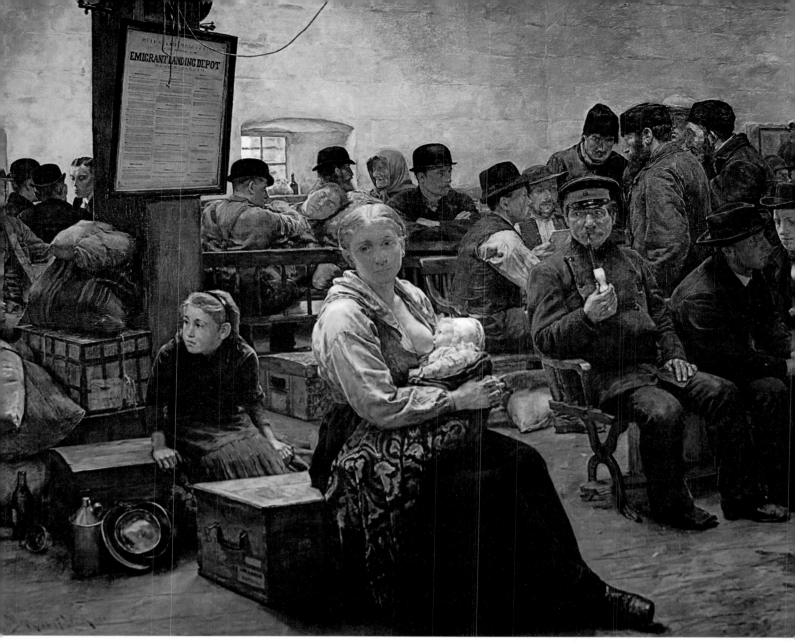

Castle Garden, New York was the port of entry to the U.S. for millions of European immigrants.

"Give me your tired, your poor"

Increasingly throughout the 19th century, immigrants were arriving from Europe. But the increase was not steady. It dropped sharply after the depressions of 1873 and 1892, and in the 1880's there was a definite shift in the nationalities involved.

A potato blight that hit Ireland in the 40's and Germany in the 50's set off a wave of immigration to the United States that peaked five years before the Civil War. These two ethnic groups often aroused political resentment in the U.S. because they tended to settle in small areas of cities and vote in blocks, making their votes decisive in city politics.

The Scandinavians generally encountered less resentment, because they settled in more sparsely inhabited areas and plied a larger variety of trades. They were often skilled fishermen, lumberjacks and carpenters. The Asians, who settled on the West Coast, met with more hostility than any other group, partially because of their racial difference, but also because organized labor objected to their willingness to work for low wages.

In the 1880's, with the "new immigration" from southern, central and eastern Europe, the trickle became a flood. Instead of thousands, millions of Italians, Poles, White Russians, Armenians, Yugoslavs, Croats, Hungarians, Greeks and East European Jews poured through the gates of Ellis Island seeking freedom from peace-time military draft, political and religious oppression and poverty. To the new country they brought both unskilled and skilled labor. Even though many kept to their traditional ways, they all wanted to become Americans — and they did.

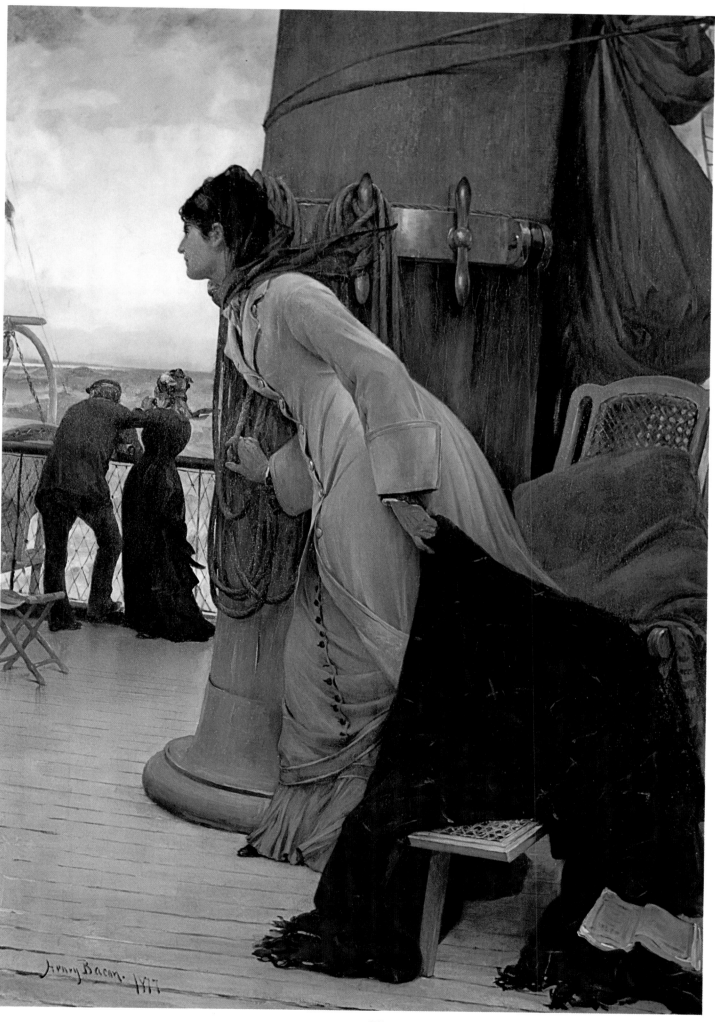

First sight of land! Some European immigrants could afford quite comfortable accommodations.

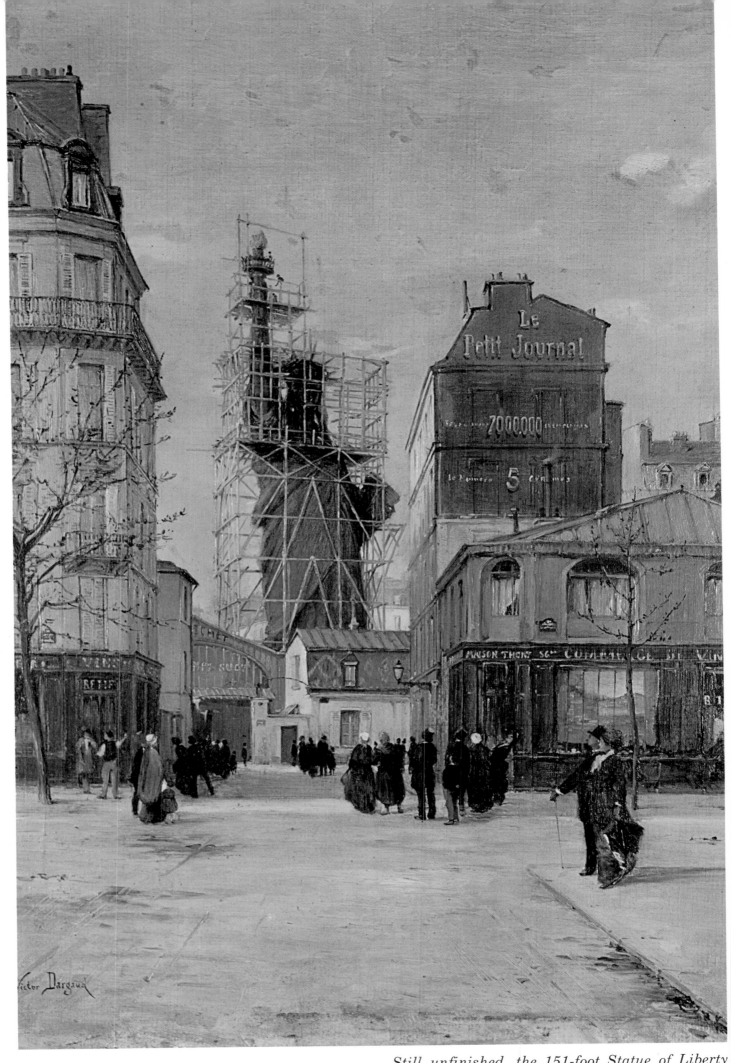

Still unfinished, the 151-foot Statue of Liberty rises beside sculptor Bartholdi's Paris studio.

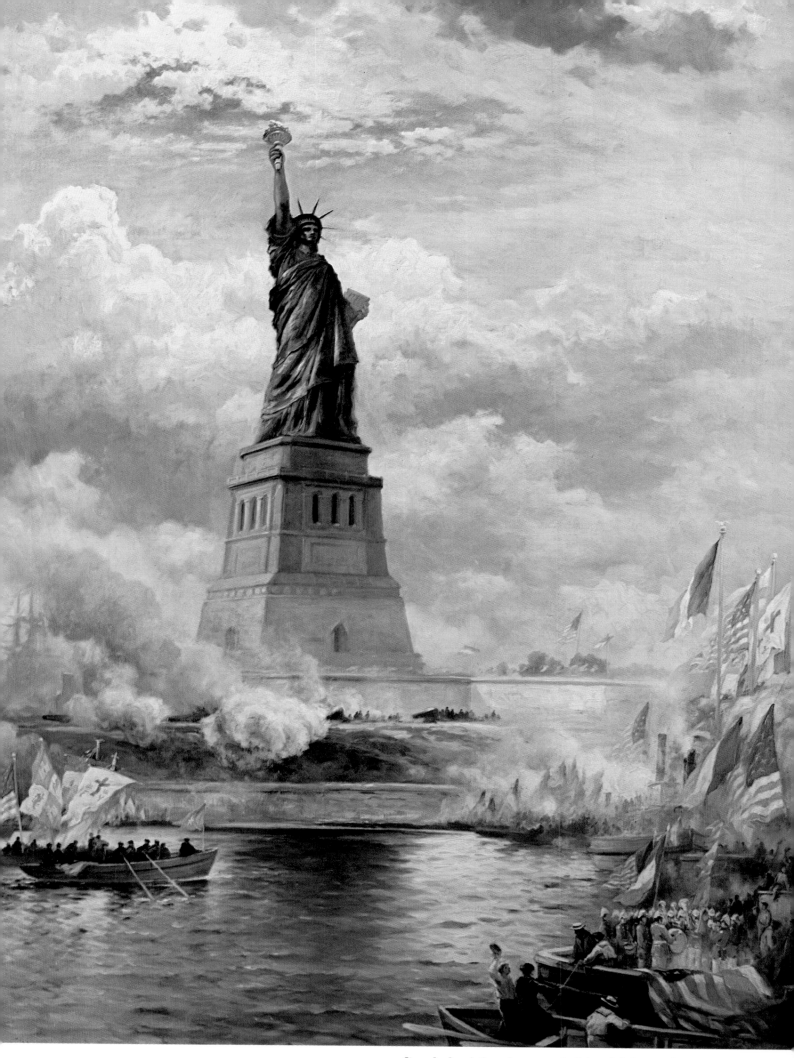

Symbol of freedom and friendship with France,
Miss Liberty was unveiled October 28, 1886.

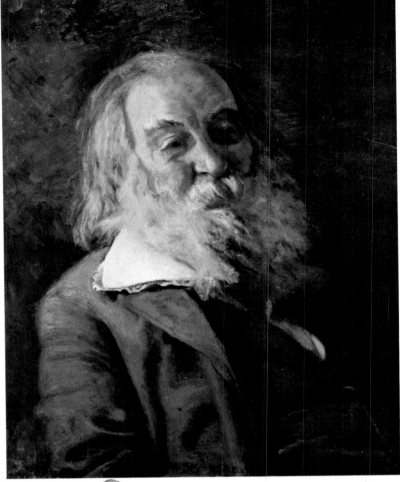

*The 68-year-old Whitman, by Thomas Eakins.
The poet had already undergone a severe stroke.*

Walt Whitman

"I sound my barbaric yawp over the roofs of the world," exclaimed Walt Whitman in the concluding lines of "Song of Myself," thereby founding a distinctly American tradition in letters. He had succeeded in capturing the brash spirit of the New World.

Whitman is essentially a man of one book. From a slender volume of 12 poems in 1855, *Leaves of Grass* flowered into a large anthology containing over 900 pieces in the 1892 "Deathbed" edition. Sometime between 1850 and 1855, Whitman chose to become the rough-hewn champion of nature, singer of heroes and of derelicts, the prototype of the untutored bard. To launch this image, Whitman, whose previous career (as editor of the *Brooklyn Daily Eagle* and undistinguished author of a sentimental temperance novel) contained little to inspire the public's imagination, wrote his own unsigned reviews in this immodest vein:

"Of pure American breed, large and lusty — age thirty-six years — never once using medicine — never dressed in black, always dressed freshly and cleanly in strong clothes. . . ."

But Whitman beat his own drum to no avail. The first edition, which was published at the author's own expense, did not sell, and by 1857 he was back to editorial work, this time for the *Brooklyn Daily Times*.

With the exception of a laudatory note from Ralph Waldo Emerson, critics initially condemned *Leaves of Grass*. But Whitman's enthusiasts slowly became more numerous than his detractors, although the former tended to exalt his work en bloc, and to equate the author with it. After 1860, female admirers of his poetry occasionally offered him their bodies as well as their souls, but the poet prosaically replied that "the actual W. W. is a very plain personage and entirely unworthy of such devotion."

The last years of Whitman's life were marked by increasing fame, infirmity and poverty. Samuel Clemens and Oliver Wendell Holmes joined with other admirers to present the almost indigent poet with a horse and buggy. After several paralytic strokes during the last 20 years of his life, Whitman died on March 26, 1892.

Though never acclaimed as such during his lifetime, Whitman thought of himself as the poet of the American spirit. He did not think of himself solely, nor even preponderantly, as a national poet, despite numerous poems on President Lincoln and the Civil War. His insistence on the self's uniqueness, the worth and native genius of the individual mind, on the one hand, and his enthusiasm for the common cause of collectivities on the other, make his poetry the clearest expression of the spirit of democracy.

The founding of the Museum of Fine Arts in 1870 confirmed Boston's role as a cultural center.

The Passing of the Gilded Age

Mark Twain dubbed the generation to which he belonged "The Gilded Age," thereby immortalizing the postbellum hybrid of glittering dreams, gaudy tastes and rapid reversals of fame and fortune. Full of railroad barons and captains of industry in the North, a gallantly dispossessed aristocracy in the South, Easterners who looked down their noses at uncultured Westerners who in turn distrusted New York bankers and Philadelphia lawyers, and disdained greenhorns and city-slickers, it was a period that was united politically but had not yet evolved a way of talking to itself about itself. Blind to the present, the nation tended to see the future through the eyes of the past, and awaited the only art form capable of delivering it from its superannuated reveries: American realism. But Romanticism, though abandoned by the more serious authors, was far from dead. Horatio Alger's "rags to riches" novels

A witty but serious critic of "the damned human race," author Mark Twain scrutinized his era.

231

It was fashionable in the late 19th century to take leisurely cultural cruises to the Mediterranean.

were the best-selling books of the era. They satisfied the common aspiration, dreamed the American Dream.

Realism, the antidote for crass, nouveau riche Victorianism and neo-Romanticism, was reflected in much of the literature of the period.

Incomparable depiction of day-to-day speech with its colloquial twists and local intonation, peculiarities of dress, humor, hypocrisy, deceit and self-delusion — shot through with ironic insight and awkward situations baring the nature of the human animal, yet graced with the overriding absolution of wit — such was the gift that Samuel Langhorne Clemens bestowed upon a receptive public. Appearing during the 70's and 80's, *The Gilded Age, The Adventures of Tom Sawyer, The Adventures of Huckleberry Finn* and *Life on the Mississippi* soon established their author's international fame under the pseudonym Mark Twain.

The poles of the political spectrum were Herbert Spencer's "survival of the fittest," social Darwinism and laissez-faire "constructionism" on the right, and, on the left, a host of emerging social critics pushing for regulatory legislation, backing organized labor and reading utopian literature. One of the most popular works of this type was Edward Bellamy's *Looking Backward*

(1888), a lucid exposition of why the rich get richer, followed by a somewhat less convincing solution to the "labor question," as it was then called. The rich were in fact getting richer, but Andrew Carnegie rather confused the dialectic by leaving nine-tenths of his $300 million fortune to libraries, schools and peace research organizations. Oil-rich John D. Rockefeller had begun making donations for public purposes that would well exceed a half billion dollars.

Realism found new psychological realms beneath the pen of novelist Henry James. Creating an objective correlative for his own inner world as American emigré to Europe, James lived vicariously through the personages of his early novels *The American, Daisy Miller* and *Portrait of a Lady*. His three last works, *The Ambassadors, Wings of the Dove* and *The Golden Bowl* equal the great 19th-century Russian novels in exploring the less accessible portions of the human psyche.

The novelist's brother William James, younger by one year, laid the foundations of American psychology with his renowned *Principles of Psychology* in 1890. Soon afterwards he turned toward philosophy and founded "pragmatism," a school of philosophical thought that equates the truth of an idea with how well it works.

*Jules Harder, first chef of Palace Hotel, with a
fresh lobster from the Bay of San Francisco.*

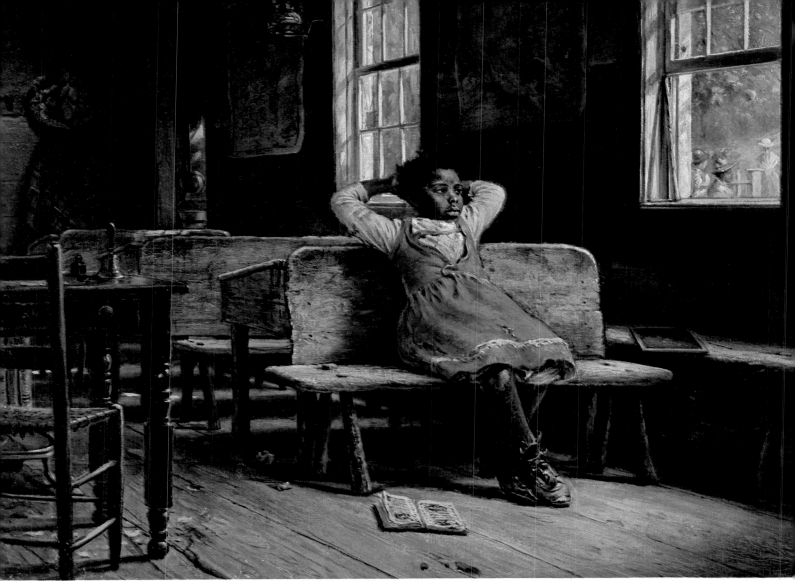

Negro schools were still new to some regions in 1888 when Edward L. Henry painted Kept In.

Reconstruction and the Negro

If Abraham Lincoln had lived, he probably would have continued his firm but slow-moving policy for change in the crushed Confederacy. But Democratic Vice-President Andrew Johnson, who acceded to the Presidency in the early months of Lincoln's second term, soon antagonized Congress by his overly conciliatory attitude toward Southern politicians.

Johnson unwisely left the issue of Negro suffrage up to the discretion of the individual states. The newly established Southern Governments instituted "Black Codes" that denied the Negro the right to vote, deprived him of equal legal status and set up new vagrancy laws that subjected him to indenture if unemployed.

The prevailing Congressional opinion, manifested in the Reconstruction Act of 1867, was that the South was conquered territory, possessed no lawful government and was subject to Congressional rule. Congress divided the South into five districts to be governed by generals, it established the Freedmen's Bureau to help start Negro schools and ratified the 14th Amendment to grant at least technical legal equality to the four million ex-slaves who had been freed.

The white Southerners responded to the occupation by lynching blacks, using Ku Klux Klan terror tactics, employing administrative foot-dragging and by myriad forms of covert but efficacious resistance. By 1877 all of the Reconstruction Governments had disintegrated in the South, and the last Federal troops had been withdrawn.

With or without Northern protection, the Negro's plight remained much the same. Granted suffrage but lacking education, he was an easy political pawn for carpetbaggers (opportunist Northern politicians in the South) and scalawags (Southern white Republicans) out to capture the Negro vote by fair means or foul. And the reality of his economic dependency could

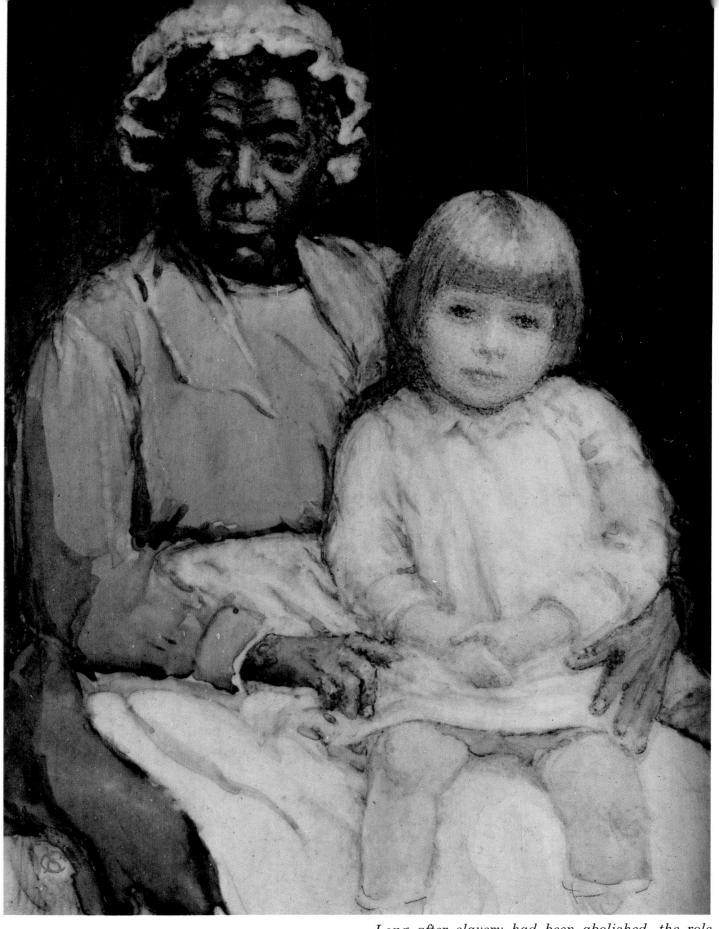

Long after slavery had been abolished, the role of the negro "mammy" endured in the South.

not be legislated away.

Before the turn of the century, separationist practices became the established norm in the South, and to a lesser degree in the North. A Supreme Court decision in 1896, originally concerning transportation facilities, but subsequently interpreted as applying to all public facilities, opened the "separate but equal" era of legal policy. In fact, separation, not equality, became the rule.

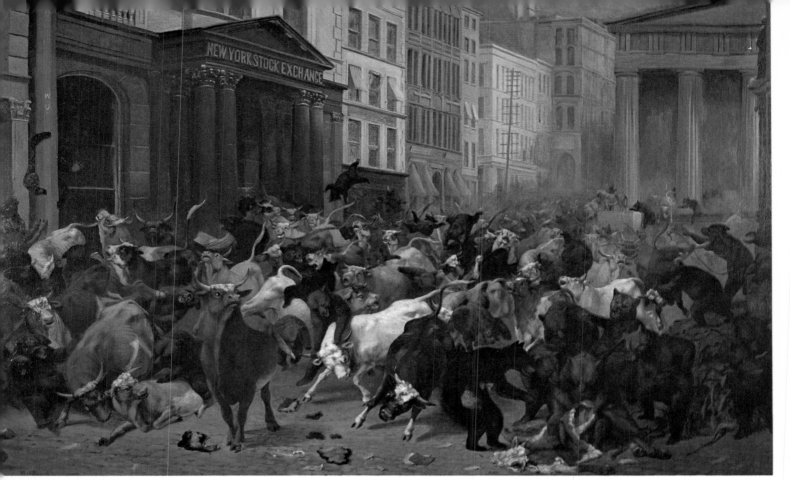

The allegorical Bulls and Bears in the Market *was painted in 1879 when Wall Street rallied* *after a six-year depression. "Bulls" attempt to drive the prices up, "bears" to lower them.*

Capital and Labor

In the 19th century, a man with money to invest often listed himself in the phone directory as a "capitalist." Without him, the rapid industrialization of America would have been impossible. The sums needed to construct railroads and factories were so large that individual capitalists increasingly pooled their resources to form new corporations. Taxes were low, and aimed at landowners rather than stockholders. The laissez-faire Government policy encouraged open competition, and when Washington did intervene in the economic arena it was mainly in order to protect domestic industry against foreign imports. The militia's traditional role, to protect private property, naturally ranged it on the stockholders' side in labor disputes. In this era before antitrust laws, anti-pollution laws, corporate taxes, unemployment benefits and effective labor unions, investment skyrocketed.

Stimulated by the proliferation of telegraph lines, the electric stock ticker and possibly by the laws against other forms of gambling, stock market speculation also began to flourish. By the end of the 1880's Wall Street had become the undisputed center of the nation's financial structure. During these years there was no lack of dubious practices such as manipulating prices (by "cornering a market" through pooling of resources among stockholders) and speculation by exchange agents themselves (who for their own profit would postpone action on their customers' orders, sometimes indefinitely). There were occasional panics, usually followed by speedy recoveries, as was the case of the 1869 panic; but the panic of 1873 touched off a depression that lasted six years.

As capital accumulation snowballed into large fortunes (in the hands of the Vanderbilts, the Astors, Jay Gould and about 3,000 millionaires), labor organizations, such as the Knights of Labor and later (by 1886) the American Federation of Labor, began meeting and negotiating successfully with management. A bomb-throwing incident at Haymarket Square in Chicago on May 4, 1886, (which began as a demonstration for the eight-hour day and ended in bloodshed) constituted a temporary labor-management reversal. The incident produced an unfortunate association between the labor movement and anarchism in the mind of the public. But by the end of the century, the American Federation of Labor, under the judicious leadership of Samuel Gompers, had absorbed the Knights of Labor affiliates, increasing the AFL's membership to over half a million and paving the way to better working conditions.

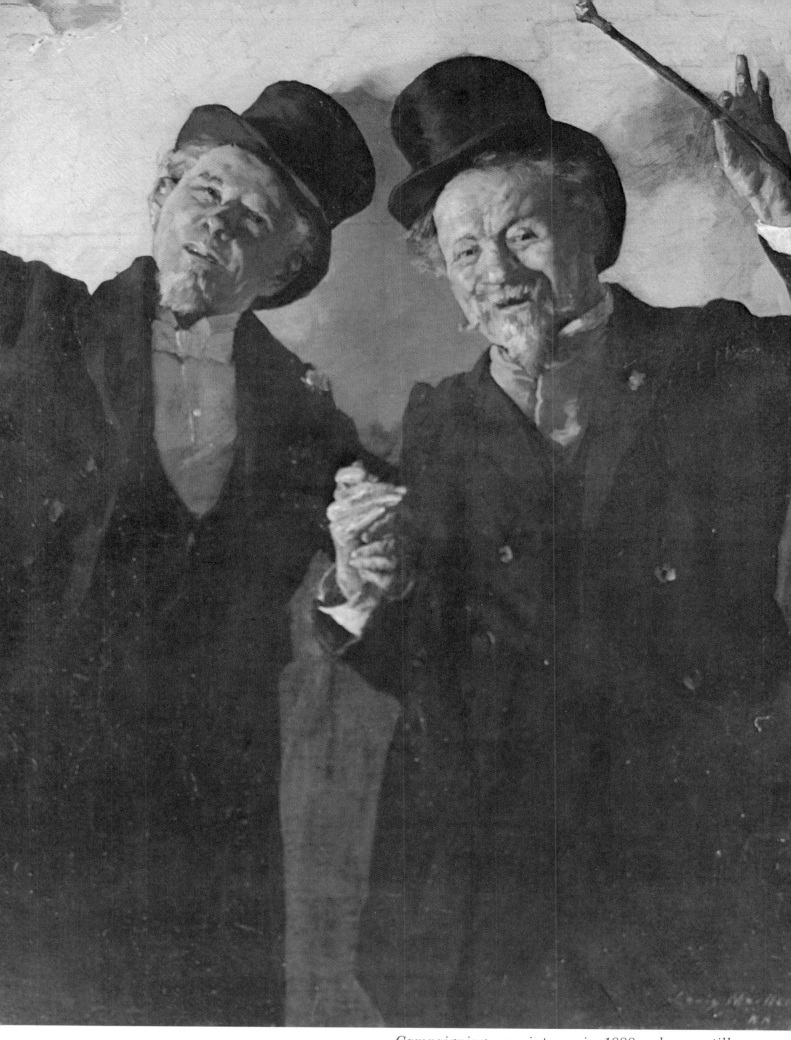

Campaigning was intense in 1888, when a still unequaled 80 percent of the vote turned out.

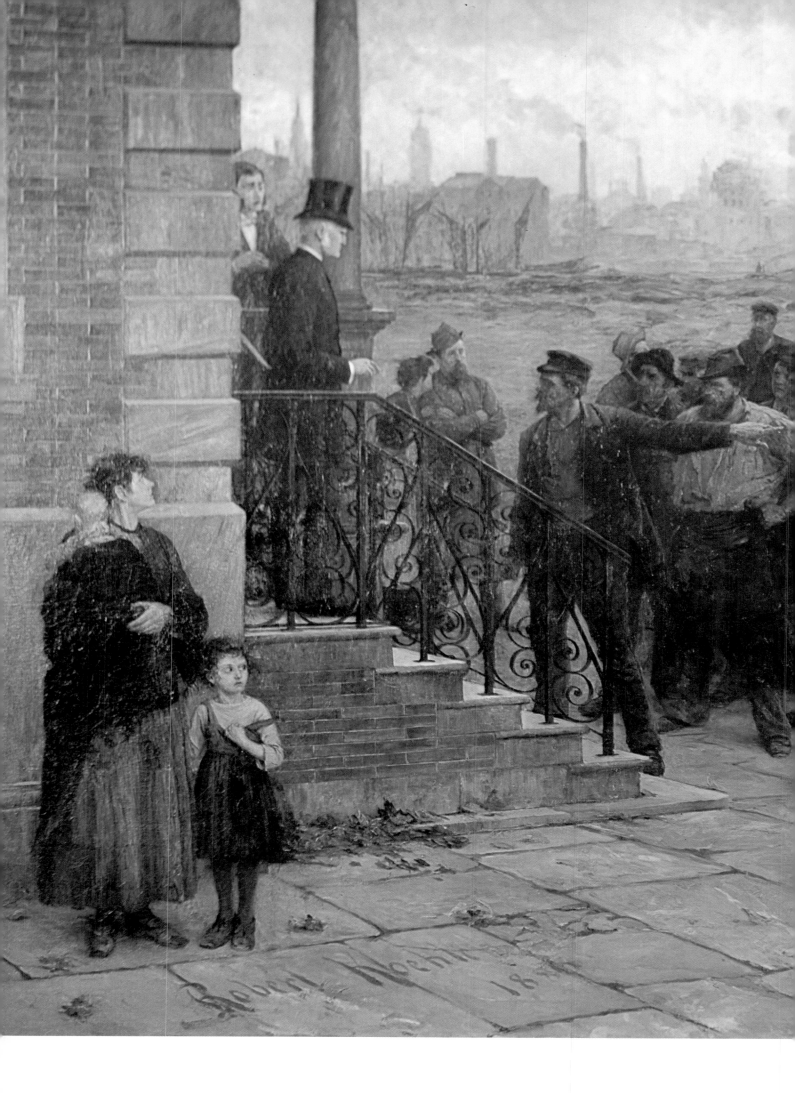

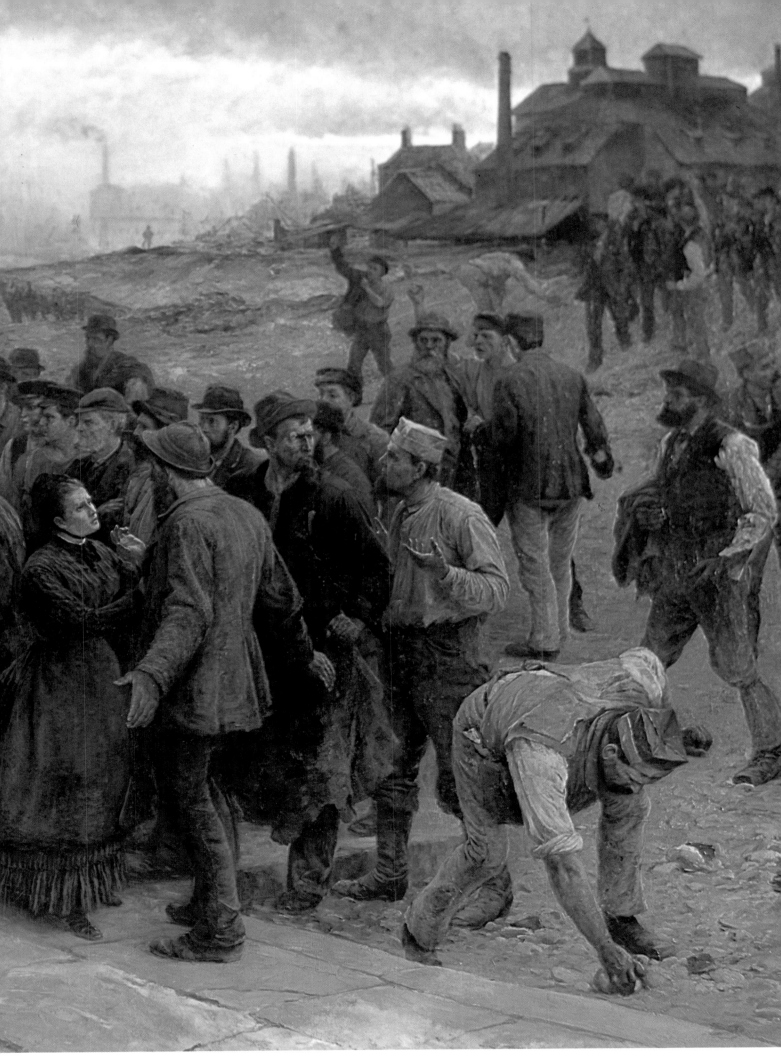

As industrialization increased, the interests of capital and labor became sharply polarized. The *factory workers of the 1880's had little bargaining power. Violent conflicts resulted.*

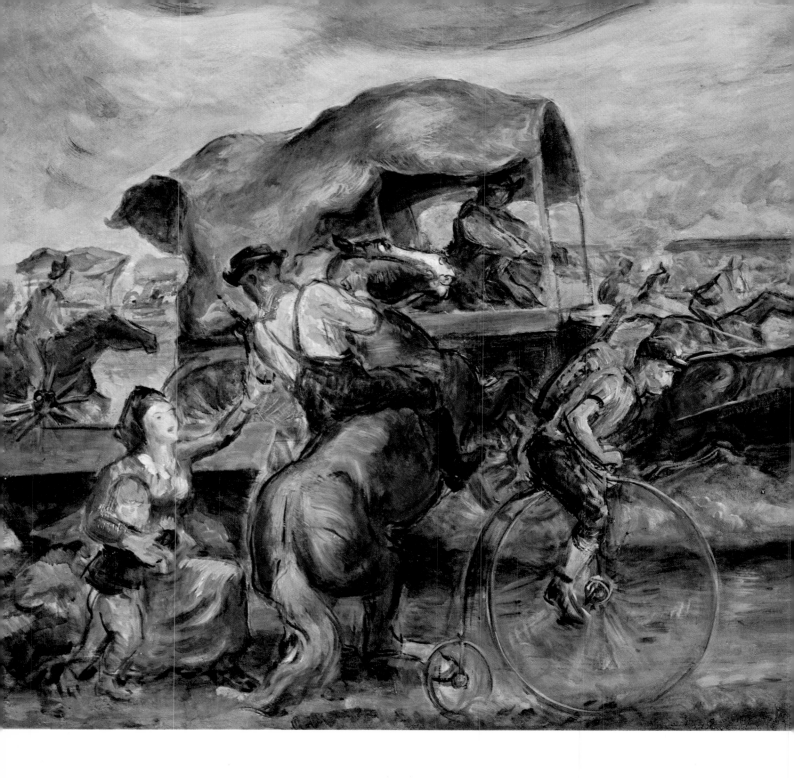

The Oklahoma
Land Rush

At the firing of a pistol at noon on April 22, 1889, about 12,000 settlers raced headlong into the new Oklahoma Territory where 6,000 free homesteads awaited settlement. But some of the land already had been occupied by the impatient "sooners" who had eluded the cavalry's border patrol and jumped the gun. Over the ensuing years, true ownership of the land was determined by violence. Questions of legal title and boundaries proved thorny indeed.

How did it come to pass that two million acres of rich grassland had suddenly become available? The story (one of the less edifying in our country's history) began during Andrew Jackson's administration when the Government removed the Five Civilized Tribes (Cherokee, Choctaw, Creek, Chickasaw and Seminole) from their lands in the Southeast. They sent the Indians west to the Indian Territory in Oklahoma.

This sudden displacement confused and disturbed the Indians. One Cherokee remarked that he could not understand the President's intentions, for a few years earlier he had told the

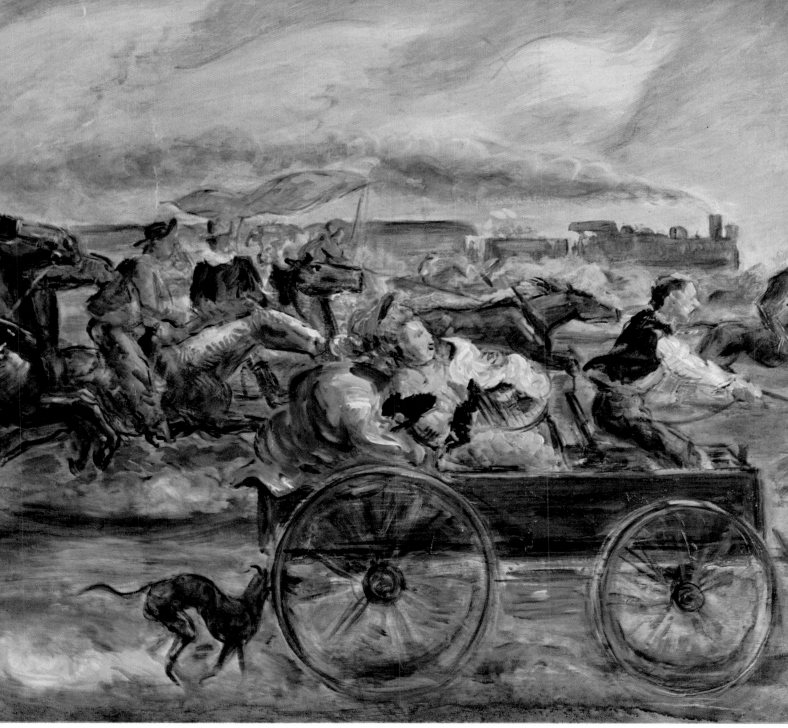

Oklahoma's biggest land rush occurred in 1893. Over 5,000 persons staked claims on first day.

Trains, cycles, horses and mules got them to a 6,500,000-acre tract of free homestead land.

Indians they should not hunt, and had given them hoes and plows to get them started as farmers. Now he promised them good hunting land west of the Arkansas River. The young brave was forced to leave his land, and embark on the long trek west that came to be called the "Trail of Tears." About one-quarter of the Cherokees who left Georgia died enroute to the Indian Territory. But at least those who made it knew that at last this new land would be forever theirs. Or so they thought.

As punishment for siding with the Confederates during the Civil War (although, in fact, some tribes had supported the Union) the Federal Government rescinded all treaty obligations with the Five Civilized Tribes, and proposed to open the Indian Territory to white settlers. Outraged Indian representatives in Washington succeeded in blocking the proposal and it was discarded. But pressure from white farmers and ranchers increased through the decades until finally in 1889, and again in 1893, huge tracts of the Indian Territory were purchased by the Government and became the free homesteads of the Oklahoma Territory.

In 1901 the Five Civilized Tribes, which numbered over 51,000 in the 1890 census, were granted U.S. citizenship. Six years later Oklahoma became the 46th state to enter the Union.

Ethan Allen and George M. Patchen were two renowned trotting stallions, by Currier & Ives.

Sports and Recreation

Most people in rural and small-town America found there were always endless chores waiting to be done — candles to be dipped, cows to be milked, bread to be baked. The tasks were inescapable, but could sometimes be lightened with sociability. In New England, for instance, a "whang," or group of neighboring housewives would team up on spring cleaning, mitigating drudgery with lively gossip. "Change-work" was frequent. By this arrangement soap-making, canning and rug-making could be done collectively by a group of matrons, first at one house, then another, in the course of a friendly visit. House-raisings, feast holidays, weddings (and barbecues and rodeos in the West) occasioned dances, merriment and almost certainly some unexpected incident or unusual circumstance that would freshen the stream of

German immigrant artist Louis Maurer catches the critical moment of the race at goalpost.

Winslow <u>Homer</u>'s sensitive <u>watercolor</u> reveals all the contained excitement of the <u>bear</u> hunt.

Waterfowl shooting is theme of Eakins' canvas depicting a sportsman with his black servant.

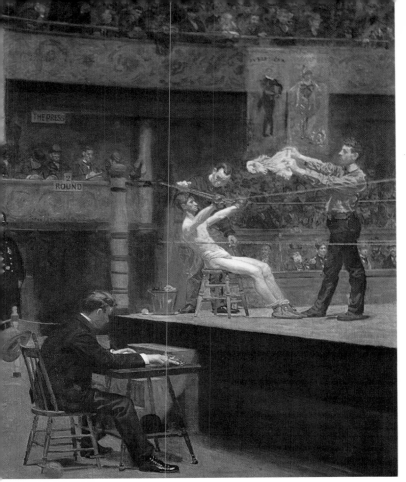

The Queensbury Rules, requiring rest periods and gloves, helped legalize boxing in America.

Madison Square Garden in 1895. Sports fans flocked to its innovative indoor stadium.

local storytelling.

As urbanization increased, and outdoor physical activity was no longer necessarily a part of everyday life, interest in sports grew. Often that interest, in contrast with the British emphasis on fair play and good form, reflected a vigorous spirit of American competitiveness, a desire to win the game.

Boxing had had a long history in England before finding its American heroes and enthusiasts. John L. Sullivan, an Irishman who became known as "the strong man of Boston," was undoubtedly the most famous of 19th-century pugilists. Despite his love of Irish whiskey and loose living, he held the heavyweight title for 10 years. True, there are those who feel that he might not have held the honor quite that long if he had not "drawn the color line" against the Australian Negro, Peter Johnson, who was both an outstanding boxer and swimmer. Badly overweight, John L. lost the title in 1892 to James J. Corbett, the first man to take seriously the study of the technique of boxing.

The game of "two-hole cat," a sort of poor man's cricket played by the children of the American colonists, slowly developed into the game of baseball which came into vogue after the Civil War. By the 1880's a contemporary writer found that baseball had been developed "to such a point of perfection that soon two well-matched teams will be unable to score a single run against each other."

Football was becoming a popular college game. The first intercollegiate meet took place in 1869 between Princeton and Rutgers. But the modern game with 11 men to a side, an egg-shaped ball, the possession of the ball as a tactic and the system of "downs" became official in 1882.

The rich invested in racehorses and yachts. Kentucky proved the ideal location for breeding and raising Thoroughbreds, which were first imported from England. The first Kentucky Derby was won by Aristides in 1875, almost 100 years after the English Derby (pronounced "darby") was founded.

Yacht clubs and boat-racing proliferated after the war. Millionaires and multimillionaires such as William Astor and J. Pierpont Morgan built sumptuous sail- and steam-driven vessels, and middle-income families were beginning to take to pleasure crafts for fishing, racing and sailing in inland waters.

The "safety bicycle," much like our two-wheeler of today, replaced the chancy "high-wheeler" around 1885. Road racing on bicycles became popular, and special arenas with inward-sloping tracks were built. In 1891 the first six-day bicycle race was held in Madison Square Garden, New York. The invention of the tandem, or "bicycle built for two," provided a vehicle for changing social mores.

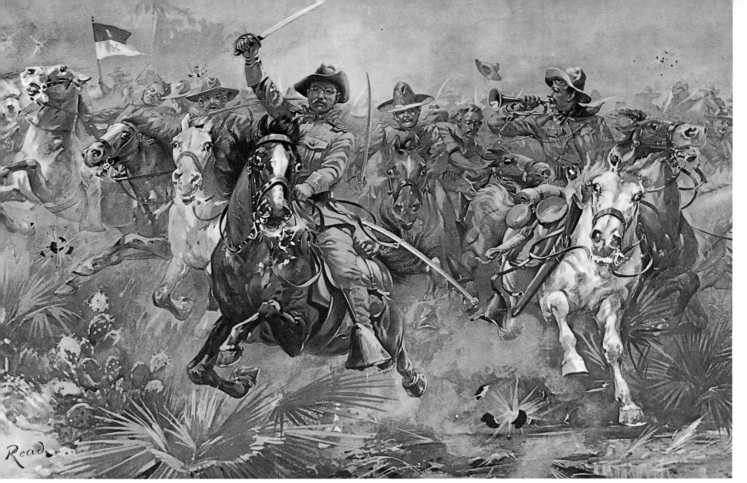

On July 1, 1898 Colonel "Teddy" Roosevelt led "Rough Riders" up Kettle Hill near Santiago.

The Spanish-American War

Rebellion against Spain broke out in 1895 on the island of Cuba. The American public, informed of the repressive methods used by the Spaniards, sympathized with the rebels, but President McKinley initially opposed U S intervention. Then on February 15, 1898, the battleship *Maine,* which had been sent to Havana to evacuate U S citizens, mysteriously exploded. Hearst's popular New York *Journal* and Pulitzer's *World* blamed the Spaniards and so did their readers. Although Spain's attitude was conciliatory, it was too late to avoid war. McKinley authorized intervention on April 11.

Commodore George Dewey was dispatched to ready an attack on the Spanish colonies in the Philippines where another insurrection was smoldering. Most Americans were surprised when the news broke that Dewey had destroyed a Spanish fleet in Manila Bay on May 1. In Cuba, Rear Admiral W. T. Sampson blocked another Spanish fleet in the harbor of Santiago on May 28. During the following month, 15,000 U S troops besieged Santiago. The bottled-up Spanish fleet attempted to run the American blockade on July 3, but all their ships were destroyed or captured. Santiago surrendered on

July 17. One week later U S troops took over Puerto Rico. In mid-August, American contingents arrived in the Philippines and occupied Manila. On August 12, 1898, Spain ceded Guam and Puerto Rico to the United States and granted Cuba its freedom, but the armistice left the Philippine question unsettled.

The complication with the Philippines resulted from the Filipino rebels' desire for self-government. They had fought to assist the United States in ousting Spain, and were disappointed when they learned that later in the year the Americans planned to purchase the Philippine Archipelago from Spain for $20 million. The Spanish-American War drifted into a Filipino-American War, which lasted over three years.

Opposition within the United States to the annexation of the Philippines was strong. By May of 1899 an Anti-Imperialist League, formed "to oppose . . . the acquisition of the Philippine Islands, or of *any* colonies away from our shores . . .," had 30,000 members. Mark Twain suggested that the American flag might appropriately have "the white stripes painted black and the stars replaced by the skull and crossbones." But others felt it was economically and militarily advantageous to annex footholds in the Pacific. By the turn of the century the Philippines, the Hawaiian Islands and half of Samoa had become American possessions.

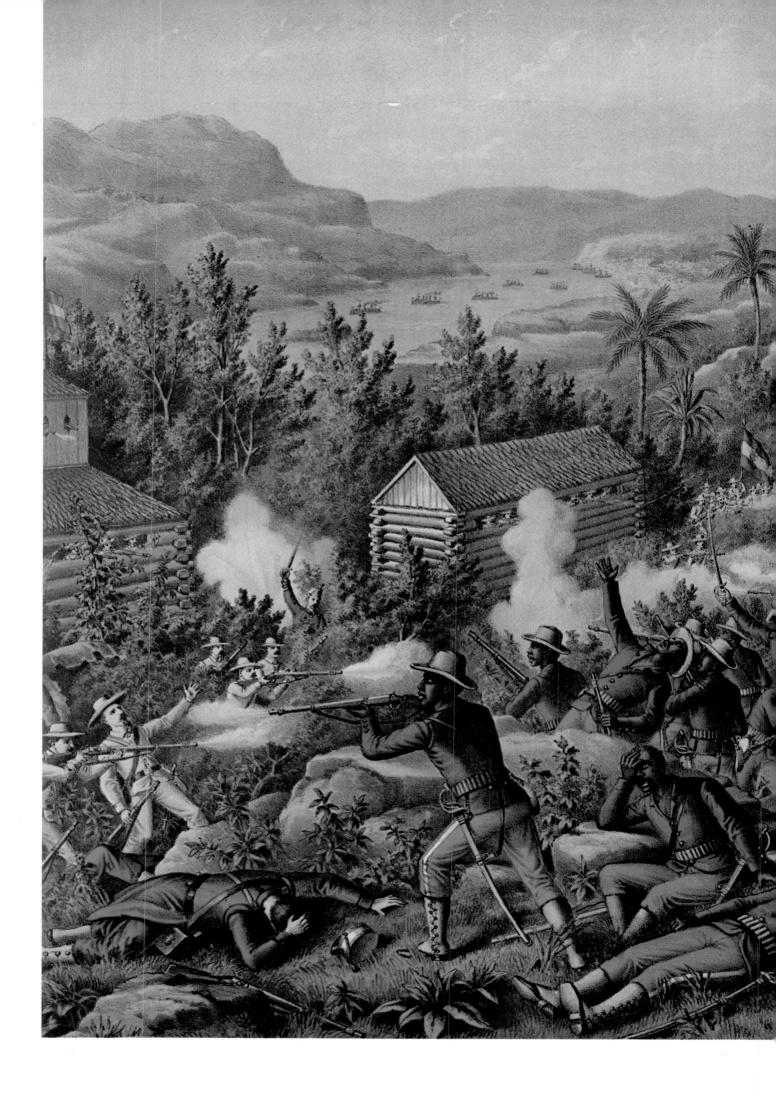

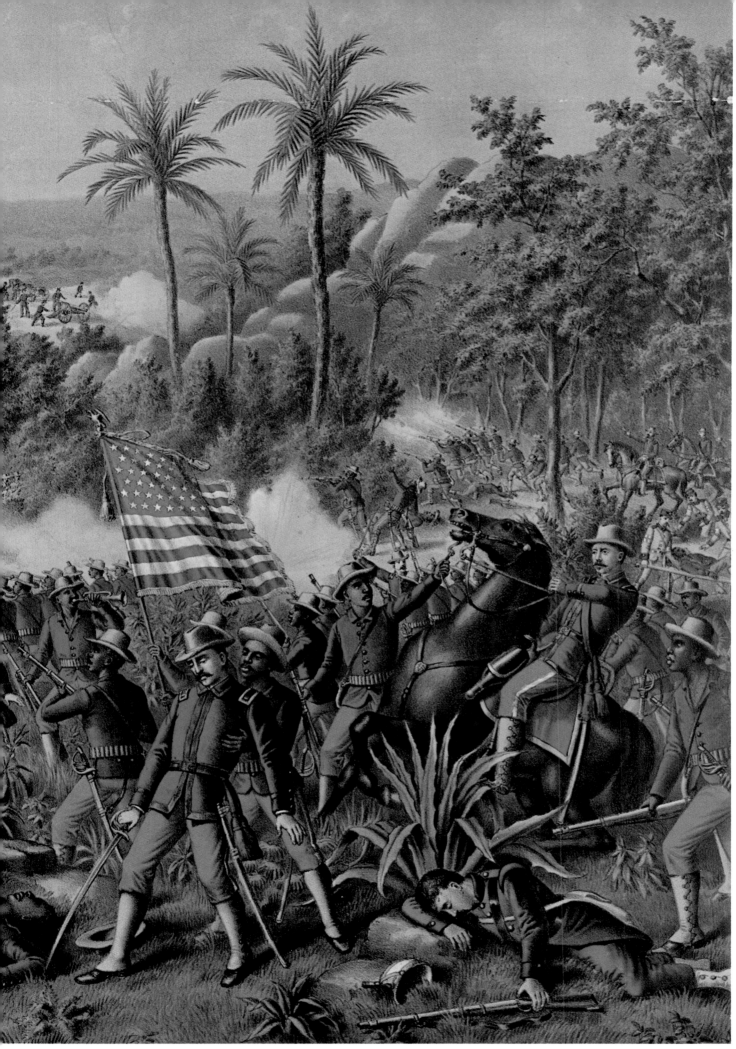

The Colored Cavalry had white commanders who wore red tassels in Santiago compaign. The Army ran out of khaki, so all wore blue wool. For each man killed, thirteen died of <u>disease</u>.

Yellow Fever

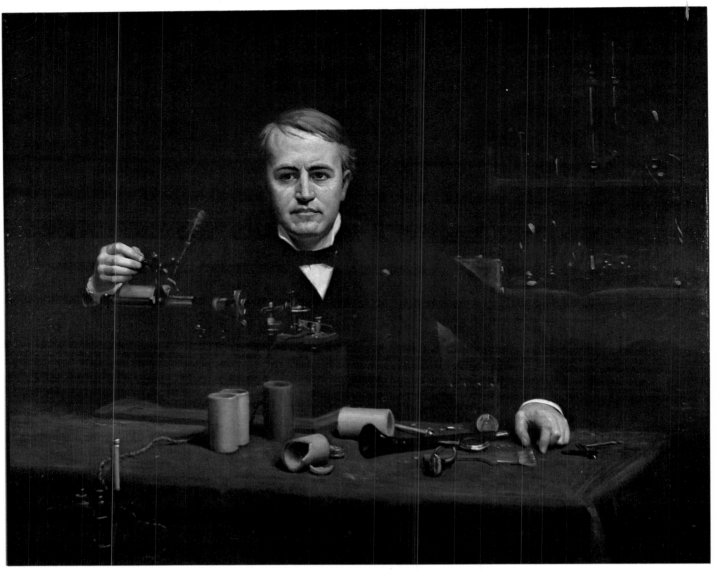

Edison proudly demonstrating his second model phonograph, featuring cylindrical wax records.

Edison and the Age of Electricity

The Age of Electricity began, not with the discovery of electricity, but with a series of key inventions, most of which were made during the last three decades of the 19th century by one man: Thomas Edison.

Thomas A. Edison, born in 1847 in Milan, Ohio, did not get an easy start in life. With only three months of formal education, no financial resources beyond what he could make selling newspapers, and a severe hearing loss which began at the age of 12 and deteriorated throughout his life, he might have seemed an unlikely subject to become the world's most prolific inventor.

So well did Edison succeed in integrating his deafness into his life and work, they appear almost as inseparable as El Greco and his astigmatism. In his own opinion, it made him better able to concentrate, prompted his invention of the phonograph (on which he could hear his favorite classical music by holding his head against the speaker), and induced him to improve Bell's telephone to the point where even he could use it.

In 1879 came the most dramatic and world-transforming invention of them all, the incandescent lamp. A vacuum glass bulb containing two wires connected by a carbonized filament, originally of carbonized bamboo, shone for 40 hours, heralding the era of electric lights. That same year he set up the world's first central power station for lighting, and was soon embarked in the electrical industry. He invented an improved dynamo, power lines, cables, switches, sockets: in short, the entire electrical system, much as we know it today.

Edison died on October 18, 1931, at the age of 84, honored by the Congress of the United States and by many foreign nations. Over a span of 50 years, he had taken out over 1,000 patents, many of which enhanced the lives of millions.

1900-1929
THE COUNTRY UNITED

The activist president, Theodore Roosevelt, takes office and swings the big stick in domestic and foreign affairs. The Panama Canal is begun and completed. America becomes involved in the European war; President Woodrow Wilson attempts to maintain neutrality but is increasingly influenced by the Allied cause. America goes to war. Prohibition, bootlegging, and the rise of gangsterism. Women win the right to vote. Lindbergh flies the Atlantic. The country is riding the crest of a boom.

HISTORICAL CHRONOLOGY	ART CHRONOLOGY
1901 *McKinley assassinated; Theodore Roosevelt becomes President.*	*1902* *Henry James publishes* The Wings of the Dove *and, in the next two years,* The Ambassadors *and* The Golden Bowl.
1902 *Reclamation Act begins a government conservation program.*	*1903* *Jack London publishes* The Call of the Wild. The Great Train Robbery, *produced by Edwin S. Porter, first film with a plot.*
1903 *Theodore Roosevelt's antitrust activities culminate in court order to dissolve the Northern Securities Company.*	*1906* *O. Henry – William Sydney Porter – publishes his first collection of short stories of New York City,* The Four Million.
1906 *Pure Food and Drug Act one of the important victories of the muckrakers and the reform government.*	*1908* *Group exhibit by "The Eight," or "Ash Can School" of American realists: Henri, Sloan, Glackens, Luks, Shinn, Davies, Lawson, Prendergast.*
1909 *Income Tax Amendment (16th) submitted to the states; adopted 1913.*	*1911* *Edith Wharton publishes her best-known novel,* Ethan Frome.
1912 *Election of Woodrow Wilson.*	*1913* *Armory Show opens in New York City; first full-scale presentation in the United States of European and American post-Impressionistic art.*
1914 *Panama Canal completed. Undeclared war with Mexico. Federal Trade Commission established.*	*1915* *Edgar Lee Masters publishes* Spoon River Anthology.
1915 *Sinking of* Lusitania *followed by periodic notes to Germany concerning U-boat attacks.*	*1916* *Democracy and Education by John Dewey revolutionizes teaching. Publication of Carl Sandburg's* Chicago Poems.
1917 *War declared against Germany.*	*1918* *Willa Cather publishes her novel of prairie life,* My Antonia.
1918 *Armistice comes November 11, after 364,000 US casualties.*	*1920* *Sinclair Lewis publishes* Main Street.
1919 *Failure of Wilson's hope for American leadership in the League of Nations. Prohibition Amendment ratified.*	*1925* *Fitzgerald publishes* The Great Gatsby.
1927 *Charles A. Lindbergh flies the Atlantic. Sacco and Vanzetti executed in Massachusetts.*	*1926* *John Marin paints* Movement, Boat off Deer Isle. *Ernest Hemingway publishes* The Sun Also Rises.
1928 *Hoover defeats Alfred E. Smith for the Presidency.*	*1927* *First full-length sound movie,* The Jazz Singer, *with Al Jolson.*
1929 *The nation is at the peak of prosperity – until October.*	*1929* *Arthur Dove paints* Fog Horns. *Museum of Modern Art founded in New York City.*

Even the toolbox on the running board was brass on this magnificent horseless carriage of 1907.

A Continent in Motion

Peopled with a restless, impatient, striving breed, the U.S.A. was, at the beginning of the 20th century, poised, ready to move into its place in the sun. Messages hummed across the continent with electronic speed; travelers, settlers and goods of all description roared over steel rails. But one dimension was missing in this pattern of motion. In a most vital segment of transportation, from the railheads to the farms and villages and back again, there had been no practical improvement since the arrival of the horse. Indeed, in the all-out enthusiasm for overlaying a network of railroads on the country, railroad mileage had exceeded highway mileage as far back as 1880, and the existing wagon roads had been permitted to deteriorate. It is an axiom in anthropology that the Vehicle Precedes the Road; feet came before

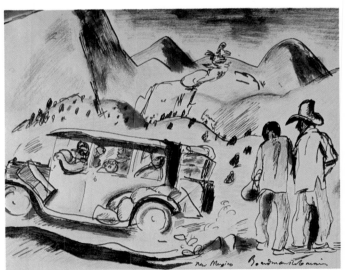

Tourists showed up in the strangest places as the automobile made all America open to travel.

A farewell to the horse was predicted as early as 1899 by some automobile fanciers, but in 1906, and for many years to come, the stagecoach, often with armed guard, was the means of travel.

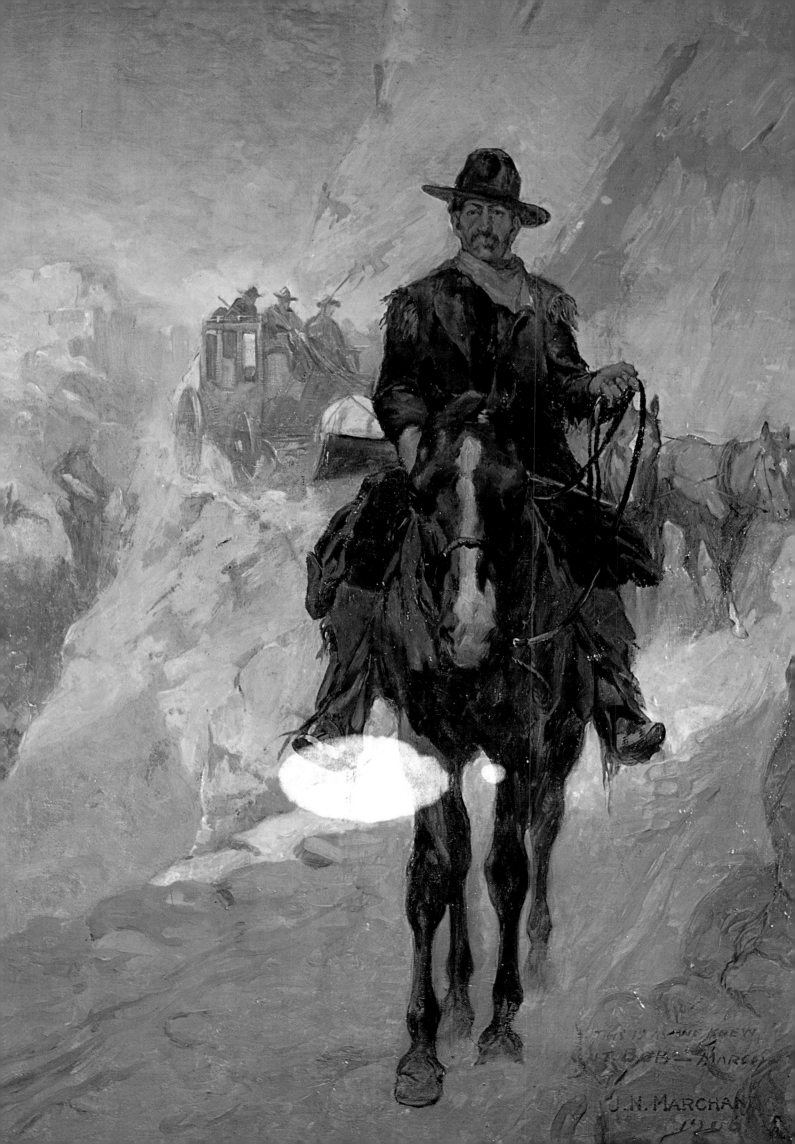

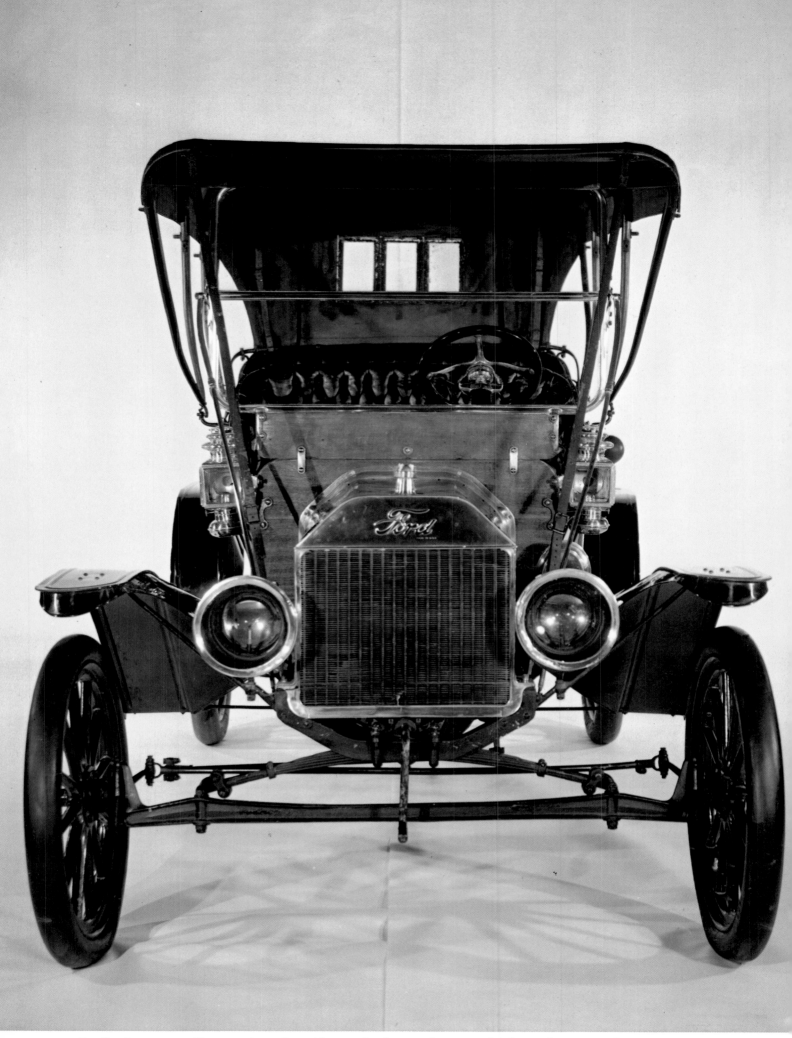

Perfection, according to the adage, is reached not at the point at which nothing can be added, *but at which nothing can be taken away. If not perfect, this 1910 Model T serves as a work of art.*

footpaths, stagecoaches before turnpikes, locomotives before rails. Horse-drawn vehicles were too slow to excite the new nation; bicycles, although 300 factories were churning out a million a year, were not practical. Some entirely new concept was needed to make the final connection between the cities and the more numerous rural population.

As it turned out, the instrument which brought about the true age of motion in America was not new at all; it had just been side-tracked. Some 130 years before a Frenchman had built a self-propelled vehicle which, over the years, had somehow turned into the steam locomotive. Nearly a century elapsed until, in 1862, the first gasoline-powered automobile was running around hesitantly in Belgium. The motor car fever came to America in the 1890's, but the pioneers in the horseless carriage, most of whom were self-taught, broke away from the European patterns in order to build their own cars in their own way.

One of these was a Michigan farm boy ("Chicken is for hawks, milk is a mess" he wrote in his grammar school copy book) who escaped to Detroit and tinkered with engines in his spare time. His name was Henry Ford. His first contribution to automotive design was to build an engine so big that he could not put it in the traditional place, under the seat, and had to stick it up front. On a subsequent model he anticipated the possibility of a road so wide that one car could pass another going in the same direction, and changed the steering wheel from the right-hand side to the left to make the operation safer. Another Ford innovation was to tie a rope to the bare frame of a vehicle-to-be and pull it past piles of parts. Assemblers walked along with it, picking things up and bolting them on. Perfected, this became known as an automobile assembly line.

There were other American manufacturers — some 4,100 companies over the years — but it was Henry Ford who made the greatest contribution to the century of motion. He was by no means the first to build a motor car. He was 37 years old in 1901 when he won his first auto race; neither he nor the car had ever raced before, for he had just finished it that morning. At 40 he demolished all speed records, skidding over a frozen lake at 91 miles an hour. At 44, in 1908, he brought out the most famous piece of hardware the world has ever known, the Model T.

This ungainly contraption was a revolution in automobile engineering. Its transmission was so simple — push a pedal down with your left foot and off you went — that women and children could drive it. Its plain reliable engine and tough, lightweight chassis would take it over the muddy country roads. Farmers could jack up the wheels and use it to run all kinds of equipment. It cost $850 the first year, but the price came down steadily to a low of $260 in 1924. At one time every other car in the world was a Ford. Fifteen million

Henry Ford, a farm mechanic who never put on airs, was a billionaire when he posed in 1931.

Model T's were sold; The Tin Lizzie stimulated songs, poems, jokes, cartoons and books. For example: Did you hear about the man who wanted his flivver buried with him? He'd never been in a hole yet that his Ford couldn't get him out of. Of the thousands of jokes on the Model T, however, perhaps the most apt is a true anecdote. Asked why she had a Model T but no bathtub, a farm wife answered sharply, "I can't go to town in a bathtub."

And this was the first great contribution of the Model T: It brought the farm family to town. It is ironic that this major element of the transportation revolution was first appreciated by two of society's most conservative elements, the farmer and the country doctor, for it was they, not the city slicker with his trolley car, who bought automobiles and demanded roads to drive them on. The automobile forced dramatic changes in road building. Heavy equipment was developed to move earth and rock, to crush stone into gravel. Crude oil was used to bind materials into a smooth hard surface. In 1912 the Federal Government appropriated $500,000 to improve 425 miles of highways. In 1914 the highway mileage surpassed the railroads. After World War I the War Department's gift of 28,000 surplus vehicles was a major impetus in the creation of the world's finest and largest highway network.

From an economic standpoint, Henry Ford and his fellow automobile manufacturers set in

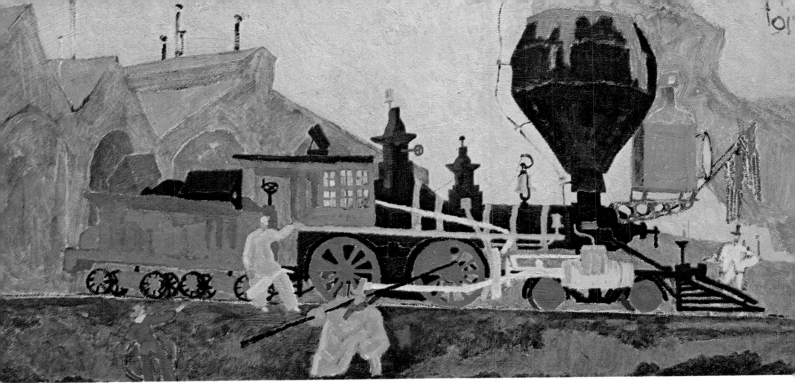

The lure of the locomotive was so powerful that Lyonel Feininger, known for his abstract, Cubist- *oriented style, almost approached representation when he painted this monarch of the rails in 1910.*

motion the industrial program which made the United States the wealthiest and most productive nation on earth. Rubber, glass, steel, to say nothing of oil, grew as supporting industries. The motor vehicle stimulated agriculture, developed the power for aviation. It was a major ingredient in the growth of the motion picture industry. It supported tens of thousands of local businesses — dealerships, garages, service stations. Along with other items which Americans wanted but could not pay cash for, it forced the development of an installment payment system which in time came to be applied to practically all merchandise. And the automobile offered further proof that America was indeed the land of opportunity. Where else could a man working in an automobile factory purchase an automobile? Economists of the day speculated on this phenomenon with an air of incredulity.

The sociological impact of the automobile was equally dramatic. School buses made it possible to consolidate one-room schools into educational institutions serving hundreds of children with all the benefits of mass economics — more teachers, books, aids, football uniforms, band instruments. Even religion was affected, as tiny crossroads churches were consolidated into large establishments serving people of all ages with a variety of programs. Moralists, of course, remarked that teenagers, or at least those old enough to borrow the family car, were escaping from the parlor sofa and its surveillance to use the automobile as a mobile couch.

In 1907 the president of Princeton University, Woodrow Wilson, warned the students against the snobbery of the auto and its symbol as an "arrogance of wealth." As a new breed of home mechanics emerged with the ability to patch up a secondhand car and keep it running, the auto became a symbol of freedom, of independence. No longer was it necessary to head west by wagon train or railroad to find greener pastures. With a car a young man, or a man with a family, for that matter, could explore the possibilities in the neighboring counties or states. Sociologists observed that the country was all too rapidly becoming a nation of nomads.

All this had the effect of filling in the spaces in the network overlaying the country. Now, in thousands of squares bounded by railroads and navigable rivers, local roads and population proliferated together and the nation grew internally as well as by expansion.

Henry Ford, who effected another sociological change by paying the unheard of wage of $5 a day (10,000 men applied for work the day after the announcement), once mused that the automobile would bring humanity together so that there would be no more wars. His dream was somewhat overblown. Indeed, one could point out that the automobile has killed and injured more Americans than all the nation's wars since the Revolution.

But the flivver, or national chariot, brought the means of swift individual motion to a country fertile for it. It characterized the spirit of the country, which seemed to be almost angry with time, so earnestly did it seek to overcome it. Nothing would satisfy this craving to make something faster, to hear or see or do or go — faster, faster, faster. This was the spirit of America, truly a continent in motion, as the motor car ushered in the 20th century.

Nickelodeon to Movie Palace

Mankind has always been absorbed by motion — surely the original Americans loved to watch birds fly, waves break. With the new century came a new way to observe motion — the motion pictures. In its first years, audiences were content to watch flickering images of smoke blowing, trains running. In 1903 a cameraman named Edwin S. Porter turned out a short film which told an exciting story — and the cinema as we know it today, the first art form to which the United States made the outstanding contribution, was born.

The movie palace of the early 1900's was grand in name only. Usually a vacant store with chairs for seats and a bed sheet for a screen, it derived its title from the price of admission and the Greek word for theater — *nickelodeon*. It was patronized by working class people, especially immigrants, for the language of the silent film was universal. It was a form of entertainment everyone could understand. As American films improved, as early as 1910, they were shown around the world, in European capitals, in jungle clearings. The stars of the silent screen were as well-known in Moscow and London and Papeete as they were in Hollywood. American goods of all kinds, clothing, refrigerators, motor cars, were introduced by the movies. Hollywood, a sleepy village in 1910, was as well-known as Washington — perhaps better, for as many as 400 correspondents covered the town — in its golden years.

By 1916 the cinema was the country's fifth largest industry; the automobile industry was sixth. Along with radio, which came in during the twenties, the movies tended to standardize the nation, especially with the advent of sound pictures, in such cultural criteria as clothes, customs, songs and an accentless standard of speech. Strangely, although it was during this period that the cinema flowered as an art form, it was virtually ignored on the intellectual level. Scholarly interest in films as a serious art form was to come much later.

The American realist John Sloane, a member of the "Ash Can School," glorified the grubby nickelodeon a bit when he painted this in 1907. Will the ladies kindly remove their hats?

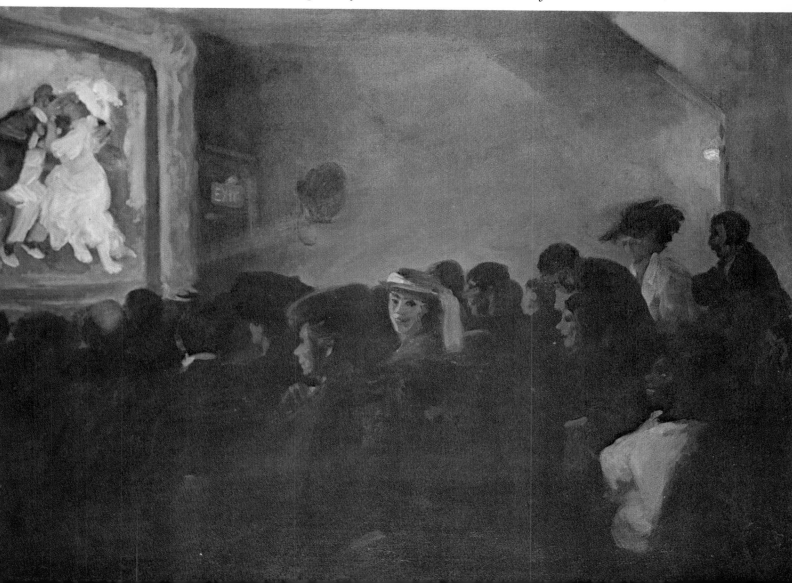

At Last
a Westward Passage

One August day in 1914 the sea distance from New York to San Francisco was miraculously reduced by 8,000 miles. From that day on, ships could take 12 hours to go through the Panama Canal rather than weeks rounding Cape Horn.

For almost four centuries the sea-going nations of the world had dreamed of a canal through the narrow isthmus separating the Atlantic from the Pacific. The primary factor in turning dream into reality was that fitting symbol of a restless, active nation, President Theodore Roosevelt.

A nearsighted, sickly boy, Roosevelt built himself into a husky young man through sheer determination and the special gymnasium provided by his wealthy New York father. He boxed at Harvard, rode the range on his Dakota ranch, played cops and robbers as New York City police commissioner, led the charge up San Juan Hill, swept into national office as vice-president in 1900, and dramatically took over the nation when President McKinley was assassinated in 1901. One of the many challenges awaiting this man of action was the construction of a canal across the isthmus. Ever since the battleship *Oregon* had taken 71 days to get from the Pacific to the Caribbean during the Spanish-American War, the American people — and TR himself — had been tired of pussyfooting around. "Make the dirt fly" was the cry. Dig that canal.

It was not that simple. There were two possible locations — northern Colombia, where the isthmus is only some 40 miles wide but the terrain is rugged, or Nicaragua, where a large natural lake provides an existing navigable stretch to cut the greater distance. There were diplomatic problems, too, not only with the two countries which owned the potential routes, but with Britain and France. And of course there was Congress, which had to approve and appropriate. Pushed by the President, Congress made the decision, Colombia over Nicaragua, aided by some shenanigans on the part of a French company which had unsuccessfully attempted to build the canal before, and its Wall Street stockholders and their attorney.

When the final offers were made, $40 million to the French-American company for its abortive efforts, $10 million cash and $250,000 a year rent to Colombia for some 650 square miles of real estate, the Colombian Senate balked at the terms. TR had a fit, and wrote his Secretary of State, "We may have to give a lesson to those jackrabbits." Before he could take direct action, however, a revolution was arranged and, with a US battleship standing by to discourage any Colombian action, the Republic of Panama was formed. It received instant recognition, and $10 million cash.

And now a technical problem arose, how to build the canal through rugged terrain annually flooded by torrential rains. One approach would

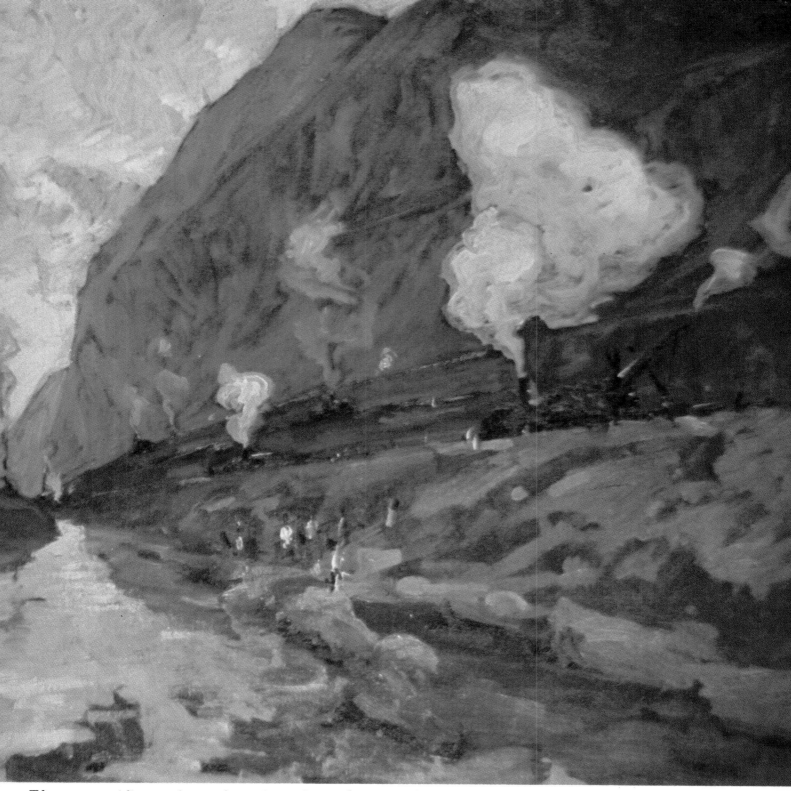

That magnificent feat of engineering, the Panama Canal, was nearing completion in 1913

when Jonas Lie painted the Culebra Cut, eight miles gouged out of the Continental Divide.

be simply to dig a sea-level canal from coast to coast. Another would be to dam up two rivers, one on the east coast, one on the west, thus creating two lakes in their valleys some 80 feet above sea level, and connect them by cutting an eight-mile gorge through the Continental Divide. To reach the resulting waterway ships would be raised and lowered in gigantic locks. The question was referred to the International Board of Consulting Engineers, which voted 8-5 in favor of the sea-level route. Roosevelt's chief engineer, John F. Stevens, a forceful leader,

agreed with the minority, however, and the canal was built in accordance with the more complex system of dams, lakes and locks. The unimpeachable arbiters, time and usage, have fortunately approved the decision.

The Panama Canal cost $380 million in addition to continuing expenditures, but annually collects well over $100 million from more than 14,000 ships passing through. It was a positive success, as well as a symbol of the new big stick policy of the United States and its aggressive President.

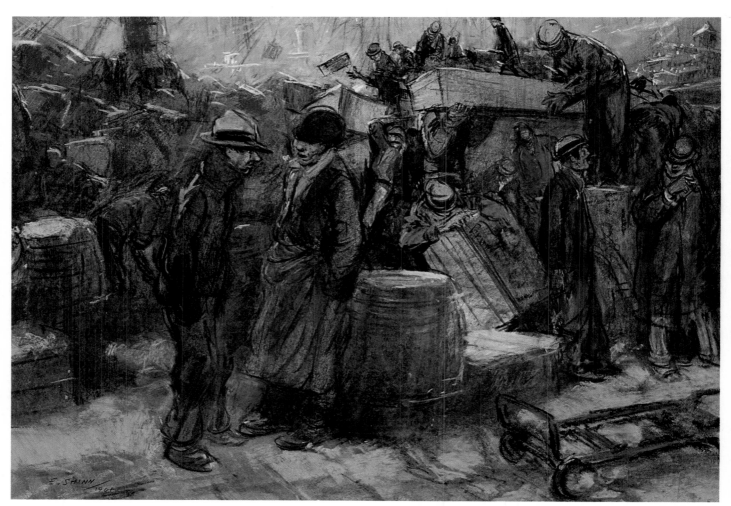

Everett Shinn painted fashionable scenes, but in 1901 he depicted the dock worker's drudgery.

Labor Begins Its March

Teddy Roosevelt knew he had no power to settle a labor dispute, but neither had he any intention whatever of permitting schools and churches and homes to remain unheated that winter of 1902 because of the coal strike. He called a meeting, at which the young president of the United Mine Workers agreed to arbitration for his miners' demands for a nine-hour day and a wage increase over their current average income of $560 a year. The multimillionaire representing the operators, however, said he objected "to being called here to meet a criminal" and refused to discuss the matter further. TR, always the activist, slammed down his fist, threatened to call out the Army to work the mines, and put pressure on the operators through his Wall Street connections. The miners got a ten percent increase in pay and a ten percent decrease in hours, went back to work, and the schoolrooms of the nation were warm that winter.

But of far greater importance, the trend, gradual though it may be, toward parity between the rights of the individual worker and the long-established rights of property had begun. Labor would still be subject to economic and bloody set-backs over the next generations, but it would be difficult to forget that a President of the United States had stepped into a labor dispute and that the miners were the richer for it.

In at least one case even management got into the act. Henry Ford doubled his workers' wages to the unheard-of figure of $5 for an eight-hour day in 1914. It made an impression on capital and labor alike, although the impact was somewhat different; some capitalists thought Ford was downright dangerous. There was reaction against President Woodrow Wilson, too, when he successfully requested from Congress legislation setting an eight-hour day, with overtime, for railroad workers. Other legislation favorable to labor was passed during the Wilson administration, including an act designed to protect children under 14 years old; the

The spirit of both the American realists and the coal miner is reflected here by George Luks.

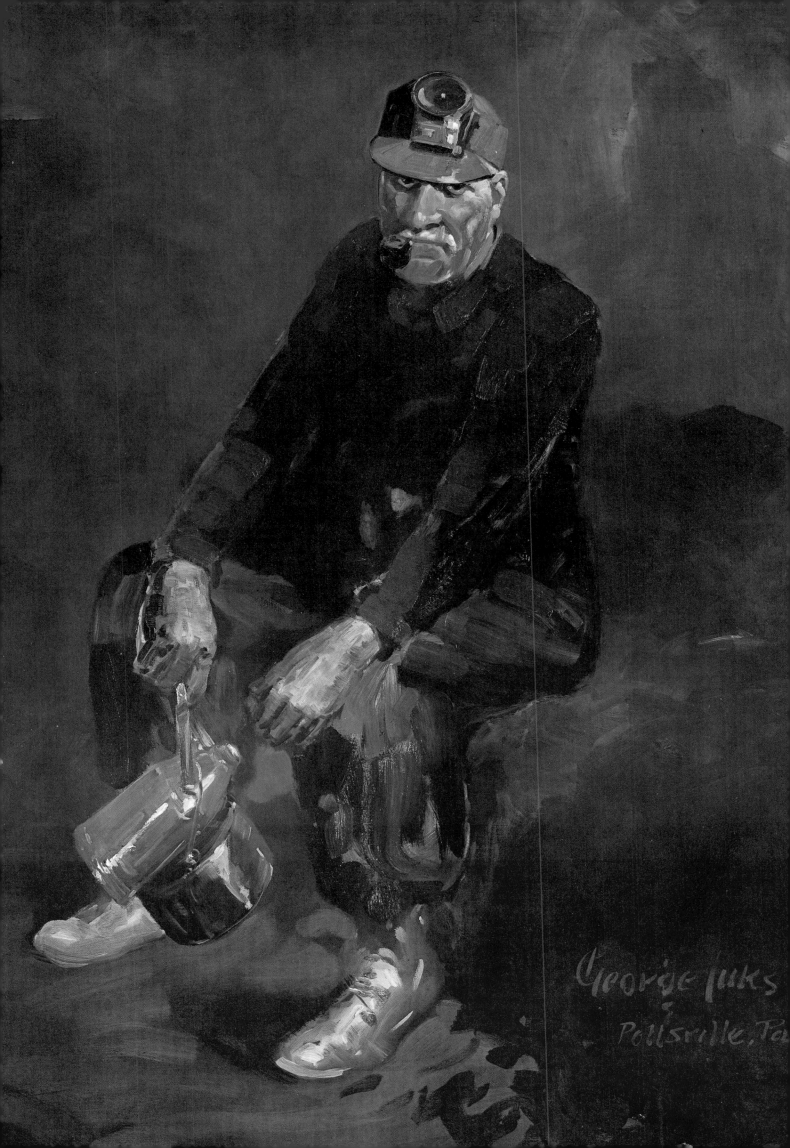

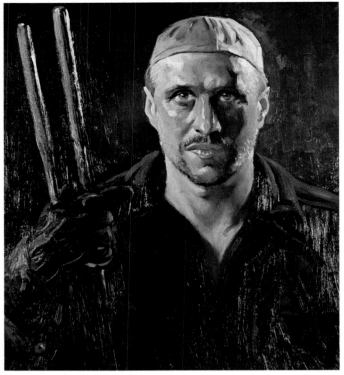

This 1919 shop steward proudly accepted the title Constructive Radical *posing for Gerrit Beneker.*

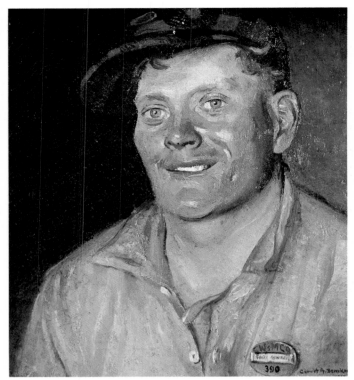

And a Hungarian immigrant steelworker posed on the very day he took out his citizenship papers.

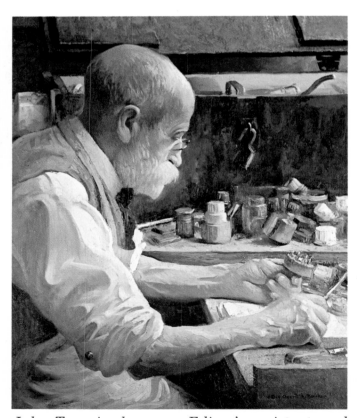

Jules Tournier began as Edison's assistant, and remained an inventor over a period of 45 years.

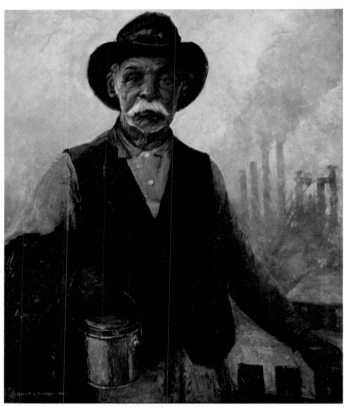

Watchman in Cleveland plant gave evidence of northward movement, and acceptance of Blacks.

legislation was declared unconstitutional but individual states passed laws to protect children. Hours, working conditions and wages were, for many Americans at least, getting better.

Other Americans could see little, if any, improvement in their lot. Union membership was still considered un-American in many circles. The prevailing mood of the Supreme Court, expressed on several issues including the "yellow-dog" contracts in which prospective employees had to sign a statement that they would not join any union before they could be

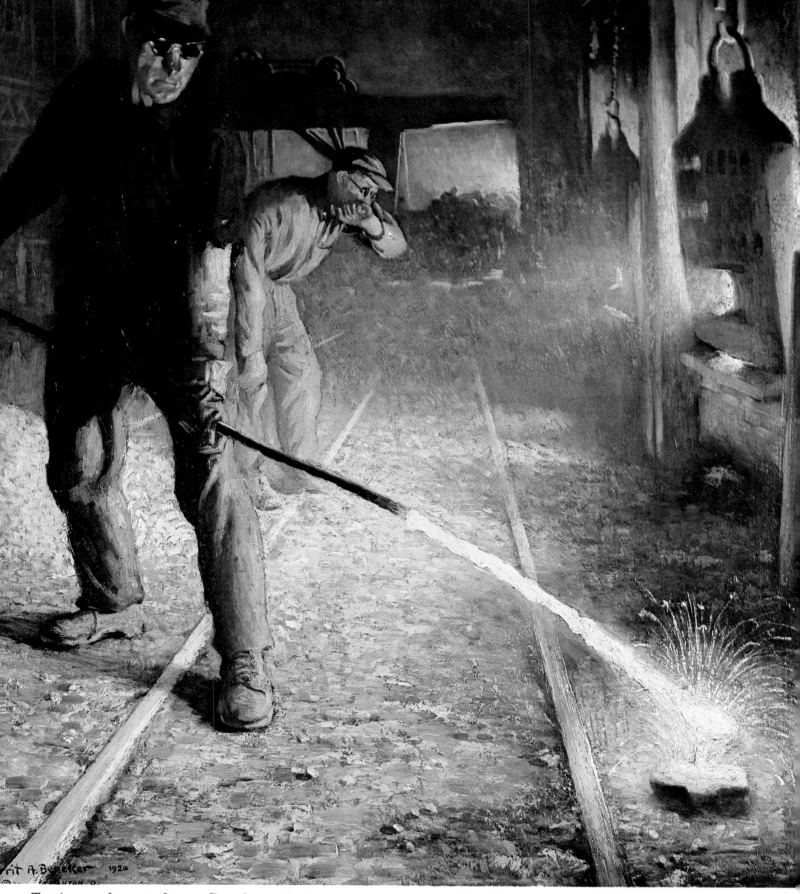

Testing molten steel gave Beneker a fitting scene to prove the theme of the <u>five paintings</u> on these

pages, that the working man building America was achieving his just dignity and recognition.

hired, was that the Constitution prohibited any interference in relationships between employer and employee. During 1919 some four million Americans were on strike for union recognition, most of them unsuccessfully so. And in 1921 a strike of steelworkers seeking a reduction in

their 12-hour day was brutally broken.

But still union membership increased, as did the number of men and women sympathetic with labor's problems. As the third decade of the 20th century ended, the labor movement was ready to make its greatest strides.

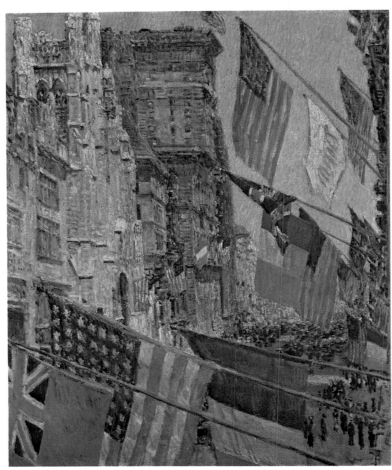

Old Glory, the Union Jack and Tricolor dominate this patriotic painting of Allies Day.

To Make the World Safe for Democracy

President Woodrow Wilson, the earnest intellectual, faced an anguishing decision. He had run for reelection in 1916 on the slogan, "He kept us out of war," but now he was leaning the other way.

There had been no thought of American participation when war broke out in Europe in 1914. It was strictly a European affair, complete with centuries-old internecine hatreds, private grudges and secret treaties. The major nations involved were Germany, Austria-Hungary and Turkey, which as the Central Powers controlled a broad swath of Europe from the Baltic Sea through the Balkan Peninsula, and the Allies — England, France, Russia, Italy and Serbia. Combat had degenerated into periodic spasms of massive slaughter. Millions of men on each side gave their lives to prove the invincibility of the newly-perfected machine gun by charging emplacements and being mowed down.

While armies lived in muddy, rat-infested trenches, emerging from time to time on the whims of their commanders to charge "over the top" into "no man's land," both sides sought to exhaust the other's resources through naval blockade. The English patrolled the seas with conventional warships; the Germans unleashed their U-boats, or submarines. Although the submarines came close to winning the battle of the blockade, they were the catalyst by which Germany lost the war. For in order to get food and munitions England and France came to the United States. They found a welcome market, and by the spring of 1917 they had built up a debt of some $3 billion. As England was down to a three weeks' supply of food, and the French Army was beginning to mutiny, it began to look as though that money might go by default.

But just as the war introduced the submarine and machine gun, so did it inaugurate the first large-scale use of propaganda. Atrocity stories flooded the country: German soldiers were raping Belgian nuns, bayoneting children, injecting prisoners with tuberculosis germs. Though these charges were dubious, the dread submarines were not. The loss of 128 Americans on a torpedoed English liner first inflamed American opinion, then more lives were lost as merchantmen were sunk. The Germans were winning the war on the ground and under the sea, but were losing it in public opinion. On April 2, 1917, Wilson, speaking from the conviction born of anguished months, asked Congress to

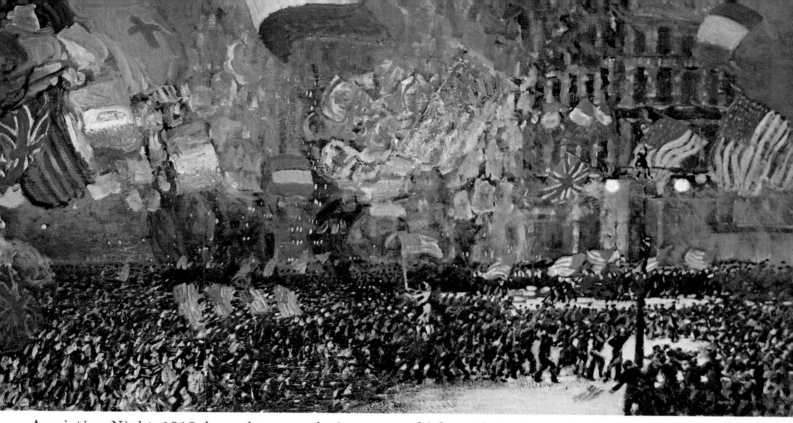

Armistice Night 1918 brought to a glorious finale America's first global military venture, one *which unified the nation and established the stature of the USA throughout the entire world.*

declare war against Germany, saying, "The world must be made safe for democracy."

Entry into the World War was the biggest thing that had happened to America up to that time. While the Army and Navy raised men, the Treasury collected money, and farms and industry turned out materiel, the nation went on a unity spree. "The Yanks are coming," sang George M. Cohan in *Over There*; "Oh, how I hate to get up in the morning," wrote Irving Berlin. Famous entertainers toured the country, selling the Liberty Bonds which financed most of the cost of the war. Production and profits soared as the "arsenal of democracy" poured out munitions, vehicles, ships.

Did the United States win the war? No, but it would never have been won by the Allies without America. U.S. entry meant a tremendous boost in morale to the war-weary French and English. When American troops finally arrived, General John J. "Blackjack" Pershing ("Lafayette, we are here") sent them charging out of the trenches. Casualties were heavy, but the human waves overran the tired Germans and shortened the war.

As the fresh troops and new materiel wore down the Germans overseas, zealous patriots at home burned German books, discontinued teaching the language in schools, changed the name of sauerkraut to liberty cabbage, and passed sweeping espionage and sedition laws which flagrantly violated the Bill of Rights. When Germany surrendered, there was truly dancing in the streets. In the aftermath of war Wilson's idealistic Fourteen Points were emasculated abroad and the League of Nations

unsupported at home. Nor did the Great War make the world safe for democracy.

But from a pragmatic economic standpoint, the war was the greatest bargain in the nation's history. The U.S. lost 116,516 men, of whom more than half died of influenza; total casualties were some 320,000. France, Germany, Austria, Russia each lost a million more than that in dead alone. The U.S. went into the war with a national debt of a billion dollars and came out with $26 billion — but the other nations were practically bankrupt and owed America $14 billion. Wall Street became the financial center of the world. The United States took over the European economic colonies, particularly South America; within ten years the number of American bank branches jumped from zero to more than a hundred. The war had forced a tremendous jump in manufacturing, food production. The U.S. now had a third of the world's shipping tonnage, 85 percent of its automobiles. It had surplus money, surplus goods, surplus foods, and the market to sell them.

Other results included the wholesale entry of women into the national work force, and the movement of large numbers of Negroes into the North. Almost five million members of the armed forces — the U.S. had entered the war with only some 200,000 under arms — moved about the country and the world. As the song said, "How you gonna keep 'em down on the farm, after they've seen Paree?" All in all, the World War brought about the greatest changes, both internally and in its relationship to the world, in the nation's century and a half of existence.

In spite of the repressive spirit of the period, a few good newspapers presented reliable coverage.

Repression

Bolsheviks and anarchists, socialists and syndicalists — the labels were indistinguishable to an America almost paranoiac as far as any political philosophy left of center was concerned. The Russian Revolution, which released German soldiers to fight our doughboys on the Western Front, provided legislators, both federal and state, the final excuse to pass repressive laws. A person could be sentenced to 20 years imprisonment and fined $10,000 for criticizing the Red Cross or YMCA. In the postwar anti-red hysteria, legally-elected Socialists were prevented from taking office, while the FBI rounded up some 6,000 radicals and deported 249 of them back to Russia on the "Soviet ark." The national mood retarded the growing labor movement. West Virginia police, for example, forced more than a hundred steel workers striking against the 12-hour day to kneel and kiss the American flag.

In this atmosphere two Italian immigrants who were also atheists, anarchists and draft dodgers had the misfortune to be accused of a murder of which they may have been entirely innocent, and were executed. Their names, Nicola Sacco and Bartolomeo Vanzetti, and their martyrdom were perpetuated in protests, literature and persons influenced by the case.

During this period of repression of the radical left, incidentally, the radical right, particularly the Ku Klux Klan, proliferated. A quarter-million strong in 1924, the anti-Negro, anti-Semitic, anti-Catholic, anti-labor movement controlled the legislature of at least one state, Indiana, and its bloody and sadistic excesses extended as far north as Oregon. Fortunately, between the extremes of left and right the great mass of the American people proceeded on, undisturbed in the parade toward prosperity.

This bitter polemic relates the execution of Sacco and Vanzetti, the hypocrisy of responsible citizens.

Up in the Sky

The whole world was talking about it that drizzly May of 1927. Thousands of people went to the airfield every night, hoping to see an airplane, a very special airplane, take off in the morning mist. Scores of reporters turned out hourly bulletins. Who would be the first to fly non-stop, New York to Paris, and win $25,000 and eternal fame? Who would go down in the cold and stormy North Atlantic?

The favorite entry was the already famous Commander Richard Evelyn Bird, and his tri-motored plane, team of experienced pilots and $100,000 bankroll. Next was a tested single-engine plane with two less well-known but equally experienced pilots. Both entries were waiting for good weather when a boyish-looking pilot flew in, all alone in a single-engined plane, saying that he intended to fly the North Atlantic, too. The reporters dubbed him The Flying Fool, and serious protests were made to his sponsors and authorities in an effort to keep the young man from starting on his suicide mission and damaging the progress of aviation by crashing, as he was bound to do. For even if the plane could make the flight, how could anyone stay awake those long hours without relief to fly it?

The pilot's name was Charles A. Lindbergh, Jr., and though he was indeed the youngest pilot involved in the contest, it was fitting that he was just about the same age as aviation. He had been a year old when two brothers named Orville and Wilbur Wright had built their first plane, made their own engine to go in it, and dared to fly it. Orville, lying down on the bottom wing, steering the plane with wires connected to his hips, made the first powered flight, 120 feet in 12 seconds.

Strangely, the first flight did not evince much interest in the United States at the time. Though the Wrights kept improving their planes and flying them noisily in broad daylight, many newspapers expressed skepticism that they could fly it at all. It was not until 1908, when the Wrights took their latest plane, the *White Flier*, to France and flew it nonstop 77½ miles, that the world finally accepted the fact that man could fly, and got excited about it. But planes were still embryonic, and the truth of the matter is that pilots had not learned to fly them. Harriet Quimby, for example, first woman to fly the English Channel, lost her life when both she and her passenger fell out of her plane over Boston.

Flying the English Channel was the greatest challenge until 1911, when an American named Calbraith P. Rodgers flew from Long Island, New York, to Long Beach, California, in 84 days. Only three days, ten hours and twenty-four minutes of that time was spent in the air. The rest was spent putting the plane back together, for the flight antedated landing fields and in some landings his flimsy craft was almost totally destroyed. A crew that accompanied him on the ground would help him put it back together with sticks, wires, cloth and glue.

The World War gave aviation the necessary push. At the beginning the flimsy linen-covered planes were used strictly for observation; aerial combat began, literally, when one pilot threw a rock at another. Before long pilots were shooting at each other with pistols, then machine guns, then cannon; in the last few months of the war airplanes were capable of carrying pilot, gunner, guns and bombs weighing a ton. Though combat flying may not have been too effective, it was romantic. Before the United States entered the war, Americans made their way to France and organized the Lafayette Escadrille, flying with the French Air Force against the Germans. Captain Eddie Rickenbacker, the nation's leading ace, took his flight training in France.

The process of designing and building airplanes, about whose characteristics so little was known, took too long for the United States to send American designed and built planes to France, but 196 American-made airplanes of a British design did reach the Continent. More

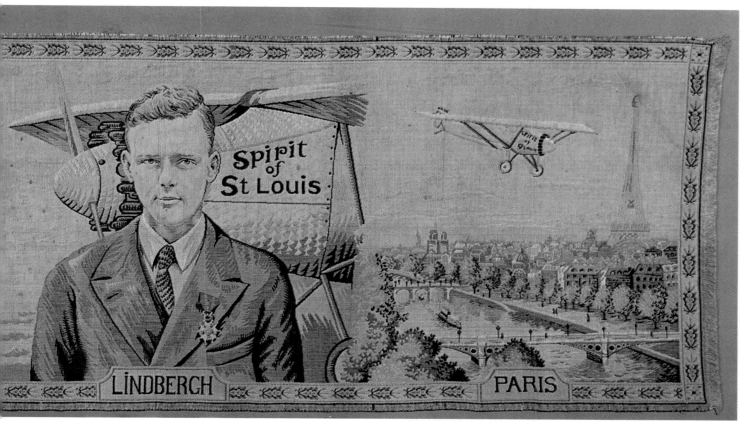

Truly a hero of the world, Lindbergh was honored in this colorful time-lapse tapestry, five *feet wide, woven in Paris. He did not, of course, fly over New York, and he landed at night.*

important than the few reliable planes designed and completed at home by war's end, were the great strides in the state of the art made during the war. Germany, England, France and America all made contributions to the new science and industry of aviation. Planes capable of sustained flight resulted from the pressure of war, as did the development of pilots who could fly them.

But instruments for flying through night and fog had yet to be developed. Pilots flew "by the seat of their pants," which meant that they learned to pay strict attention to the feel of the cloth binding on one side or the other; that way they would know even after other senses were dulled whether their plane was tilting to right or left. Sometimes even the seat of the pants was not enough, as in the first major nonstop flight made after the war. In this flight Captain John Alcock and Lieutenant A. Whitten Brown, English and American respectively, flew from Newfoundland to the Irish Coast to win a prize of £10,000. After several hours of flying in fog they became confused. A big black cat they had brought along as a mascot began acting strangely and at the last moment they realized the cat was hanging on for dear life — they were flying upside down.

All this time young Charles Lindbergh was growing up, his dream of flying becoming more practical with each new design of plane or

engine. He learned to fly, supported himself first by barnstorming — standing on the wings of someone else's plane to attract attention at small towns — then flying the airmail in open, war-surplus planes. The development of a reliable engine in the winter of 1926 stimulated his dream of flying the Atlantic. By spring he had gained the support of a group of St. Louis businessmen who underwrote his new little plane, the *Spirit of St. Louis,* and while the crews of the other planes were waiting for final weather reports, Lindbergh took off for Paris. His plane was dangerously overloaded with gasoline, he had no sleep for 24 hours, the wind was wrong, clear skies across the Atlantic were far from certain. Sometimes flying blind through fog, sometimes buffeted by storms, sitting in one cramped position unable to move his feet from the rudders or hand from the stick, he fought the elements and sleep to stay awake another 33½ hours and hit Paris on the nose.

What a hero! Parades in the major cities of the world. Decorations from many countries. Songs were written about him, among them *Lucky Lindy.* The term "Lucky" was ironic, for his fame and fortune at the age of 25 were deserved; he had planned the trip with the most meticulous care, and successfully fought both the elements and his own craving for sleep. There were many historic, record-breaking flights to follow, but there was only one Lucky Lindy.

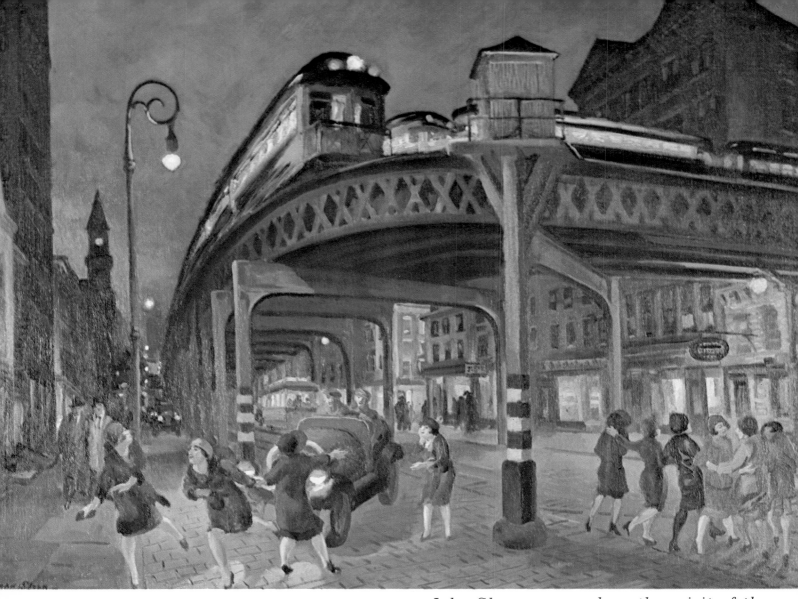

John Sloane summed up the spirit of the Roaring Twenties at Sixth Avenue and Third.

Ridin' High

Seldom in history has a boom lasted so gloriously long as the Golden Twenties. The postwar depression ended in 1922 and until the very end of the decade prosperity, production and profits went up, up, up, right along with the stock market.

This was also the Jazz Age. After the war the inevitable cynicism set in — what, after all, had it proved? For the first time in America, young people talked openly about "necking" and "petting" — as well as doing it. Dresses rose higher and higher, up the calf, over the knee. Bathing attire shrank from costumes complete with sleeves, stockings, even shoes, to trim one-piece suits.

The greatest influence on morality was Prohibition. Passed in 1919, the constitutional amendment prohibiting alcoholic beverages was simply ignored by a large segment of the population. People broke the law and everybody

knew it. The nation became conditioned to "getting away with it," if not to actual lawbreaking. In another development which was to bear ugly fruit, the prohibition of legitimate business from providing alcohol resulted in the emergence of illegitimate business. Gangsters fought bloody wars on the city streets. The mobs extended their hegemony from illicit booze to other ventures, legal and illegal, and thus got their foot in the door of many major cities throughout the nation.

Art, too, was influenced by the atmosphere of easy money. Multi-millionaires were paying inflated prices for all qualities of European art, but a group of American artists whose work was later to be recognized as having great importance could not find galleries to show them. Known as The Eight, this group of realists had made a serious break with convention in order to deal frankly with social problems. But during the Twenties their revolutionary resolve faded with prosperity.

It was all too good to last. "Ridin' High" became "Riding for a fall. . . ."

1929-1945
ONLY YESTERDAY

Stock market collapse brings an economic depression. Franklin D. Roosevelt's New Deal government fights back with new legislation best known by the initials: WPA, SEC, TVA, FDIC, CCC, AAA, FERA, NRA. A progressive Congress passes the Social Security Act. Germany's attack on Poland and France and its threat to England brings the US closer to World War II. Japan attacks Pearl Harbor. The Allies defeat Germany and America ends the war with Japan with the atom bomb.

HISTORICAL CHRONOLOGY	ART CHRONOLOGY
1929 Stock market drops $30 billion in three weeks.	**1929** Thomas Wolfe publishes Look Homeward Angel.
1929-32 85,000 businesses fail; unemployment rises to nearly 5 million; national income drops 50 percent.	**1930** Grant Wood exhibits American Gothic.
1930 More than 1,300 banks close as result of depression.	**1931** Star Spangled Banner officially declared national anthem.
1931 The 102-story Empire State Building opens in New York City.	**1932** Pearl Buck's The Good Earth is published.
1933 Franklin D. Roosevelt inaugurated President, immediately begins New Deal programs for economic recovery. End of prohibition.	Charles Burchfield uses realistic approach when he paints November Evening. Harburg and Gorney's Brother, Can You Spare A Dime? musically echoes the depression.
1935 Collective bargaining legalized. CIO founded.	**1933** Balanchine, invited to US, founds the American Ballet, forerunner of the New York City Ballet (1948).
1936 Landslide victory for FDR second term.	**1935** Over 5,300 artists in 44 states decorate public buildings, index works of art, and teach in the Federal Art Project.
1939 U S policy is neutrality despite acts of aggression in Europe.	WPA Federal Theater Project brings live drama to millions.
1941 After attack on Pearl Harbor, USA declares war on Japan, Germany and Italy.	Opening of Gershwin's Porgy & Bess.
1942 Defeat of Japanese at Midway Island tilts balance to U S forces in Pacific. First controlled self-sustaining nuclear chain reaction set off by Enrico Fermi and associates in Chicago.	**1936** Frank Lloyd Wright enters the most fruitful years of his career.
1943 North African phase of war ends with surrender of 200,000 of the Axis forces to Allies. Italy surrenders shortly thereafter.	**1938** Aaron Copland's ballet Billy the Kid is produced.
1944 D-Day invasion of Europe begins on June 6. FDR dies; Harry S Truman becomes President.	**1939** The Grapes of Wrath by John Steinbeck is published. New York World's Fair representing 60 countries opens.
1945 Atom bomb dropped. World War II ends. United Nations formed in San Francisco.	**1943** Rogers and Hammerstein's Oklahoma, choreographed by Agnes DeMille, opens.
	1945 Tennessee Williams' The Glass Menagerie opens.

Crash, Depression, New Deal

This was the most momentous peacetime period in the nation's history. In less than four years the USA built up to an uncontrolled tempo, came to a shuddering, shocking standstill, twitched helplessly for almost three years, then, under a new and charismatic leader, burst out of its paralysis with refreshed energy and a revived dynamic momentum.

It began in October, 1929. When the frantic boom of the Twenties began crumbling on the 29th, the day known as Black Thursday, the value of stocks started to drop. Within a few weeks stockholders in American corporations had lost more than the national debt — $30 billion. In three years they would lose $40 billion more.

Why did the bottom fall out? Economists do not agree on what caused the stock market crash. One of the simplest explanations is that fluctuation is the nature of the economy; the USA had already undergone a score of depressions and panics in its short history, and this was only one more. Another is that $90 billion was tied up in the stock market, for better or worse, instead of in circulation. Whatever the cause, the results were horrendous; to detail them is an exercise in fiscal masochism. Tens of thousands of investors had borrowed the money to buy the shares from their brokers, who in turn had borrowed from the banks. But as the value of shares fell, the banks demanded more security from the brokers, who sold out their customers, leaving them financially helpless. Thousands were ruined and rumors — generally unfounded — of suicides swept the country. In a sick joke of the times a man asked a hotel clerk for a room on the 20th floor, and the clerk replied, "To sleep in or to jump out of?"

As loans were called in, business spending was curtailed, and production reduced. That resulted in layoffs, and when people begin losing their jobs and their spending power the dominoes really begin to fall. In the next three years the production of the USA was cut in half. There was almost no new construction — millions of jobs were terminated. Agricultural prices dropped and a million families abandoned their farms. Thirteen million people were out of work, and as many more were down to part-time work for lower wages.

As America went, so went the world. Foreign trade dropped $3 billion. Efforts to ameliorate the situation through higher tariffs boomeranged, for other nations raised tariffs too, and an economic cold war resulted. Nations like the USA and Britain with their own sources of raw materials

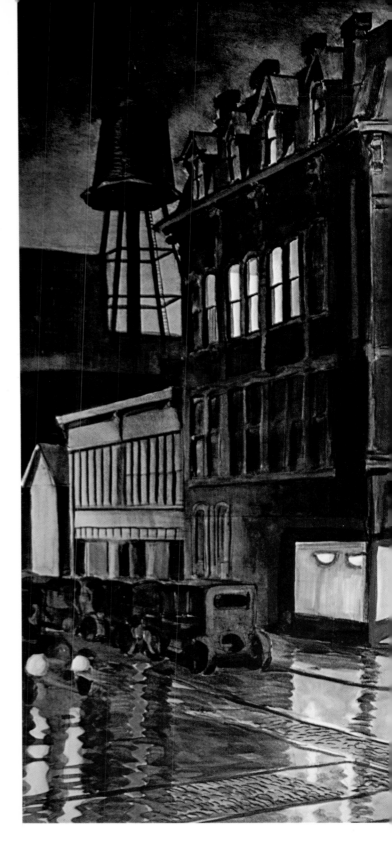

benefited. Japan, with only three of the 25 basic raw materials, could either collapse peacefully or expand through military conquest; the Japanese war party came into power and Japanese soldiers moved into Manchuria. Germany, still shaky after its defeat in the Great War, was so shaken by hard times that it chose the panacea of national socialism. The seeds of another global war were nurtured by world depression.

These were horrible times. The mood of the country was ugly; never before in its history had

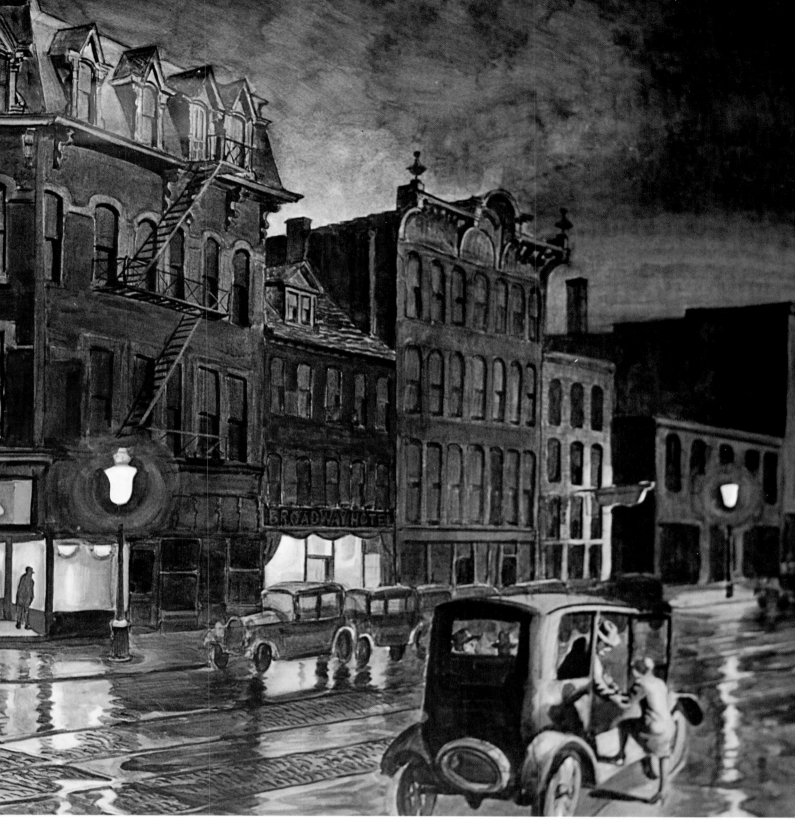

Charles Burchfield was working in Buffalo when he painted Rainy Night *at Broadway and Elliott streets, capturing the feel of 1930 in middle America early in the country's worst depression.*

plain, ordinary, true-blue citizens been so close to overt activity — looting, even revolt. Socialist and Communist factions gained members, as did counterrevolutionary movements of homegrown Fascists. President Herbert Hoover, an honest man with an excellent, even compassionate, record as a business executive, was hesitant to commit the Government to any forceful action on behalf of its people. Rather, his most dramatic operation was against the epitome of the nation's people, its war veterans. Tens of thousands of World War veterans, promised bonuses in the distant future, marched on Washington to claim them now. They camped in an instant ghetto of tarpaper shacks called, like many another vagrant camp throughout the country, Hooverville. After sending warnings which the erstwhile heroes could not take seriously, Hoover sent an Army detachment under General Douglas MacArthur and Major Dwight D. Eisenhower to chase the veterans from the capital.

Down went the national morale. Stocks

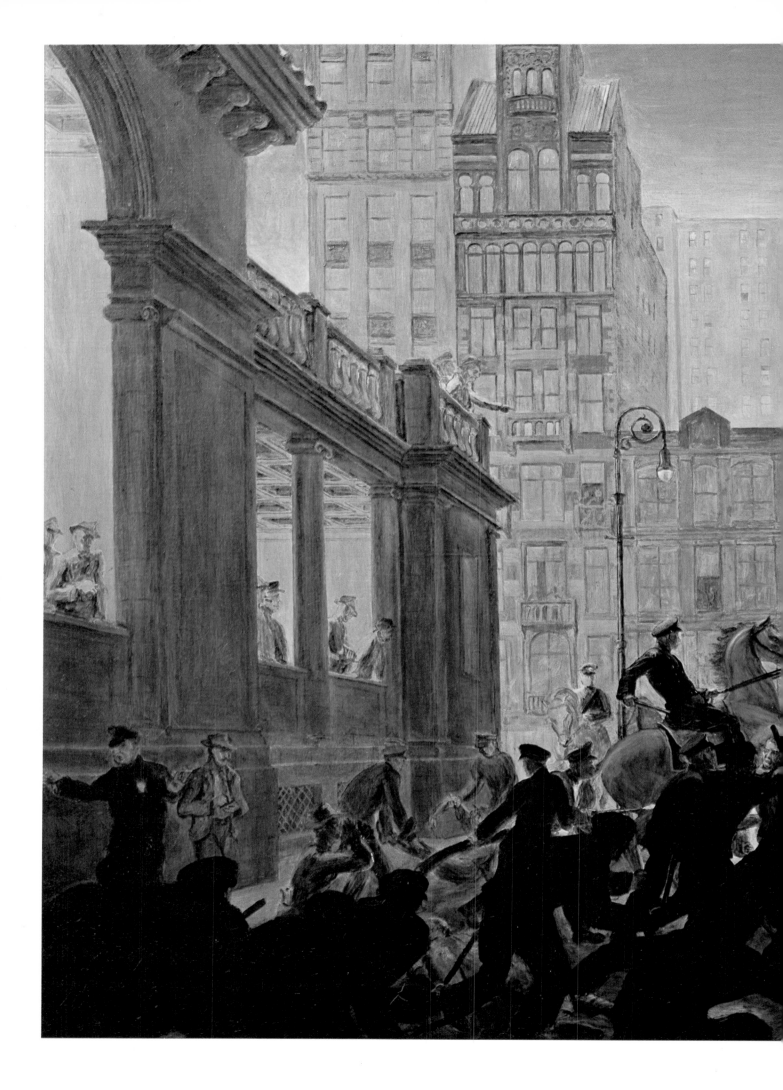

272

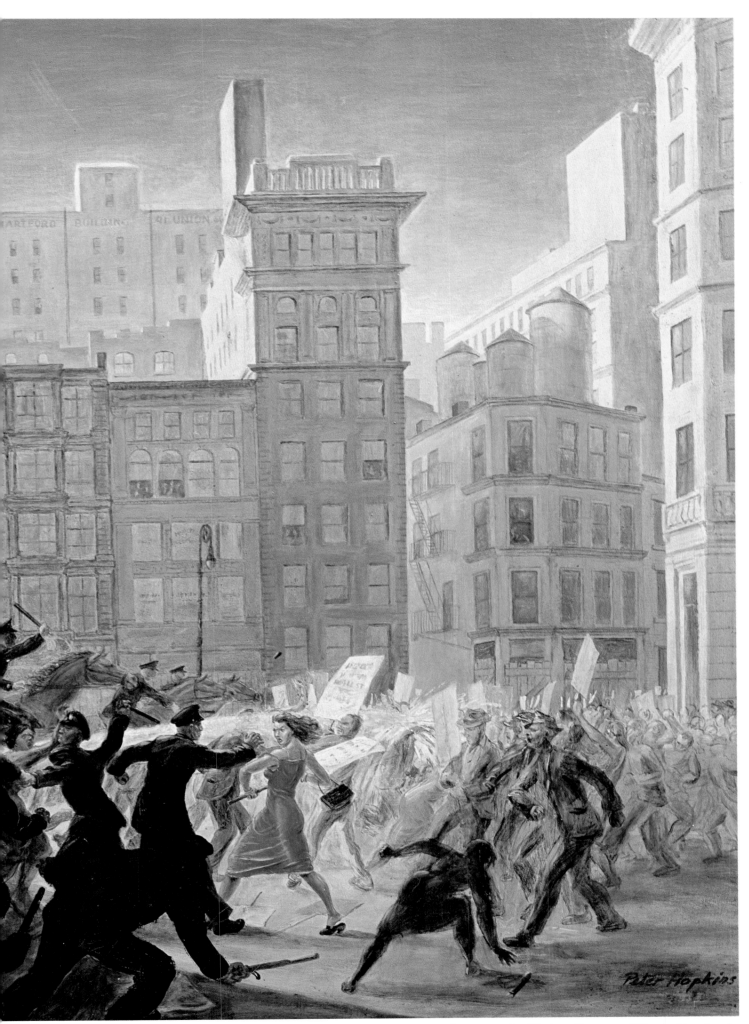

On March 6, 1930, the active Communist party in New York staged a demonstration against unemployment in Union Square. The police broke up the riot, along with some heads.

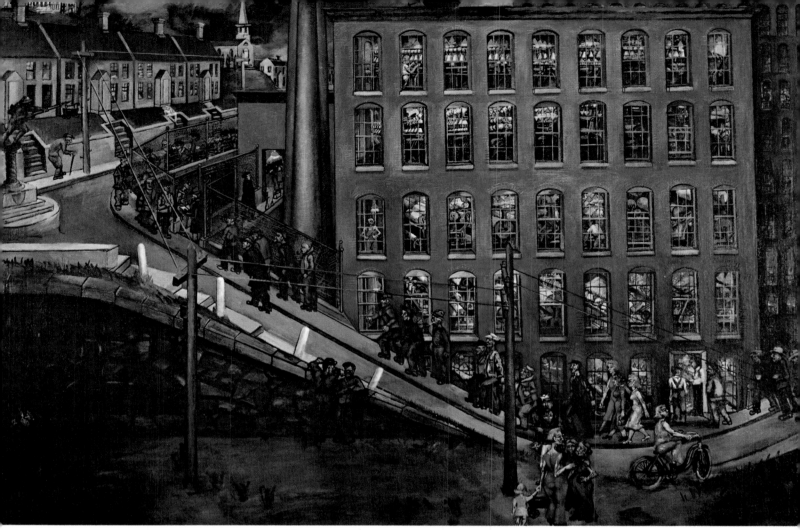

Through the Mill *was the storytelling title given by Philip Evergood to this imaginative painting* *showing the unpleasant effects of an over-industrialized, technically-oriented world.*

continued their drop — Remington Rand fell from 59 to 1, General Electric from 403 to 8½, Sears, Roebuck from 181 to 10. Farm prices declined. Banks closed. Mortgages were foreclosed. Down, down, down went the country.

And up, up, up rose the political fortunes of Franklin Delano Roosevelt, then Governor of New York, and the personification of paradox. In the massive inertia which so uncharacteristically marked the America of the Great Depression, he was the man in motion — yet he himself could barely stand on polio-crippled legs. He was the descendant of a Dutch patroon, scion of two families of great wealth and social position, yet he was the hero of the common man and a bane to many members of his own social strata. Though a vital man of great ego, he had been crippled by polio at the age of 39, and had had to be cajoled back into the national scene after his illness.

Now, in the presidential election year of 1932, America had one of its most clear-cut choices since choosing between Federalism and the Democrat-Republicans in 1800. Aside from the other issues, the question was really whether the nation would continue its three-year period of standing still and hoping something would happen, or whether it would revert to its dynamic

characteristic of a nation on the move.

Was the issue ever really in doubt? The Republicans were boxed into a corner with their candidate, glum, pudgy, Hoover; to shift candidates would be an admission that they had been wrong all along. Roosevelt got off to a literally flying start. On receiving the Democratic nomination he flouted tradition by going to the convention and accepting it *in person*. And further, he flew there in an airplane.

He was the man of action, and he looked it. Fifty-one years old but appearing younger, complete with beaming smile, long cigarette holder sticking up at a jaunty angle, appealingly distinctive voice, expansive gestures, colorful, forceful oratory, and, above all, confidence, he was the very definition of charisma. As George Washington had had his Hamilton, so Roosevelt had a circle of advisers, later known as the Brain Trust. Out of their early suggestions came two concepts almost magical in their appeal. One was the promise of a "New Deal" — a hard-hitting, visual analogy of the need not for a new deck of some other type of political philosophy, but for the same old American cards, tried and true, shuffled and dealt out again. His other catch phrase was "the forgotten man." Too

many Americans, that discouraging year, identified with that description. They, and a vast majority of others eager for that New Deal, elected Roosevelt the 32nd President.

Few presidents have faced such a challenge so fearlessly. On March 3, 1933, some 5,000 banks closed their doors, many with their depositors' money gone forever. That was Roosevelt's welcome to office, for on the following day he was inaugurated. At the very beginning of his acceptance he declared, and millions heard him on the radio, "First of all, let me assert my firm belief that the only thing we have to fear is fear itself." It struck a responsive chord in the nation. Since when had this nation of pioneers feared fear? And so began the New Deal.

On Monday Roosevelt took his first giant step. He closed down every bank in the nation. It left people without funds all over the country, but it showed that this President was going to do something. On Thursday Congress responded to his call for a special session, and on that one day completed legislation that opened the banks again under strong, reassuring conditions. Thus began that exciting, constructive period known in history as The Hundred Days — the length of that special session. During those hundred days, either by executive order or through congressional legislation, the following were accomplished: Beer was legalized and the demise of prohibition begun, the Securities Exchange Commission set up, mortgage foreclosures slowed down, bank deposits insured, banks aided, circumventions of the tariff act effected, businesses induced to produce more with higher wages, a half billion dollars appropriated for relief and the way paved for many times that to come, programs set up to furnish work, the great Tennessee Valley Authority begun.

This was just a start of the New Deal program. Roosevelt had chosen the most dynamic course of action in economics — government spending to prime the pump of productivity — and its effects were exhilarating. And at the end of his first term he received one of the largest popular votes in history for reelection.

The clean precise orderly lines of the River Rouge plant of the Ford Motor Company, lovingly presented by Charles Sheeler, illustrate the vitality of American industrial power.

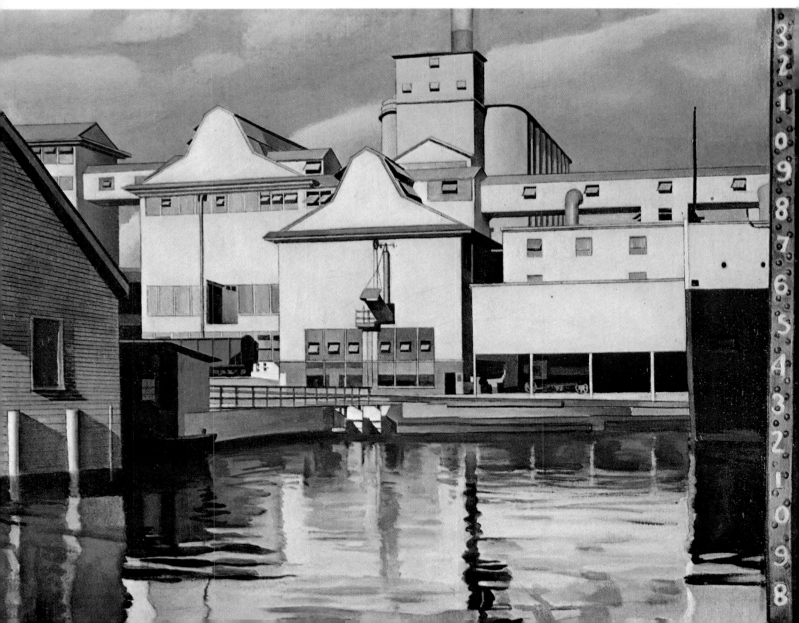

Labor and the Arts

Never since the election of the father of his country had an American president received such a mandate — for his second term President Roosevelt carried every state except Maine and Vermont. The New Deal had surely put America back in motion, where the great majority of Americans wanted to be. So great was the landslide that the jaunty, confident President made his first major misjudgment: He attempted, through legislative subterfuge, to tamper with that established American institution, the Supreme Court, failed, and lost supporters.

By now an initial-conscious nation knew him as FDR, and his active administration gave birth to the first crop of initials in government — AAA, CCC, PWA, WPA, NRA, NYA, REA, TVA, SEC, NLRB. They proliferated so rapidly that not even the bureaucrats could keep up.

Most of the new programs were inaugurated by progressive forces in Congress or, more likely, by the Brain Trust, an unusual group of individuals. Typical of the jaunty leader's administration were the nicknames given members of the group. Thomas C. Corcoran, for example, with his sharp mind and irrepressible sense of humor, was of course known as Tommy the Cork; Henry Morgenthau, Jr., more solemn, was Henry the Morgue. Harry Hopkins, Harry the Hop, was the personification of the Brain Trust, a midwestern, unpretentious social worker whose brains, perceptivity and energy made him one of Roosevelt's most trusted and effective lieutenants. Others in the group included the economist, Rex Tugwell, and another Columbia professor, Raymond Moley. To this group of well-educated, sensitive, native-born savants was added Sidney Hillman, immigrant president of the Amalgamated Clothing Workers. "Clear it with Sidney," was an expression spoken only partly in jest at a subsequent party convention.

Some New Deal legislation grew out of the philosophies of splinter groups which also proliferated during the period. Social security and labor legislation had been major planks on the platform of the Socialist Party. A large number of Socialists felt they could accomplish more through the party of the New Deal, and Socialism never recovered from their loss. But its leader, Norman Thomas, the eminently respectable Presbyterian minister, continued his increasingly lonely life mission, calling the New Deal's programs Roosevelt's "pale pink pills."

In 1932 a large group of some of the country's most prestigious writers had announced their intention to vote the Communist ticket. In spite of this temporary recognition, however, the Communist Party was never a serious political factor. Homegrown movements, including EPIC (End Poverty in California) and the Townsend Plan advocating total security for the aged, enjoyed some popularity. On the Populist front it was the Share Our Wealth Society, led by the colorful and effective Huey P. Long of Louisiana, which constituted the only conceivable threat to the New Deal. With a well organized movement and a foot-stomping march, *Every Man a King,* Huey had a base of three states when he was assassinated in 1935.

His successors took the Society over into the right wing of American politics. There awaited some small Nazi and Fascist groups, but the most numerous gathering was that composed of the radio flock, 20 million strong, of Father Francis E. Coughlin, a Michigan priest whose amazing popular appeal grew out of his Sunday evening radio talks. He was the master of the microphone, but after promising nine million votes to a third party he disconsolately found that American citizens do not always vote the way they listen.

The American capacity to absorb ideas from the political extremes without becoming extremist had been built into that marvelous document, the Constitution. And so Roosevelt and his advisers took what was good from the splinter movements and let the rabble-rousers exhaust themselves.

One institution supported by foreign ideologies, but as American as apple pie, was the labor movement. Unions had made little headway during the boom, even less during the depression, but the New Deal pushed through regulations and legislation giving organized labor support. American unions in 1935 could be personified by one of its leaders, a potential giant who had firmly held on while his union decreased in numbers, bankroll and prestige, and now saw the opportunity to advance. He was John L. Lewis, heavy-jowled, bushy-eyebrowed president of the United Miners Union. His schoolteacher wife had coached him in vocabulary and oratory; his speeches rumbled powerfully right up from his big belly. He had been a Republican, but he knew when to switch. Advanced thinkers in the labor and radical movements had long recognized the potential power of the industrial union, composed of all workers in the plant, rather than the diffused hodgepodge of horizontal unions with different strata of workers in different plants. At the 1935 convention of the moribund American Federation of Labor John Lewis and a few others broke out of the parent organization to form the Committee for Industrial Organization — CIO. Within two years it had close to four million members.

The two mighty bastions of non-unionism in the country were the steel and automotive

Jo Davidson, like Rodin before him, preferred rough surfaces, fitting for President Roosevelt.

industries. Lewis and the fledgling organization dared take them both on, assigning his No. 1 assistant, Philip Murray, to steel. Murray's success made him Lewis' successor as president of CIO. Out of the equally-successful automobile campaign emerged one of labor's most respected leaders, the young, earnest, incorruptible redhead, Walter Reuther.

For the first time in national history the Government also made special efforts on behalf of its artists, writers, musicians and theatrical people. They could get as hungry as anybody else, the Works Project Administration leaders realized. Enabling them to work in the areas of their own talents helped maintain — or regain — their self-respect. In the Federal Theater Project some 15,000 professionals, working in 40 theaters across the country, brought live drama and musicals to audiences totaling 25 million. The Federal Writers Project produced valuable, well-executed guides to states and regions, preserving priceless folklore. Fifteen thousand musicians were employed, and three WPA symphony orchestras — Utah, Buffalo and Oklahoma City — become permanent.

The Federal Art Project produced the Index of American Design, a complete compendium of native crafts. Some 5,000 artists and sculptors turned out a vast quantity of work for schools, hospitals, town halls, public buildings of all kinds. At the height of the program there were 103 art centers across the USA, enabling younger artists to learn and practice at home rather than being forced to go to larger cities — which during the depression was for many impossible. Townspeople seeking enrichment in their lives were able to learn something about working with wood, stone, clay, textiles and paint at these centers.

In the mural program alone such well-known artists as Henry Varnum Poor, Ben Shahn, Frank Mechau, Boardman Robinson, William Gropper, John Steuart Curry and Thomas Hart Benton produced a recognized body of work. Though there has been some criticism of the WPA murals, on the whole they were well received, and the appreciation of many has grown over the years. They were painted, after all, by a group of artists who were generally enthusiastic and excited, and grateful for the opportunity to express their talent for gain.

The entire period of boom, bust and depression was important in the development of American arts and letters. The vitality of the painting in the Twenties provided a foundation for the expression of bitter social protest in the Thirties, but the most important phenomenon was what the critic Lewis Mumford described as "the discovery of art as a vital factor in contemporary American culture." He added: "The worth of the WPA arts projects has been proved: a magnificent achievement."

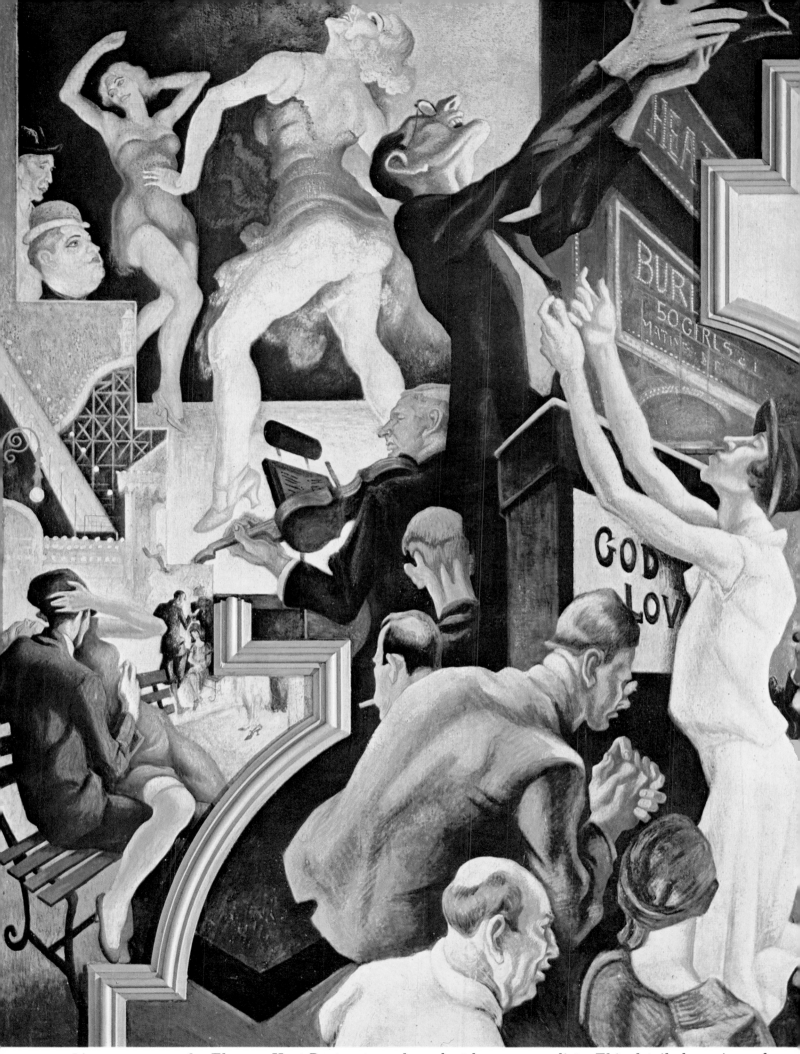

It's easy to see why Thomas Hart Benton turned from easel painting to become one of America's best-known muralists. This detail shows joyously what impressed him about the American scene.

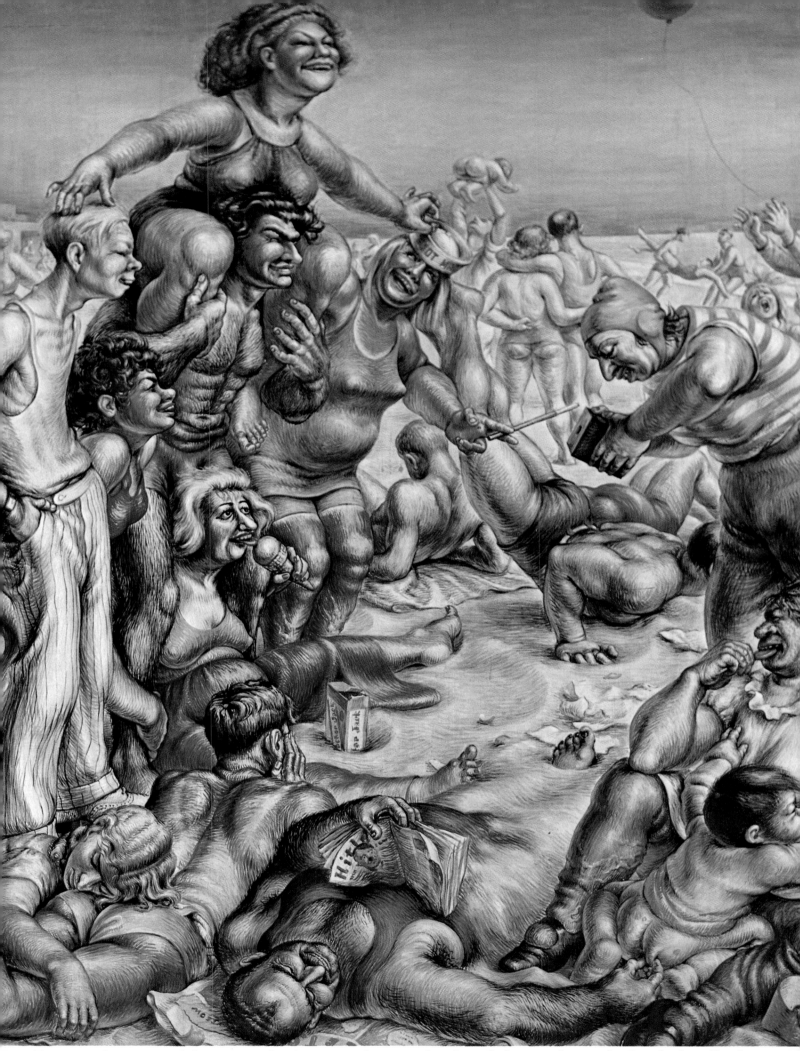

To some this scene of Americans having a good time at Coney Island might appear to stress the vulgarity of the people on the beach, but Paul Cadmus saw humor and warm compassion.

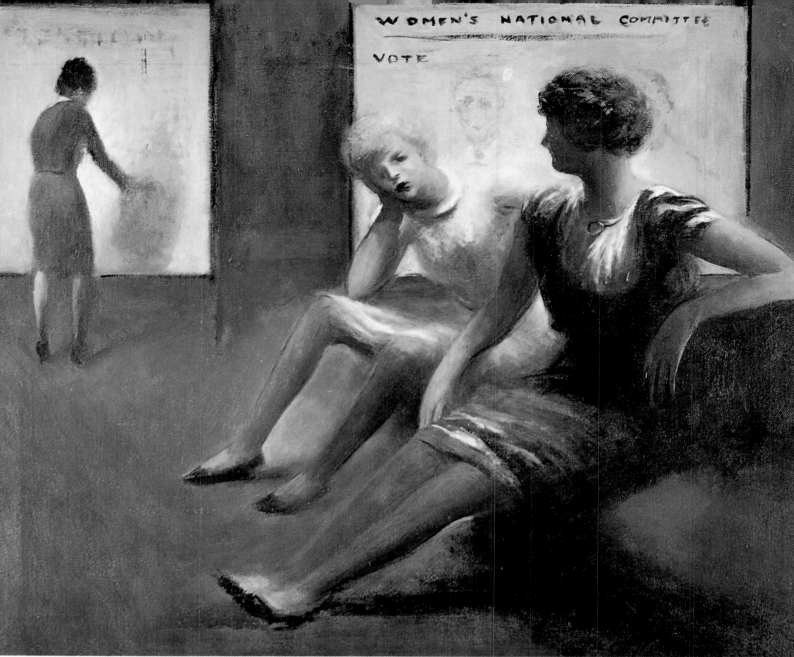

"The Leaguers," as members of the League of Women Voters proudly call themselves, obviously *intrigued Guy Pène du Bois, a sophisticated New York boulevardier who painted night club scenes.*

Women in Peace and War

One of Franklin D. Roosevelt's greatest assets was a slightly bucktoothed lady of no great beauty but of tremendous vitality and charm. She was his wife, Eleanor. Her name was, in fact, Eleanor Roosevelt Roosevelt, for she was her husband's fifth cousin and the niece of President Theodore Roosevelt. Most active First Lady in history, she was not only her husband's legs, but his eyes and ears as well — and, some said, his heart, for it was Eleanor's warm, sincere humanitarianism that attracted many members of minorities to the New Deal.

It was high time, in this restless country with its changing appreciations, for a woman to come so strongly to the fore. It is doubtful that the President could have kept Eleanor at home if he had wanted to, but having her warmth and peripatetic nature at his disposal, he made the most of it. For she was more than the First Lady, with the title's implication of housewife; she was representative of the American woman on the final lap toward liberation.

Twenty-two years had passed, on FDR's election to office, since the adoption of the Nineteenth Amendment giving women the right to vote. In those years their life styles had certainly changed: Women were smoking cigarettes — and in public! They wore bobbed hair and short skirts, and they drank cocktails. They were having fewer babies, and were far less tied to children and kitchen. They were seeking higher education, and not just in the women's colleges and state normal schools, but in major

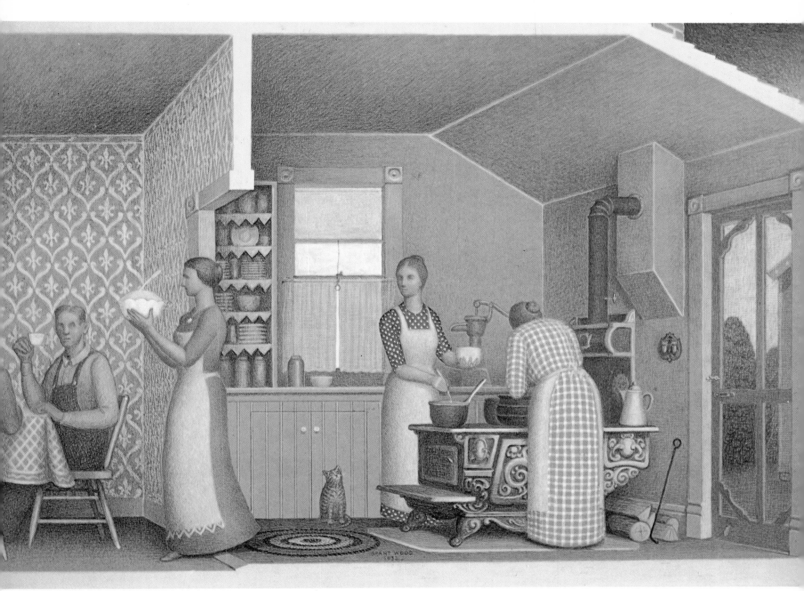

Women may have won the vote, but to Grant Wood, who liked best to depict the homespun *rural life of his native Iowa, they still fed the family and hired hands, kept farms producing.*

universities and graduate schools.

The General Federation of Women's Clubs, dating back to 1889, was active, as were its better-known member organizations like the Daughters of the American Revolution and the Colonial Dames. Coming to the fore as the condensation of women's increasing interest in the government which was now their own was the League of Women Voters, organized in 1920 along with the adoption of women's suffrage. Working for peace, prosperity, education and human welfare, the league specialized in political education as a necessary part of democratic government. It was gradually developing into a collection and dispersal agency for accurate information of vital issues. The league became the agency which makes a dispassionate study of the views and qualifications of all candidates for office, from councilman to President. Describe someone as "a leaguer," and any woman knows what you mean.

But still 12 years went by before the first woman was appointed to the presidential Cabinet. She was Frances Perkins, a compassionate, efficient social worker who had been largely responsible for reducing the number of the hours in the work week for women in New York state from 54 to 48. She continued to merit the trust of the President while in the Cabinet, and was his choice to head the commission which proposed the Social Security program.

It was war which effected the greatest acceleration of woman's acceptance in non-domestic walks of life. Not too many decades had passed since women were welcome in only the most menial jobs; in the war years 18 million joined the work force, building ships (like Rosie the Riveter) and planes and tanks. A thousand woman pilots ferried airplanes, including the speediest fighters and heaviest bombers, throughout the country. Indeed, the commanding general remarked that he preferred the ladies — they read the instructions on how to fly a new model before taking off in it. Some 200,000 women in all served in the various auxiliaries of the armed forces.

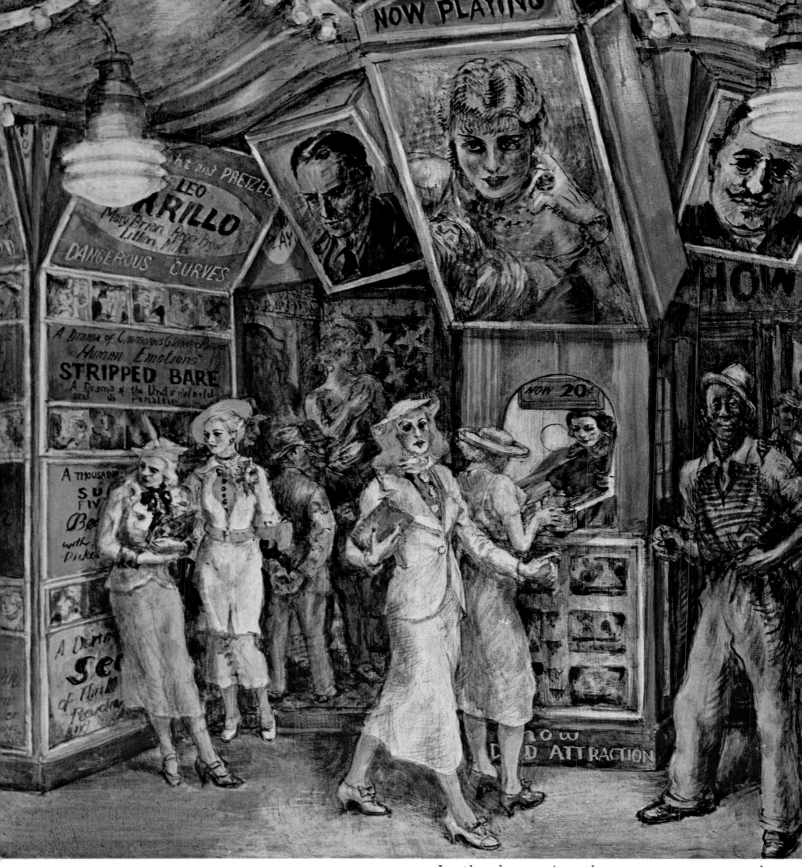

In the depression theatre owners not only reduced the price of admission to twenty cents,

Radio + Cinema = TV

Never before had a president made personal contact with so many people at one time, nor with such good news. In the first of his radio "Fireside Chats," President Roosevelt told 35

million Americans, in the distinctive voice blending warmth and friendliness with an upper-crust Eastern accent, that American banks would open in the morning, and that all was well. It was an auspicious beginning of an institution. All over the country neighbors would join together in the homes of those who had radio sets, as FDR, that master of the opportune,

but put on bingo games, gave away dishes, and presented double features.

exploited the new form of communications to the fullest in bringing his presence to the people. At first "Good evening, my friends," perhaps the most imitated words in the world that decade, brought comforting reassurance. As the years went on, and newspapers began attacking him, the President used his fireside chats to report directly to the people, to take his case to the public in person. They ignored the printed word in election after election, and voted for the person talking to them on their radio sets.

The Thirties began a glorious quarter century of radio's reign. Movie attendance dropped a third during the depression, but somehow or another Americans managed to buy the new radio sets that were no longer dependent upon batteries, but could be plugged in. Like the President, the new entertainers moved right in with American families. There were Amos 'n' Andy, Fibber McGee and Molly, Kate Smith, Jack Benny, Fred Allen, George Burns and Gracie Allen, and a dozen others on the evening shows, and the young people stayed up late to listen to the new idol of the college set, Guy Lombardo. News, too, was personalized, as the familiar voices of Lowell Thomas, Gabriel Heatter, Boake Carter and H.V. Kaltenborn came into the living rooms.

Motion pictures were floundering in a technical changeover in the early Thirties. The silent film, just at its peak, had been ended by the talkies, and the use of sound required the cinema experts to learn everything all over again. Scenes could not be shot on location, for example. Actors spoke their lines instead in sound-proofed studios, in front of previously-shot scenes of outdoors, or city streets, or stormy seas. A whole new school of special effects technology developed. Shipwrecks, escapes from burning buildings, wars and spectacles, all were created in the studios, often in miniature. The make-believe began to look better than the real thing.

With audiences already decreased, filmmakers were reluctant to make films with a social message, lest it be the wrong one. Instead, they used the new techniques and the new toy of sound to produce some of the greatest pure entertainment of all time — lavish musicals, swashbuckling adventure, and wacky comedy. Another innovation, the animated cartoon, rode in on the back of a mouse named Mickey.

As the industry got its techniques together, again Hollywood assumed international leadership in technology, artistry, and the sheer dazzling impact of its films. With the return of confidence, the industry dared to make message films, and they became a small but prestigious segment of production. Only its own monster, the industry's censorship office, limited the scope of films from the Forties on.

Expertise developed in radio and cinematography, with an assist from war-accelerated technology in electronics, led inexorably to the greatest form of communications of them all, television. As World War II ended, the new medium was ready, needing only public demand to produce the equipment and expertise which would result in its world wide acclaim.

George Washington Carver developed some 500 products from peanuts and sweet potatoes.

Paul Robeson played Othello in 1923-24 in the longest Shakespeare run on Broadway.

The Beginnings of Black Power

Of the American Negro in the Thirties it could truly be said that there was nowhere to move but up. If the years of depression, New Deal and war were momentous for most Americans, they were absolutely vital to that hungry, deprived minority, the Blacks. At least 15 million were without full citizenship rights when the Thirties began. Worst off of all were the 800,000 tenant farmers and sharecroppers, many of whom existed on an average of ten cents a day.

Even in those most trying of times, the groundwork was being laid for Negroes to join in the upward motion that characterized the USA. In New York the Harlem Renaissance of poets and writers in the Twenties attracted attention. Entertainers were moving out of the minstrel-show stereotype, into full acceptance. When the magnificent contralto, Marian Anderson, was not permitted to give a concert in Constitution Hall, owned by the Daughters of the American Revolution, the bitter irony was such that many Daughters, including Eleanor Roosevelt, resigned in protest.

The National Association for the Advancement of Colored People and the Urban League, both interracial groups, were slowly expanding in membership and respect. The new CIO's vertical unions accepted hundreds of thousands of Blacks hitherto frozen out of organized labor. People of good will inaugurated and supported interracial operations like the Delta Cooperative Farm in Mississippi, where members of both races worked side by side in a communal type arrangement similar to that of Jamestown three centuries before. Homogenous groups were beginning, like the Black Muslim movement.

Though President Roosevelt was sympathetic to interracial movements, he was a practical man who saw improvement coming from education, training and jobs. His 1941 executive order forbidding discrimination in defense work was a milestone, followed by orders ending discrimination in the armed forces.

It was the war, in fact, which brought all the ingredients together to make the giant steps of the next decades possible. Defense work enabled Blacks to leave the tenant farms for the north and west. More than a million Negroes served in the armed forces, 7,768 as commissioned officers. At war's end 53,000 were in college. Men who fought for their country felt understandably strongly about not being able to vote. Now they had the education, the support of many whites, and the organizations to do something about it.

The number of sharecroppers in the Southern states was decreasing rapidly when Robert

Gwathmey painted these two in 1939 as mechanical equipment was replacing humans.

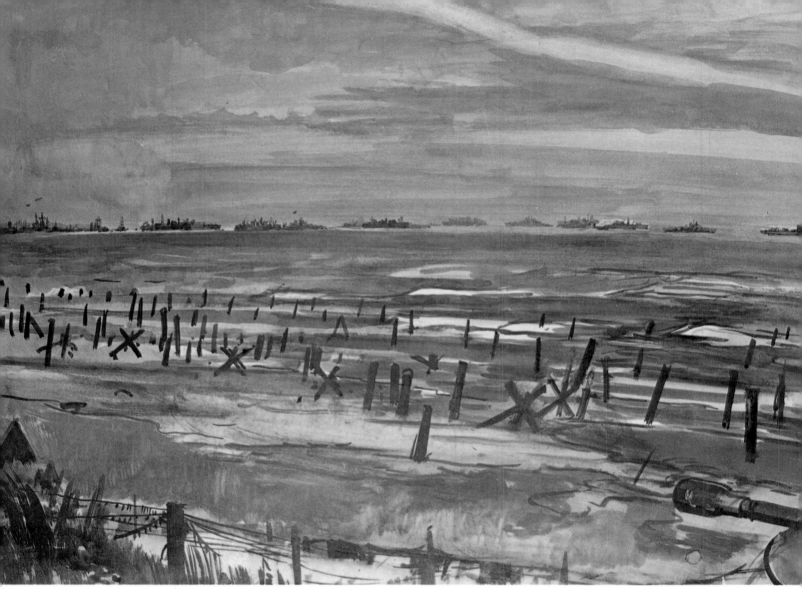

The artist who painted this scene of Allied ships off the coast of Normandy that June morning must have been tempted to finish quickly, for he was one of the Germans dug in the cliffs.

The Last World War?

The nation had lived through the boom and the crash, through depression, recovery and reform. But there were even greater sacrifices and rewards to come. Across both oceans, in Europe and in Asia, nations were hurtling toward that ultimate adventure of life and death, war. On December 7, 1941, the Japanese attack on Pearl Harbor drew America into the vortex. Referring to that "unprovoked and dastardly attack" on "a date that will live in infamy," President Roosevelt asked and received a declaration of war from Congress.

For several months the global situation was grim. The Japanese swept through southeast Asia and the islands of the South Pacific; the Germans spread through Eastern Europe and even North Africa. From today's vantage point, however, the final outcome was never in doubt.

The American energy produced an invincible war machine. As a military strategist later observed, if the USA had produced nothing but bows and arrows we would still have overwhelmed the enemy with sheer quantity.

As Americans at home turned out the materiel, members of the armed forces joined their Allies abroad in this global war. Americans chased the Germans across the sands of Africa, up the rainy hills of Italy, across France, through Germany, into Austria and Czechoslovakia. They flew over the North and South Atlantic, dropped bombs and shot down planes over North Africa and Europe. On the other side of the globe Americans captured islands of the South Pacific, fought in the Philippines and Burma. They covered the seas and they covered the skies, from India eastward to Japan, from the murky Aleutians south to Australia. Americans were everywhere. The cost was higher than in World War I, for the USA lost 292,100 dead and missing, one out of every 450 of the total population, but again it was low in comparison to Britain's 544,596; Germany's 2,850,000, one out

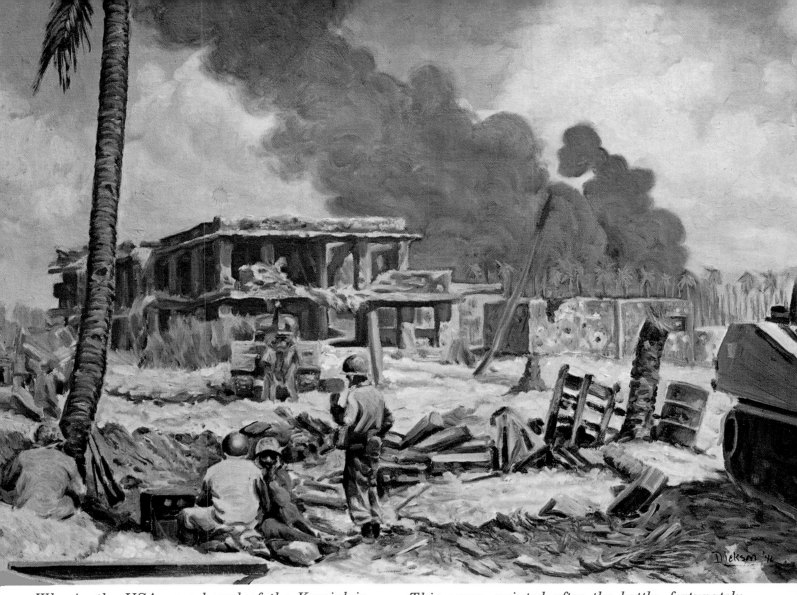

Who in the USA ever heard of the Kwajalein Atoll, let alone Namur, before World War II?

This scene, painted after the battle, fortunately survived; many of the artist's works were lost.

of 25; Japan's 1,506,000 and Russia's 7,500,000, one out of 22. It would have been higher had not the new President, Harry S Truman, made the agonizing decision to unleash that terrifying force, the atom bomb.

With the end of the war came the end of that part of the history of the USA that is readily assessable; a new period began, the significance and direction of which only the future will be able to judge. From the old world birthplace of mankind its peoples had spilled over into America from Asia to the West, Europe and Africa to the East. They had restlessly explored every inch of their vast, rich land, settling where they chose, filling it up. Always on the move, during the war they had spread out again, over the entire globe. No longer could even the world satisfy that restless drive of these people on the move. The whole universe was out there waiting.

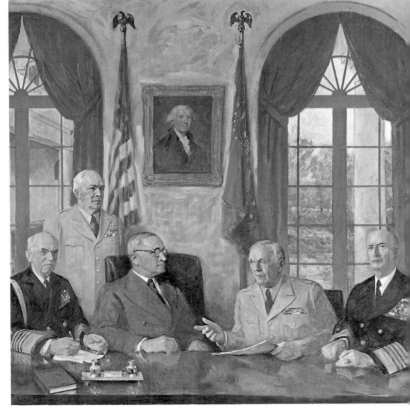

Harry S Truman, "the man from Missouri" made the most momentous decision of the war.

WORKS OF ART

jacket top: *Indians Fishing;*
John White, c. 1577-1590
watercolor
British Museum, London

jacket bottom: *The Wedding;*
anon., c. 1805
pen and watercolor; 37.1 x 51.4 cm
Philadelphia Museum of Art

1 *Brooklyn Bridge: Variation on an Old Theme:*
Joseph Stella; 1939
oil on canvas; 177.8 x 106.6cm
Whitney Museum of American Art

4-5 *The Station on the Morris and Essex Railroad;*
Edward L. Henry; c. 1864
oil on canvas; 27.9 x 50.8 cm
From the Whitney Museum of American Art's exhibit "The Painters' America"; The Chase Manhattan Bank Art Collection, New York

17 Bone flute, 32 cm; knife, 26 cm; abalone shell dish, 22 cm
Pre-Columbian c. 1000 A.D.
Southwest Museum, Pasadena, California

18 Inscription Rock, New Mexico
petroglyph
photograph by Bradley Smith

19 Venus; Hohokam Culture
ceramic; 17.8 x 8.9 cm
Southwest Museum, Pasadena, California

20-21 Helmet Pot (detail); Hohokam Culture, Santa Cruz phase
700-900 A.D.; clay; 19.1 cm diameter, 7.6 cm depth
Courtesy of Mr. and Mrs. Glenn E. Quick, Sr., Phoenix, Arizona

22 (top center) over-laid turquoise frog; 5.1 cm diameter
(mid center) incised ring; 2.5 cm diameter
(bottom center) over-laid turquoise frog; 4.4 cm wide x 5.1 cm long;
(left and right) female figures;
Hohokam Culture
700-900 A.D.; clay; 12.7 cm high
All courtesy of Mr. and Mrs. Glenn E. Quick, Sr., Phoenix, Arizona

23 (top) Paint Palette; Hohokam Culture
700-900 A.D.; slate; 12.4 x 7 cm
Courtesy of Mr. and Mrs. Glenn E. Quick, Sr., Phoenix, Arizona

23 (bottom) Two men holding a bowl;
Hohokam Culture, Sacatom phase
500-700 A.D.; sandstone; 10.8 cm long x 8.3 cm high x 5.7 cm wide
Courtesy of Mr. and Mrs. Glenn E. Quick, Sr., Phoenix, Arizona

24 Man and Bear Bowl; Mimbres Culture
c. 800-1300 A.D.; clay
Bill Faris Collection

25 (top) Hunter with Rabbit Bowl;
Mimbres Culture
c. 800-1300 A.D.; clay
Bill Faris Collection

25 (center) Shaman with Birds Bowl;
Mimbres Culture
c. 800-1300 A.D.; clay
Bill Faris Collection

25 (bottom) Ritual of Puberty Bowl;
Mimbres Culture
c. 800-1300 A.D.; clay
Bill Faris Collection

26 Male and Female Figures; Anasazi Culture
c. 900-1400 A.D.; cream slip; male, 17.8 cm high; female, 14.9 cm high
Courtesy of Mr. and Mrs. Glenn E. Quick, Sr., Phoenix, Arizona

27 Human Effigy; Anasazi, Pueblo III Culture
c. 700-1100 A.D.; clay; 23 cm high
Southwest Museum, Pasadena, California

28 Whales and Pelican;
Pre-Columbian
c. 1000 A.D.; stone; all 10 cm
Southwest Museum, Pasadena, California

29 (top) Dog, Mountain Sheep, Wild Cat; effigy jars
dog, wild cat; Anasazi Culture, c. 700-1100 A.D.
sheep; Hohokam Culture, c. 500 A.D.
all clay; approximately 6 cm
Southwest Museum, Pasadena, California

29 (bottom) Effigy Water Vessel;
Anasazi Culture
c. 700-1100 A.D.; clay
Southwest Museum, Pasadena, California

30 Kneeling Man; Mound Builder Culture, Shiloh, Tennessee
c. 1200-1600 A.D.; carved limestone; 25.4 cm
Smithsonian Institution, Washington, D.C.

31 Seated Cat Figure; Key Dweller Culture, Key Marco, Florida
c. 1000-1600 A.D.; carved wood; 15.2 cm
Smithsonian Institution, Washington, D.C .

32 Nata-aska (Black Ogre) Kachina;
Pueblo Culture, Hopi Tribe
pre-1900; carved cottonwood root, coated with Kaolin, native dye paints; 45.7 cm high
The Heard Museum, Phoenix, Arizona

33 *One of the Wives of Winginia;*
John White; c. 1577-1590
watercolor; 23.5 x 13.3 cm
British Museum, London

34-35 (top) *The New World in the Year 1500;* Juan de la Cosa; 1500
Museo Naval, Madrid, Spain

35 (bottom) *The Virgin of Christopher Columbus;* anon.; early 16th C.
oil on canvas
Museo Lazaro Galdiano, Madrid, Spain

36 *Newspaper Rock*
petroglyph
Courtesy of the Utah Travel Council

37 (top) *Cavalry Uniform of New Spain;* anon.; 17th C.
Archivo de Indias, Seville, Spain

37 (bottom) *Cavalry Officer's Uniform of New Spain;* anon.; 17th C.
Archivo de Indias, Seville, Spain

38-39 *R. de Laudonnière and the Timucua Indians;*
Jacques Le Moyne; 1564
gouache
New York Public Library

40 *Sitting Around the Fire;*
John White; c. 1577-1590
watercolor; 21.6 x 20.3 cm
British Museum, London

41 *The Camp of Englishmen on St. John's Island;*
John White; c. 1577-1590
watercolor; 36.8 x 44.5 cm
British Museum, London

42-43 *The Coast from Chesapeake Bay to Cape Lookout;*
John White; c. 1577-1590
watercolor; 47.9 x 23.5 cm
British Museum, London

44 (left) *Wife and Daughter of a Chief;*
John White; c. 1577-1590
watercolor; 26.4 x 14.9 cm
British Museum, London

44 (center) *A Secotan Chieftain's Wife;*
John White; c. 1577-1590
watercolor; 26 x 14 cm
British Museum, London

44 (right) *Indian Woman of Florida;*
John White; c. 1577-1590
watercolor; 26 x 13.7 cm
British Museum, London

45 (left) *Eskimo Man;*
John White; c. 1577-1590
watercolor; 22.5 x 16.6 cm
British Museum, London

45 (center) *Indian in Body Paint;*
John White; c. 1577-1590
watercolor; 26.4 x 14.9 cm
British Museum, London

45 (right) *Indian Man of Florida;*
John White; c. 1577-1590
watercolor; 26.7 x 14.3 cm
British Museum, London

45 (bottom) *The Town of Pomeiock;*
John White; c. 1577-1590
watercolor; 22.2 x 21.6 cm
British Museum, London

46 *Religious Dance* (detail);
John White; c. 1577-1590
watercolor; 27.3 x 35.6 cm
British Museum, London

47 *A Meal;*
John White; c. 1577-1590
watercolor; 21.6 x 21 cm
British Museum, London

48 *Pocahontas;* anon. c. 1616
oil on canvas; 76.8 x 64.1 cm
National Portrait Gallery, Smithsonian Institution, Washington, D.C.

93 *George Washington in the Uniform of a British Colonial Colonel;* Charles Willson Peale; 1772 oil on canvas; 129.5 x 106.6 cm Washington and Lee University, Lexington, Virginia

94 *A View of Mount Vernon;* anon.; 1790 or later oil on canvas; 95.5 x 110 cm National Gallery of Art, Washington, Gift of Edgar Wm. and Bernice Chrylser Garbisch

95 (top) *A Portrait – George Washington;* H. Humphrey; 1796 The New York Historical Society, New York

95 (bottom) *The Washington Family;* Edward Savage; c. 1796 oil on canvas; 213.6 x 284.2 cm National Gallery of Art, Washington, Andrew W. Mellon Collection

96 *High Street from the County Marketplace;* William Birch; 1799 hand-colored etching; 28.2 x 34.3 cm Philadelphia Museum of Art, Gift of Mrs. Walter C. Janney

97 *Knickerbocker Hall;* W. Seaman; c. 1850 oil on canvas; 72.4 x 90.8 cm The New York Historical Society, New York

98 *Memorial to Herself;* Eunice Pinney; 1816 watercolor; 31.1 x 39.3 cm New York State Historical Association, Cooperstown

99 *Washington and Liberty;* anon; c. 1810 oil on canvas; 187.9 x 111.7 cm New York State Historical Association, Cooperstown

100-01 *Indian Treaty of Greenville,* anon.; 1795 oil on canvas; 55.5 x 68.5 cm Chicago Historical Society

102 (top) *Tontine Coffee House;* Francis Guy; 1797 oil on canvas; 107.3 x 163.2 cm The New York Historical Society, New York

102 (bottom) *Harvest Scene;* Mary Woodhull; between 1775-1800 needlepoint, wool on linen canvas; 54 x 65.4 cm Colonial Williamsburg Foundation, Williamsburg, Virginia

103 *Quaker Meeting;* anon.; 1790 oil on canvas; 63.5 x 76.2 cm Museum of Fine Arts, Boston

104 *Thomas Jefferson;* Rembrandt Peale; 1805 oil on canvas; 73.7 x 61 cm The New York Historical Society, New York

105 *Aaron Burr;* James Van Dyke; 1834 oil on canvas; 24.4 x 19.7 cm The New York Historical Society, New York

106-07 *Landscape;* Bradley Smith; 1955 Kodachrome; 20 x 25.4 cm Collection of Bradley Smith

107 *Captain Meriwether Lewis;* Charles Saint-Mémin; 1806 watercolor on paper; 15.9 x 9.5 cm The New York Historical Society, New York

108 *Stephen Decatur at Tripoli;* William A. K. Martin; c. 1850 oil on canvas; 73.3 x 99 cm Naval Photographic Center, Washington, D.C.

109 *Burning of the Frigate Philadelphia in the Harbor of Tripoli, February 16, 1804;* Edward Moran; 1804 oil on canvas; 152.4 x 106.7 cm Naval Photographic Center, Washington, D.C.

110-11 *Constitution and Guerriere;* Thomas Birch; oil on canvas; 116.8 x 162.5 cm Courtesy United States Naval Academy Museum, Annapolis, Maryland; prints available

112-13 *The Battle of New Orleans;* Hyacinthe De Laclotte; 1815 oil on canvas; 74.3 x 91.4 cm New Orleans Museum of Art

114-15 *The Wedding;* anon.; c. 1805 pen and watercolor; 37.1 x 51.4 cm Philadelphia Museum of Art; the Edgar M. and Bernice Chrysler Garbisch Collection

116 *Quilting Party;* John Lewis Krimmel; 1813 oil on canvas; 42.8 x 56.8 cm Courtesy, The Henry Francis du Pont Winterthur Museum, Delaware

117 *The Poor Author and the Rich Bookseller;* Washington Allston; 1811 oil on canvas; 78.7 x 71.1 cm From the Whitney Museum of American Art's exhibit "The Painters' America"; Museum of Fine Arts, Boston

118-19 *Itinerant Painter;* C. B. King; c. 1815 oil on canvas; 113.7 x 144.8 cm New York State Historical Association, Cooperstown

120-21 *Costumes le Danse de Guerra;* Login A. Choris; 1816 watercolor on pencil; 27.3 x 22.9 cm Reproduced by permission of the Director, The Bancroft Library, Berkeley, California

122-23 *View Taken near Monterey;* Richard Beechey; c. 1826 watercolor on pencil; 24.4 x 41.9 cm Reproduced by permission of the Director, The Bancroft Library, Berkeley, California

123 (bottom) *Danse des Californiens;* Login A. Choris; 1816 watercolor on pencil; 17.8 x 29.2 cm Reproduced by permission of the Director, The Bancroft Library, Berkeley, California

124 *Knickerbocker Hall;* W. Seaman; c. 1850 oil on canvas; 72.4 x 90.8 cm The New York Historical Society, New York

125 *Interior of the Park Theatre;* John Searle; 1822 watercolor; 57.2 x 78.7 cm The New York Historical Society, New York

126 *The Dinner Party;* Henry Sargent; c. 1820 oil on canvas; 151.1 x 121.9 cm Museum of Fine Arts, Boston

127 *The Artist in His Museum,;* Charles Willson Peale; 1822 oil on canvas; 262.9 x 203.2 cm Courtesy of the Pennsylvania Academy of the Fine Arts, Philadelphia

128 *Eli Whitney;* Samuel F. B. Morse; 1822 oil on canvas; 90.2 x 70.2 cm Yale University Art Gallery, Gift of George Hoadley

129 *Birth Certificate of Mary E. Motz;* Reverend Young; bet. 1830-1840 watercolor; 32.7 x 20.3 New York State Historical Association, Cooperstown

130 *Politicians at a Country Bar;* James Goodwyn Clooney; 1844 oil on canvas; 43.5 x 53.6 cm New York State Historical Association, Cooperstown

131 (top) *Smith and Dimon Shipyard;* James Pringle; 1833 oil on canvas; 91.4 x 139 cm New York State Historical Association, Cooperstown

131 (bottom) *Patrick Bryant's Oyster Stand;* Nicolino V. Calyo, c. 1840 watercolor; 26.2 x 35.5 cm Museum of the City of New York

132-33 *New York from Brooklyn Heights;* J. W. Hill; 1837 aquatint; 49.8 x 80.6 cm The New York Historical Society, New York

134 *Broadway, New York – Corner of Canal Street to Beyond Niblo's Garden;* Thomas Hornor; 1836 lithograph; The New York Historical Society, New York

135 *Girls' Evening School;* anon.; c. 1840 pencil and watercolor; 34.2 x 46 cm Museum of Fine Arts, Boston, The Karolik Collection

136 *The "Innocent Boy";* anon.; 1836 lithograph; 32.7 x 44.8 cm The New York Historical Society, New York

137 *Ellen Jewett;* anon.; 1836 lithograph; 30.5 x 42.9 cm The New York Historical Society, New York

138 *Return of Rip Van Winkle;* John Quidor; 1829 oil on canvas; 101 x 126.4 cm National Gallery of Art, Washington

139 *Ichabod Crane and the Headless Horseman;* attributed to John William Wilgus; c.1835 oil on canvas; 53.3 x 76.7 cm National Gallery of Art, Washington

140-141 *Sing Sing Camp Meeting;* Joseph B. Smith; c. 1838 hand-colored lithograph; 48.5 x 80 cm Museum of Fine Arts, Boston

142-43 *Niagara Falls;* Samuel F. B. Morse; 1835 oil on canvas; 61 x 76.2 cm Museum of Fine Arts, Boston, The Karolik Collection

144 *Wild Turkey;*
John James Audubon; c. 1827-1838
Lithograph
National Audubon Society

145 *John James Audubon* (detail);
Victor and John Audubon; 1841
oil on canvas; 111.7 x 152.4 cm
American Museum of Natural
History, New York

146-47 *Last of the Mohicans;*
Thomas Cole; 1827
oil on canvas; 63.5 x 88.9 cm
New York State Historical
Association, Cooperstown

148 *The Trapper and His Family;*
Charles Deas; 1840-41
watercolor; 34 x 49.5 cm
Museum of Fine Arts, Boston, The
Karolik Collection

149 (left) *Little Wolf, a famous
warrior, Iowa Tribe;*
George Catlin; between 1831-37
oil on canvas; 73.6 x 61 cm
National Collection of Fine Arts,
Smithsonian Institution

149 (right) *She Who Bathes Her Knees,
Cheyenne Tribe:*
George Catlin; between 1831-37
oil on canvas; 73.6 x 61 cm
National Collection of Fine Arts,
Smithsonian Institution

149 (botton) *Travels Everywhere, a
warrior, Plains Ojibwa Tribe;*
George Catlin; between 1831-37
oil on canvas; 73.6 x 61 cm
National Collection of Fine Arts,
Smithsonian Institution

150 *Running Fight, Sioux and Crows;*
Alfred Jacob Miller; c. 1840
watercolor on brown paper;
20.3 x 29.5 cm
Museum of Fine Arts, Boston, The
Karolik Collection

151 (top) *Hidatsa Village, Earth
Covered Lodges on Knife River;*
George Catlin; between 1831-37
oil on canvas; 28.5 x 36.8 cm
National Collection of Fine Arts,
Smithsonian Institution

151 (bottom) *Sioux Indians on
Snowshoes Lancing Buffalo;*
George Catlin; between 1831-37
oil on canvas; 49.5 x 70.2 cm
National Collection of Fine Arts,
Smithsonian Institution

152 (top) *Scalp Dance;*
James W. Abert; 1845
watercolor and pencil
Courtesy of John Howell-Books,
San Francisco

152 (bottom) *Celebrators;*
James W. Abert; 1845
watercolor and pencil
Courtesy of John Howell-Books,
San Francisco

153 *The Coup Counter;*
James W. Abert; 1845
watercolor and pencil
Courtesy of John Howell-Books,
San Francisco

154 (top) *Militia Training*
James Goodwyn Clooney; 1841
oil on canvas; 71 x 101.6 cm
Courtesy of the Pennsylvania
Academy of the Fine Arts,
Philadelphia

154 (bottom) *Daniel Webster at His
Farm;* anon.; date unknown
oil on canvas; 50.8 x 66 cm
Museum of Fine Arts, Boston

155 *Election Scene at Catonsville;*
Alfred Jacob Miller; 1845
pencil and wash on brown paper;
20.6 x 27.5 cm
Museum of Fine Arts, Boston, The
Karolik Collection

156-57 *Taking of Monterey;*
William Henry Meyers; 1842
watercolor and ink over pencil;
25.9 x 38.3 cm
Reproduced by permission of the
Director, the Bancroft Library,
Berkeley, California

158 *Zachary Taylor;*
William Carl Brown, Jr.; 1847
oil on canvas; 76.2 x 91.4 cm
National Portrait Gallery,
Smithsonian Institution,
Washington, D.C.

159 (top) *Harney's Dragoons Swimming
the Rio Grande;* from *My
Confessions* by Samuel
Chamberlain; 1846
watercolor on paper
Life Magazine, Time Inc.

159 (bottom) *View of Monterrey from
Independence Hill;* from *Mexican
War Lithographs* by Captain D. P.
Whiting; 1847
lithograph
Instituto Nacional de Antropología
y Historia, Mexico City

160 *Opening the Wilderness;*
Thomas P. Rossiter; c. 1846
oil on canvas; 45 x 82.5 cm
Museum of Fine Arts, Boston

161 *Mountain Jack and a Wandering
Miner;* E. Hall Martin; c. 1850
oil on canvas; 182.9 x 97.8 cm
The Oakland Museum, Gift of
Concours d'Antigues Art Guild,
Oakland, California

162 *The Vaquero;*
Hugo W. A. Nahl; c. 1851
oil on canvas; 58.4 x 48.3 cm
The Oakland Museum, Oakland,
California, The Kahn Collection

163 *Roping the Bear;*
James Walker; c. 1850
oil on canvas; 99.1 x 59.1 cm
The Oakland Museum, Oakland,
California

164 (top) *The Way They Go to
California;*
Nathaniel Currier; 1849
hand-colored lithograph;
43.8 x 27.3 cm
The Oakland Museum, Oakland,
California

164 (bottom) *The Way They Come from
California:* Nathaniel Currier; 1849
hand-colored lithograph;
43.8 x 27.3 cm
The Oakland Museum, Oakland,
California

165 *Covered Wagon Camp;*
W. C. Weisel; 1854
watercolor; 17.9 x 21.4 cm
Museum of Fine Arts, Boston, The
Karolik Collection

166-67 *Panning Gold, California;*
William McIlvaine; c. 1849-1856
watercolor over pencil;
47.3 x 69.9 cm
Museum of Fine Arts, Boston, The
Karolik Collection

168 *Washing Gold, Calaveras,
California;* anon.; 1853
gouache; 41 x 55.9 cm
Museum of Fine Arts, Boston, The
Karolik Collection

169 *William D. Peck, Rough and Ready,
California;* Henry Walton; 1853
watercolor; 32.4 x 37.4 cm
The Oakland Museum, Oakland,
California

170-71 *Sunday Morning in the Mines;*
Charles Nahl; 1872
oil on canvas; 182.9 x 274.3 cm
E. B. Crocker Art Gallery,
Sacramento, California

172 *Yosemite Valley;*
Thomas Hill; c. 1860
oil on canvas; 174 x 212.1 cm
The Oakland Museum, Oakland,
California, bequest of Dr. Cecil B.
Nixon

174 (top) *Whaling Off the Coast of
California;* Coleman; c. 1860
colored chalks on prepared board;
51.3 x 74 cm
Museum of Fine Art, Boston, The
Karolik Collection

174 (bottom) *Portrait of Donald McKay;*
anon.; date unknown
daguerreotype
Metropolitan Museum of Art,
New York

175 *Flying Cloud;*
Frank Vining Smith; 1953
oil on canvas; 101.6 x 76.2 cm
From the Fine Arts Collection of
The Seamen's Bank for Savings,
New York

176 *Sansome Street Market, San
Francisco* (detail);
Wilhelm Hahn; c. 1850
oil on canvas; 152.4 x 243.8 cm
E. B. Crocker Art Gallery,
Sacramento, California

178-79 *Burning of the Storeships Manco
and Canonicus;*
Charles Nahl; 1853
oil on canvas; 66 x 97.8 cm
Courtesy of the Fireman's Fund
American Insurance Companies,
San Francisco, California

180-81 *One Sunday, July 18;*
anon.; c. 1850
oil on canvas; 114.3 x 59.7 cm
The Oakland Museum, Oakland,
California

182 *Sioux Encampment;*
Jules Tavernier; c. 1874-1884
oil on canvas; 171.5 x 99 cm
The Oakland Museum, Oakland,
California, The Kahn Collection

183 *Scalp Dance of the Dacotahs;*
Seth Eastman; 1850
watercolor; 21.9 x 30.5 cm
Museum of Fine Arts, Boston, The
Karolik Collection

184-85 *Grand Canyon of the Yellowstone;*
Thomas Moran; 1893
oil on canvas; 243.9 x 426.7 cm
National Collection of Fine Arts,
Smithsonian Institution,
Washington, D.C.

186-87 *Fort Defiance II;*
Seth Eastman; c. 1850
watercolor; 14.8 x 24.3 cm
Museum of Fine Arts, Boston, The
Karolik Collection

188-89 *Hudson Bay Trading Post on
Flathead Indian Reservation,
Montana Territory;*
Peter Petersen Tofft; c. 1860
watercolor; 15.2 x 23 cm
Museum of Fine Arts, Boston, The
Karolik Collection

190 *Taking the Census;*
Francis William Edmonds; 1854
oil on canvas; 71.1 x 96.5 cm
From the Whitney Museum of
American Art's exhibit "The
Painters' America"; Private
Collection

191 *Broadway and Spring Street;*
Hyppolite Sebron; 1855
oil on canvas; 74.3 x 108 cm
From the Whitney Museum of
American Art's exhibit "The
Painters' America"; Graham and
Schweitzer Gallery, New York

192 *Revival Meeting;*
Jeremiah Paul; c. 1850
oil on panel; 71 x 47.5 cm
Ira Spanierman Collection,
New York

193 *Independence – Squire Jack Porter;*
Frank B. Mayer; 1858
oil on composition board;
30.5 x 40.3 cm
National Collection of Fine Arts,
Smithsonian Institution,
Washington, D.C.

194 *The Book Bindery;* anon.; 1852
pencil and watercolor;
15.2 x 22.5 cm
Museum of Fine Arts, Boston, The
Karolik Collection

195 (top) *Women Playing Billiards;*
anon.; date unknown
lithograph; 54 x 78.7 cm
The New York Historical Society,
New York

195 (bottom) *L. J. Levy & Co.'s Dry
Goods Store;*
Max Rosenthal; c. 1857
lithograph; 55.9 x 67.9 cm
The New York Historical Society,
New York

196 *The Suspension Bridge;*
anon.; 1855
oil on canvas; 76.8 x 99 cm
Museum of Fine Arts, Boston

197 (top) *Steamer Niagara Passing Fort
Washington;* James Bard; 1852
oil on canvas; 91.4 x 142.2 cm
New York State Historical
Association, Cooperstown

197 (bottom) *Saddled Horse, Moving to
the Left;* C. Scherich; 1851
ink and watercolor; 45.7 x 58.6 cm
Museum of Fine Arts, Boston, The
Karolik Collection

198 *After a Long Cruise (Salts Ashore);*
John Carlin; 1857
oil on canvas; 50.8 x 76.2 cm
From the Whitney Museum of
American Art's exhibit "The
Painters' America"; Metropolitan
Museum of Art, New York

199 *On to Liberty;*
Theodor Kaufmann; 1867
oil on canvas; 91.4 x 142.2 cm
From the Whitney Museum of
American Art's exhibit "The
Painters' America"; Hirschl and
Adler Galleries, New York

200 *Slave Market in Richmond,
Virginia;* Eyre Crowe; 1852
oil on canvas; 55.2 x 81.3 cm
From the Whitney Museum of
American Art's exhibit "The
Painters' America"; Collection of
Hon. and Mrs. John Heinz III,
Washington, D.C.

201 *Slaves Escaping Through the
Swamp* (detail);
Thomas Moran; 1863
oil on canvas; 86.4 x 111.8 cm
From the Whitney Museum of
American Art's exhibit "The
Painters' America"; Philbrook Art
Center, Tulsa, Oklahoma

203 *The Bone Player;*
William Sidney Mount; 1856
oil on canvas; 91.4 x 73.6 cm
Museum of Fine Arts, Boston

204 (top) *Sketch of Ships of Perry
Expedition;* anon.; 1854
color on paper
University of Tokyo

204 (bottom) *Townsend Harris meeting
with representatives of the
Tokugawa Shogunate;* anon.; 1857
color on paper
Tsuneo Tamba Collection,
Yokohama, Japan

205 *Lincoln Reading the Emancipation
Proclamation to His Cabinet*
(detail); Alonzo Chappel; c. 1862
oil on paper; 41 x 55.9 cm.
Museum of Fine Arts, Boston, The
Karolik Collection

206 *Lincoln Crushing the Dragon of
Rebellion:* David G. Blythe; 1862
oil on canvas; 45.7 x 55.8 cm
Museum of Fine Arts, Boston,

207 *Zouaves at Astor House, New York
City;* unknown; 1860
oil on canvas; 66 x 82.2 cm
New York State Historical
Association, Cooperstown

208 *Confederate Blockade Runner and
Union Man-of-War;*
F. Mullen; 1861
oil on canvas; 58.4 x 91.1 cm.
National Gallery of Art,
Washington, gift of Edgar M. and
Bernice Chrysler Garbisch

209 (top) *The Mississippi in Time of
War;* Fanny Palmer; 1862
pencil, watercolor and gouache;
45.9 x 71.1 cm.
Museum of Fine Arts, Boston, The
Karolik Collection

209 (Bottom) *Monitor and the
Merrimac;* Alexander G. Stuart;
Courtesy of Jay P. Altmayer,
Mobile, Alabama

210-11 *The Army of the Potomac* (detail);
James Hope; 1863
oil on canvas; 45 x 86 cm
Museum of Fine Arts, Boston

212 (top) *The Letter Home;*
Eastman Johnson; 1867
oil on canvas; 58.4 x 69.8 cm
Museum of Fine Arts, Boston

212 (bottom) *Home, Sweet Home;*
Winslow Homer; c. 1863
oil on canvas; 53.3 x 40 cm.
From the Whitney Museum of
American Art's exhibit "The
Painters' America"; Collection of
Mrs. Nathan Shaye, Detroit,
Michigan

213 *Emancipation Proclamation;*
A. A. Lamb; c. 1863
oil on canvas; 82.2 x 137.2 cm.
National Gallery of Art,
Washington

214-15 (top) *Battle of Gettysburg* (detail);
James Walker;
Courtesy of Jay P. Altmayer,
Mobile, Alabama

215 (bottom) *The Battle of Gettysburg;*
David G. Blythe; 1863
oil on canvas; 66 x 88.6 cm
Museum of Fine Arts, Boston

216 *Sherman's March Through Georgia,
1864;* Andrew B. Carlin; 1871
oil on canvas; 88.9 x 120.6 cm
Mrs. McCook Knox, Washington, D.C.

217 *The Statue of Liberty Enlightening
the World* (detail);
Edward Moran; 1886
oil on canvas; 100.3 x 125.7 cm
Museum of the City of New York,
The J. Clarence Davies Collection

218 (top) *On "Muster Day" at the
Agency;*
Paul Frenzeny; c. 1873-1880
gouache and wash on buff paper;
35.7 x 50.3 cm.
Museum of Fine Arts, Boston, The
Karolik Collection

218 (bottom) *Custer's Fight on the
Washita with Black Kettle and the
Cheyennes;*
Ho-gŏn (Silver Horn); 1868
painting on muslin;
105.4 x 165.1 cm
Southwest Museum, Pasadena,
California

219 *The Big Medicine Man;*
Paul Frenzeny; between 1873-1880
pencil, watercolor, gouache on
paper; 31.8 x 47.3 cm
Museum of Fine Arts, Boston, The
Karolik Collection

220-21 *Battle of Little Big Horn;*
Kicking Bear; 1898
watercolor on muslin;
91.4 x 180.3 cm
Southwest Museum, Pasadena,
California

222 *Indian Village Routed;*
Frederic Remington; 1896
oil on canvas; 68.6 x 101.6 cm
Courtesy of Coe Kerr Gallery, Inc.,
New York

223 *Trail of the Iron Horse;*
Charles Russell; c. 1910
watercolor and pencil;
15.2 x 22.9 cm
Collection of Mr. and Mrs. S. H.
Rosenthal, Jr., California

224 *Driving the Last Spike;*
Thomas Hill; 1881
oil on canvas
Courtesy of the State of California,
Department of Commerce

225 (top) *Purchase of Alaska;*
Emanuel Leutze; 1867
oil on canvas; approx. 152 x 121 cm
Courtesy of the State of Alaska,
Division of Tourism

225 (bottom) *The Unaslaska S. O.
Hunting Fleet;*
Willie Peterson; 1896
watercolor
Courtesy of the Alaska State
Museum, Juneau, Alaska

226 *In the Land of Promise – Castle
Garden;* Charles Ulrich; 1884
oil on canvas; 72 x 90 cm
From the Whitney Museum of
American Art's exhibit "The
Painters' America"; Corcoran
Gallery, Washington

227 *First Sight of Land;*
Henry Bacon; 1877
oil on canvas; 72.4 x 49.8 cm
From the Whitney Museum of
American Art's exhibit "The
Painters' America"; Collection of
Mr. and Mrs. John Baur, Katonah,
New York

228 *Statue of Liberty on the Rue de
Chazelles,* Paris;
Victor Dargaud; 1884
oil on canvas
Musée Carnavalet, Paris

229 *The Statue of Liberty Enlightening
the World;* Edward Moran; 1886
oil on canvas; 100.3 x 125.7 cm
Museum of the City of New York,
The J. Clarence Davies Collection

230 *Walt Whitman;*
Thomas Eakins; 1887
oil on canvas; 76.2 x 61 cm
Courtesy of the Pennsylvania
Academy of the Fine Arts,
Philadelphia

231 (top) *The Lawrence Room, Museum
of Fine Arts, Boston;*
Enrico Meneghelli; 1879
oil on masonite; 40.6 x 50.8 cm
Museum of Fine Arts, Boston

231 (bottom) *Mark Twain;*
Carroll Beckwith; 1890
oil on canvas; 45.7 x 61 cm
Mark Twain Memorial, Hartford,
Connecticut

232 *The Yacht Namouna in Venetian
Waters;* Julius Stewart; 1890
oil on canvas; 142.2 x 195.6 cm
From the Whitney Museum of
American Art's exhibit "The
Painters' America"; Wadsworth
Atheneum, Hartford, Connecticut

233 *Jules Harder, First Chef of the
Palace Hotel;*
Joseph Harrington; 1874
oil on canvas; 72.4 x 90.2 cm
The Oakland Museum, Oakland,
California

234 *Kept In;* Edward L. Henry; 1888
oil on canvas; 34.3 x 45.1 cm
New York State Historical
Association, Cooperstown

235 *Mary and Mammy;*
Sarah Eakin Cowan; c. 1900
watercolor on ivory; 13.3 x 10.2 cm
National Collection of Fine Arts,
Smithsonian Institution,
Washington, D.C.

236 *The Bulls and Bears in the Market*
(detail); William H. Beard; 1879
oil on canvas; 97.5 x 152.4 cm
The New York Historical Society,
New York

237 *The Senators;* Louis Moeller; 1890
oil on canvas; 20.3 x 25.4 cm
Courtesy of Goldfield Galleries,
Los Angeles

238-39 *The Strike* (detail);
Robert Koehler; 1886
oil on canvas; 181.6 x 275.6 cm
From the Whitney Museum of
American Art's exhibit "The
Painters' America"; Collection of
Lee Baxandall, New York

240-41 *Oklahoma Land Rush;*
John S. Curry; 1938
oil on canvas; 72.1 x 150.5 cm
National Gallery of Art,
Washington

242 (top) *Trotting Stallions* (detail);
1858
lithograph by Currier & Ives

242 (bottom) *A Hot Race from the Start*
(detail);
Louis Maurer; between 1853-1893
pencil and wash on colored paper;
45.7 x 73.7 cm
Museum of Fine Arts, Boston, The
Karolik Collection

243 (top) *Bear Hunting, Prospect Park,
Essex County, New York;*
Winslow Homer; 1892
watercolor; 34.3 x 48.3 cm
National Collection of Fine Arts,
Smithsonian Institution,
Washington, D.C.

243 (bottom) *Will Schuster and
Blackman Going Shooting for Rail;*
Thomas Eakins; 1876
oil on canvas; 56.2 x 76.8 cm
From the Whitney Museum of
American Art's exhibit "The
Painters' America"; Yale
University Art Gallery

244 (left) *Between Rounds;*
Thomas Eakins; 1899
oil on canvas; 127.6 x 101.6 cm
From the Whitney Museum of
American Art's exhibit "The
Painters' America"; Philadelphia
Museum of Art

244 (right) *Second Madison Square
Garden;*
W. Louis Sonntag, Jr.; 1895
watercolor; 44.5 x 61.9 cm
Museum of the City of New York

245 *Teddy's Rough Riders;*
W. G. Read; 1898
Library of Congress

246-47 *The Battle of Cuasimas Near
Santiago, June 24th, 1898, The 9th
and 10th Colored Cavalry;*
Kurtz & Allison; 1899
lithograph
Library of Congress

248 *Thomas Alva Edison;*
Abraham A. Anderson; c. 1889
oil on canvas; 113.7 x 133.4 cm
National Portrait Gallery,
Smithsonian Institution,
Washington, D.C.

249 *A Drink of Water;*
Gerrit A. Beneker; 1911
oil on canvas; 91.4 x 61 cm
Courtesy of Edward L. Shein,
Providence, Rhode Island

250 (top) *Gray and Brass;*
John Sloane; 1907
oil on canvas; 55.8 x 68.9 cm
Courtesy of Arthur G. Altschul,
New York

250 (bottom) *Tourists, New Mexico;*
Boardman Robinson; c. 1933-37
watercolor; 45.7 x 43.8 cm.
Los Angeles County Museum of
Art, The Mr. and Mrs. William P.
Harrison Collection

251 *The Narrow Pass;*
John Marchand; 1906
oil on canvas; 66 x 45.7 cm
Courtesy of Goldfield Galleries, Los
Angeles

252 *Ford;* 1910
photograph; 20.3 x 25.4 cm
by Bradley Smith

253 *Henry Ford portrait;*
Wilbur Fiske Noyes; 1931
oil on canvas; 83.8 x 115.6 cm
Courtesy of Ford Motor Company

254 *The Old Locomotive;*
Lyonel Feininger; 1910
oil on canvas; 50.2 x 100.3 cm
Courtesy of E. V. Thaw, New York

255 *Movies Five Cents;*
John Sloane; 1907
oil on canvas; 59.6 x 80 cm
Herbert A. Goldstone Collection,
New York

256-57 *Canal Bottom at Culebra;*
Jonas Lie; 1913
oil on canvas; 76.2 x 91.4 cm
West Point Museum, U.S. Military
Academy

258 *The Docks, New York City;*
Everett Shinn; 1901
pastel; 39.3 x 55.9 cm
Munson-Williams-Proctor
Institute, Utica, New York

259 *The Miner;*
George Benjamin Luks; 1925
oil on canvas; 153.1 x 128 cm
National Gallery of Art,
Washington, gift of Chester Dale

260 (top left) *Constructive Radical;*
Gerrit A. Beneker; 1920
oil on canvas; 61 x 50.8 cm
Courtesy of Edward L. Shein,
Providence, Rhode Island

260 (top right) *Declarant;*
Gerrit A. Beneker; 1919
oil on canvas; 45.7 x 40.6 cm
Courtesy of Edward L. Shein

260 (bottom left) *Jules Tournier, the
Inventor;* Gerrit A. Beneker; 1924
oil on canvas; 76.2 x 63.5 cm
Courtesy of Edward L. Shein

260 (bottom right) *Rufus Payne, Safety
First;* Gerrit A. Beneker; 1921
oil on canvas; 91.4 x 76.2 cm
Courtesy of Edward L. Shein

261 *The Test;* Gerrit A. Beneker; 1920
oil on canvas; 91.4 x 81.3 cm
Courtesy of Edward L. Shein

262 *Allies Day, May 1917;*
Childe Hassam; 1917
oil on canvas; 92 x 76.8 cm
National Gallery of Art,
Washington, gift of Ethelyn
McKinney

263 *Armistice Night 1918;*
George Benjamin Luks; 1918
oil on canvas; 94 x 174.6 cm
Whitney Museum of American Art

264 *Morning News;*
Francis Luis Mora; c. 1912
oil on canvas; 29.8 x 40.6 cm
Fine Arts Gallery of San Diego,
California

265 *The Passion of Sacco and Vanzetti;*
Ben Shahn; 1931-32
tempera on canvas;
214.6 x 121.9 cm
Whitney Museum of American Art

266-67 *Lindbergh-New York to Paris;*
unknown; 1927
tapestry; 142.2 x 48.2 cm
San Diego Aero-Space Museum,
California

268 *Sixth Avenue Elevated at Third
Street;* John Sloane; 1928
oil on canvas; 76.2 x 101.6 cm
Whitney Museum of American Art

269 *The Senator;* Joseph Hirsch; 1941
oil on canvas; 40.6 x 81.28 cm
Whitney Museum of American Art

270-71 *Rainy Night (Broadway and Elliott
Streets, Buffalo, N.Y.);*
Charles E. Burchfield; 1930
watercolor; 81.3 x 111.8 cm
Fine Arts Gallery of San Diego,

272-73 *Riot in Union Square, March 6,
1930;* Peter Hopkins; 1947
oil on canvas; 94 x 122 cm
Museum of the City of New York

274 *Through the Mill;*
Philip Evergood; 1940
oil on canvas; 91.4 x 132 cm
Whitney Museum of American Art

275 *River Rouge Plant* (detail);
Charles Sheeler; 1932
oil on canvas; 50.8 x 60.9 cm
Whitney Museum of American Art

277 *Franklin D. Roosevelt;*
Jo Davidson; 1934; bronze
Courtesy of Franklin D. Roosevelt
Library, Hyde Park, New York

278 *City Activity with Subway* (detail);
Thomas Hart Benton; c. 1930
egg tempera wall mural;
408.9 x 231.1 cm
New School for Social Research,
New York

279 *Coney Island* (detail);
Paul Cadmus; 1934
oil on canvas; 81.9 x 92.1 cm
Los Angeles County Museum of Art

280 *League of Women Voters;*
Guy Pene DuBois; c. 1930
oil on canvas; 50.8 x 60.9 cm
Goldfield Galleries, Los Angeles

281 *Dinner for Threshers (section II);*
Grant Wood; 1933
pencil on brown paper; 45 x 67.9 cm
Whitney Museum of American Art

282-83 *Twenty Cent Movie, 1936;*
Reginald Marsh; 1936
egg tempera on board;
76.2 x 101.6 cm
Whitney Museum of American Art

284 (left) *George Washington Carver*
Betsy Graves Reyneau; 1942
oil on canvas; 112.4 x 88.9 cm
National Portrait Gallery,
Smithsonian Institution,

284 (right) *Paul Robeson;*
Betsy Graves Reyneau; 1943-44
oil on canvas; 127.6 x 96.5 cm
National Portrait Gallery,
Smithsonian Institution,

285 *Share Croppers;*
Robert Gwathmey; c. 1939
watercolors; 45 x 32.4 cm
Fine Arts Gallery of San Diego,

286 *Allied Flotilla off Normandy Coast
during Invasion;*
Muller-Linow; 1944
watercolor; 59 x 74.9 cm
U.S. Army
Audio-Visual Agency

287 (top) *After the Battle, Namur;*
Colonel Donald L. Dickson; 1946
watercolor; 45.7 x 61 cm
U.S. Marine Corps Art Collection

287 (bottom) *Truman and His Military
Advisors;* Augustus Tack; 1949
oil on canvas; 242.5 x 246.4 cm
National Portrait Gallery,
Smithsonian Institution,

SELECTED BIBLIOGRAPHY

Alden, John R., *History of the South III, The South in the Revolution, 1763-1789.* Louisiana State University Press, Baton Rouge, La., 1957.

Bailey, Thomas A., *The American Pageant.* D. C. Heath and Company, Boston, 1956.

Bailyn, Bernard, *Pamphlets of the American Revolution,* vol. 1, (1750-1765). Belknap Press of Harvard University Press, Cambridge, Mass., 1965.

Beebe, Lucius and Charles Clegg, *The American West.* E. P. Dutton & Co., New York, 1955.

Beebe, Lucius and Charles Clegg, *U.S. West – The Saga of Wells Fargo.* E. P. Dutton & Co., New York, 1949.

Beer, G. L., *British Colonial Policy (1754-1765).* Peter Smith, Gloucester, Mass., 1958.

Boxer, Charles R., *The Dutch Seaborne Empire: 1600-1800;* in J. H. Plumb ed., *The History of Human Society.* Alfred A. Knopf, New York, 1965.

Burroughs, John, *John James Audubon.* Small, Maynard & Co., Boston, 1902.

Butterfield, Roger, *The American Past.* Simon & Schuster, Inc., New York, 1966.

Chamberlain, Samuel E., *My Confession.* Harper & Brothers, New York, 1956.

Crouse, Russel, *Murder Won't Out.* Doubleday, Doran & Co., Inc., Garden City, N.Y., 1932.

Donnelly, Joseph P., S.J., tr., *Wilderness Kingdom, The Journals and Paintings of Nicolas Point,* S.J. Holt, Rinehart and Winston, New York, 1967.

Drucker, Philip, *Indians of the Northwest Coast.* The Natural History Press, Garden City, N.Y., 1955.

Galvin, John, *Through the Country of the Comanche Indians.* John Howell Books, San Francisco, 1970.

Gardner, Alexander, *Gardner's Photographic Sketch Book of the Civil War.* Dover Publications, New York, 1959.

Glaab, Charles N., *The American City: A Documentary History.* The Dorsey Press, Inc., Homewood, Ill., 1963.

Greenway, John, ed., *Folklore of the Great West.* American West Publishing Co., Palo Alto, Calif., 1969.

Hanna, Archibald and William H. Goetzmann, eds., *The Lewis and Clark Expedition,* 3 vols. J. B. Lippincott Co., Philadelphia, 1961.

Herndon, Booton, *Ford.* Weybright & Talley, New York, 1969.

Hofstadter, Richard, ed., *Great Issues in American History from the Revolution to the Civil War, 1765-1865.* Vintage Books, New York, 1958.

Great Issues in American History: From Reconstruction to the Present Day, 1864-1969. Vintage Books, New York, 1958.

Hudson, Winthrop S., *Religion in America.* Charles Scribner's Sons, New York, 1965.

Kouwenhoven, John A., *The Colombia Historical Portrait of New York.* Doubleday & Co., Inc., Garden City, N.Y., 1953.

Larkin, Oliver W., *Samuel F. B. Morse and American Democratic Art.* Little, Brown and Co., Boston and Toronto, 1954.

Lens, Sidney, *The Forging of the American Empire.* Thomas Y. Crowell Co., Inc., New York, 1971.

Lorant, Stefan, ed., *The New World, The First Pictures of America.* Duell, Sloan & Pearce, New York, 1946.

Mabee, Carleton, *The American Leonardo, A Life of Samuel F. B. Morse.* Alfred A. Knopf, New York, 1943.

MacKay, Douglas, *The Honourable Company: A History of the Hudson's Bay Company.* McClelland & Stewart, Toronto, Canada, 1948.

Martin, Quimby & Collier, *Indians Before Columbus.* University of Chicago Press, Chicago, Ill., 1967.

Mather, Frank Jewett, Jr., *Estimates in Art.* Books for Libraries Press, Freeport, N.Y., 1931.

Mendelowitz, Daniel M., *A History of American Art,* 2nd ed. Holt, Rinehart and Winston, New York, 1970.

Miller, Lillian B., et al., *In the Minds and Hearts of the People, Prologue to the American Revolution 1760-1774.* New York Graphic Society, Greenwich, Conn., 1974.

Morison, Samuel Eliot, *The European Discovery of America: The Southern Voyages A.D. 1492-1616.* Oxford University Press, New York, 1974.

Morison, Samuel Eliot, *The Oxford History of the American People.* Oxford University Press, New York, 1965.

Morse, Jedidiah, *Annals of the American Revolution.* Kennikat Press, Port Washington, N.Y., 1968 reissued.

O'Crouley, Pedro Alonso, *A Description of the Kingdom of New Spain.* Tr. and ed. by Seán Galvin. John Howell Books, San Francisco, 1972.

Parry, Elwood, *The Image of the Indian and the Black Man in American Art 1590-1900.* George Braziller, Inc., New York, 1974.

Pierson, William H., Jr. and Martha Davidson, eds., *The Arts of the United States, A Pictorial Survey.* University of Georgia Press, Athens, Georgia, 1960.

Poesch, Jessie, *Titian Ramsey Peale 1799-1885 and His Journals of the Wilkes Expedition.* The American Philosophical Society, Philadelphia, 1961.

Pourade, Richard F., *The Explorers – The History of San Diego.* Union Tribune Publishing Co., San Diego, Calif., 1960.

Rauch, Basil, ed., *The Roosevelt Reader.* Holt, Rinehart and Winston, New York, 1957.

Roland, Charles P., *The Confederacy.* University of Chicago Press, Chicago, Ill., 1960.

Rose, J. Holland, ed., *The Cambridge History of the British Empire.* The University Press, Cambridge, England, 1929.

Santa Maria, Father, *The First Spanish Entry into San Francisco Bay, 1775,* tr. and ed. by John Galvin. John Howell Books, San Francisco, 1971.

Scott, John Anthony, ed., *The Diary of the American Revolution 1775-1781,* compiled by Frank Moore. Washington Square Press, New York, 1967.

Sloane, William Milligan, Ph.D., L.H.D., *The French War and the Revolution.* Charles Scribner's Sons, 1893.

Smith, Bradley, *Columbus in the New World.* Doubleday & Co., Inc., Garden City, N.Y., 1962.

Untermeyer, Louis, *Makers of the Modern World.* Simon & Schuster, Inc., New York, 1955.

Ver Steeg, Clarence L. and Richard Hofstadter, eds., *Great Issues in American History from Settlement to Revolution, 1584-1776.* Vintage Books, New York, 1969.

Wells, Peter, *American War of Independence.* Funk & Wagnalls, New York, 1967.

Wish, Harvey, *Society and Thought in Early America,* vols. 1 and 2. David McKay Co., Inc., New York, 1950.